FROM YOUR FRIENDS
AT
HUSKY

AFRICA

ART WOLFE

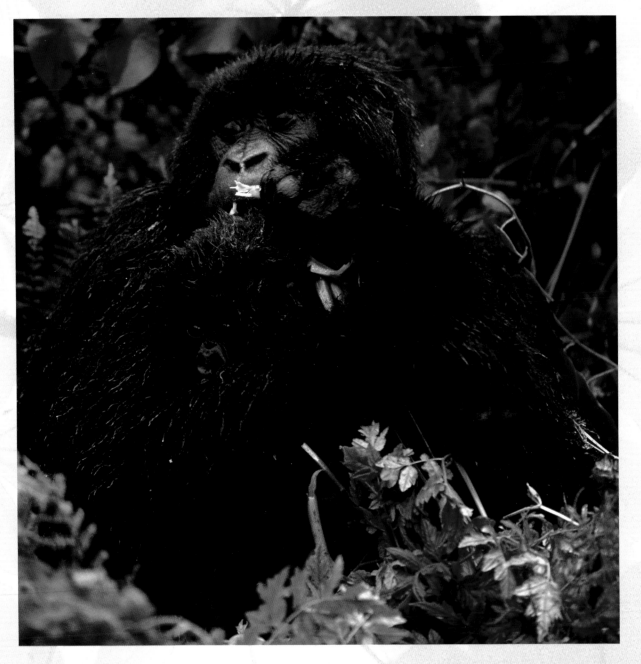

WILDLANDS PRESS™

FOREWORD BY JANE GOODALL **TEXT BY MICHELLE A. GILDERS**

GARY M. STOLZ, SCIENCE ADVISOR

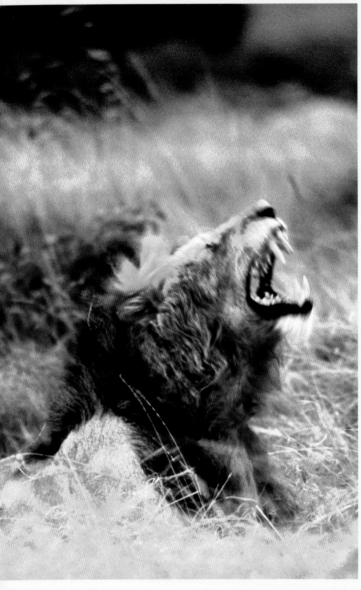

LION (*Panthera leo*),
KRUGER NATIONAL PARK, SOUTH AFRICA

The first time I visited Africa, in November 1980, I went with friends to climb Tanzania's Mount Kilimanjaro and to tour the Ngorongoro Crater and the fabled Serengeti. From a starting point on East Africa's high plains at 4,000 feet (1,219 meters), we reached the 19,340-foot (5,895-m) summit of Kilimanjaro in just four days. Even after many treks in the high Himalaya, my climb of Mount Kilimanjaro remains one of the most difficult climbs I have ever done, simply because we allowed ourselves no time to acclimatize to the altitude.

In 1980 East Africa was in violent turmoil. Tanzania was virtually at war with Idi Amin's Uganda. It had closed its border with Kenya after Kenya harbored several of Amin's supporters. The economy continued to deteriorate with cycles of floods and droughts. Travelers intrepid enough to tour the region at all would fly into Nairobi and visit only the parks and preserves within Kenya, which was relatively safe thanks to the oppressive regime of Daniel arap Moi. Very few people ventured south to Tanzania, which at that time was a militant socialist state. We did, however, flying directly into Moshi, the Tanzanian provincial capital near Kilimanjaro.

After descending the mountain, we rented a car and traveled west. The lodges we visited were deserted—completely unlike today. Our first stop was the Ngorongoro Crater, a vast volcanic depression, habitat for legions of animals. In 1980 we could still camp inside the crater. We pitched our tents at the base of the crater's rim. During the first night a pride of lions came right through our camp. Several roared to other members of the pride in the distance. The sound of a roaring lion no more than fifteen feet away, in the darkness of night, separated from you by only a flimsy tent wall is unnerving. But it was a grand introduction to the wildlife of Africa and left an indelible impression on me.

Since that first trip to Mount Kilimanjaro, I have returned to Africa twenty-five times and visited more than a dozen countries, all primarily to film the wildlife. On a few occasions I have had the great fortune to document the extraordinary indigenous cultures of Africa. Sadly, as the entire world races toward industrialization, many, such as Botswana's San Bushmen, are themselves endangered like so much of the continent's wildlife. The plight of the San is an all-too-typical example of what has happened to so many indigenous peoples in Africa and all around the world. The government of Botswana has exercised a policy of relocating the once-nomadic San to a few small settlements along the periphery of the same desert they roamed freely for untold generations. The resettled San have been forced to join the prevailing culture, abandoning completely their traditional way of life.

In June 1993, I accompanied a guide to the Kalahari Desert to one of these small San settlements occupied by a band that still regularly returned to the desert to hunt as they always have. We accompanied them on one of their forays. We watched as they collected water from the most unlikely places, as they made snares and poison arrows. We ended the day around a warming fire. At night, in the clear air of the high desert, the temperature fell to just 20°F (−6°C). The water bottles in our tents actually froze. The San, after cooking their dinner, slept among the embers of the cook fire—miraculously without burning themselves. I was very impressed. The entire day was eye opening. Here we were in this desolate landscape, yet the San were so attuned to this land and its plants and animals that they could survive there.

Two years later, my fellow photographer, Gavriel Jecan, and I traveled to the arid Omo River region of Ethiopia to photograph the tribes along the north side of the river. The people here live a nomadic life with their herds of goats and cattle. Finding forage for their animals is of utmost concern; the livestock translate to wealth and life itself. Consequently, all the tribes of the region are at odds over the best grazing lands. Often we found ourselves traveling from one village to another only to find that the two villages were at war. It was an amazing journey. It laid the foundation for my book *Tribes*, which recorded the facial decorations of these peoples and native peoples worldwide. I simply had to share all that I saw in Ethiopia and among indigenous cultures around the world.

Africa is faced with so many problems—droughts, famines, political turmoil, poverty, and disease. We see these featured in the news every day. Yet Africa remains one of the most amazingly positive places I have ever visited and the wildlife is unlike any I have seen anywhere else, in terms of both abundance and diversity. The landscapes are so sweeping and expansive. Africa is earthy and alive like nowhere else on Earth.

All of us must help Africa in any way we can to overcome the many challenges its people and wildlife face today. I hope this book and my ongoing photography in Africa can help the world see how much is really at stake. We must all act now while there is still time to ensure the future of Africa's fantastic cultural diversity and incredible array of wildlife. I hope you will use the Resource List at the back of this book to learn more about and to lend your support to the many very important non-governmental organizations listed there that are working for Africa and its richness.

The most amazing fact is that regardless of all the dire news coming out of Africa, it really is not too late to make a difference. Conservation efforts are already paying off for both the continent's native peoples and its wildlife. Despite all the challenges, there is hope. And there is so very much at stake.

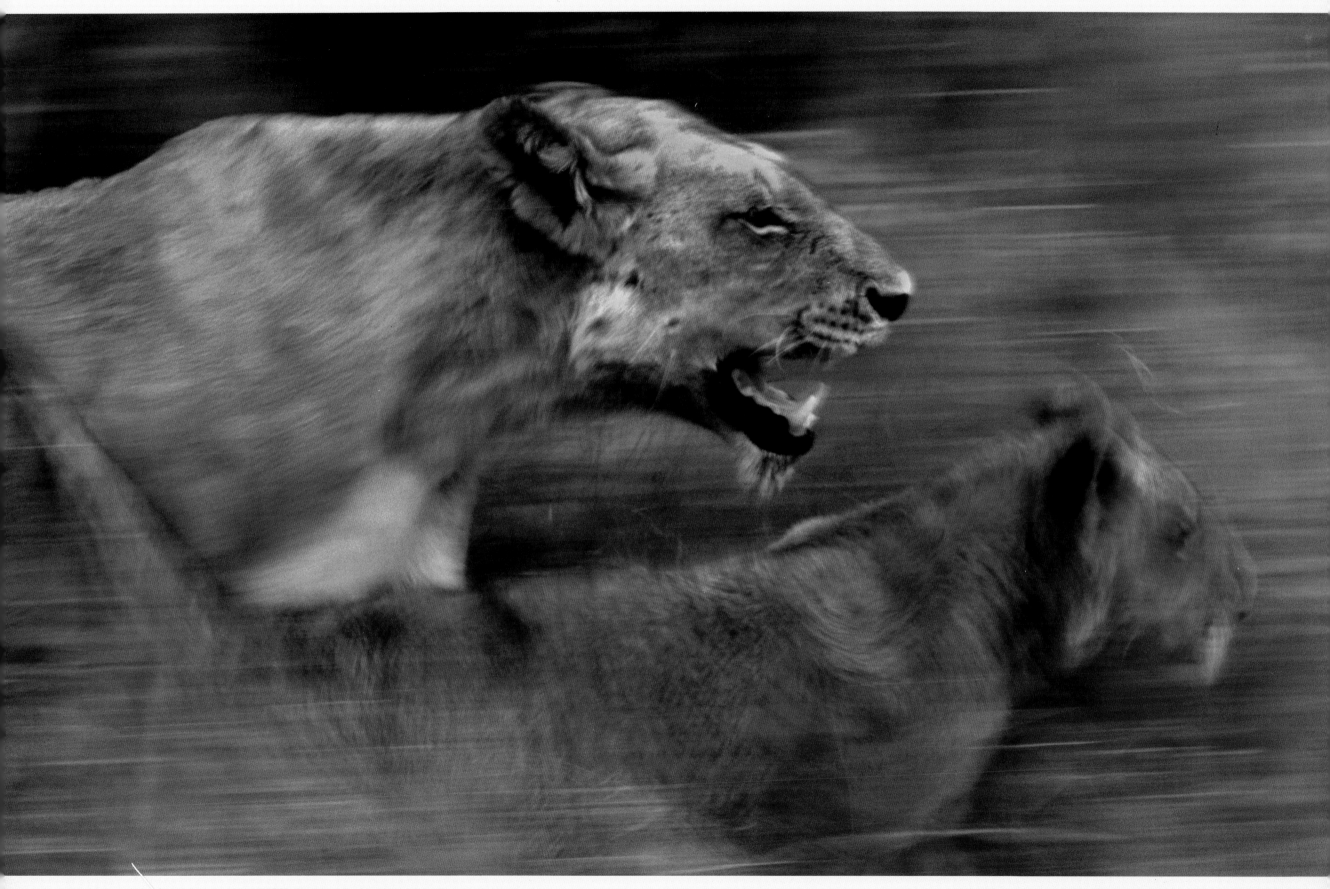

LION (Panthera leo), SABI SANDS GAME RESERVE, SOUTH AFRICA

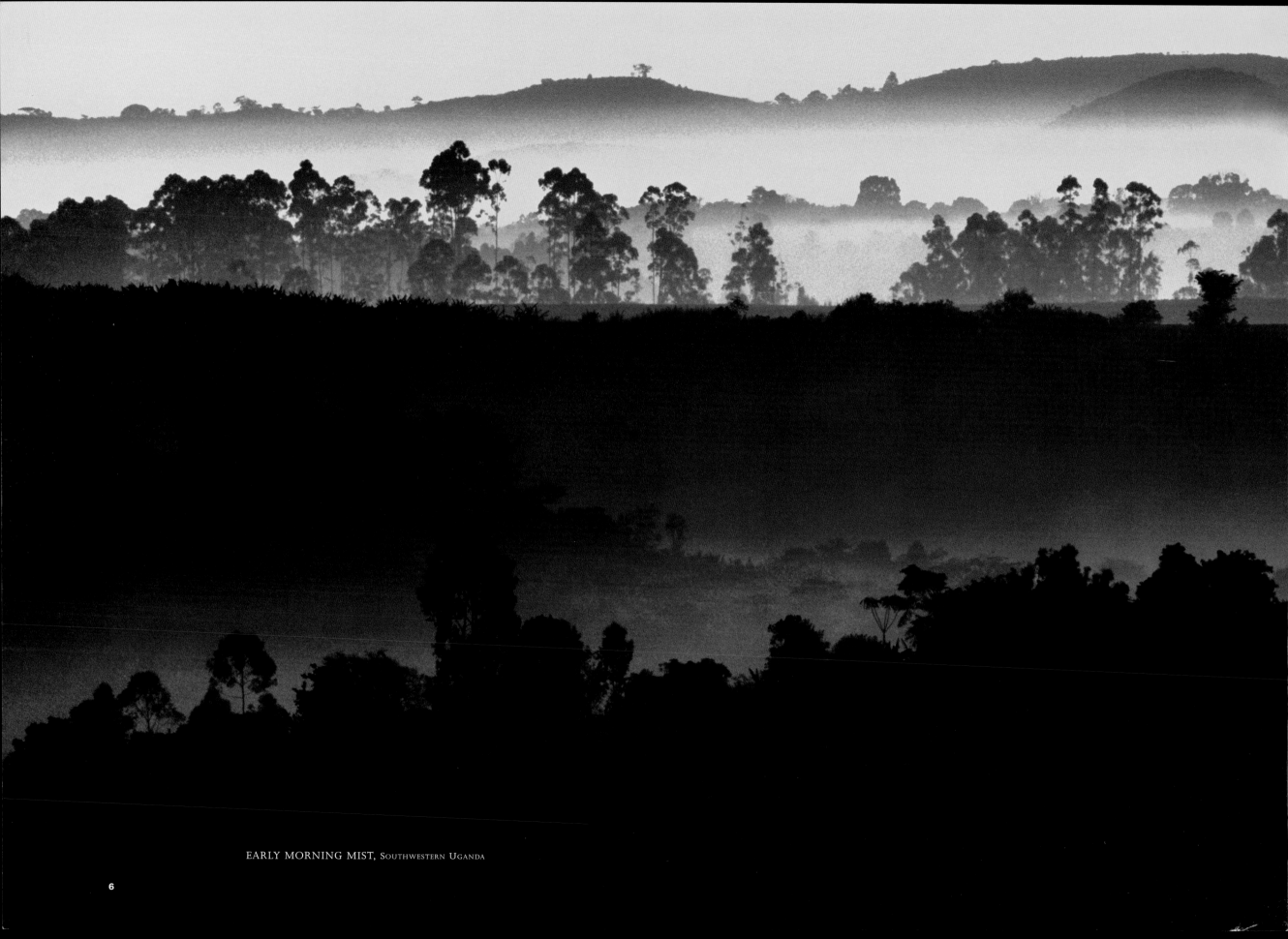

EARLY MORNING MIST, Southwestern Uganda

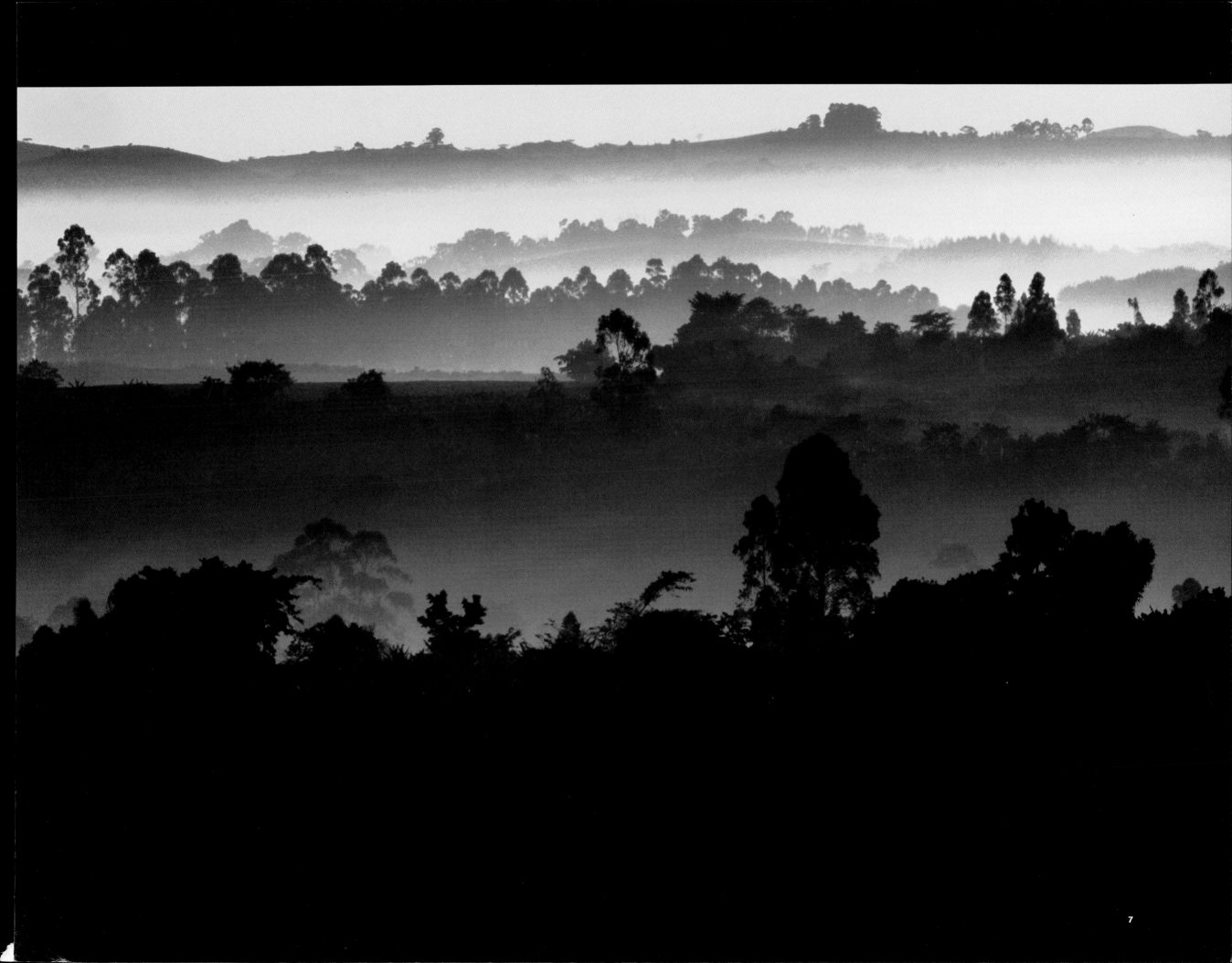

SURMA TRIBE, LOWER OMO RIVER, ETHIOPIA

Africa became important to me when I was about eight years old, when I read the Doctor Doolittle books—about the English doctor who learned the languages of all animals from his parrot Polynesia, then went on a voyage to Africa. And then I discovered Tarzan. Not Johnny Weissmuller's Tarzan, but the "real" Tarzan—Edgar Rice Burrough's Lord of the Jungle. I fell in love. I was passionately jealous of Tarzan's Jane—an utter wimp, I thought. How much better a mate I should have been!

When I eventually got to Africa, I was twenty-three years old. It was 1957 and the continent was very different from the Africa of today. Admittedly the teeming wildlife, the huge herds of animals that roamed the plains when the first European settlers arrived, had already been decimated. But there were still a lot of animals around, and there were still miles and miles of wilderness stretching from east to west, north to south.

I heard about Louis Leakey, the famed anthropologist, and went to see him. He gave me a job as his assistant at what is now the National Museum (then it was the Coryndon Museum of Natural History). I learned all I could from the museum staff, and I traveled to incredible places. In those days the wild country stretched, unbroken, way beyond the Ngong Hills. Karen Blixen made the area famous with her *Out of Africa*. For me, it was *into* Africa!

Then came what was one of the most magical experiences of my whole life—I was allowed to join a small expedition to Olduvai Gorge on the Serengeti Plains. The Leakeys used to go to the site for a few months every summer in search of fossils. Louis, with his lifelong commitment to unraveling our prehistoric past, had been alerted to the potential of Olduvai when a German butterfly hunter fell down one of the steep slopes of the gorge and found himself lying among all manner of fossils. With great presence of mind, despite a broken leg, he stuffed some of the bones in his pocket and later delivered them to Louis. That site has now yielded some very famous hominid fossils such as *Australopithecus boisei*, the "Nutcracker Man." But when I was there during that enchanted summer, the first hominid finds had yet to be made, and Olduvai was not famous at all. Instead, during their three-month-long digs, the Leakeys had found only giant pigs and baboons; cevatherium, the ancestral giraffe; equids the size of rabbits; saber-toothed tigers; and other such prehistoric creatures.

Olduvai was utterly remote. No road, no mark of any vehicle scarred the golden plains. So many animals were there, living as they had for countless centuries, in harmony with the Maasai people. Sometimes two or three young Morani, or warriors, wandered through our little camp under the acacia trees, their braided hair and blanket cloaks dyed in red ochre. They had lean, handsome, golden faces and carried spears and throwing sticks. But mostly we shared our temporary home with the animals. There, on foot, I met giraffes, zebras, antelopes, gazelles, and even lions and a rhino.

Around the campfire, under the rich, star-studded African skies, I listened entranced, as Louis shared his vast African knowledge. He talked of hippos and elephants and elephant-shrews. He spoke of the ways of the Kikuyu people, the tribe in which he had grown up, living as they lived, enduring the initiation ceremony with his adolescent Kikuyu friends. He shared with us his conviction that Africa had been the cradle of humankind, and that from Africa early humans had spread to other continents.

Louis talked, also, of chimpanzees: of one particular group of chimpanzees living on the shores of faraway Lake Tanganyika. He told us that by learning about the behavior of chimpanzees, we would perhaps gain insight into ways in which our own prehistoric ancestors may have lived at the dawn of humanity. And so the seeds of my own future were sown.

Eventually funds were found and I set off to Gombe Stream Game Reserve in Tanzania, on the eastern shore of Lake Tanganyika. At first the chimpanzees, terrified by this strange white ape, ran off as soon as they saw me and, for a while, I despaired of getting any worthwhile data. Gradually, however, they got used to me. The breakthrough came when I observed chimpanzees using and making tools, hunting mammals, and sharing the kill. Eventually I became familiar with their whole complex and utterly fascinating social structure, their family relationships, and their communication systems. I also grew familiar with their differing personalities, documented their ability to reason and solve problems, and observed how they expressed emotions such as joy and sadness, fear and despair. I wrote it all down, and Louis was delighted. He arranged for me to go to Cambridge University in England to work on a doctoral dissertation. Even today, more than forty years later, our team is still finding out new facts about our closest living relatives.

When I got to Cambridge I was in for a rude shock. First of all, I learned, I should not have given the chimpanzees *names*—it would have been more scientific to label them with numbers. Moreover, it was not respectable, in scientific circles, to talk about animal personality—that was something reserved for humans. Nor did animals have minds, so they were not capable of rational thought. And to talk about their emotions was to be guilty of the worst kind of anthropomorphism (attributing human characteristics to animals). Fortunately, not having been to university, I did not know those things! And my supervisor, Professor Robert Hinde, helped me to express my findings in appropriate scientific manner so that I was protected from scathing criticism from the scientific community while not compromising my values.

Today ethological thinking and methodology has softened and it is generally recognized that the old, parsimonious explanations of complex behavior were inappropriate. Study of the animal mind is fashionable, and the examination of animal emotions is commonplace. Without a doubt, this is in large part due to the information that came in from long-term field studies: my work at Gombe, George Schaller's and Dian Fossey's work with mountain gorillas, Ian Douglas-Hamilton's work on elephants in Tanzania's Lake Manyara National Park—and, of course, Birute Galdikas' observations of orangutans in Asia. All of these carefully conducted studies, made in the natural habitat, helped show that the societies and behavior of animals were far more complex that previously supposed. The work of the early ethologists—notably that of Konrad Lorenz and Niko Tinbergen—could be tied in with work from the field, and this greatly expanded understanding of our fellow animals.

Africa, from the beginning, has been one of the most important continents not only for research on animal behavior, but also as the source of so much of the human fossil record. There were the discoveries in South Africa by Raymond Dart, John Robinson, and Robert Broom, such as the famous Taung child of Sterkfontein and Mrs. Ples. Those by the Leakeys (*Australopithecus boisei* and *Homo habilis*) at Olduvai, and Don Johansen's (Lucy) in Ethiopia are the most famous. Louis was right; Africa was where everything started.

Since my childhood, during the past fifty years human beings, in their zest to reproduce themselves and subdue wilderness areas, have destroyed thousands upon thousands of square miles of natural habitat and thousands upon thousands of species of animals and plants. Bushlands and forests have been replaced by deserts and concrete. We have only just realized the extent of our crime and the dire consequences in store for all life on our planet. Is it too late, as some tell us, to save what is left? It is unless we all make changes in our life-styles and work together to try to heal some of the wounds that have been inflicted. There are three necessary ingredients: understanding, commitment, and action. We cannot afford, if we truly care, to sit back and hope that the problems of Africa will solve themselves. We must do what we can to help.

And we should realize that one does not have to be in Africa to help solve Africa's problems. Those of us who have made efforts to help African governments develop conservation programs have quickly realized how many of Africa's environmental problems can be directly linked to the economic interests and the greed and materialism of the developed world. It is not, by and large, Africans who own the logging and mining companies.

Now is not the time for blame. Now is the time for action. The African continent is, indeed, in a state of turmoil. Everywhere it seems there is political instability. Ethnic conflicts abound. The environment is under siege as populations mushroom and refugees flee their homelands. Massive starvation and disease are

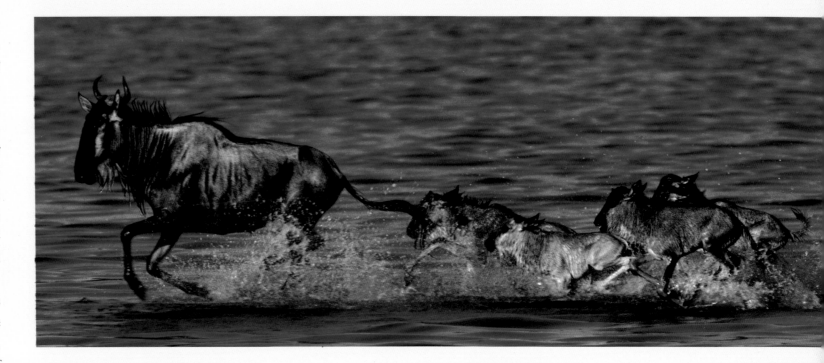

very real specters. Yet we cannot shrug our shoulders and turn away, hoping that things will sort themselves out. There is too much at stake.

When we ask about the future of wild chimpanzees, we are asking about the future of the African rainforests and all the wondrous animal and plant life found there. We become involved in concern for planet Earth itself, its changing climates, and the destruction caused by our modern technology. It is not only the forest and its animal life that is suffering because of our selfish exploitation of natural resources and our horrifying success in the sphere of reproduction, but all living beings, everywhere. Modern technology and the industrial life-style have brought nature as we know it to the brink of destruction: If we are not to perish, we must somehow learn to think and act differently, to control our birth rate, to use our technology to heal our environment. We must become saviors in order to be saved. If we cannot do it, we are doomed, for there is no other species on this planet to do it for us.

A book such as this, with Art Wolfe's brilliant and sensitive photographs, is a powerful stimulation for changing attitudes. Art is passionately involved in the life-and-death struggle of the African continent, its people, its wildlife, and its forests, woodlands, savannahs, and deserts. His love and commitment are revealed in each photograph and these, in turn, will stir the heart of the reader. I hope you will join us in our fight to save one of the most amazing, scientifically important, scenically beautiful, and richly diverse places on Earth.

Jane Goodall

COMMON WILDEBEEST (*Connochaetes taurinus*),
LAKE NDUTU, TANZANIA

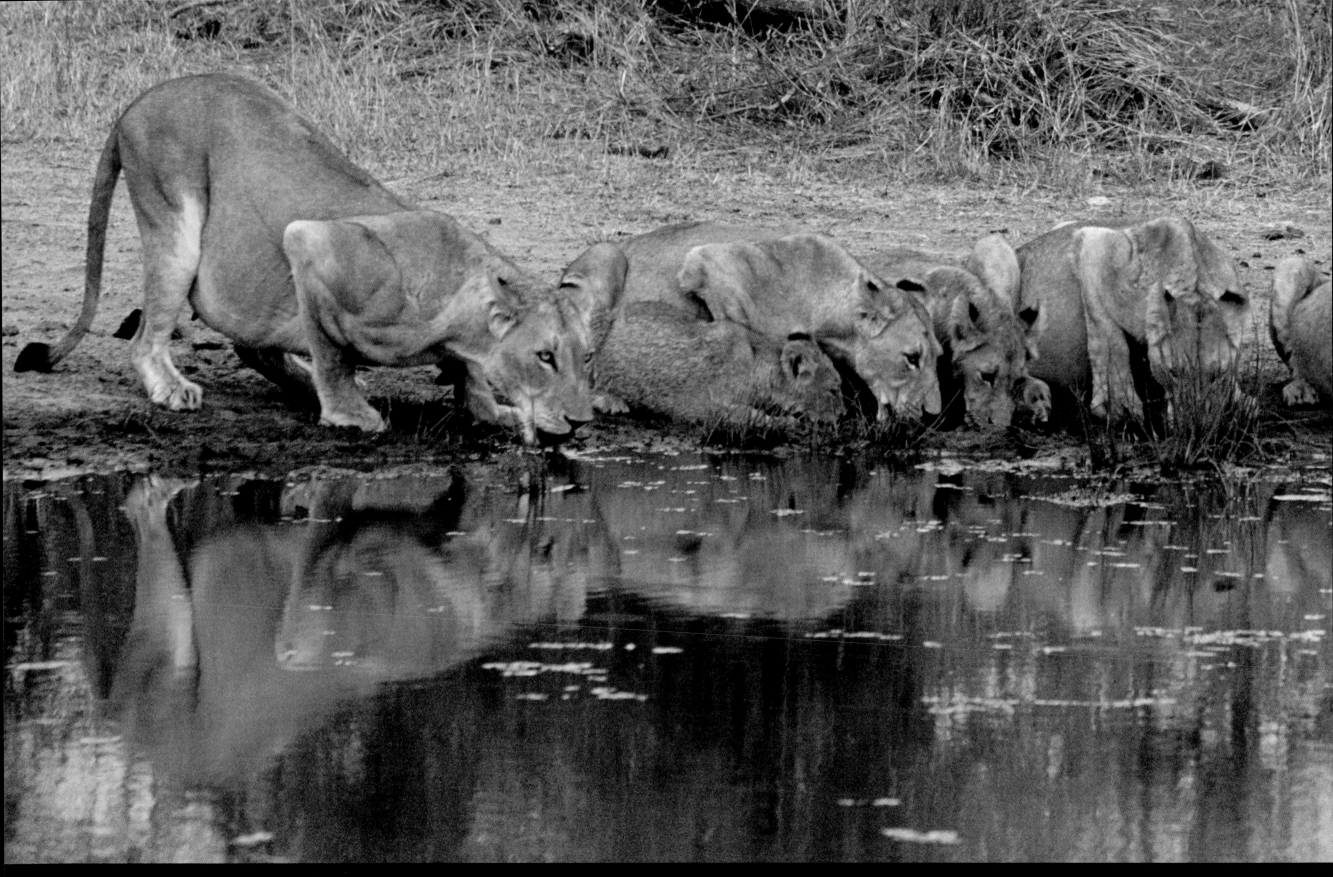

LION (*Panthera leo*), Kruger National Park, South Africa

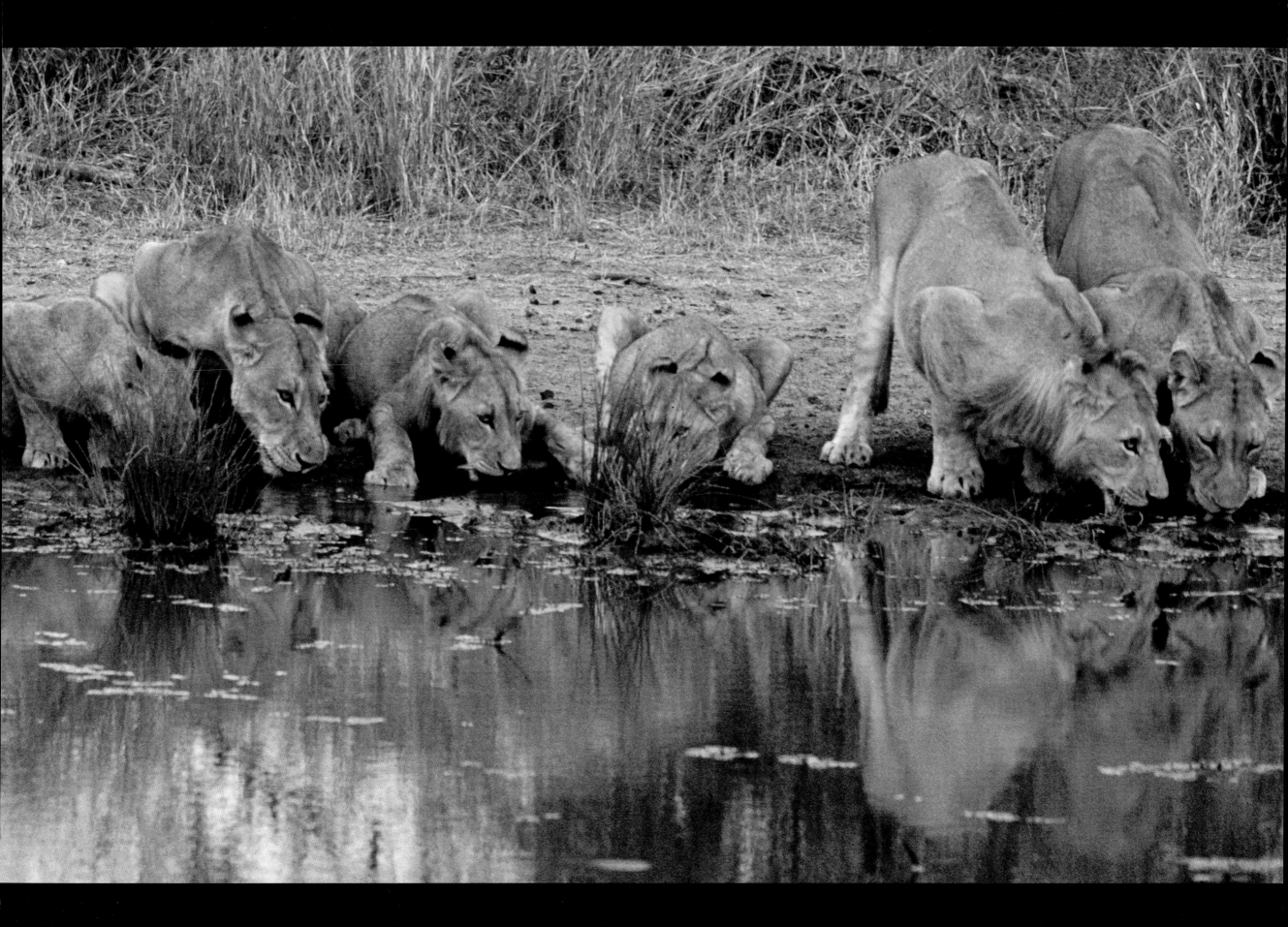

BURCHELL'S ZEBRA (*Equus burchellii*),
LAKE NDUTU REGION, TANZANIA

Africa assails the senses. It is the sound of ten thousand animals running on open plains, the taste of heat in the air, the sight of flamingos tingeing a lake pink, the smell of dampness foretelling rains to come, and the touch of the earth beneath naked feet.

Covering one-fifth of the Earth's total land area, Africa straddles the equator, second in size only to Asia. Its name comes from the Latin *aprica*, meaning "sunny," or perhaps the Greek *aphrike*, meaning "without cold." This 11,667,000-square-mile (30,217,000-square-kilometer) continent is filled with exceptional landscapes and truly spectacular biological and human diversity.

This is a land of contrasts, contradictions, and complex interactions. In its vastness, Africa encompasses deserts where daytime temperatures can reach 183°F (84°C) and nights are a frigid 10.4°F (−12°C). Half an inch (13 millimeters) of rain may fall in a year or once in a decade. At the desert fringes, however, the land is transformed as rainfall increases, and plants spread their leaves and stems more widely.

Africa's savannahs and woodlands are home to more large ungulates (some ninety species) than any other continent. Mass migrations follow the rains as they have for two million years. And following the zebra, wildebeest, gazelle, and buffalo are the carnivores that define Africa: lion, leopard, cheetah, hyena, and wild dog.

Where the rains are more abundant, forests coat the lowlands and the flanks of mountains. Literally millions of species exist here. New species of plants, birds, and even mammals await discovery, along with countless invertebrates responsible for driving the endless recycling of nutrients from the forest floor to the canopy. Deep in the forest, chimpanzees have developed tool cultures, and plants engage in chemical warfare with voracious insects. In the rainforest, life builds on life in an exhilarating display of adaptation, innovation, and natural selection.

Meandering rivers and immense lakes bisect the land. Waterfalls and cataracts break the flow with cacophonies of sound and mist. Salty remnants of ancient lakes host colonies of flamingos, and isolated freshwaters are filled with unique fish.

Savannah, woodland, wetland, rainforest, and desert are necessarily arbitrary distinctions. In reality, they blend, merging in ways that can often combine the features of several habitats. Animals range between them, favoring savannah at one time of year, woodland at another. Some species are so finely adapted to particular conditions that they can survive nowhere else, while others are so catholic in their abilities that few places are without them, save those where humans have intervened.

Leopards range from arid deserts to tropical rainforests. Mountain gorillas are isolated in the Virunga volcanoes that divide the Democratic Republic of Congo (formerly Zaire) from Rwanda and Uganda. Burchell's zebras thrive on ample grasslands, while Grevy's and mountain zebras cling to remote strongholds. Wildebeests mass in herds of phenomenal size that give moving, thundering life to the great migration, while sitatungas and lechwes live their lives in swamps with relative anonymity.

Habitats shift and change. Fires sweep through the savannah, killing saplings but giving new life to grasses and fire-resistant plants. Rains fail one year, but return the next. Rivers change course, isolating vast lakes that gradually dry, leaving immense salt pans to bake under the sun. Glacial periods come and go. Continents shift, altering rainfall patterns and drying vast areas, as well as redirecting air masses around rising mountain ranges. Change is the only ecological constant.

Rivers flow from mountains still being uplifted by tectonic forces. Deserts rely on water evaporated from distant seas. Rainforest trees depend on elephants to disperse their seeds. Griffon vultures need hyenas to break the bones of their prey into manageable pieces and expose the edible marrow. Leopard tortoises feed on hyena droppings to get the calcium they need for healthy growth. The savannah depends on fire and elephants to maintain its grasslands. Predators need their prey to survive.

In Africa, nothing can exist in absolute isolation—people included. We need Africa, simply because it is Africa, and without it we lose something that is fundamental to our existence. Humanity experienced its beginnings among the savannahs, woodlands, and rainforests of Africa. No wonder we feel a fascination for it. Africa is in our blood and in our genes.

The first small blade tools emerged in Africa. Cattle were domesticated here. The earliest hominid remains from Ethiopia and Kenya have been dated at 4.5 million years before present, and the earliest identifiably modern humans existed throughout eastern and southern Africa at least one hundred thousand years ago. From Africa, these people colonized the world.

Today, Africa is home to one thousand distinct languages and countless cultures. Only 10 percent of the world's population lives here, but in many African nations, 40 percent of the population is younger than fifteen years old, and growth projections average 3 percent a year. Twenty-eight million people struggle with famine on a recurrent basis.

Africa is Serengeti, Madagascar, Tsavo, Okavango, Virunga, Kalahari, Sahara, Congo, Kilimanjaro, Ngorongoro, and Olduvai. It is Lakes Victoria and Tanganyika. It is the Mountains of the Moon and home to "the smoke that thunders." Africa is the grandest of all places because it still harbors remnants of spectacles that have

been all but lost from other continents. However, Africa's wondrous wildlife cannot be saved by corralling it in national parks. Africa can only flourish by recognizing the needs of the people for whom the rainforest, savannahs, woodlands, and deserts are home.

In the heart of Africa, we developed our humanity and our consciousness. For whatever reason, whether biological imperative or accident, we have the ability to consider our actions and to plan our future. The next decade may well decide the fate of, among others, the black rhinoceros, mountain gorilla, and elephant. Two large mammal species have become extinct in Africa in modern times: the blue buck disappeared around 1800 and the zebra-like quagga vanished in the 1870s. Many others are on that slow descent to oblivion. Rarely does a species vanish overnight. Usually it takes decades, and a declaration of

extinction may be made years after the fact. In September 2000, Miss Waldon's red colobus was finally declared extinct. Discovered in 1933, it had not been seen in the wild since 1978, and its passing makes it the first primate taxon to have gone extinct since the 1700s. Many biologists fear that the loss of this primate is simply the portent to a wave of extinctions that may soon rob Africa of its diversity. Africa without its elephants, rhinos, primates, and carnivores is an Africa that does not bear contemplation, just as an Africa without the Berbers, Ashanti, Mbuti, Maasai, Karo, San, and Zulu becomes less than it once was.

Africa is a sensation that we must all learn to feel and protect.

Michelle Gildes

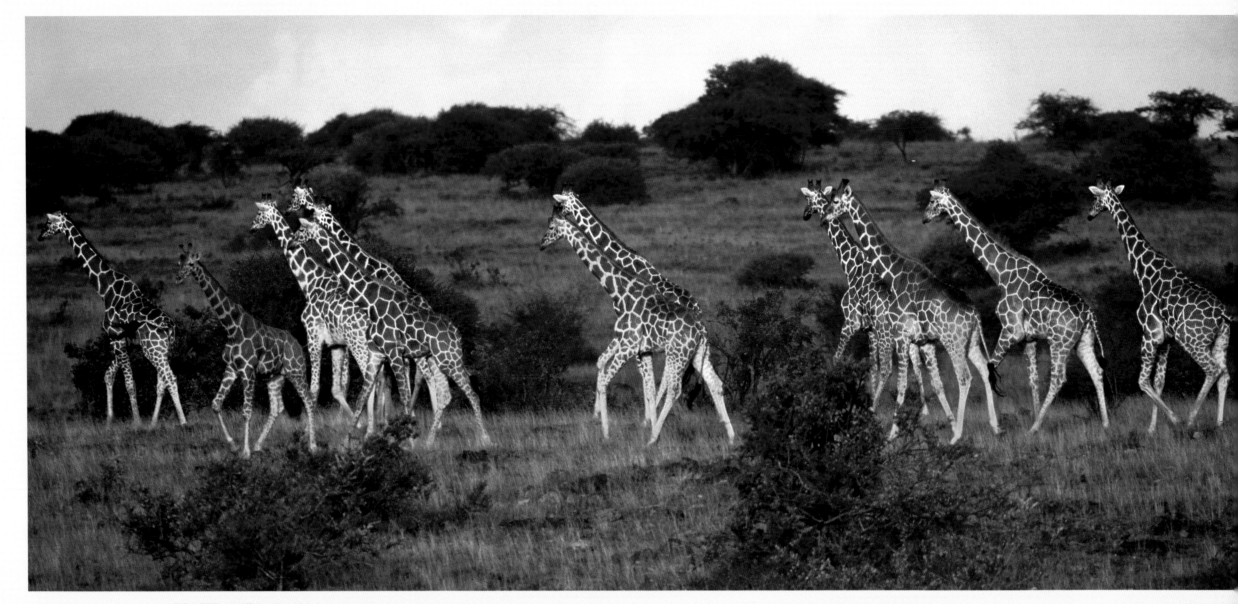

GIRAFFE (*Giraffa camelopardalis*), SAMBURU NATIONAL RESERVE, KENYA

SUNSET, SERENGETI PLAIN, Northern Tanzania

OLIVE BABOON (*Papio anubis*), Mpala Research Centre, Nanyuki, Kenya

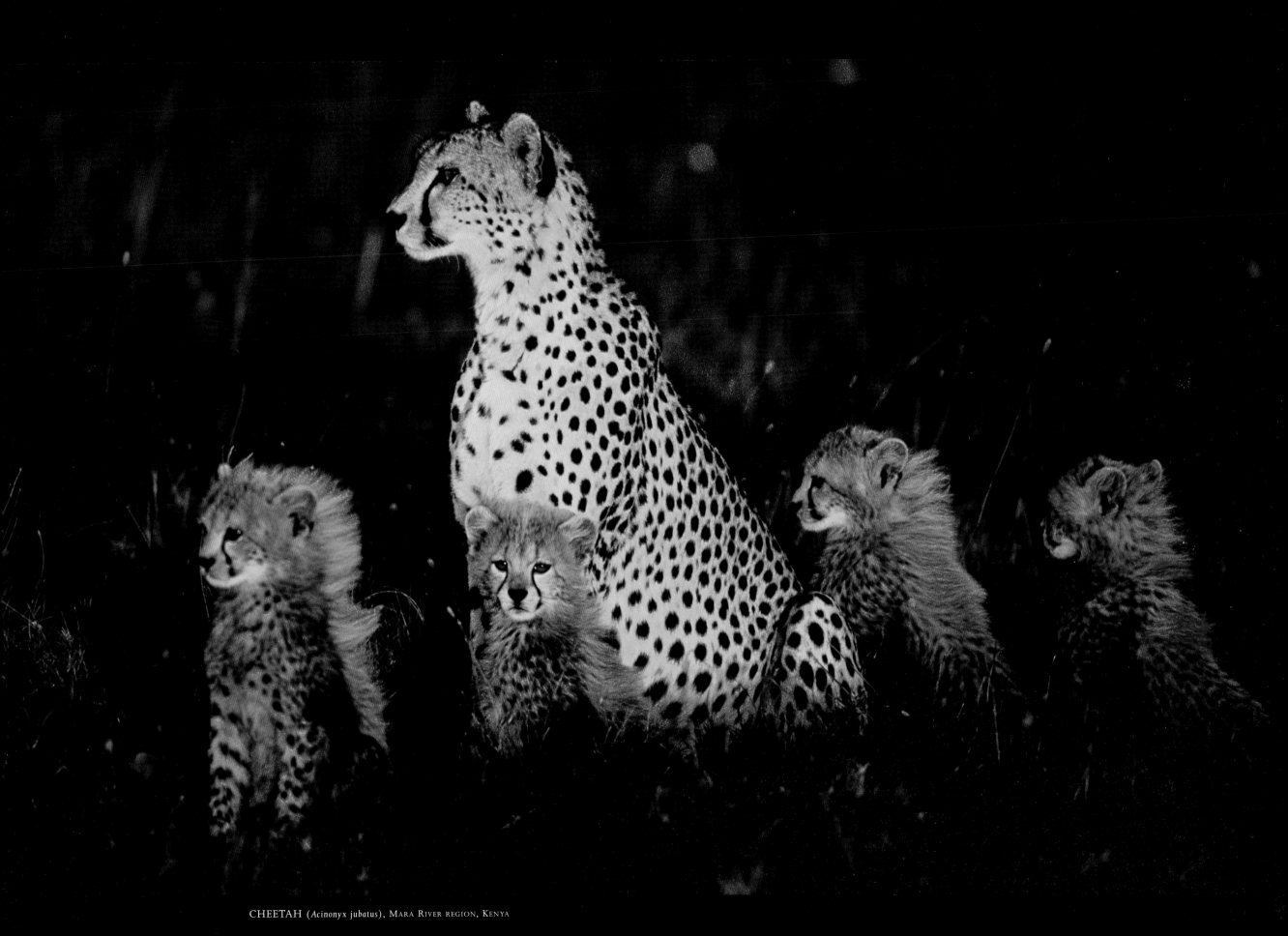

CHEETAH (*Acinonyx jubatus*), MARA RIVER REGION, KENYA

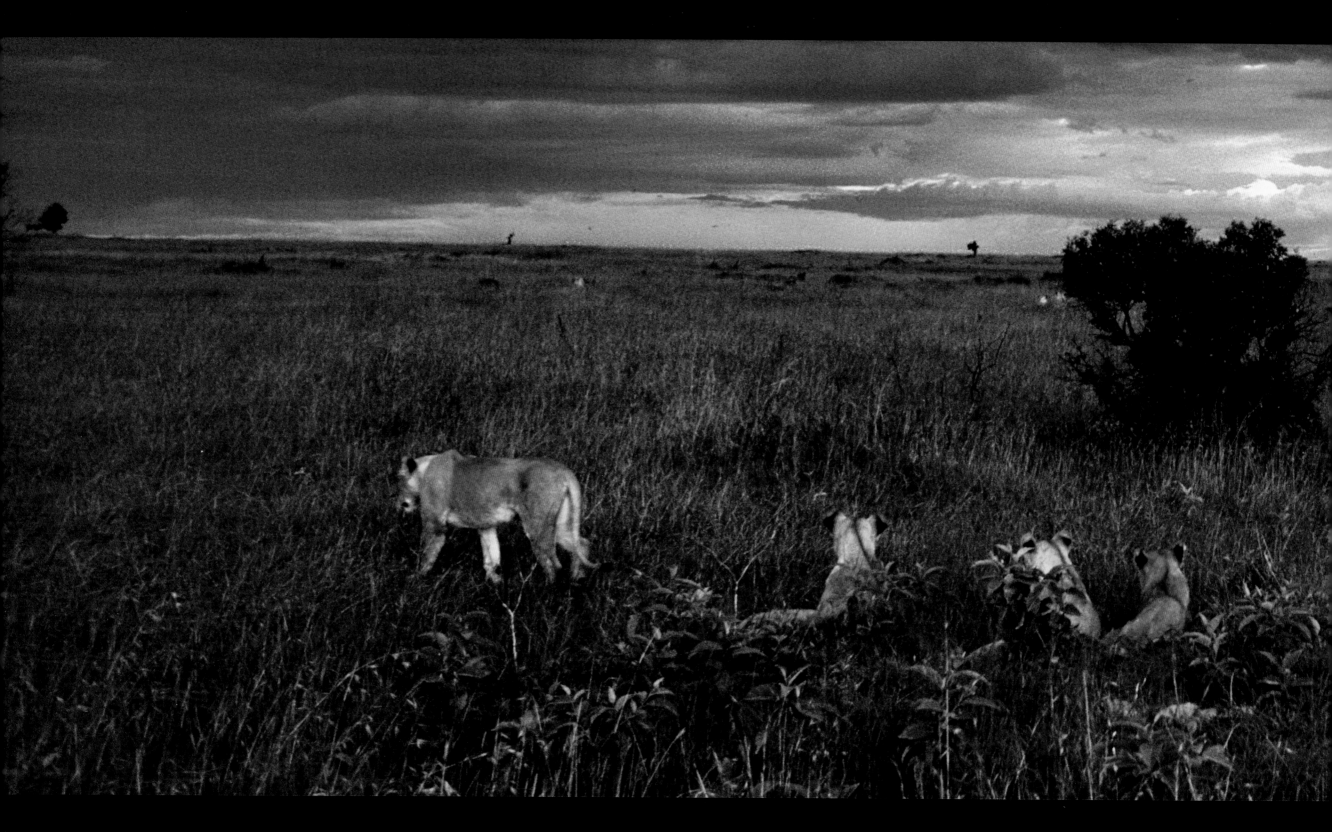

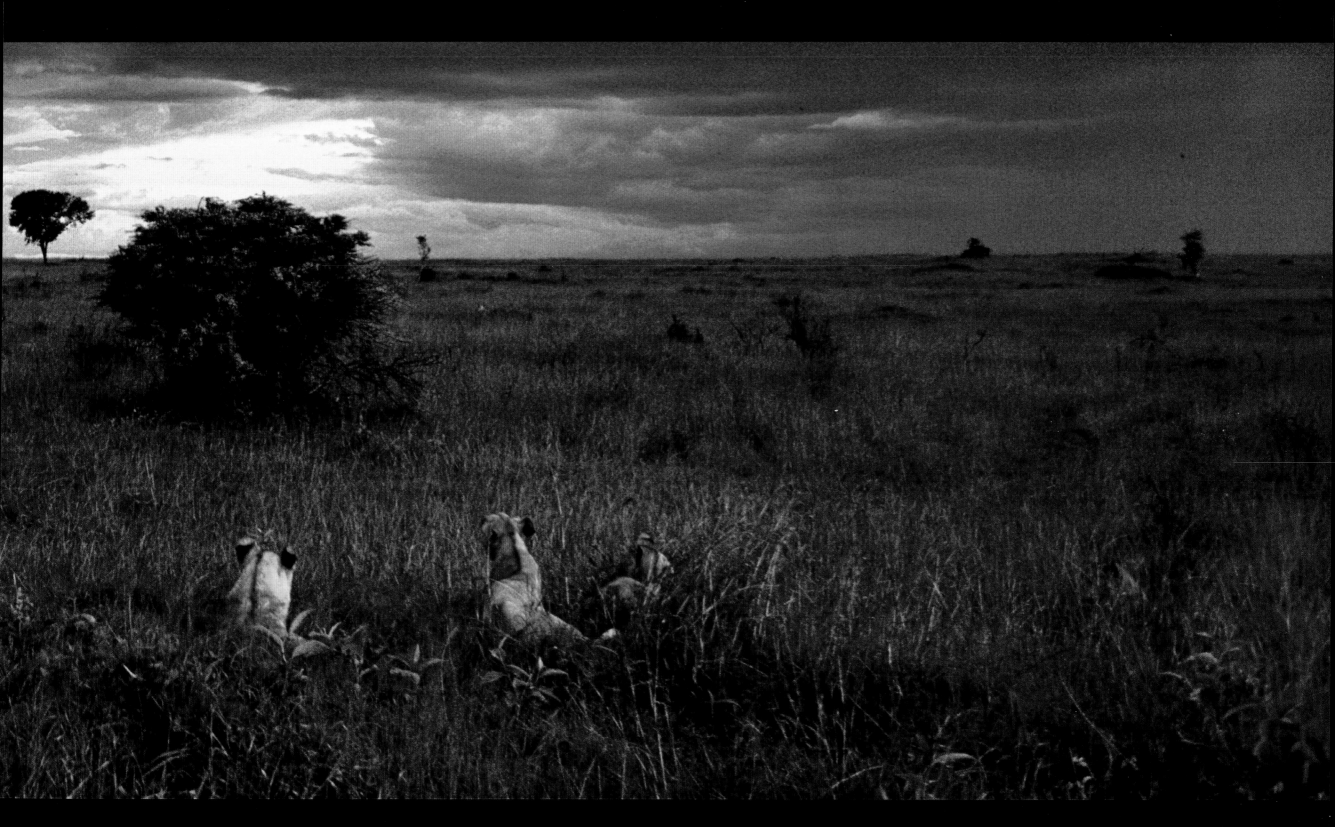

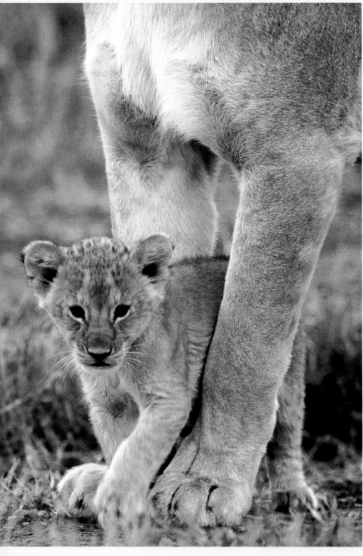

◄ LION (*Panthera leo*),
MAASAI MARA NATIONAL RESERVE, KENYA

▲ LION (*Panthera leo*),
KRUGER NATIONAL PARK, SOUTH AFRICA

There, toward the base of Kilimanjaro, are three great herds of buffalo slowly and leisurely moving up from the lower grazing-grounds," wrote Scottish explorer Joseph Thomson in 1883, providing the first description of the great game herds of the East African savannah.

"Further out on the plains," continued Thomson, "(e)normous numbers of the harmless but fierce-looking wildebeests continue their grazing, some erratic members of the herd gamboling and galloping about with . . . uncouth movements. Mixed with these are to be seen companies of that loveliest of large game, the zebra, conspicuous in their beautiful striped skin. . . . Down in that grassy bottom there are several . . . rhinoceros, with horns stuck on their noses in a most offensive and pugnacious manner. . . . See how numerous are the herds of hartebeest, and notice the graceful pallah springing into mid-air with great abounds, as if in pure enjoyment of existence. . . . The wart-hog . . . clears off in a bee-line with tail erect, and with a steady military trot truly comical. . . . Turn in whatever direction you please, they are to be seen in astonishing numbers. . . ."

The wildlife spectacular of the East African savannah has captivated observers ever since European explorers reported on their first tentative steps into this ancient continent. Africa seemed to embody the concepts of "survival of the fittest" and "natural selection" that Victorians were coming to terms with following Darwin's 1859 publication of *On the Origin of Species*. Suddenly, Africa was there to offer confirmation of the emerging theory of evolution by natural selection.

The questions to be asked are inexhaustible. What drives animal populations up or down? Are herbivores controlled by their food supply or by predators? What controls predator numbers: their prey, competition, or predation by another species? And can observations of predators and prey reveal something of the evolution of our own species? Why do some species congregate in vast herds, and others stay in small groups? Why do so many herbivores have horns? Are animals that are seen together related? What drives the great migrations? How do the millions of herbivores affect the savannah vegetation? How did the savannah evolve?

Savannahs are considered intermediate between forest and desert; most receive seasonal rainfall of less than 40 inches (1,000 mm) a year. Savannahs cover between 40 to 65 percent of the African continent. They run the complete spectrum from tall tropical grassland devoid of trees to a savannah woodland of tall, widely spaced trees.

Although savannahs are extensive across much of the continent, it is the Serengeti–Maasai Mara that usually springs to mind when people think of African grasslands. The Serengeti is a four-million-year-old ecosystem straddling 10,000 square miles (25,000 sq km) between Kenya and Tanzania. It is a precious region, recognized as a World Heritage site and a Biosphere Reserve. The Serengeti is home to the greatest gathering of large mammals in the world today: approximately 1.3 million wildebeests (*Connochaetes taurinus*), 200,000 Burchell's zebras (*Equus burchellii*), 440,000 Thomson's gazelles (*Gazella thomsonii*), 7,500 spotted hyenas (*Crocuta crocuta*), and 2,800 lions (*Panthera leo*).

The Serengeti is ruled by the rains. In the dry season (from late May to early November), the eastern plains are brown and barren, the animals having largely retreated north and west to the woodlands and river valleys of the Mara where water and forage lasts long after the rains have vanished. Others move south to the water that flows within Tarangire National Park. Only in areas where water is permanent, such as the stunning caldera of Ngorongoro, do many herbivores relinquish their migratory instincts.

On the open savannah, the horizon is vast and unbroken, except by the white cone of Kilimanjaro or the escarpment of the Rift Valley. Acacias are scattered across the grasslands, sometimes forming islands of woodland among the grasses. Small hills known as *kopjes* stand like punctuation marks on the plains. The habitat here is a mosaic of grasses, shrubs, and trees, with the rivers bringing lush vegetation deep into the grasslands and serving as verdant pathways for animals meandering the plains.

At the height of the dry season, the trees are skeletal and lifeless, bracing themselves silently against the dry winds, their black trunks scorched by past fires. The plains are quiet, and an untrained observer could easily mistake this for a perpetual wasteland.

The dry season is a time of endurance. The wind kicks up dust devils and black ash that singes the air with the smell of charcoal. The land and the air above it shimmer in the heat. The animals that have stayed are tired, hungry, and parched.

Grant's gazelles (*Gazella granti*), handsome fawn-colored animals with tapering, ringed horns, remain to feed on vegetation passed over by others. They rarely need to drink, obtaining all necessary moisture from their food. With grazing poor, warthogs (*Phacochoerus africanus*) take to their burrows, feeding on underground rhizomes and tubers. Black rhinoceroses (*Diceros bicornis*) concentrate on browsing shrubbery. Dwarf mongooses (*Helogale parvula*) range from their termite-mound homes in search of beetles, scorpions, and snakes, while hyraxes (*Procavia sp.*) form small colonies among the granitic boulders of the *kopjes*.

As long as large game are scarce, the grassland predators face lean times. The ranges occupied by these animals can be vast, although movements are limited during the time that their offspring are very small. Wild dogs (*Lycaon pictus*) may range over 800 square miles (2,000 sq km); nomadic lions travel even farther to follow the migratory herds, and cheetahs (*Acinonyx jubatus*) may have

LION (*Panthera leo*), KRUGER NATIONAL PARK, SOUTH AFRICA

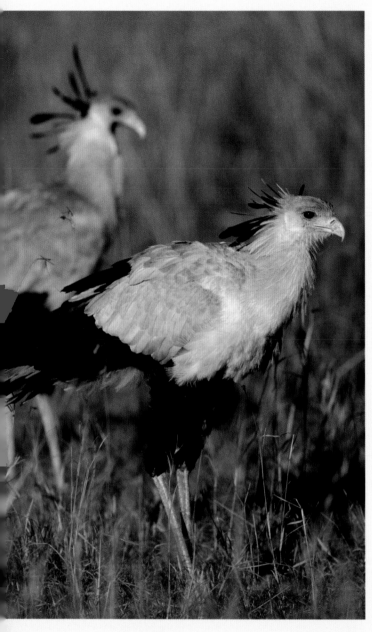

SECRETARYBIRD (*Sagittarius serpentarius*),
MARA RIVER REGION, KENYA

territories in excess of 400 square miles (1,000 sq km) to reach the migratory Thomson's gazelles that are their preferred prey.

Most lions, choose instead to defend static territories. Pride size is determined by the prey available during the leanest of times, and resident prides suffer high mortality if they have to rely on small game for long periods of time. Half of all lion cubs die in their first year, often from starvation. The true open grasslands may be completely devoid of lions simply because too little prey exists there during the dry months. Most prides favor the open woodlands or the edge habitats between savannah and woodland, where prey remains plentiful and cover aids the hunters.

The dry season takes its toll on the grasslands as well. Fires are common, particularly late in the season, when winds fan the flames, turning the parched vegetation into fuel. Lightning strikes ignite tinder-dry grasses. The savannahs feed the fires until they are blackened and exhausted. Fires are also set by humans; intentional burning has occurred here for fifty thousand years. As much as 90 percent of the standing grass may be burned each year.

The savannah has adapted to these annual fires. Perennial grasses have underground storage organs that are protected from the flames, and some plants even require fire to break the dormancy of their seeds. Because most grasses complete their development in the wet season, material burnt by the fire is expendable; nutrients are recycled into the soil and new growth is stimulated in the aftermath. Many savannah trees also have a significant investment in underground growth from which portions can be regenerated aboveground. Trees such as buffalo wood and *Terminalia avicenoides* (a tree in the Combretaceae family) have fire-resistant bark and readily grow into thickets after burning. Other common species are susceptible to fire damage, particularly as small saplings, and are dependent on an understory of fire-tolerant trees and shrubs to shield them during their first few years of growth.

While grazers and browsers may be at an initial disadvantage following a fire, many other animals flock to the still-burning land. Lions roll in the hot ashes, perhaps to remove ectoparasites from their skin. Secretarybirds (*Sagittarius serpentarius*) stalk the embers looking for casualties, while vultures and marabou storks (*Leptoptilos crumeniferus*) circle on the upwelling of warm air in search of carrion.

Just when the dry season seems at its height, the temperature rises again. The air grows heavy and thunder rumbles across the sky. The intense blue shifts to brooding purple, and flashes of lightning threaten a continuation of the fires. The animals seem wary, sniffing the air and jumping at the sound of rolling thunder. Then the sky breaks open and the rains return.

New grass shoots up more than an inch (25 mm) in twenty-four hours, transforming the once-barren land into an oasis that expands under the rain like a flood. Within days the grass is 6 inches (15 cm) tall. The acacias are filled with white or yellow blossoms. With the coming of the rains, the savannah is filled with promise.

The grasses show keen adaptations to circumstance. Just as they deal with fire, they deal with the onslaught of grazers. The growing point of a grass is at the node just above the junction between the leaf and stem; it can withstand almost complete removal of the grass sheath and still recover quickly. Grasses can also spread vegetatively, belowground, an added advantage if too much of the surface plant is destroyed.

These most abundant of vascular plants (higher plants that possess xylem and phloem—similar to veins and arteries in mammals—to conduct water, mineral salts, and food through their tissues) evolved more than sixty-five million years ago, but did not become well established until the "Age of Grasslands" during the Oligocene era, thirty-four million years ago. During this time, the global climate became cooler and drier, allowing grasses to encroach on the forests. As the forests thinned, mammalian herbivores evolved to fill the new, open habitats. They became larger and, as predators evolved to cull them, they became faster.

Speciation in Africa occurred at a tremendous rate, spurred on by the fragmentation of habitats that resulted from the changing climate. More than 90 species of large ungulates and 75 species of true carnivores soon roamed the continent. Sixty percent of all African mammals are found in savannah habitats (along with half of Africa's birds, some 708 species).

As the rains fall, animals return from their refuges in the woodlands. From the air, the savannah seethes with undulating herds rushing at rivers, jostling for position in their attempt to reach grazing grounds that have sustained their species for hundreds of thousands of years. They give the Serengeti its enduring image. Once they are on the plains, it is time to graze the new year's promise and prepare for the birth of the next generation.

The zebras come first. With front teeth in both their upper and lower jaws, they are able to graze the coarsest of grasses that survived the fires. They are just as adept, however, at dealing with fresh new growth. The wildebeests follow, benefiting from the zebras' removal of the longer grasses, and then come the gazelles, nibbling at the lowest growth. Each species thus avoids, through "competitive exclusion," direct competition with the other species with whom they share the plains.

Zebra are elegant equines that appear designed by someone with an eye for pleasing abstraction. The broad stripes are as individual as fingerprints; each species has a distinct pattern. Grevy's zebras (*Equus grevyi*) have narrow, closely spaced stripes that resemble an optical illusion, whereas mountain zebras (*Equus zebra*) have distinct black stripes and a white underbelly. It is the plains or Burchell's zebra that is the dominant species, the typical savannah zebra.

The Burchell's zebra is a species in flux. A species, as Darwin pointed out a

century and a half ago, is not immutable. The organisms that we are witness to today have evolved and continue to evolve in response to environmental pressures and the forces of sexual selection. From north to south, the stripes of the Burchell's zebra gradually fade, until some southern specimens almost completely lack stripes over their legs and hindquarters (the extinct quagga may have been an extreme southern form of this species). In future generations, the zebra may evolve into new forms, something that could be accelerated by habitat fragmentation and geographic isolation.

Burchell's zebras are not territorial, but the stallions do maintain a family group averaging one to six adult mares and their offspring. The stallion is the defender of his family, vigorously protecting his mares and foals against predators and interloping males alike. The stallion is so adept at protecting his charges that only hyenas or lions cooperating in packs or prides usually have a chance at bringing one down. When the stallion's young fillies come into heat for the first time, young male zebras rush to steal them away. Despite the stallion's best defenses, his daughters are invariably lured away to join a new family group, a family she will stay with for the rest of her life.

Why does the zebra have stripes when other savannah animals are not nearly so strikingly adorned? Vertical stripes in a grassland of vertical shapes may allow the zebra to blend in with its surroundings; alternatively, the stripes may disrupt the zebra's outline, confusing a predator as it rushes at a moving herd. The fact that pack-hunting hyenas or lions often separate their intended victim from the herd suggests that this is unlikely, or at least ineffective.

Stripes may play a secondary role against predators,—actually stallions are just as likely to turn on their attackers as flee—but their primary one is probably related to competitive behavior and reproductive success. The zebra's stripes may serve as a "flag" to others of the same species, indicating prowess and a general level of fitness that is projected to potential competitors. They may also enable animals to identify family members, allies, and companions in the herd.

Zebras live in small family groups and actively defend against predators, whereas the wildebeests with whom they coexist on the plains have taken a different path. The strategy for this ungainly looking species of antelope is safety in numbers; and what great numbers they are. Nearly 1.5 million wildebeests congregate on the East African plains. They crop the short grass with their incisors, actually promoting regrowth by trampling and fertilizing the ground. They feed almost constantly, taking advantage of their multi-chambered stomach to graze quickly and digest later, chewing the cud, a process that helps release the natural energy stored in the nearly indigestible grasses. As the females await the birth of their calves, the herds segregate into single-sex groupings.

Wildebeests have one of the most restricted birth seasons of any mammal.

Zebras stagger their birthing season through the year (although their peak is also linked to the rains), but wildebeests have evolved a strategy known as "predator swamping." Eighty to 90 percent of all wildebeest calves are born in a three-week period at the beginning of the rains. Within six minutes of birth, the young calf is on its feet. Although it can run with its mother, it cannot outrun a predator, and its mother cannot defend it effectively against attackers. The chances of survival for the calf increase if it stays in a large herd, simply because the predators cannot possibly attack all the calves.

At times, wildebeests seem to take the herd mentality a little too far. They often allow predators to approach too close for comfort, apparently content in the knowledge that the chances of any one individual being selected are low. Still, wildebeests are the primary prey of most of the large predators, including spotted hyenas and lions.

The predators of the savannah evolved in concert with their prey. Some, such as the cheetah, became sprinters; others, such as lions, stalkers; others, such as spotted hyenas and wild dogs, simply refined the chase, running their prey down with perseverance and endurance.

Cheetahs are masters of the short sprint. With their long legs powering them across the plains, cheetahs have been reliably clocked at 63.8 miles per hour (103 km per hour). They evolved to chase down the fastest of antelopes, and on the Serengeti, Thomson's gazelles constitute 91 percent of their diet. Rarely running more than 1,320 feet (400 m), the cheetah uses cover to get close to its victim before sprinting in for the kill. After slapping a gazelle to the ground by clipping its hindleg with a forepaw, the cheetah strangles its catch. If undisturbed, it may remain on its kill for up to eleven hours, even consuming the bones. Usually, though, cheetahs seem to lose their kills to lions; at around 110 pounds (50 kg), a cheetah is no match for a 415-pound (189-kg) male lion or even a 277-pound (126-kg) female.

Lions are the bane of cheetahs. Up to 95 percent of cheetah cubs can die before they reach independence (at around fourteen months), and it is predation by lions that is the primary cause (78 percent of cheetah cubs killed by predators in the Serengeti are killed by lions). Wherever lions are abundant, cheetahs are invariably scarce. African wild dogs suffer a similar fate at the jaws of this most unforgiving of competitors.

Cheetahs are largely solitary (although males will form long-term coalitions or bonds, often with their own brothers); lions are, by contrast, that rarity among the felids: social cats. A lion pride is a multigenerational, permanent social unit, varying in size from two to thirty-five animals, but typically consisting of two to eighteen related females (plus their young) and one to seven adult males unrelated to the females in the pride. Females will often stay with their natal pride for life, whereas males leave at two to three years of age, roaming the plains alone

▲▲ AND ▲ CHEETAH (*Acinonyx jubatus*),
MARA RIVER REGION, KENYA

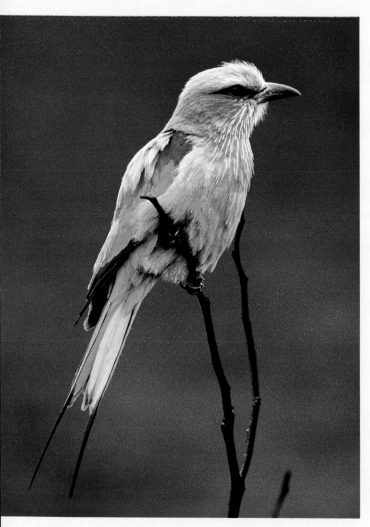

LILAC-BREASTED ROLLER (*Coracias caudata*),
SAVUTI, CHOBE NATIONAL PARK, BOTSWANA

or in coalition with several others, biding their time until they can lay claim to a pride of their own.

When a male takes over a pride, he kills any cubs that are still dependent on their mothers. In one fell swoop, the male removes the bearers of his predecessors' genes. This forces the females back into estrus so that they can mate again. For this reason, the pride may have several litters produced concurrently, and the cubs are raised communally (unlike spotted hyenas, a nursing lioness will allow any cub to suckle). A lioness typically has a reproductive life of about twelve years. Males, who usually mate only when they have tenure over a pride, have a reproductive life as short as eighteen months (rarely does tenure stretch to more than four years).

At first glance, a day in the life of a lion appears remarkably sedentary: twenty to twenty-one hours a day spent resting or otherwise inactive, two hours spent walking, and just fifty minutes spent eating (and the latter isn't even a daily occurrence). There is no clear leadership in a pride, despite the blustering and occasionally infanticidal actions of the males. Both sexes will defend the pride's range, but the males do the majority of the roaring and posturing. Prides usually avoid each other, even though ranges may overlap; should a territorial conflict occur, pride members will only confront intruders if they outnumber them.

Lions mainly hunt at night, taking advantage of the cover of darkness (although they will hunt during daylight, setting ambushes at water holes or using the early morning light to test the flight response of a herd). Lionesses do most of the hunting, and in many ways the males parasitize the females; should a lioness kill a gazelle, she may lose the entire carcass to a male. On the Serengeti, lions favor large ungulates such as topis (*Damaliscus lunatus*), wildebeests, and zebras, although they will take whatever is available, typically approaching to within 100 feet (30 m) before rushing at their intended victim.

Although lions do cooperate on occasion, much of the cooperative behavior that is observed may be inadvertent and opportunistic. When one lion brings down its prey, others rapidly join in, making it a communal feast. At the kill, each lion looks out for its own interests. Males may drive others away, and cubs are shown no quarter, even by their own mothers. A particularly hungry lion may eat up to 110 pounds (50 kg) at a single sitting.

As lions feed on their kill, spotted hyenas wait at a respectful distance, approaching with impunity only if they have the advantage of numbers. Contrary to popular opinion, this much-maligned creature scavenges little of its food, killing more than 70 percent itself. In fact, hyenas are more likely to lose their prey to scavenging lions on the plains than the other way around.

Hyenas are true predators. Even during the dry season, they retain their territories and the integrity of the clan by "commuting" up to 50 miles (80 km) to the herds that sustain them. Wildebeests are their mainstay, but even these large

antelopes are usually taken down by a single hyena, who is then joined by other members of the clan. Only zebras are regularly hunted by cooperating packs, a decision that appears to be made by the hyenas at the outset of a hunt. Animals are hunted by sight, and a hyena may pass within 6 feet (1.8 m) of a hidden Thomson's gazelle fawn without finding it.

Once they have an animal down, hyenas eat virtually everything, including bones, horns, and teeth (other carnivores waste up to 40 percent of their kills). A gazelle fawn may vanish in two minutes, a 440-pound (200-kg) wildebeest in thirty minutes. Hyenas are noisy eaters, and the commotion at the kill often attracts lions.

What little is left of the carcass is eventually dispatched by jackals (*Canis mesomelas*), vultures, marabou storks, and tawny eagles (*Aquila rapax*). Hyenas are the only carnivores that regularly chew bones, and the bone fragments left by hyenas are vital to griffon vultures (*Gyps* spp.). Without these bone fragments as part of their diet, griffon vulture chicks develop osteodystrophy, a debilitating metabolic bone disease that results from a lack of calcium.

The female spotted hyena is dominant at the kill, as she is in most clan situations. For a long time the male-female interactions in spotted hyena society were a source of considerable confusion among observers, not least because, superficially, the external genitalia of both sexes are almost identical (the more imaginative observers reported that hyenas were hermaphrodites).

Female spotted hyenas have a fully erectile pseudopenis and scrotum formed from a modified clitoris and vulva. This masculinization of the female's genitalia has been linked to high levels of male sex hormones (androgens). Female hyena androgen levels are highly variable, with the alpha female of the clan having levels well above the average found in males, and up to seven times higher than the female average. By acting like males, females probably gain increased access to food at kills, and thus can secure more food for their own pups, a strategy that has clear evolutionary advantages.

The masculinization of the female hyena's reproductive organs results in some major complications during birth, because the urogenital tract passes through the elongated clitoris. The newborn is also large by carnivore standards, weighing about 2.7 percent of maternal weight (compared to 1.35 percent in the brown hyena, 1.22 percent in lions, and 1.64 percent in wild dogs). Females may die while giving birth, or newborns may die in the process. Clearly, from an evolutionary perspective, the benefits of masculinization must still outweigh the risk of increased mortality during birthing.

Those young that survive their rather circuitous route into the world already have fully erupted incisors and canines and a very high degree of motor and behavioral development. As some observers have commented, the hyena pups literally come out fighting. They remain at the communal den for about the first

eight months. Although they are ready to eat meat at two and a half months, they rarely get the chance. Females do not return from kills bearing food. The only meat the cubs get is directly from the kills, and they won't follow their mothers away from the den until they are seven or eight months old.

During the "commuting" season, pups may be left for days as their mothers hunt. During particularly lean times, many pups die of starvation. It seems like a maladaptive strategy to sacrifice the next generation in search of a meal, but adults can always have more young.

The rarest of Africa's predators is the African wild dog, sometimes called the painted wolf. Never common, these *Innocent Killers* (as Jane Goodall and Hugo van Lawick call them in their book of the same name) are now among the most endangered mammals on the continent. Only three to five thousand survive in the wild in some six hundred to one thousand separate packs. Their historical range of thirty-four countries has been reduced to just six countries with populations of more than one hundred wild dogs. Outweighed 7:1 by a lioness and 2:1 by a hyena, and significantly outnumbered, wild dogs are easily out-competed on the savannahs.

Wild dogs commonly lose their kills to hyenas, and lions will kill both adults and pups. These dogs have also faced almost constant persecution by humans. Entire packs were routinely shot. The human reaction is puzzling, particularly because wild dogs show more of the characteristics that humans seem to admire than some of the more charismatic predators. In wild dog society, pups retain priority at kills until they are about eight months old, an interesting contrast to both lions and hyenas. In fact, wild dog society is remarkably quiet and restrained. The entire pack (averaging ten animals plus young) takes care of the young. In one closely observed pack in the Selous Game Reserve in Tanzania, the lone female died just five weeks after giving birth to nine pups, and the five males left in the pack successfully raised all of the pups.

As the rains fade from the savannah at the end of May, the herds prepare to migrate. Male wildebeests begin their rut, and the plains come alive with territorial displays and loud snorts that some have described as calls of "ge-nu, ge-nu." With much posturing, horn sweeping, and ramming, the wildebeest males renew the cycle that has governed these plains for millennia. The males lock heads with their rivals, twisting and ramming with their horns, vying for supremacy within territories that may be just a few hundred yards wide.

True horns are found only among the Bovidae, the mammalian family that includes sheep, goats, cattle, antelopes, and buffalos. It was once thought that horns evolved as an antipredator weapon, but since most bovids flee from predators, and females are hornless in a third of bovid species, it is now believed that horns may be secondary sexual characteristics that evolved as a weapon of inter-male competition; any antipredatory advantage is a bonus.

With the rut over and the next generation assured, the great herds of the Serengeti move north and west. The grass turns brown, and the plants and animals of the savannah shift with the seasons. The spotted hyenas resume their commuting. Lions subsist on gazelles and other small game. All must wait for five months to pass before the rains will come again.

The Serengeti has existed for four million years, a time frame that coincides with the evolution of our own ancestors along the Great Rift Valley. Early humans viewed the sights of the Pleistocene savannah as they strode across the plains, scavenging carcasses from hyenas, retrieving drowned wildebeests at river crossings, or digging for rodents, tubers, and termites. By observing the greatest of the world's migrations, we can catch a glimpse of our own past. On the African savannah, evolution has tendered some of its most remarkable feats for us to consider and appreciate.

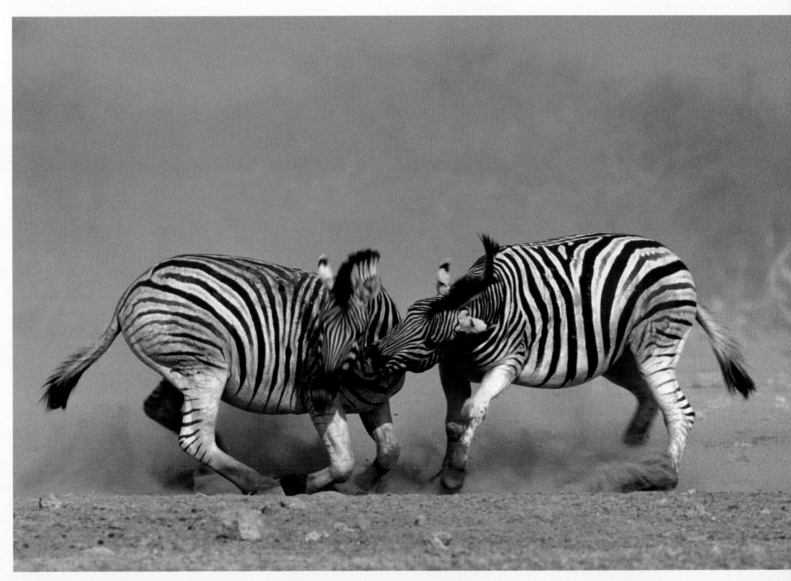

BURCHELL'S ZEBRA (*Equus burchellii*), ETOSHA NATIONAL PARK, NAMIBIA

SERENGETI PLAIN, Tarangire National Park, Tanzania

GIRAFFE (*Giraffa camelopardalis*), SERENGETI NATIONAL PARK, TANZANIA

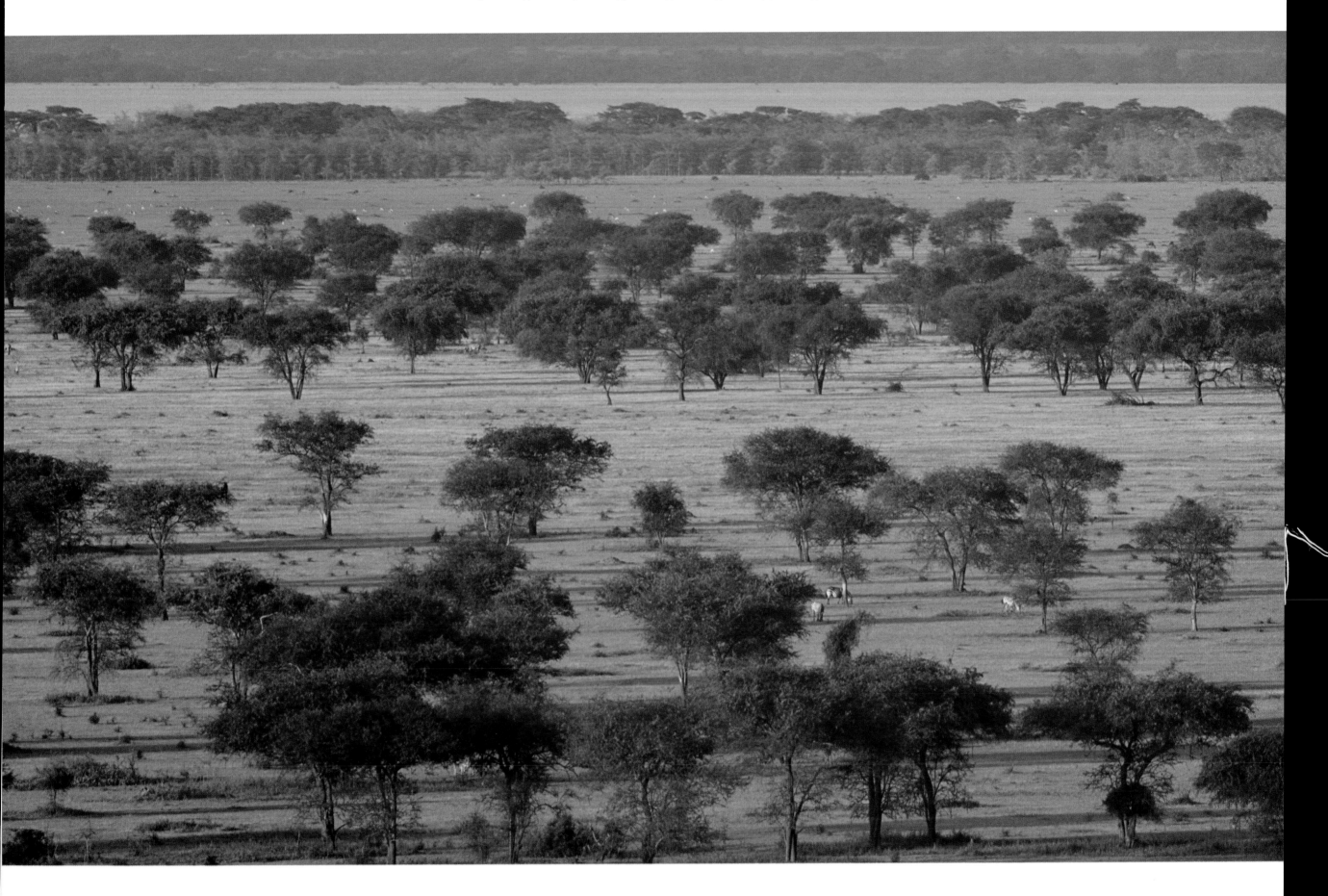

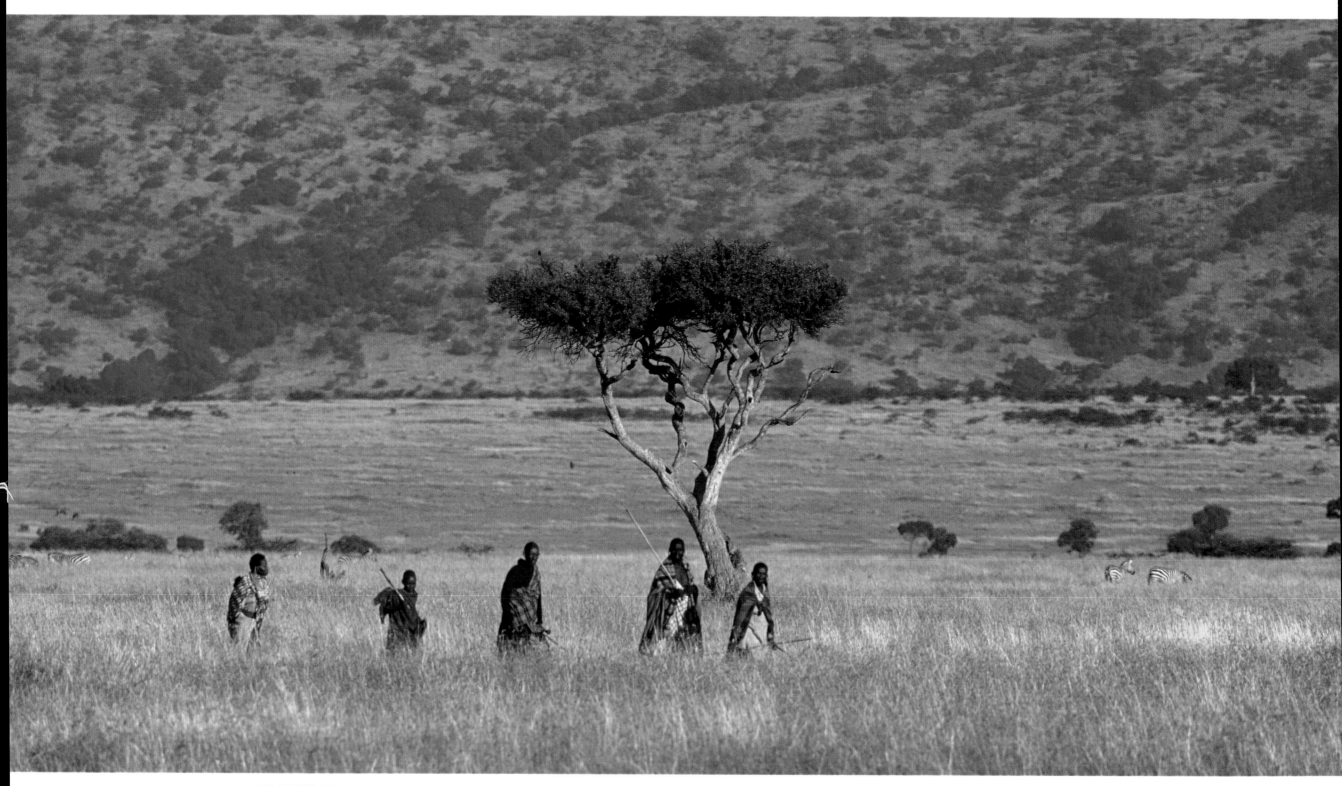

MAASAI TRIBE, Mara River region, Kenya

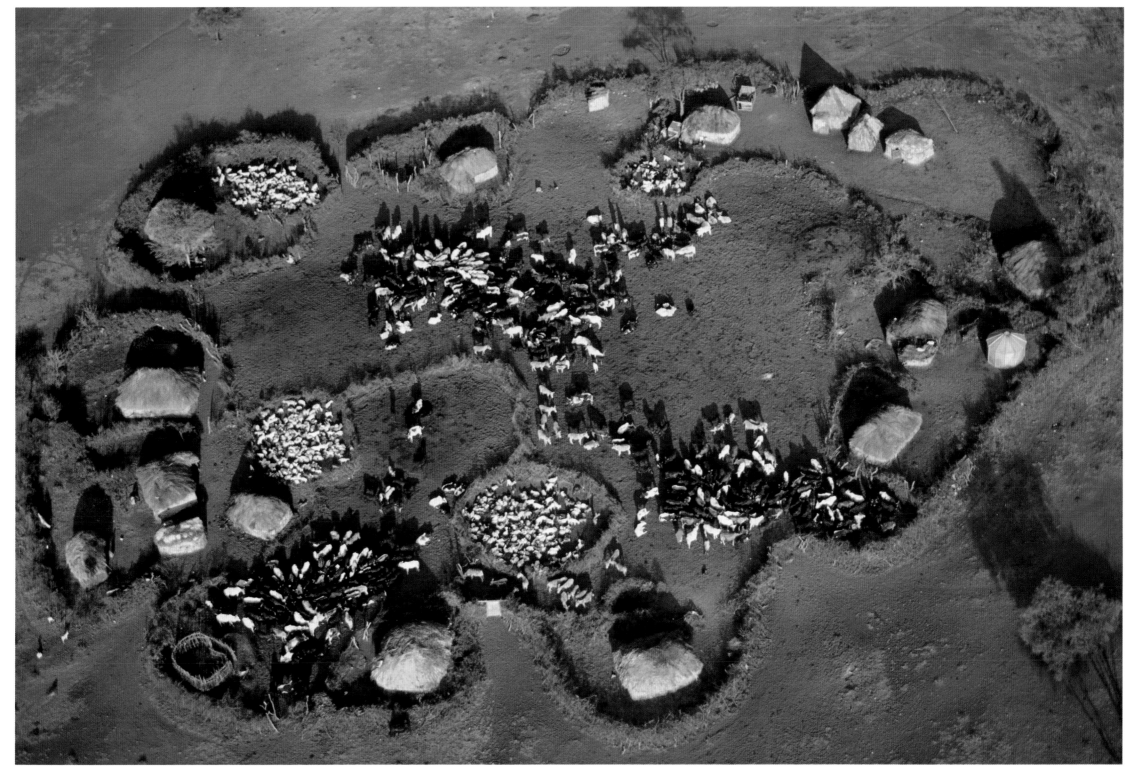

MAASAI VILLAGE, Mara River region, Kenya

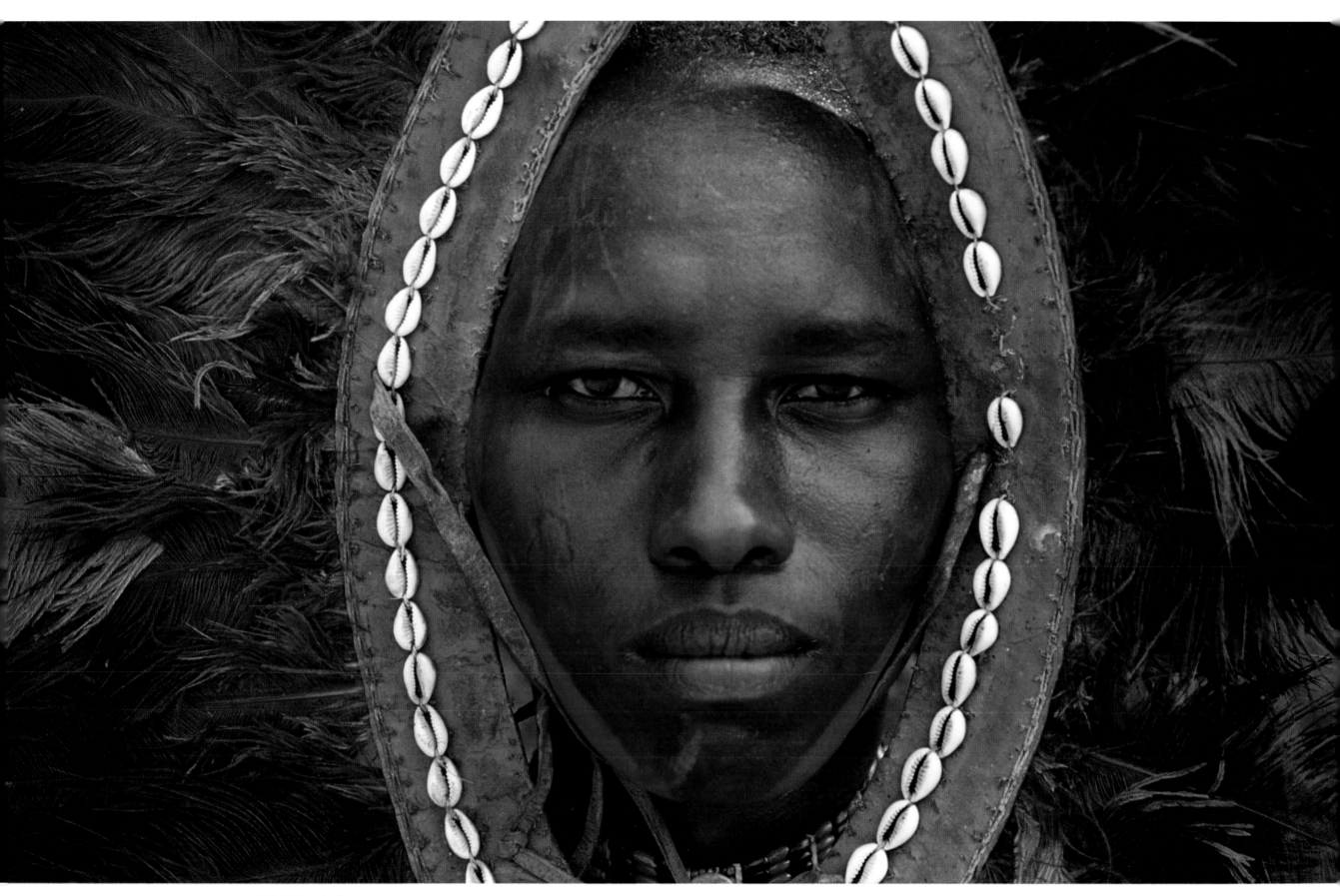

MAASAI MORAN, Mara River region, Kenya

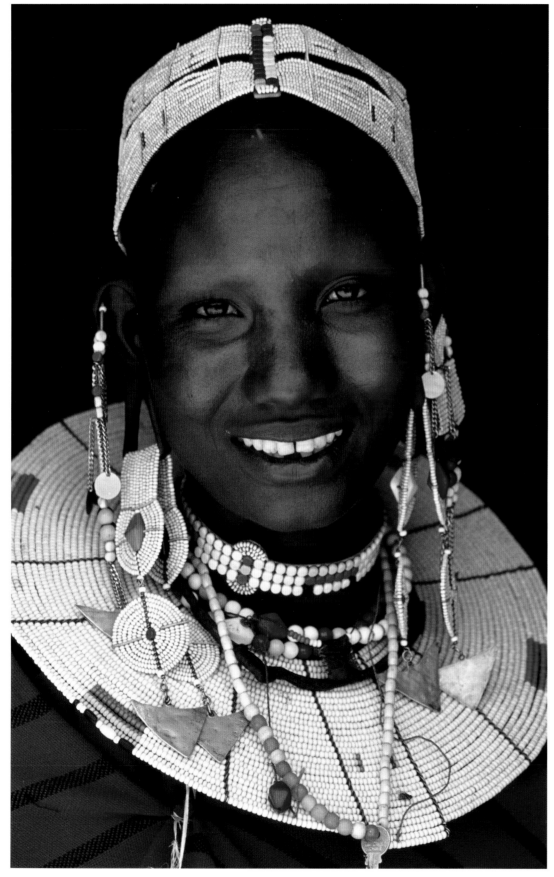 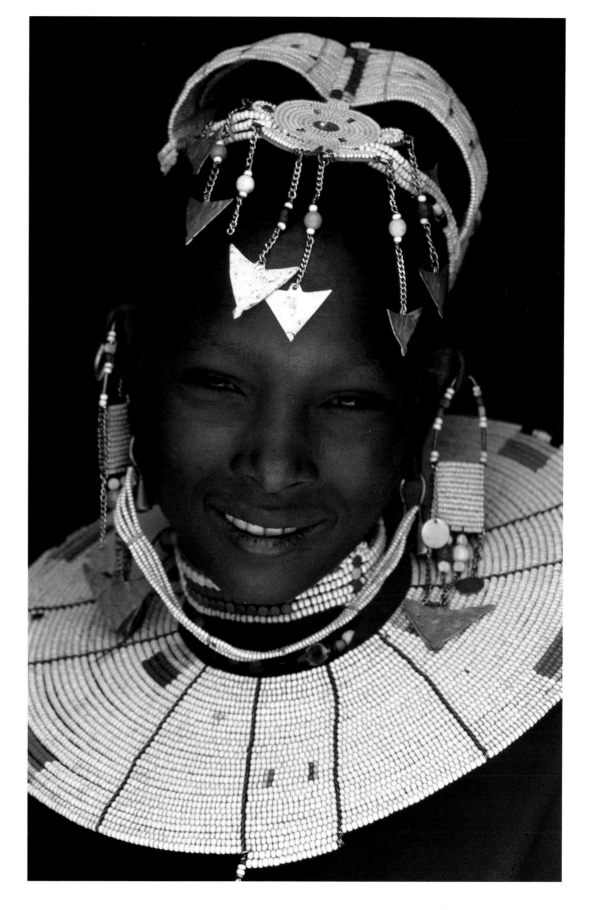

▲ AND ▶ MAASAI TRIBE, Ngorongoro Conservation Area, Tanzania

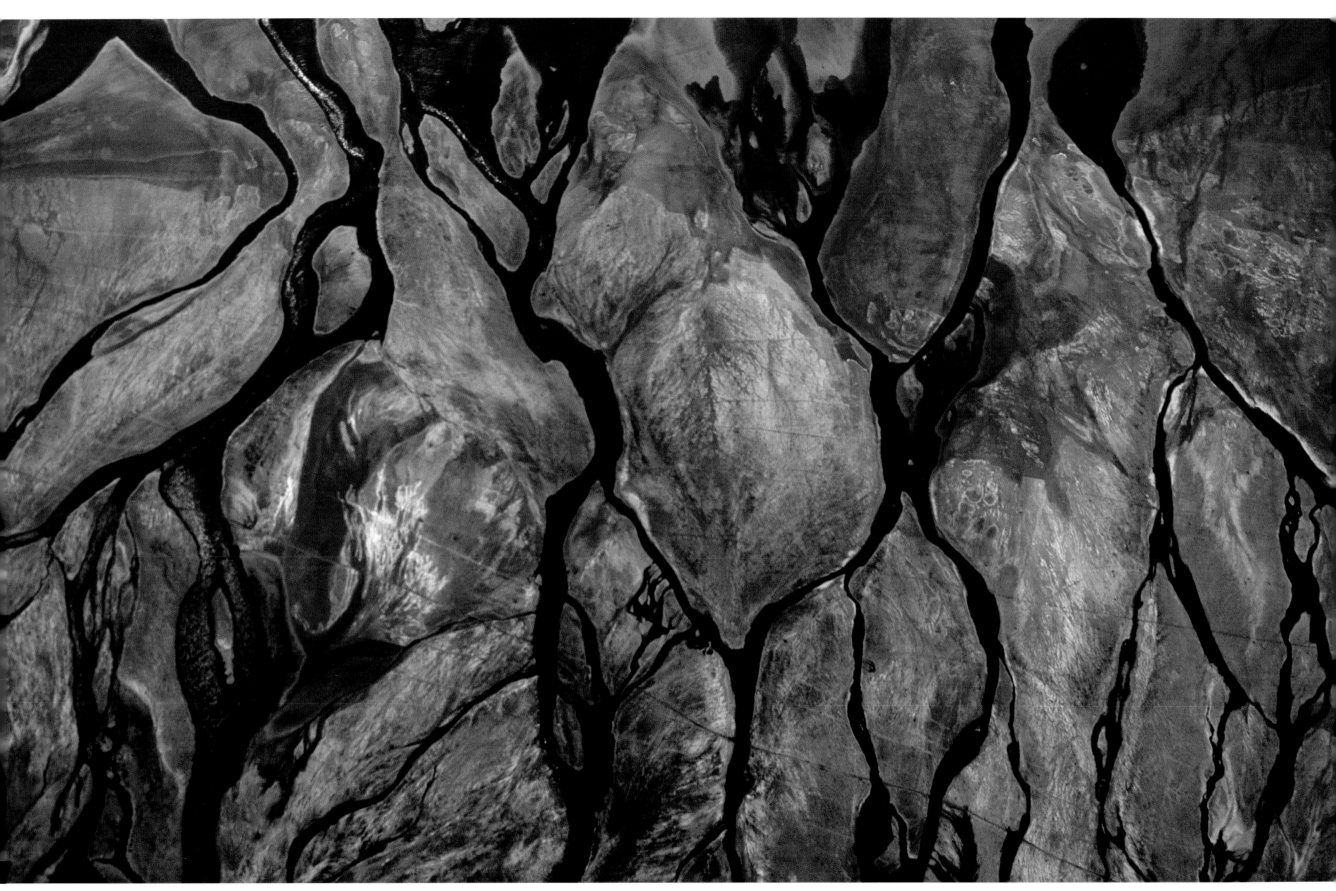

LAKE NATRON, BORDER OF KENYA AND TANZANIA

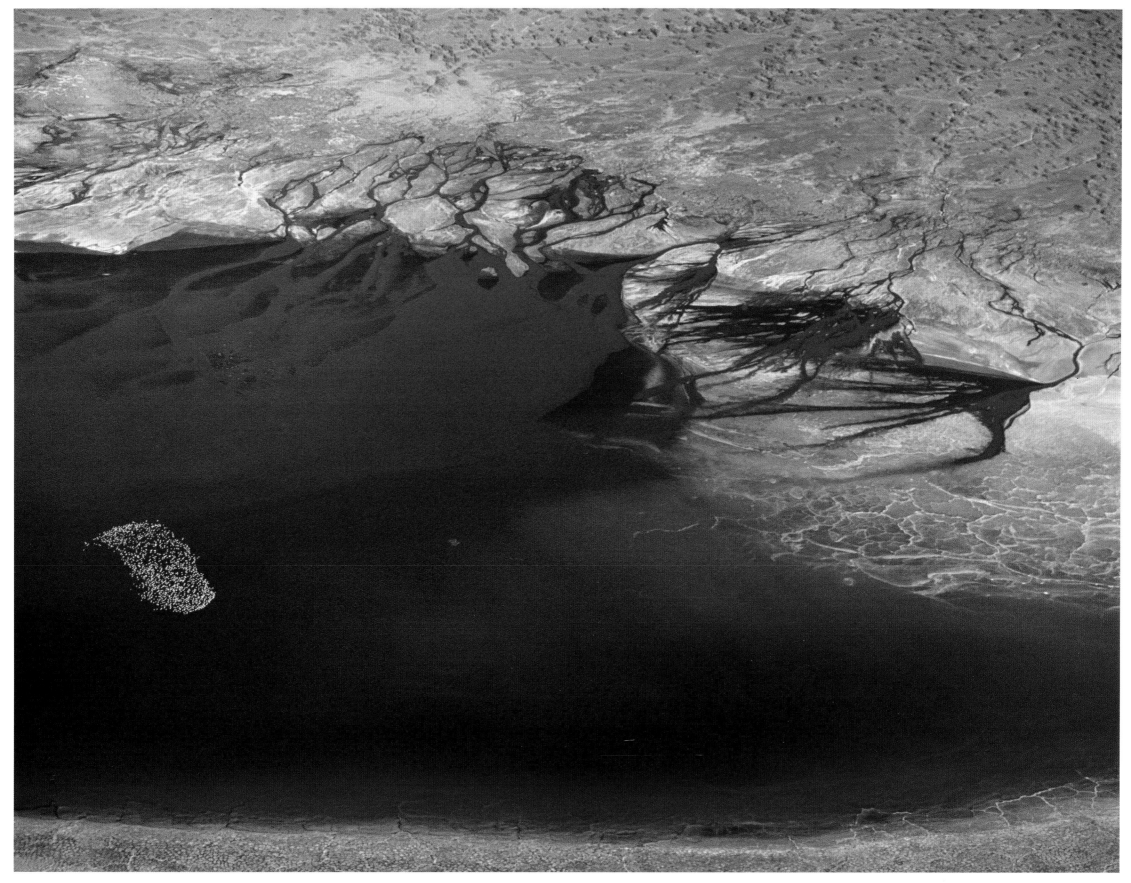

LESSER FLAMINGO (*Phoenicopterus minor*), LAKE NATRON, TANZANIA

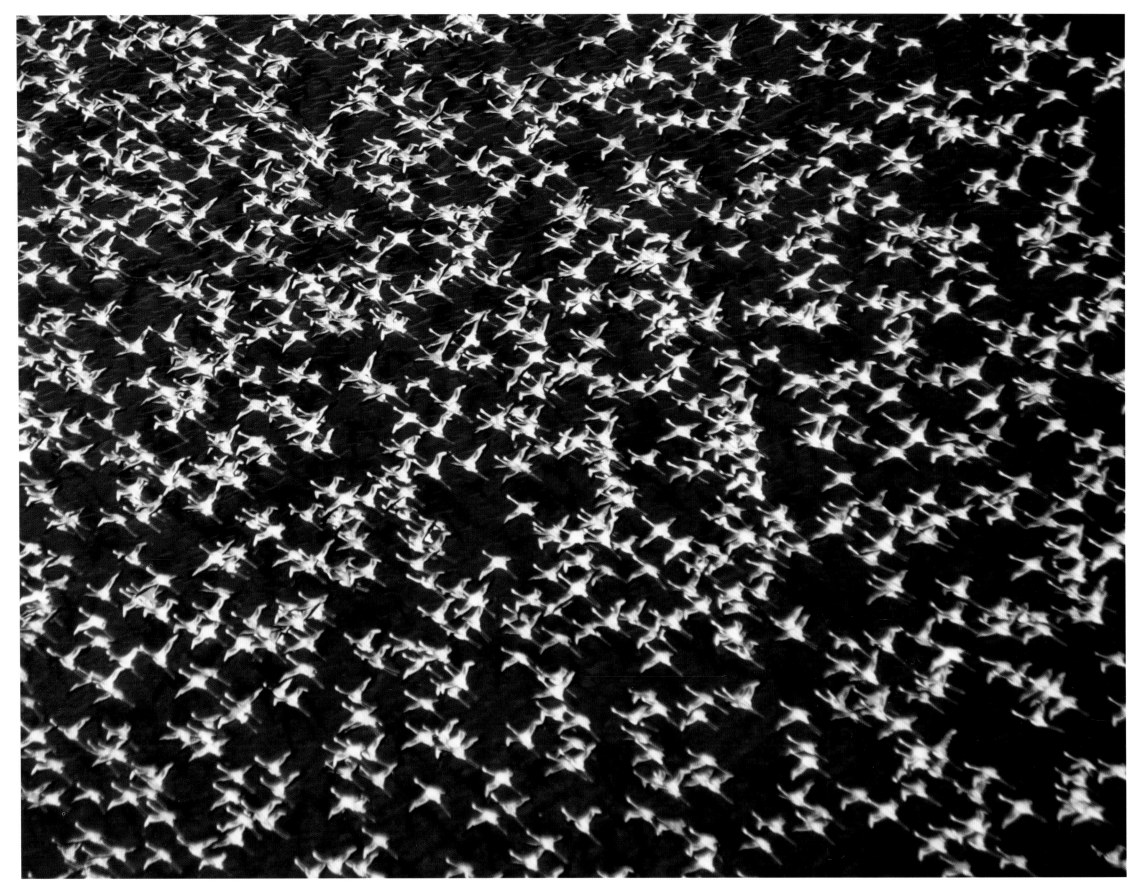

LESSER FLAMINGO (*Phoenicopterus minor*), LAKE MAGADI, KENYA

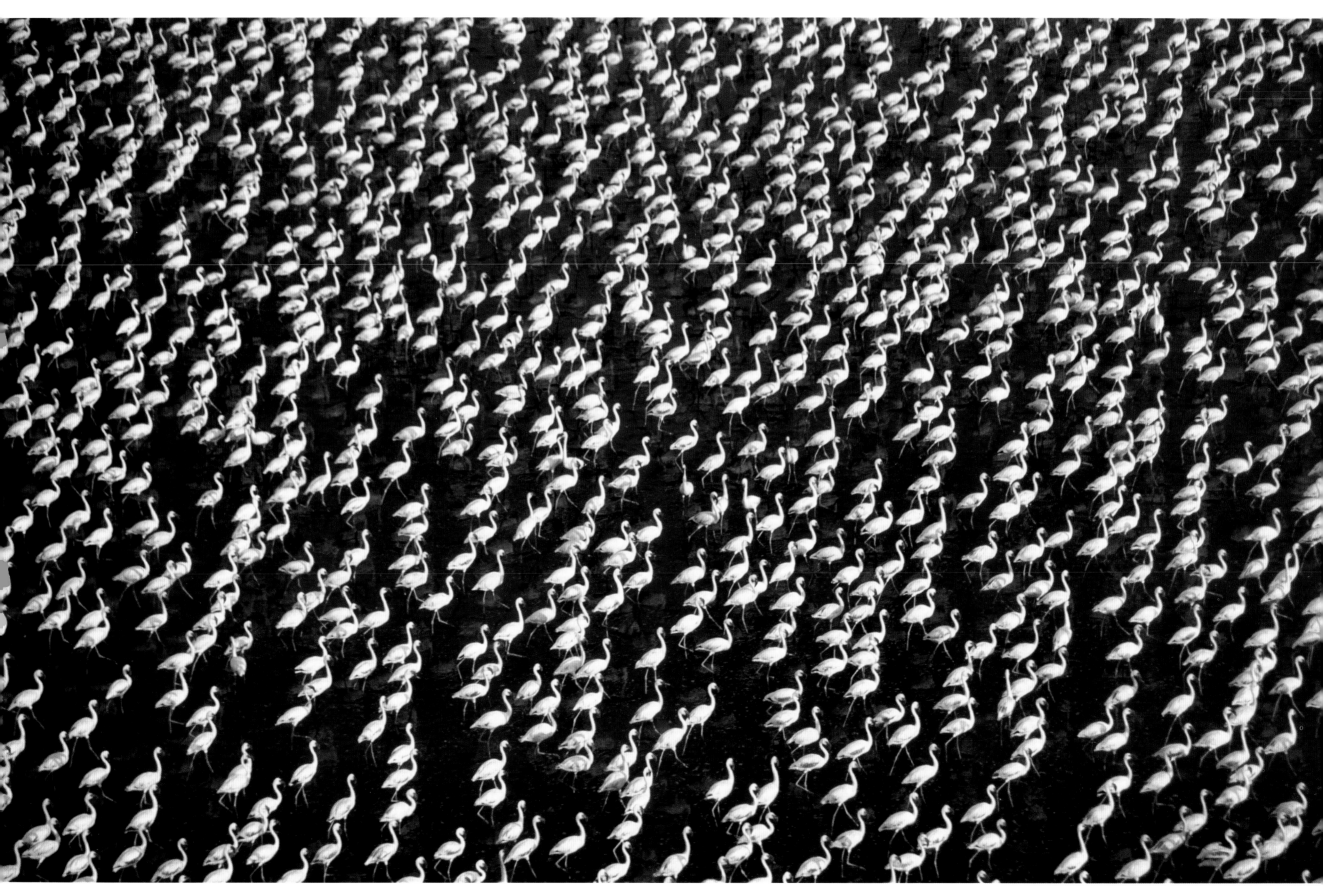

LESSER FLAMINGO (*Phoenicopterus minor*), LAKE MAGADI, KENYA

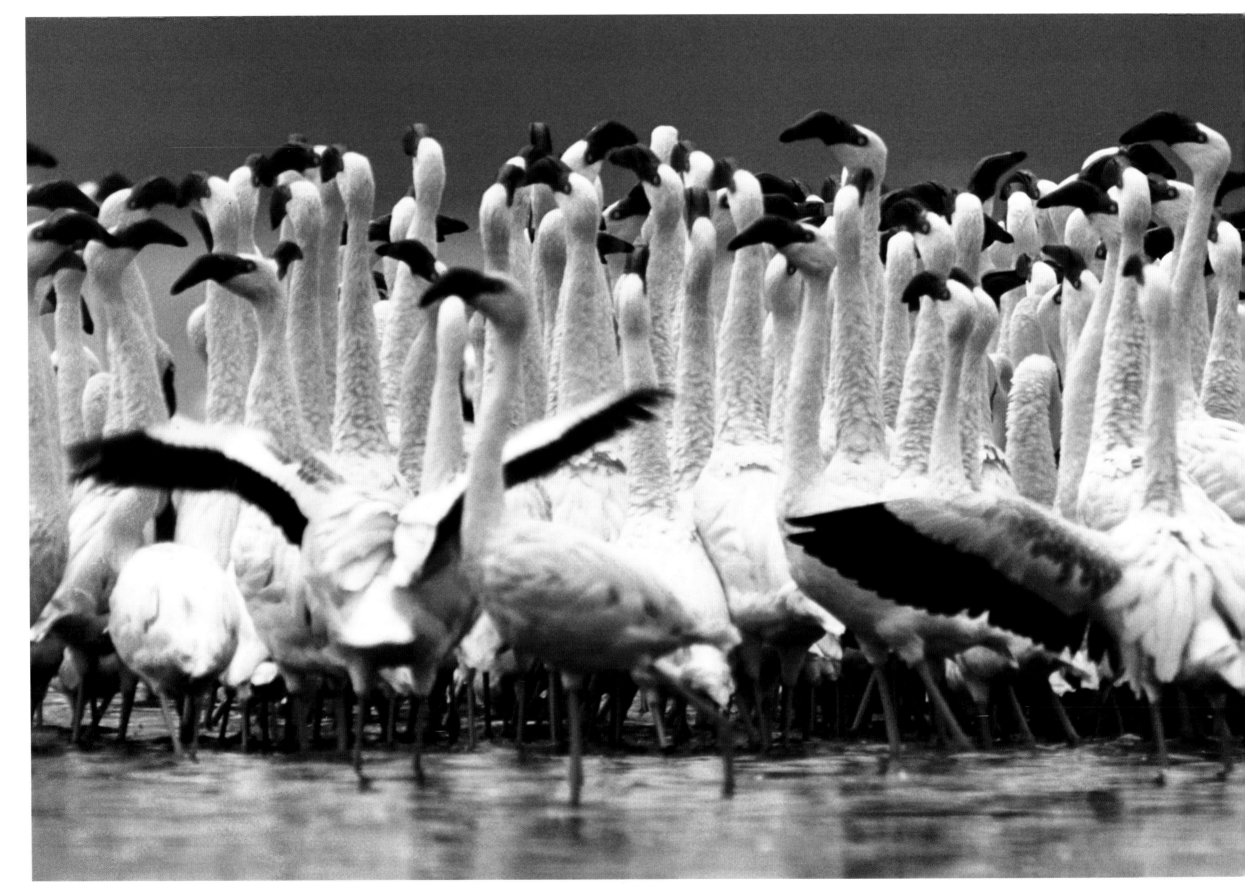

LESSER FLAMINGO (*Phoenicopterus minor*), LAKE MAGADI, KENYA

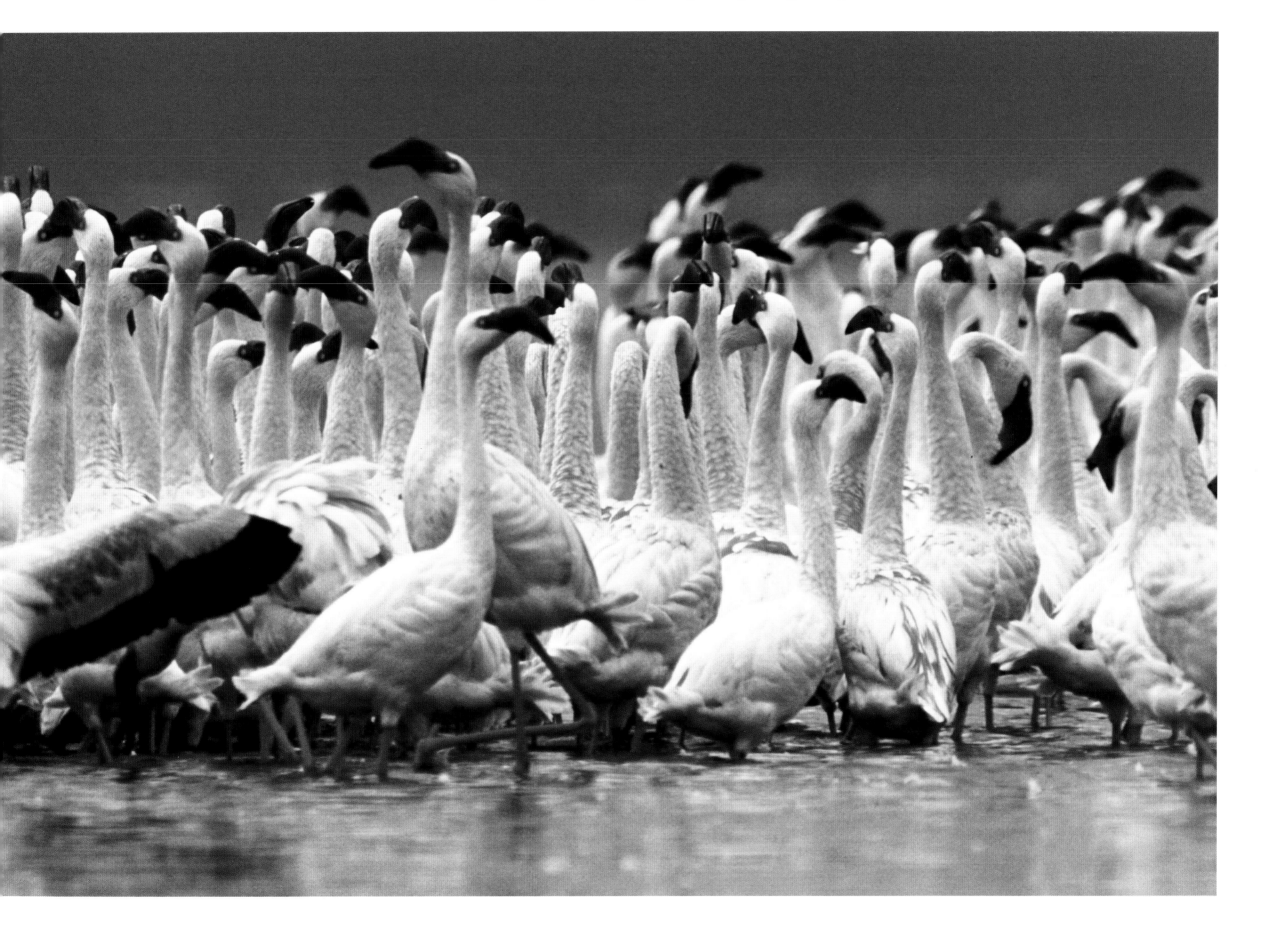

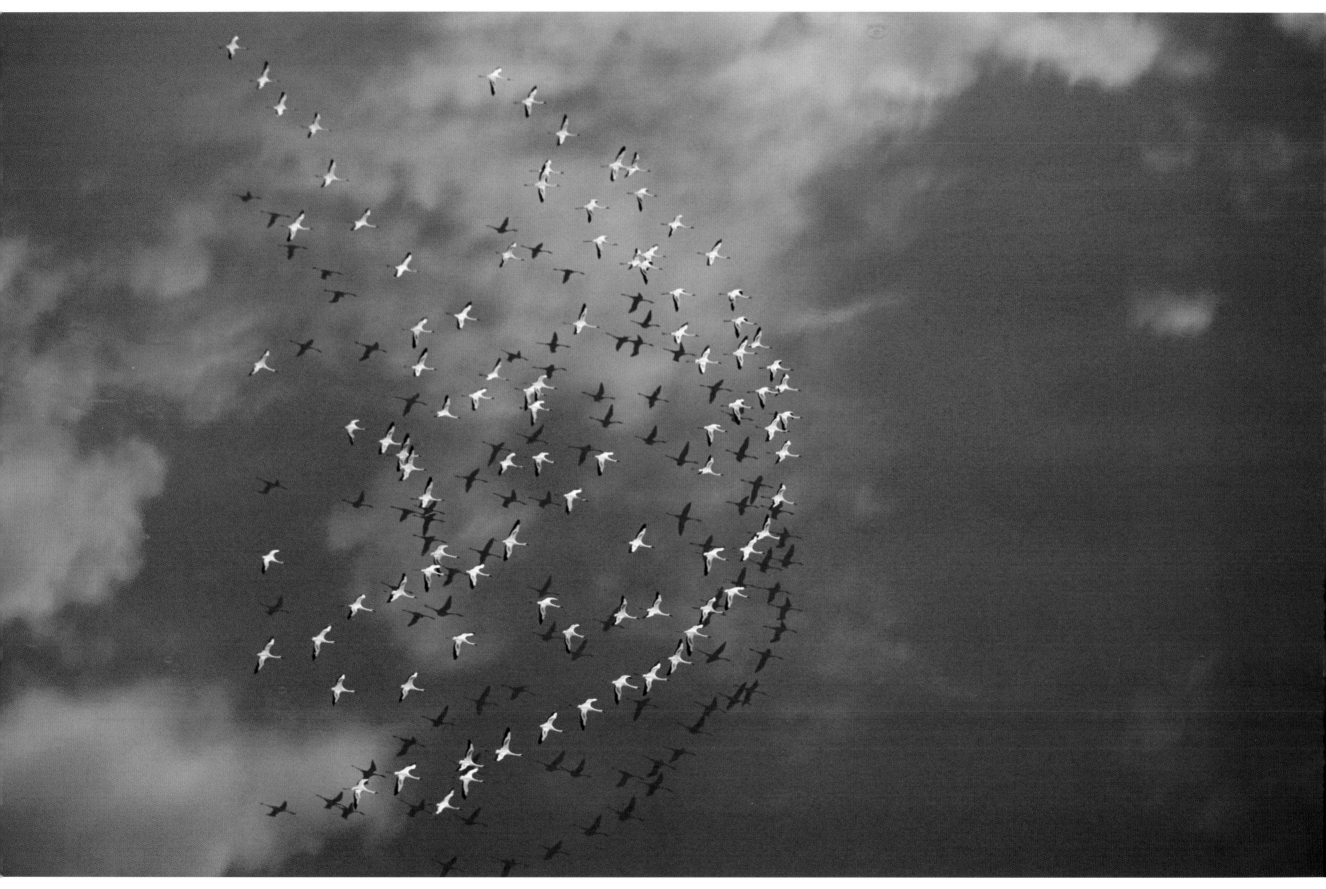

LESSER FLAMINGO (*Phoenicopterus minor*), LAKE MAGADI, KENYA

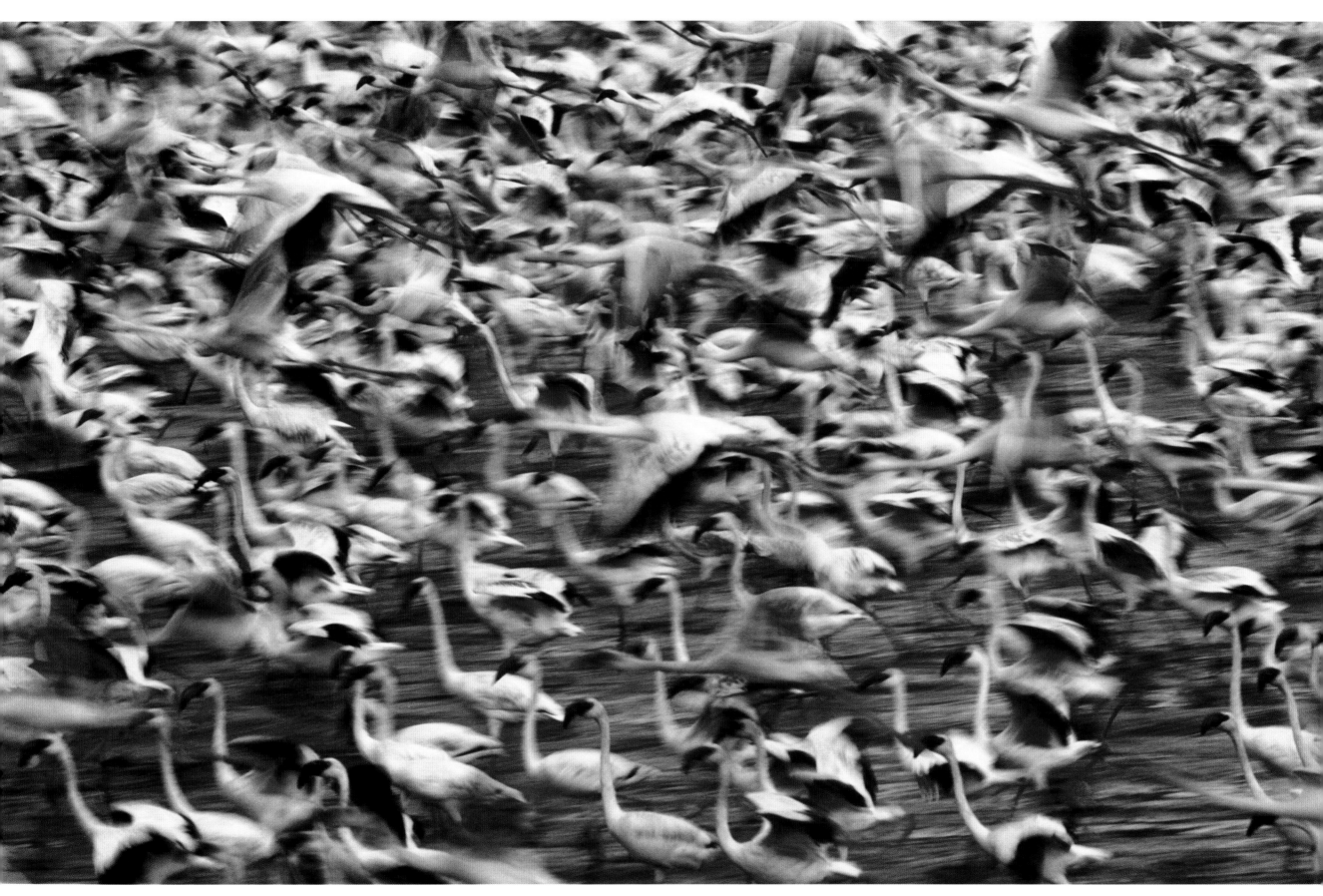

LESSER FLAMINGO (*Phoenicopterus minor*), LAKE BOGORIA, KENYA

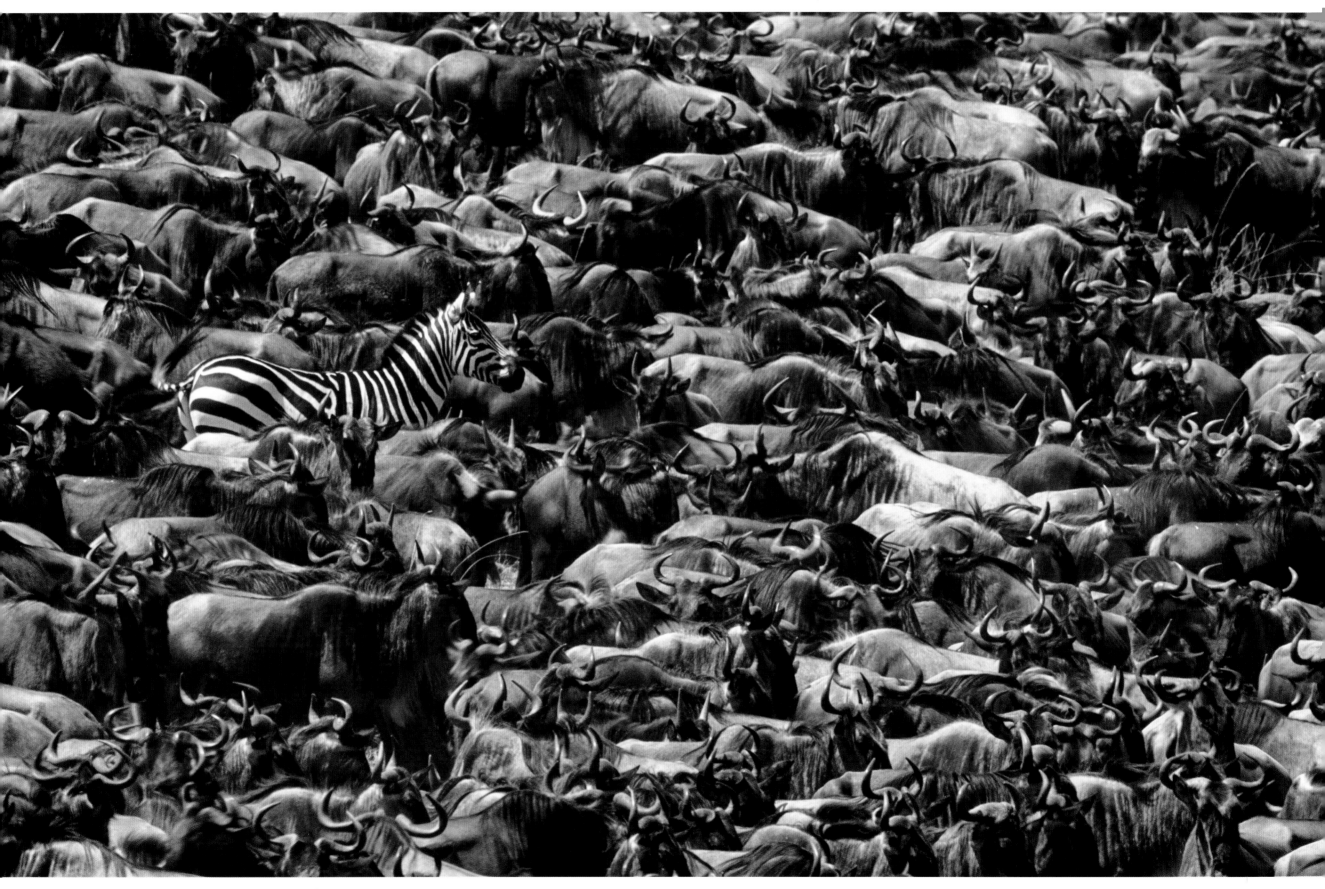

BURCHELL'S ZEBRA (*Equus burchellii*) AND COMMON WILDEBEEST (*Connochaetes taurinus*), MAASAI MARA NATIONAL RESERVE, KENYA

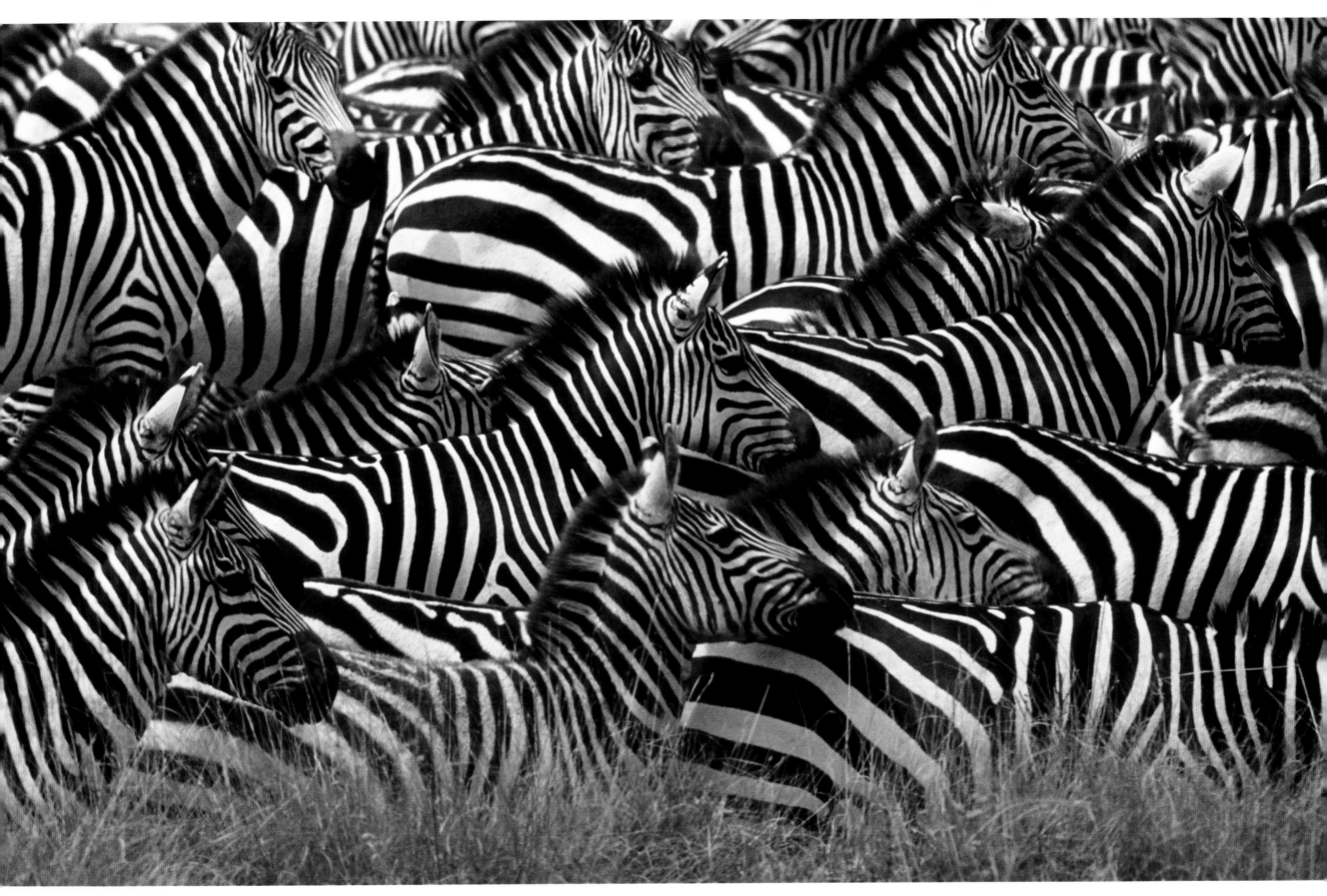

BURCHELL'S ZEBRA (*Equus burchellii*), MAASAI MARA NATIONAL RESERVE, KENYA

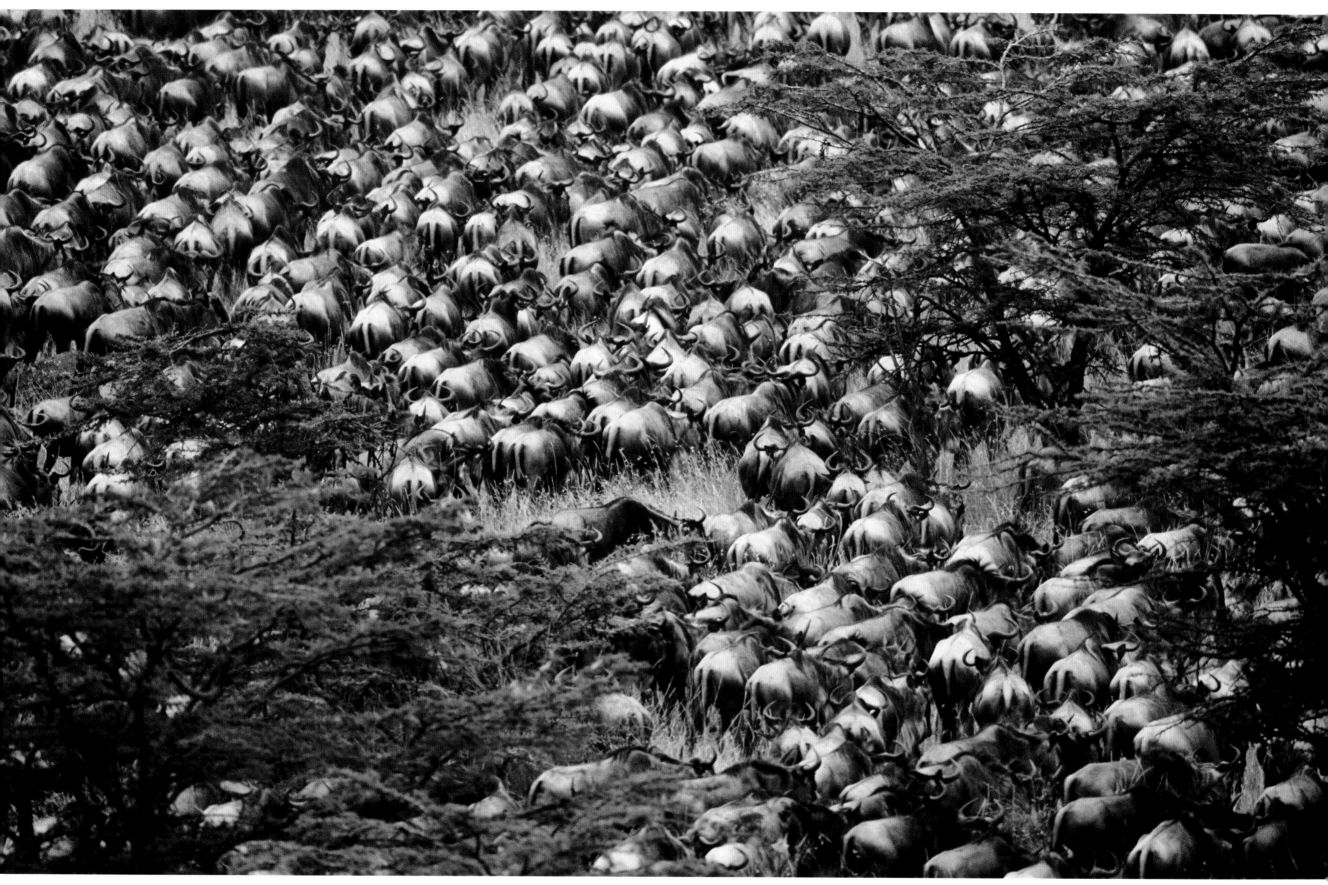

COMMON WILDEBEEST (*Connochaetes taurinus*), MAASAI MARA NATIONAL RESERVE, KENYA

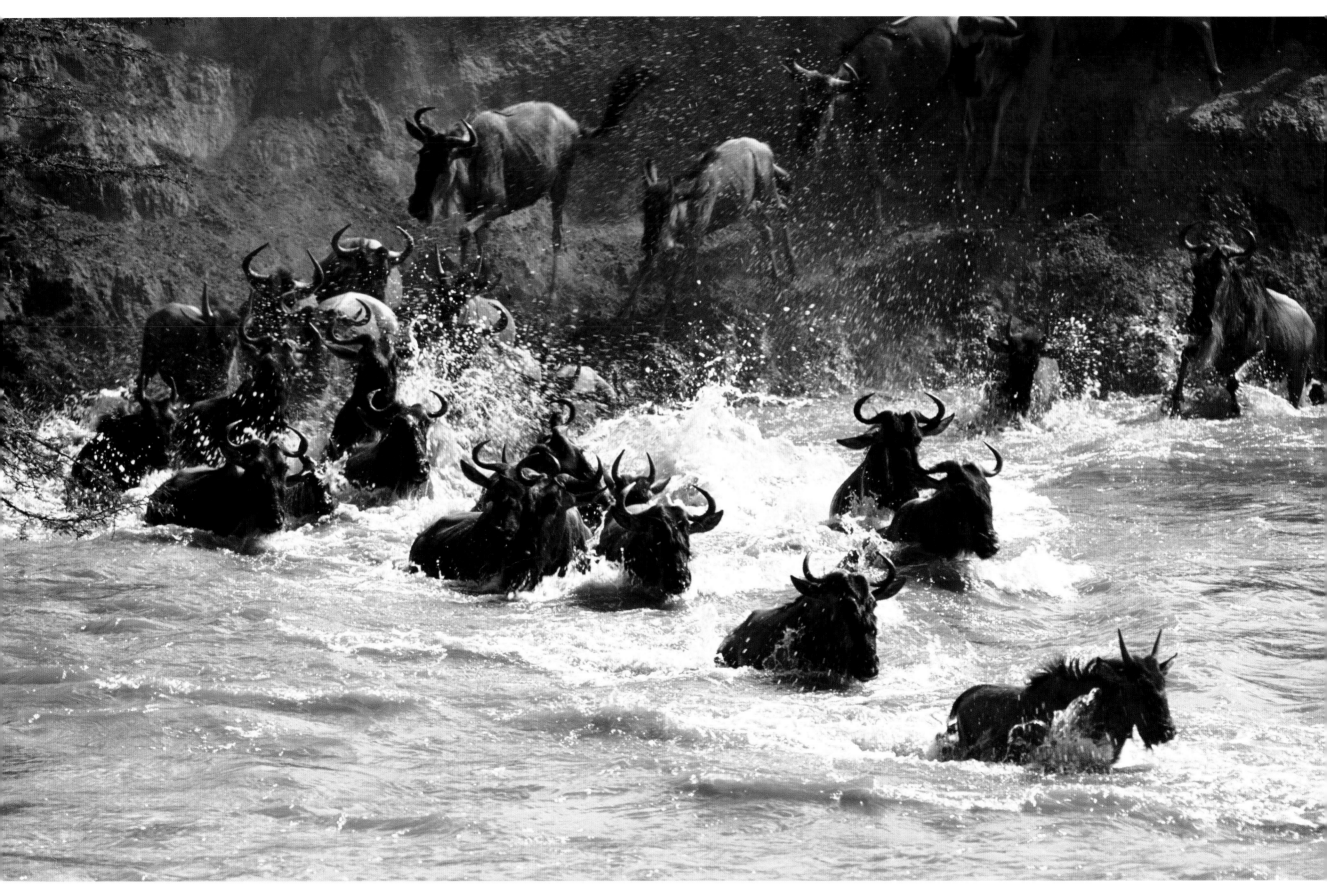

COMMON WILDEBEEST (*Connochaetes taurinus*), MARA RIVER, KENYA

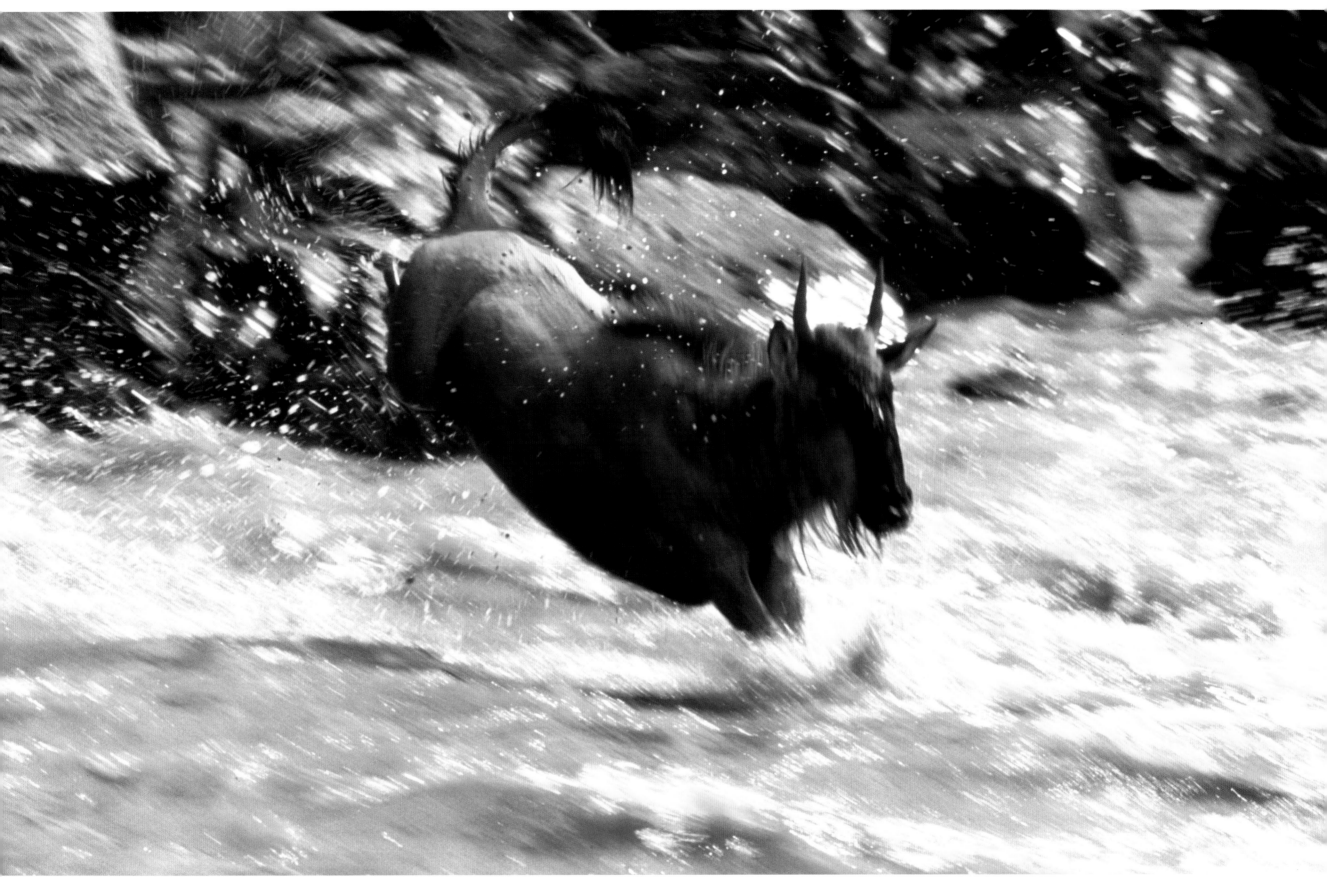

COMMON WILDEBEEST (*Connochaetes taurinus*), MARA RIVER, KENYA

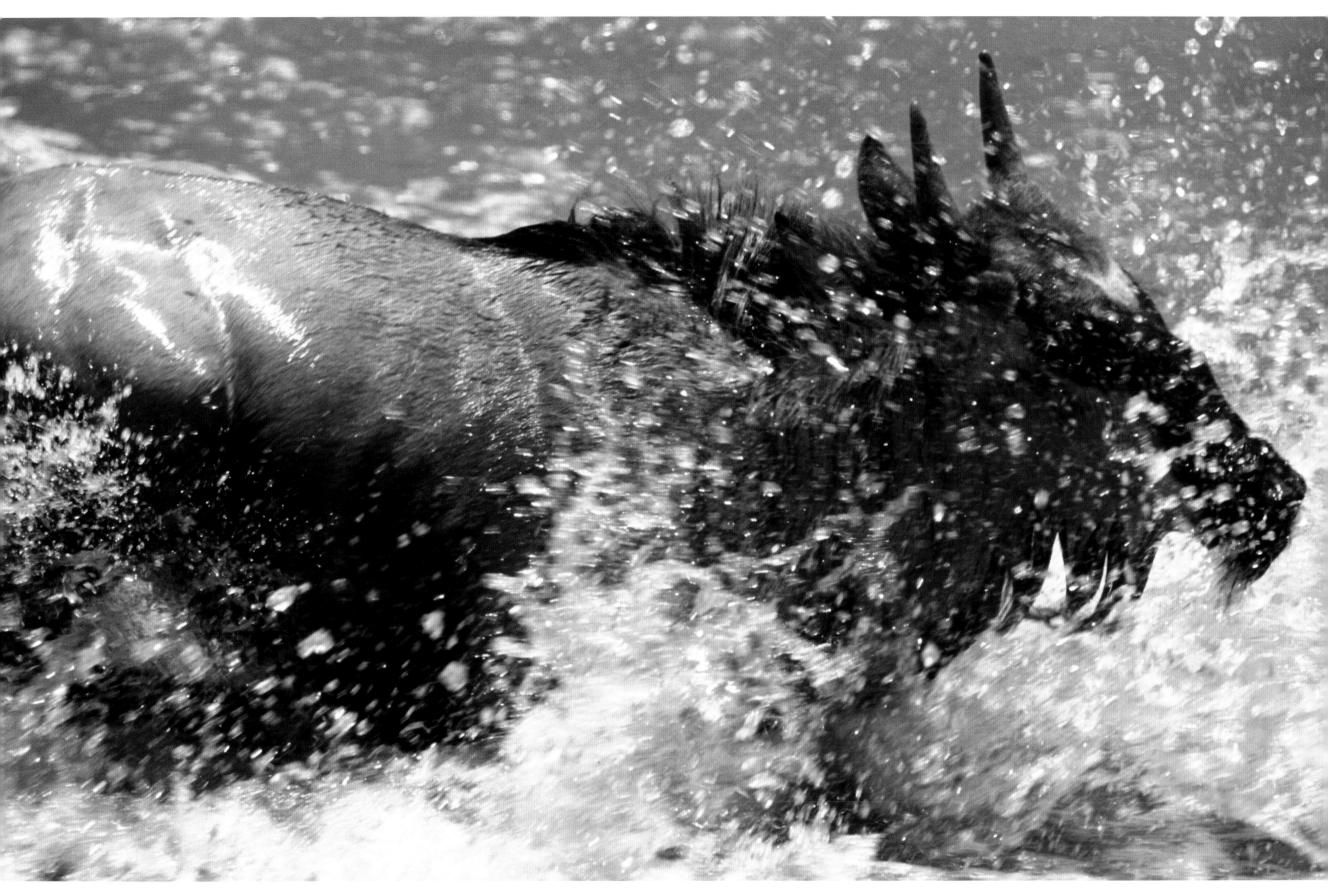

COMMON WILDEBEEST (*Connochaetes taurinus*), MARA RIVER, KENYA

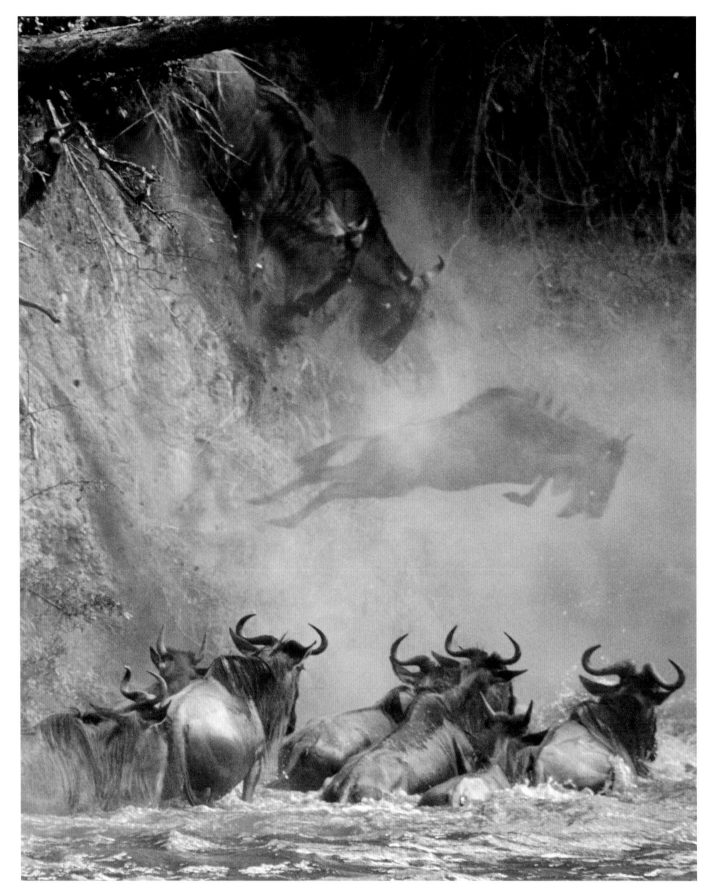

COMMON WILDEBEEST (*Connochaetes taurinus*), MARA RIVER, KENYA

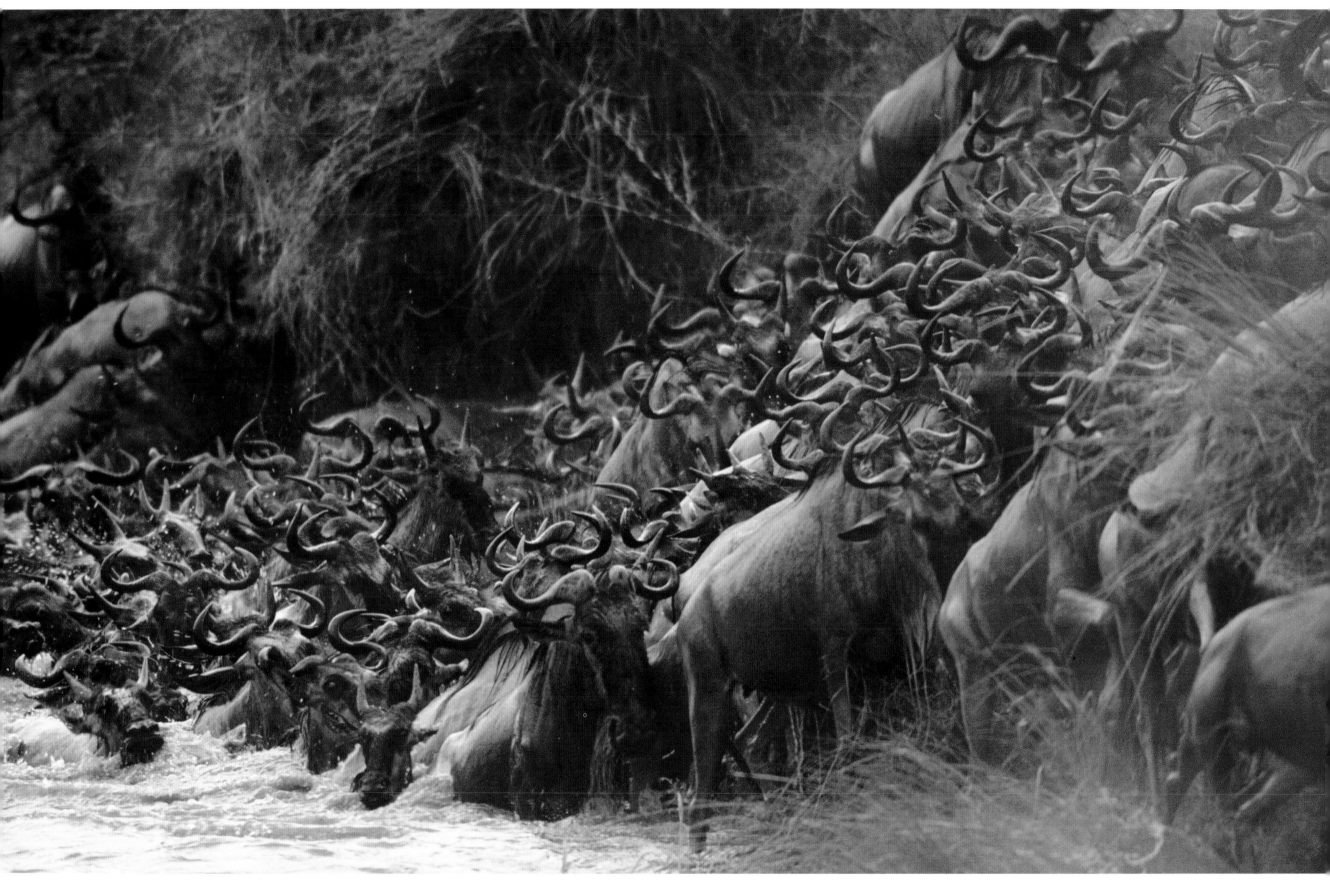

COMMON WILDEBEEST (*Connochaetes taurinus*), MARA RIVER, KENYA

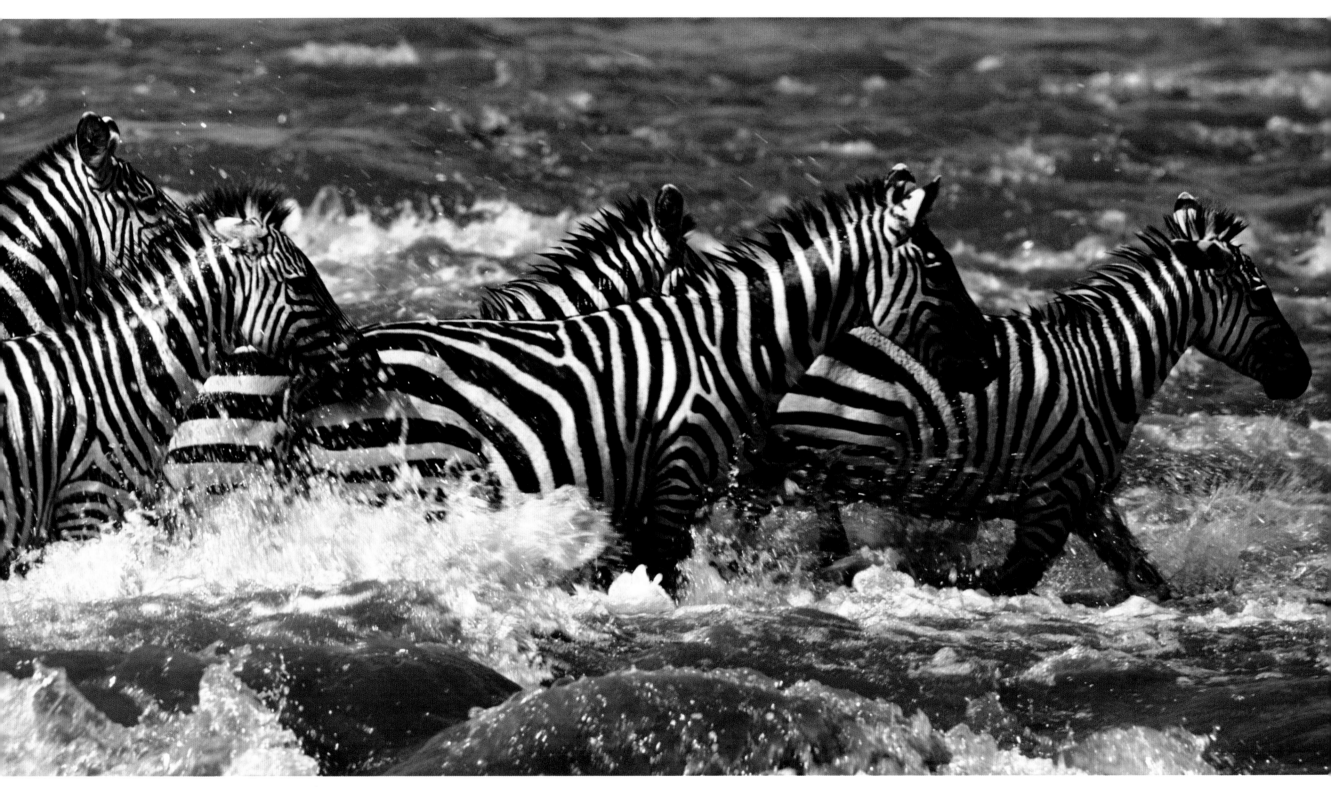

BURCHELL'S ZEBRA (*Equus burchellii*), MARA RIVER, KENYA

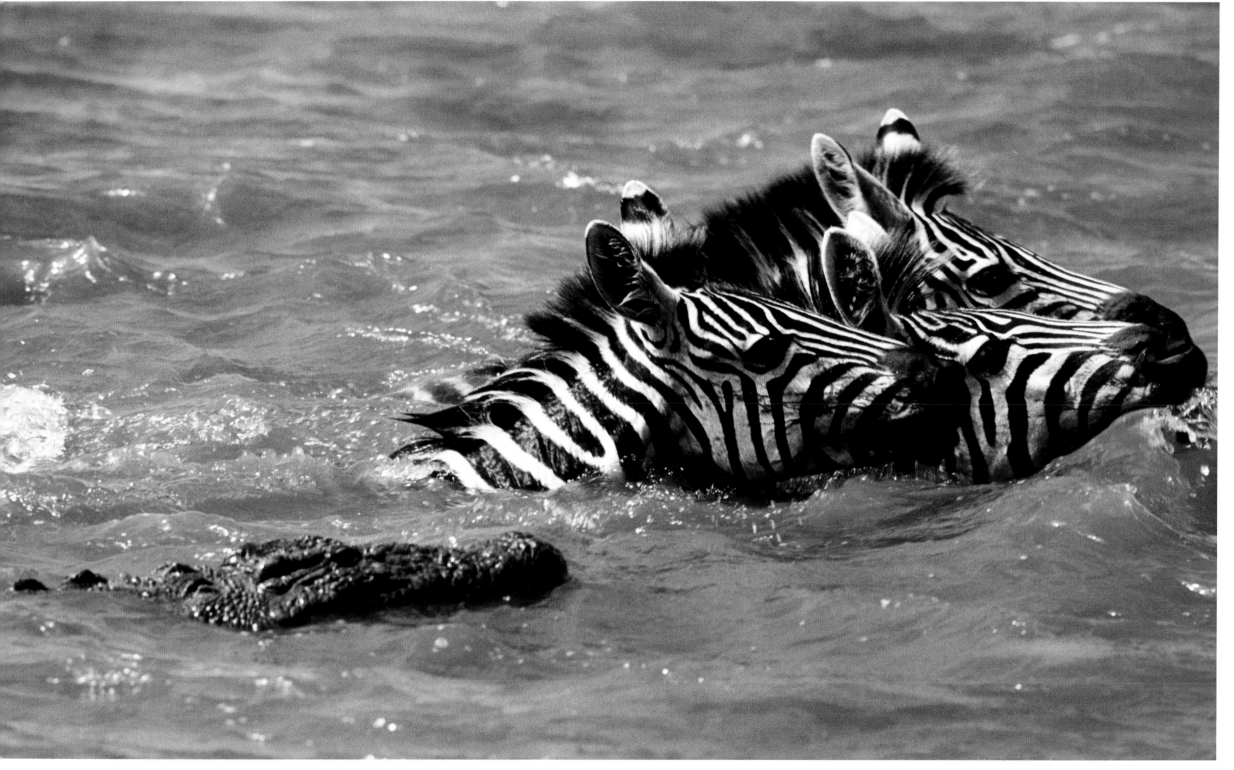

NILE CROCODILE (*Crocodylus niloticus*) AND BURCHELL'S ZEBRA (*Equus burchellii*), MARA RIVER, KENYA

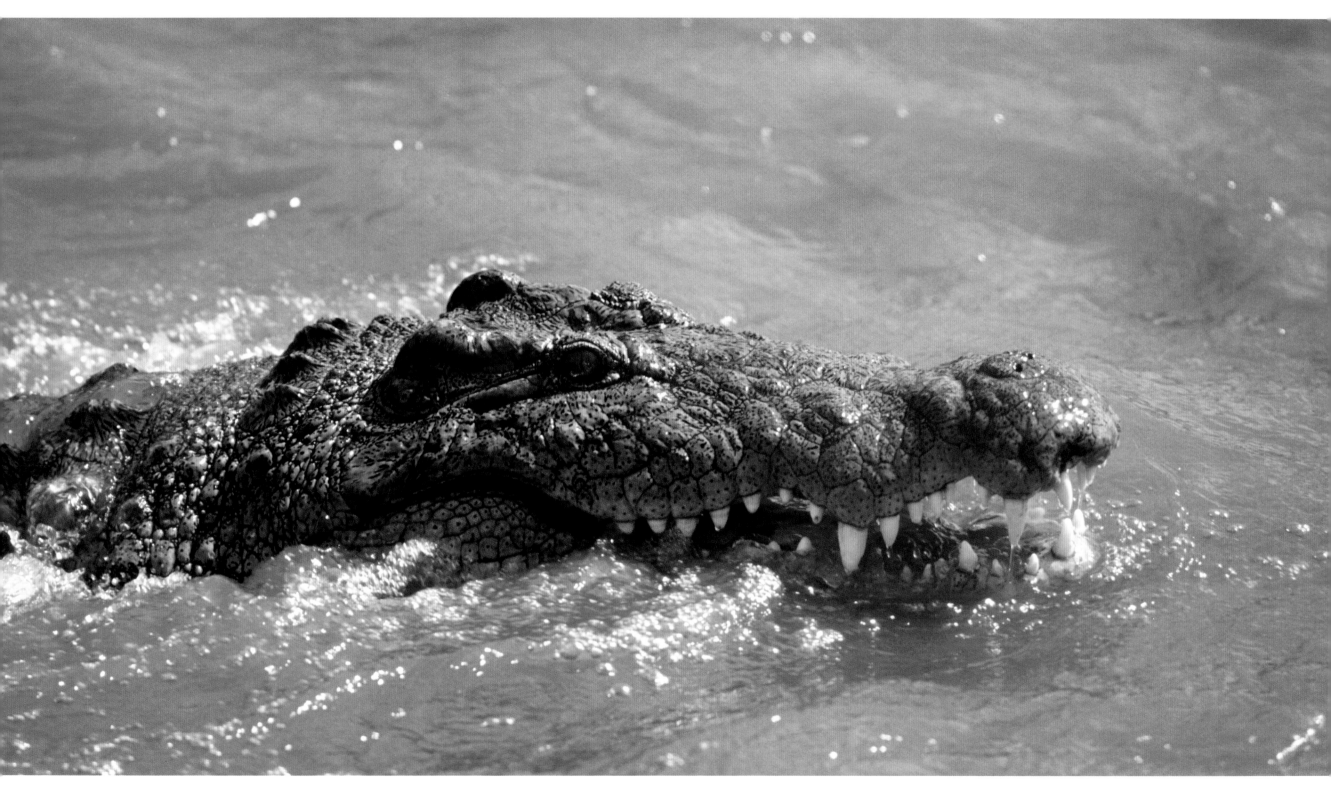

NILE CROCODILE (*Crocodylus niloticus*), MARA RIVER, KENYA

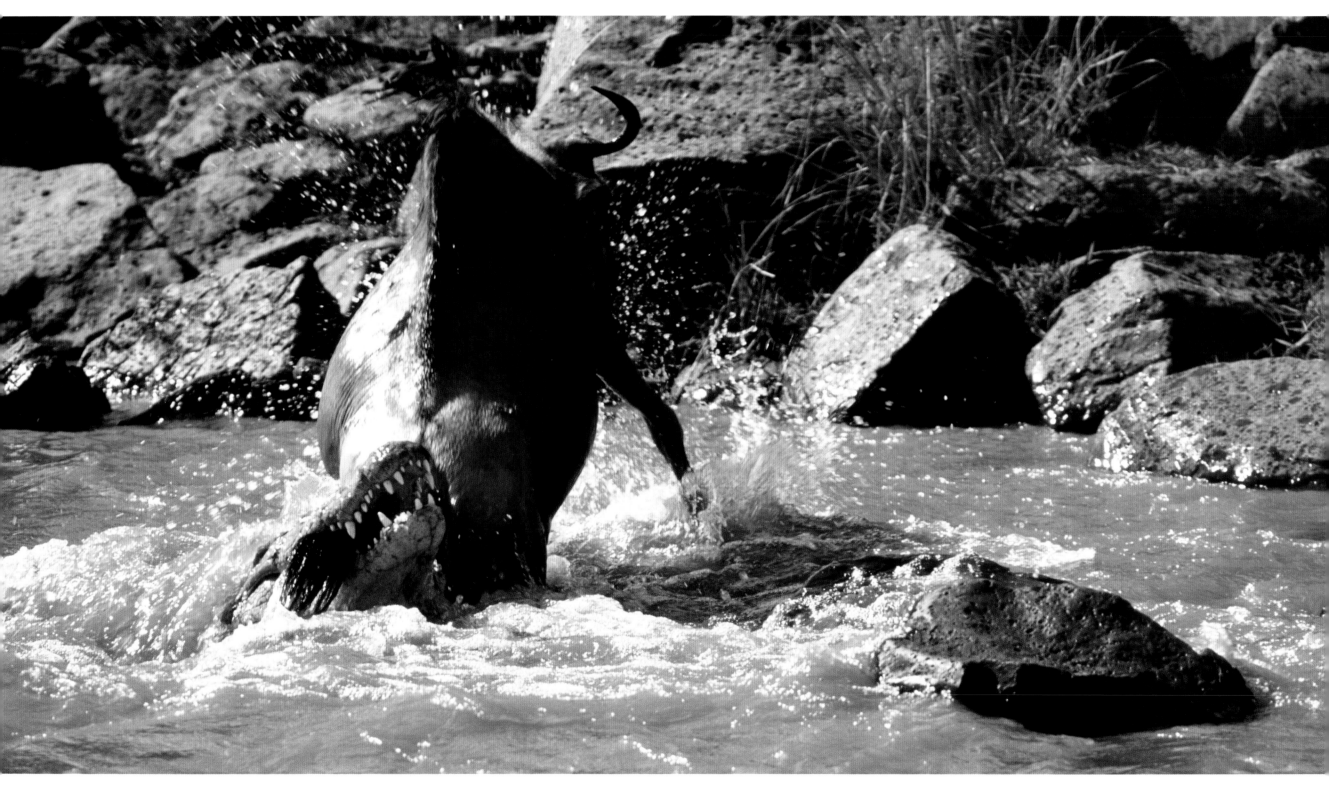

NILE CROCODILE (*Crocodylus niloticus*) AND COMMON WILDEBEEST (*Connochaetes taurinus*), MARA RIVER, KENYA

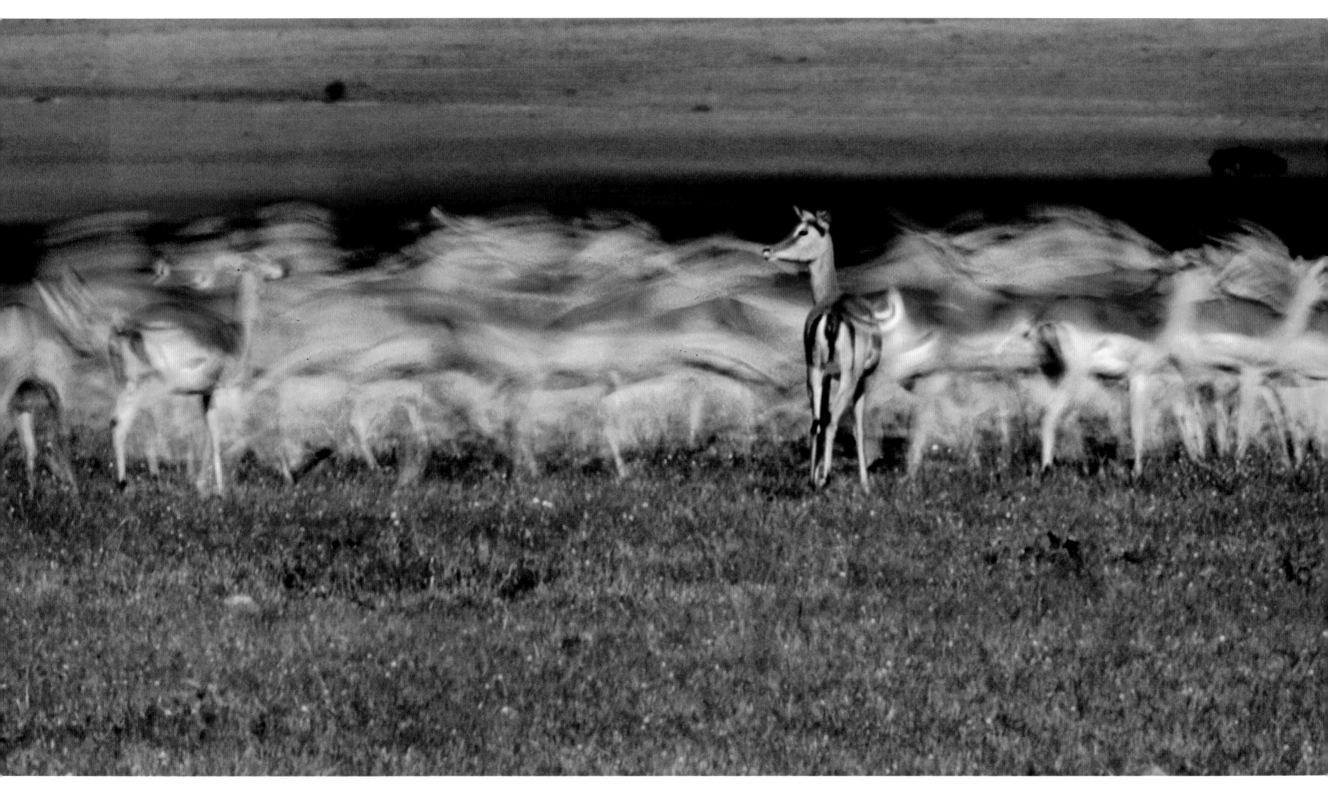

IMPALA (*Aepyceros melampus*), MARA RIVER REGION, KENYA

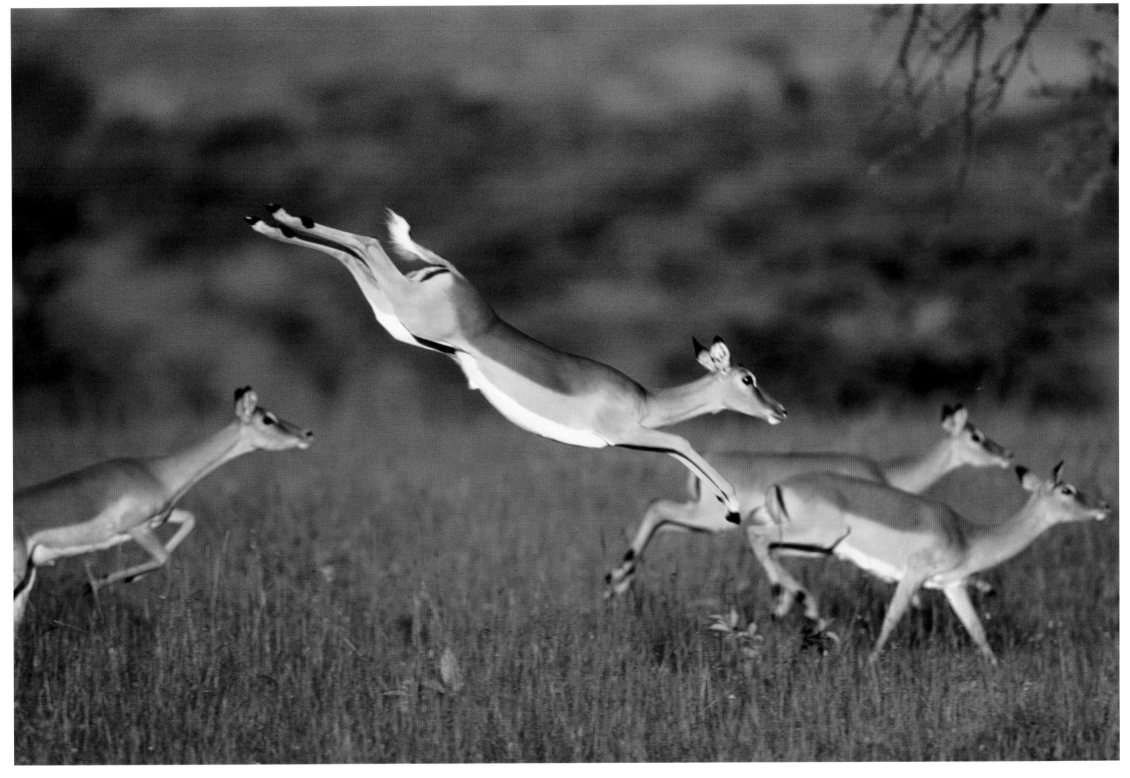

IMPALA (*Aepyceros melampus*), MARA RIVER REGION, KENYA

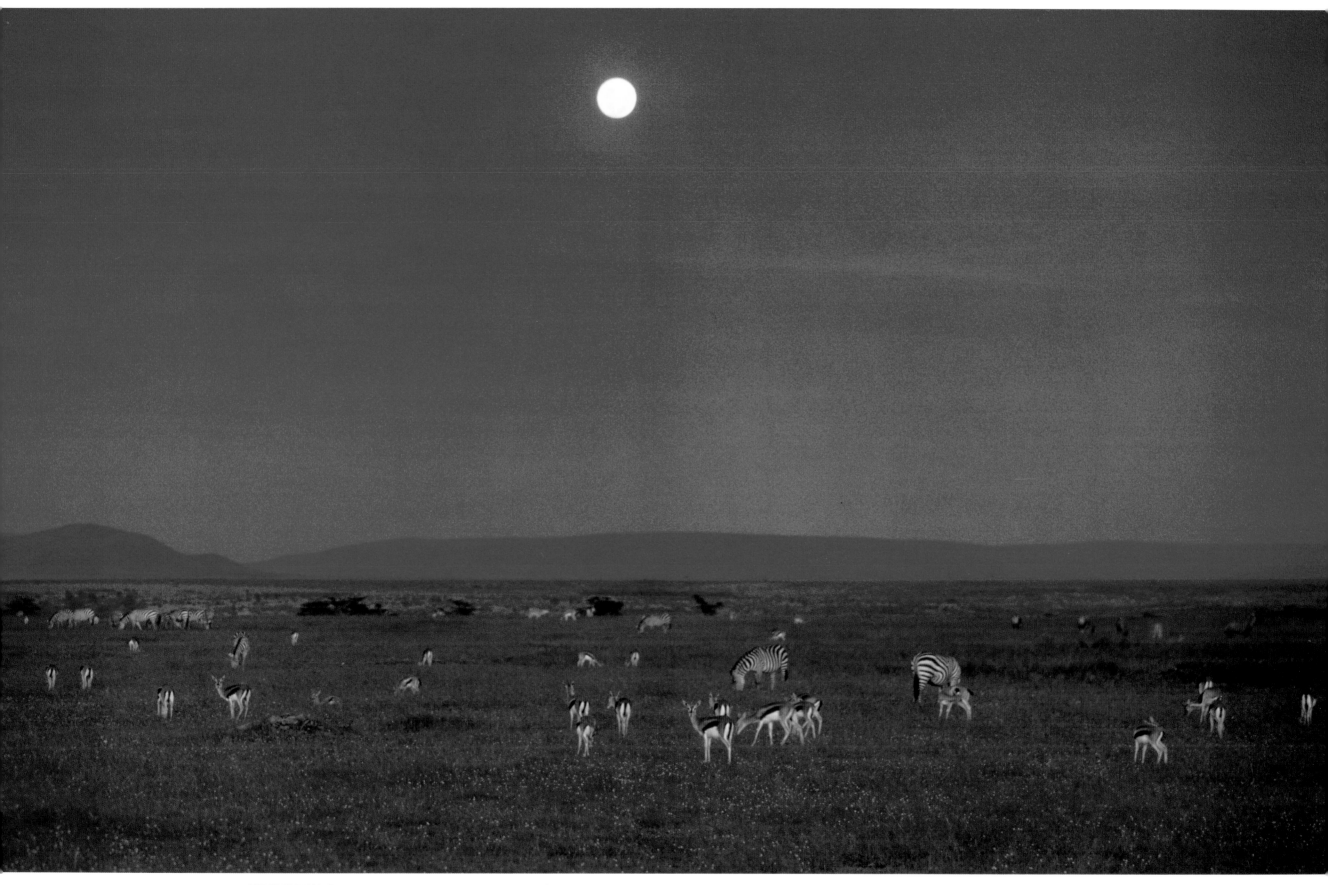

THOMSON'S GAZELLE (*Gazella thomsonii*) AND BURCHELL'S ZEBRA (*Equus burchellii*), MARA RIVER REGION, KENYA

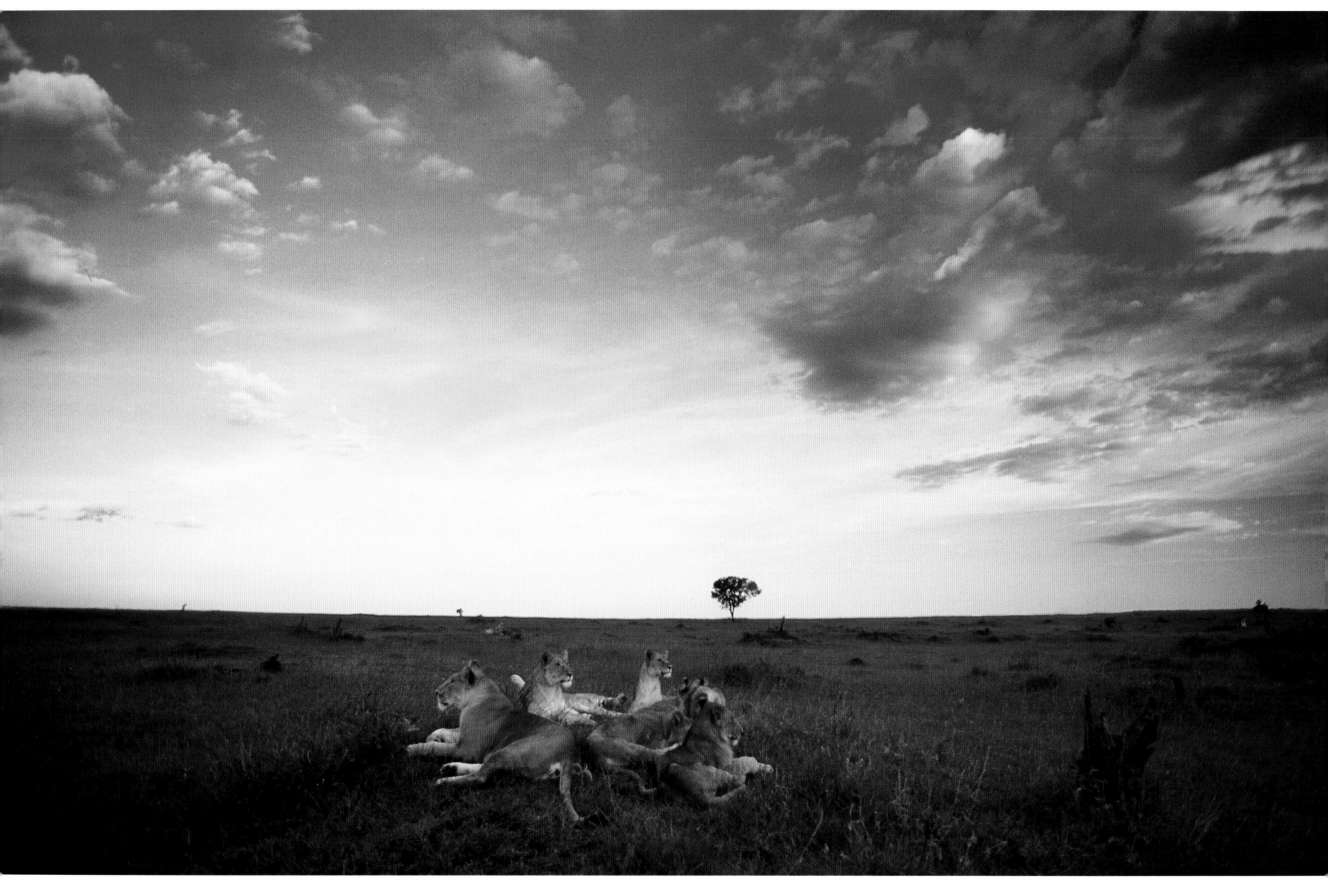

LION *(Panthera leo)*, MAASAI MARA NATIONAL RESERVE, KENYA

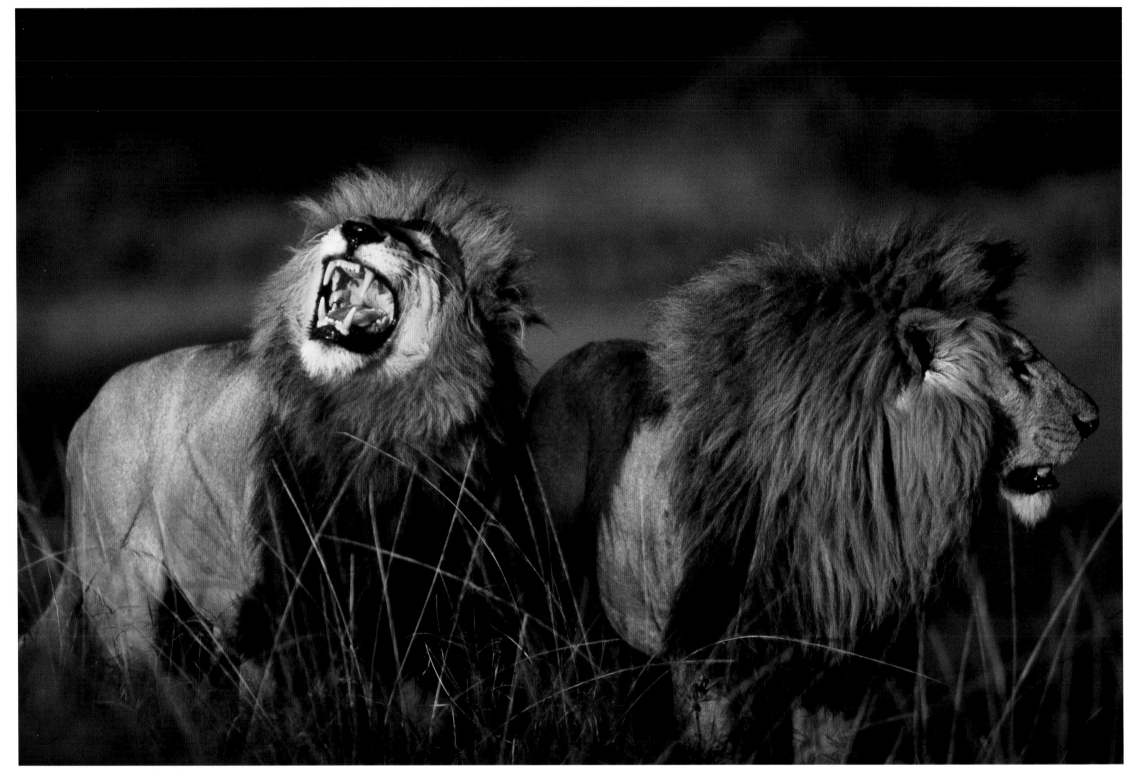

LION (*Panthera leo*), MAASAI MARA NATIONAL RESERVE, KENYA

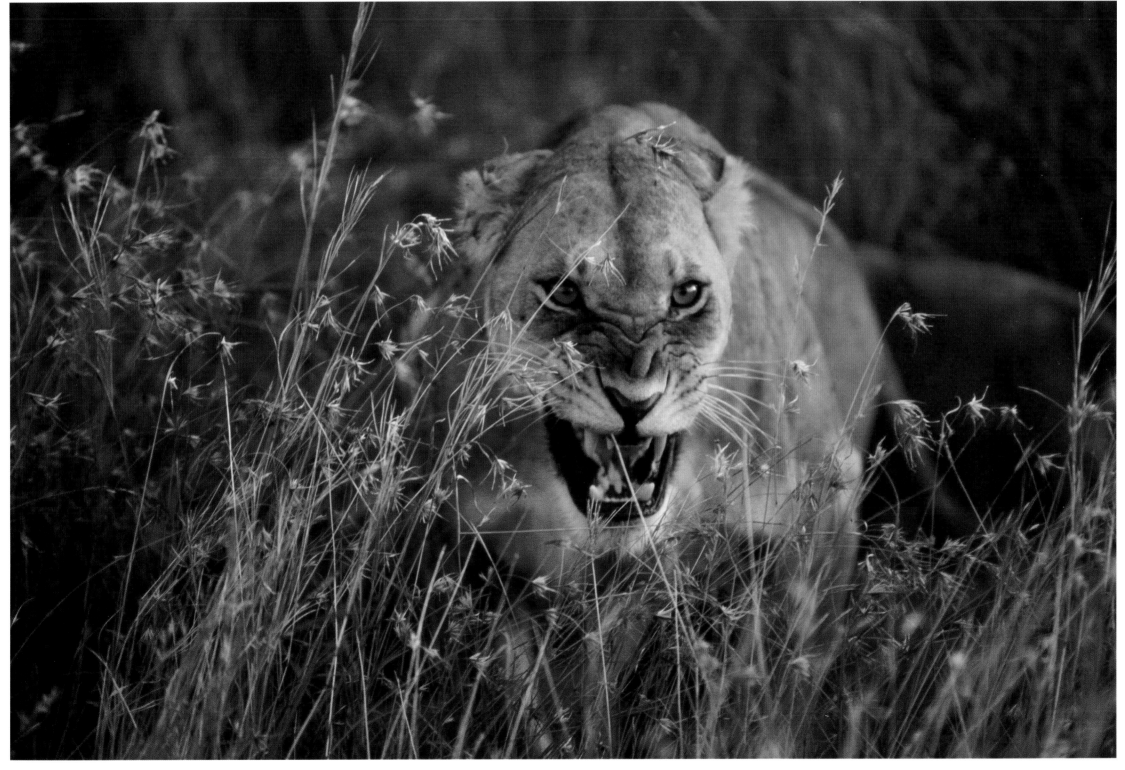

LION (*Panthera leo*), KRUGER NATIONAL PARK, SOUTH AFRICA

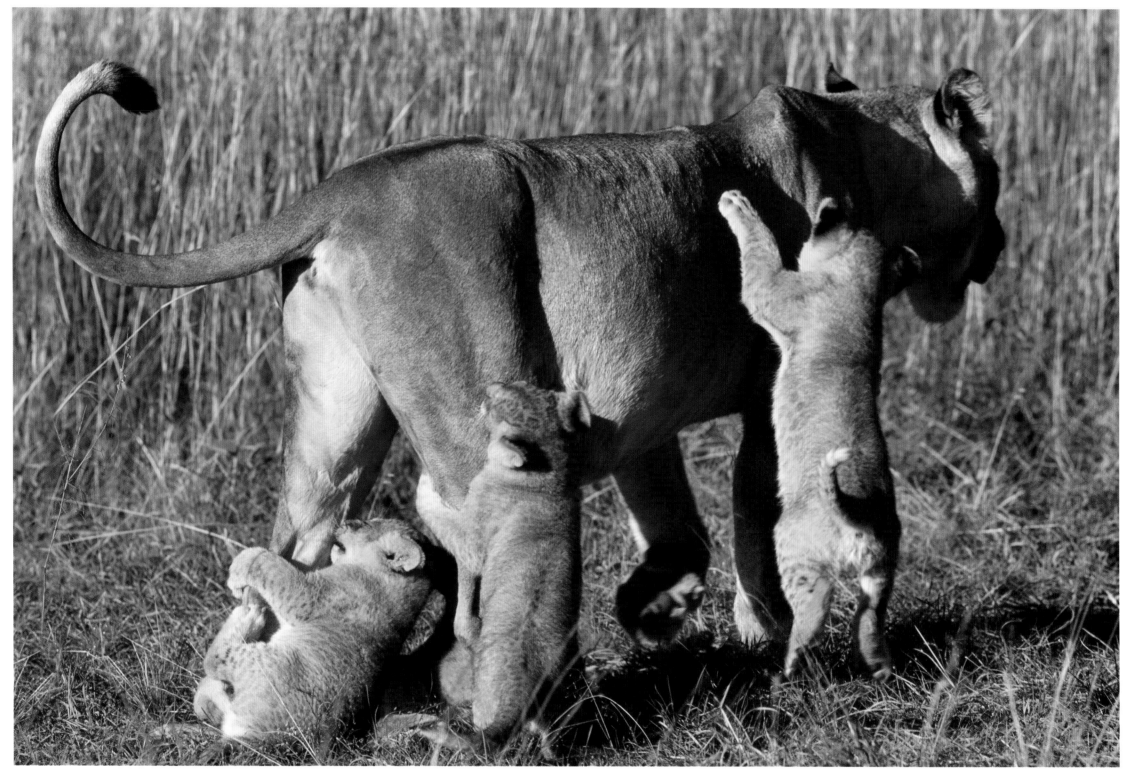

LION (*Panthera leo*), KRUGER NATIONAL PARK, SOUTH AFRICA

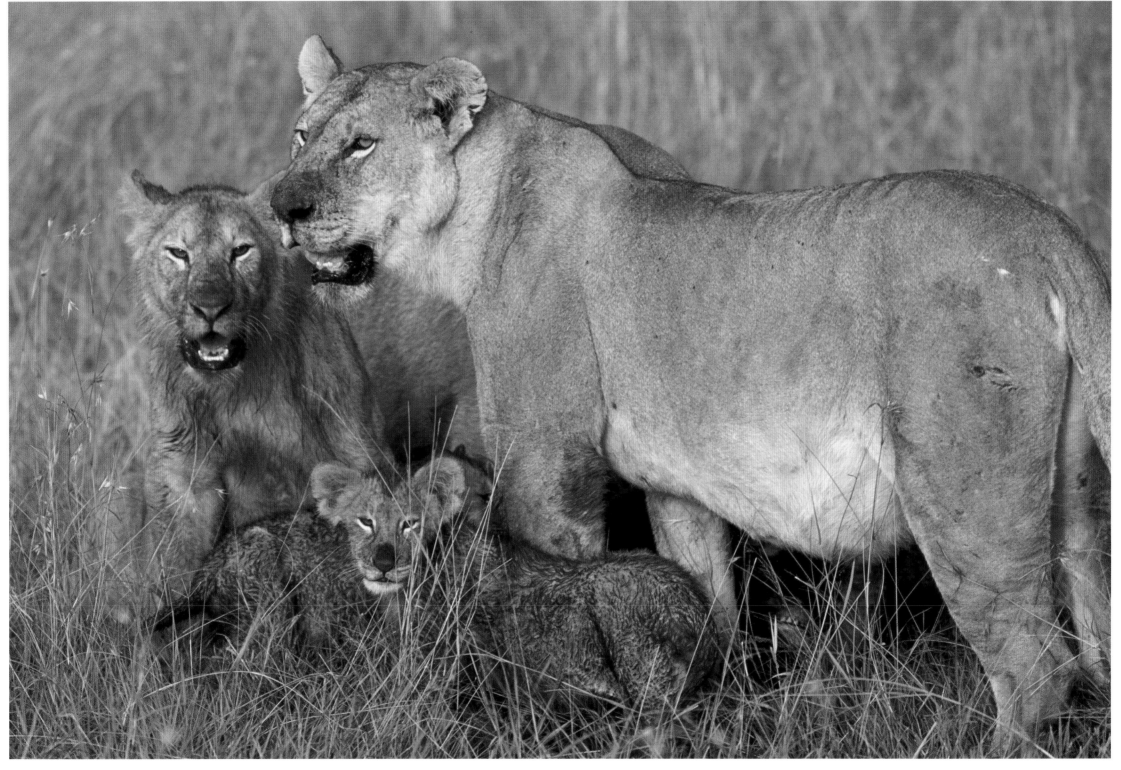

LION (*Panthera leo*), Maasai Mara National Reserve, Kenya

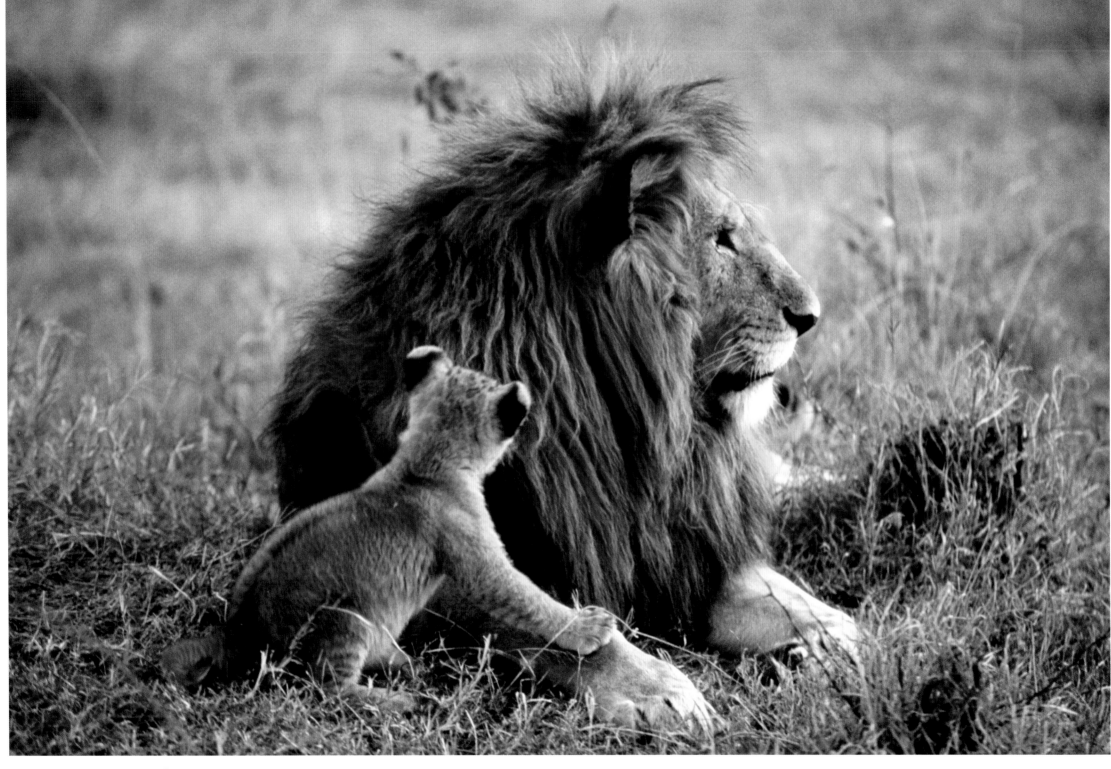

LION (*Panthera leo*), MAASAI MARA NATIONAL RESERVE, KENYA

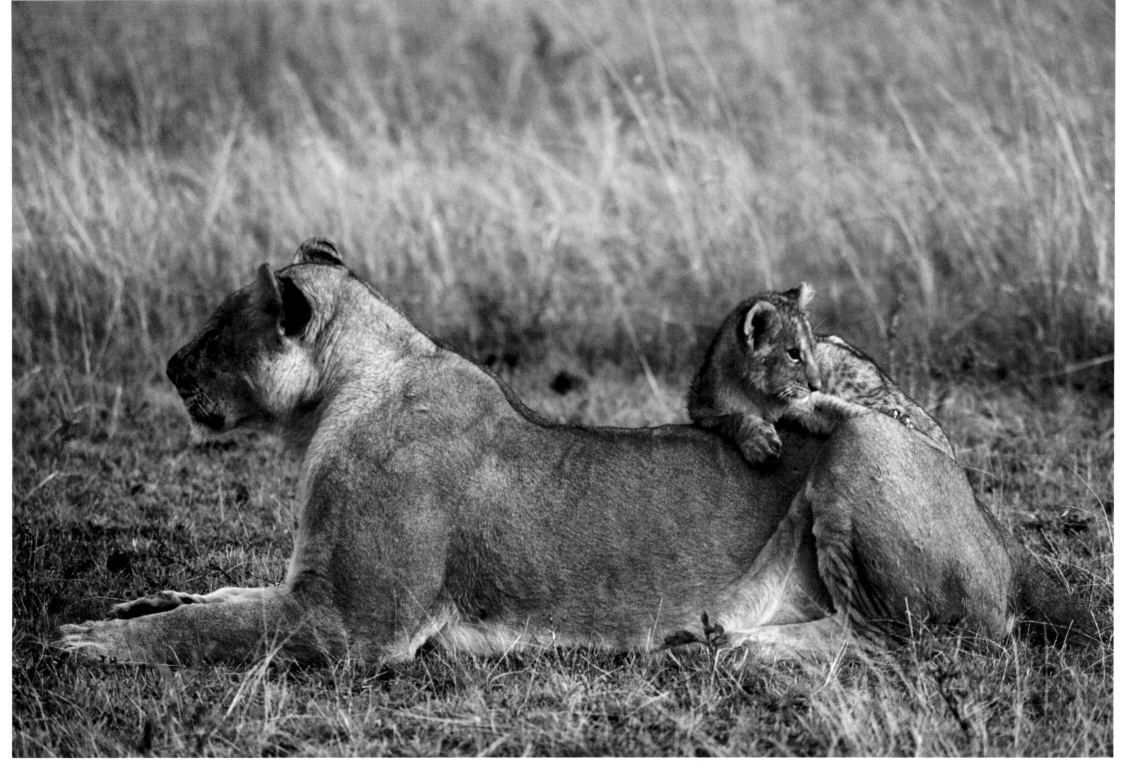

LION (*Panthera leo*), Maasai Mara National Reserve, Kenya

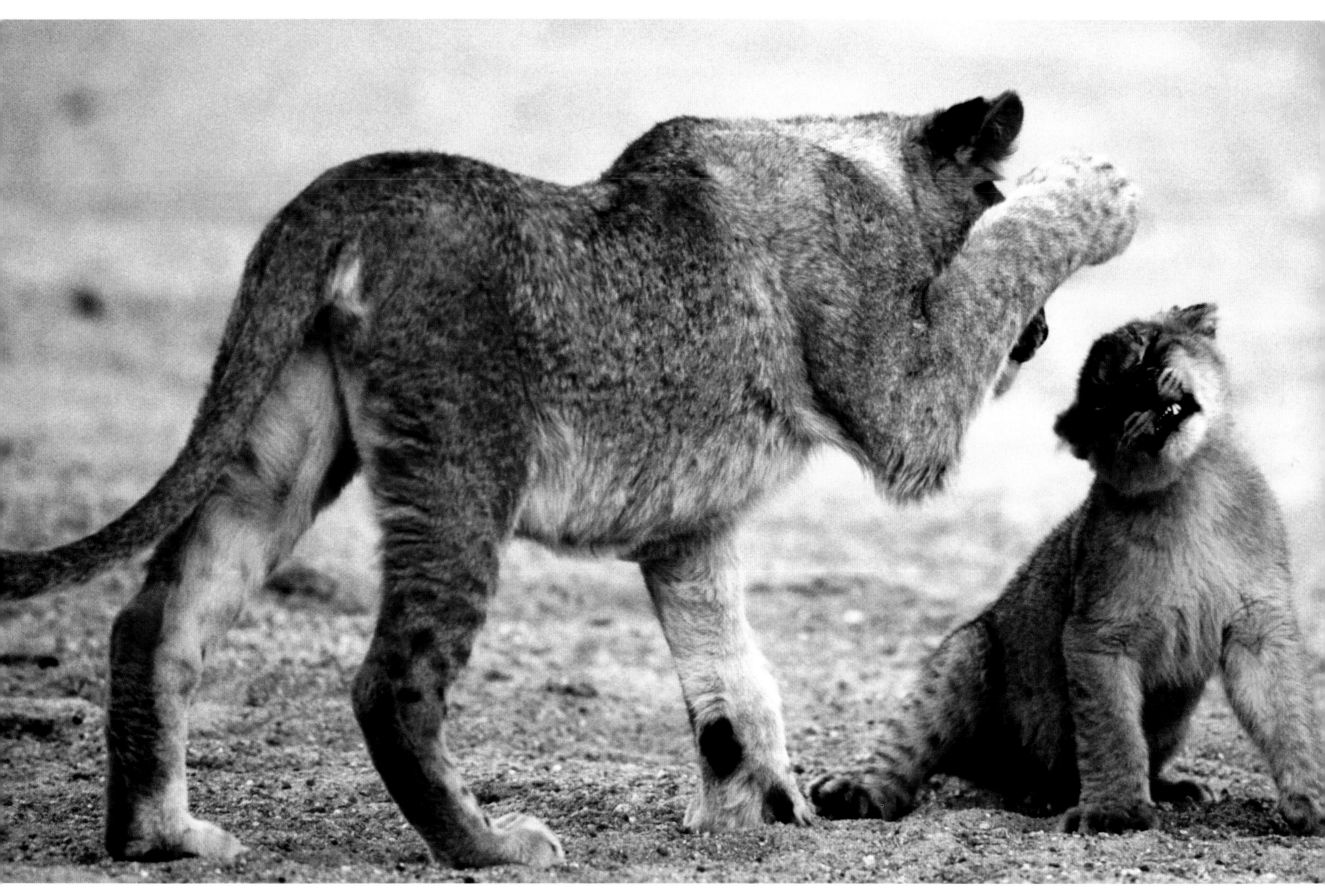

LION (*Panthera leo*), KRUGER NATIONAL PARK, SOUTH AFRICA

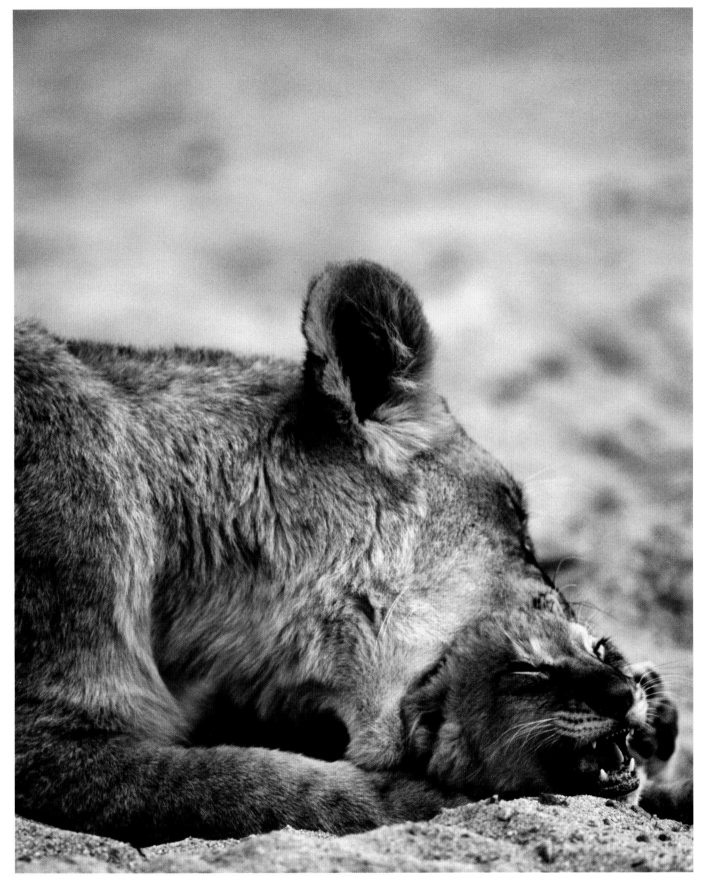

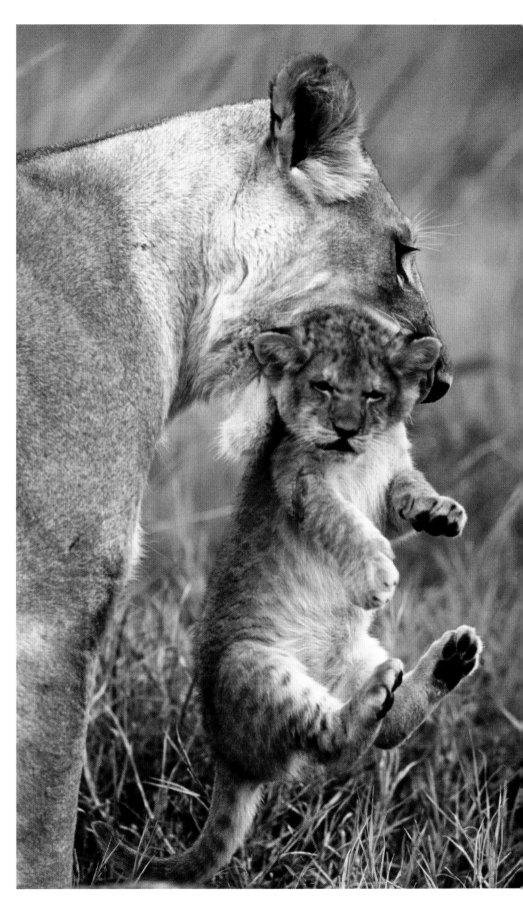

LION (*Panthera leo*), KRUGER NATIONAL PARK, SOUTH AFRICA

LION (*Panthera leo*), MAASAI MARA NATIONAL RESERVE, KENYA

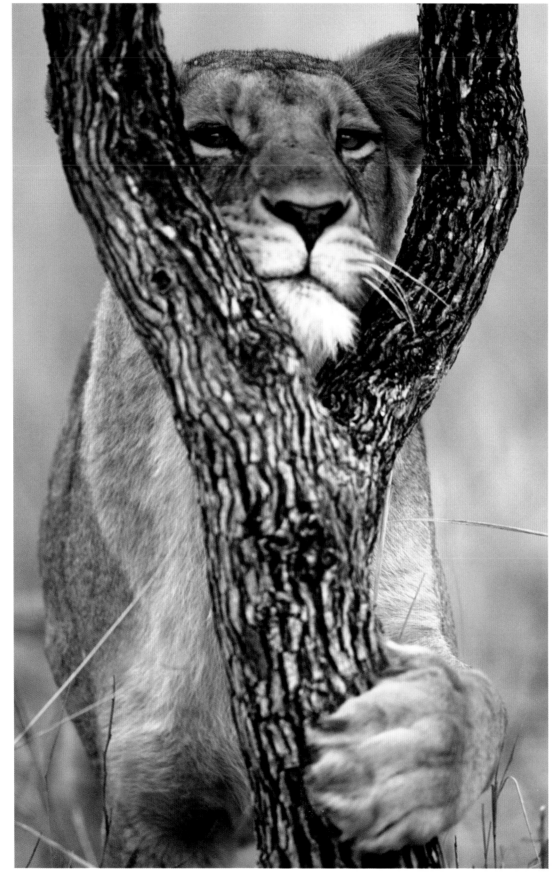

LION (*Panthera leo*), KRUGER NATIONAL PARK, SOUTH AFRICA

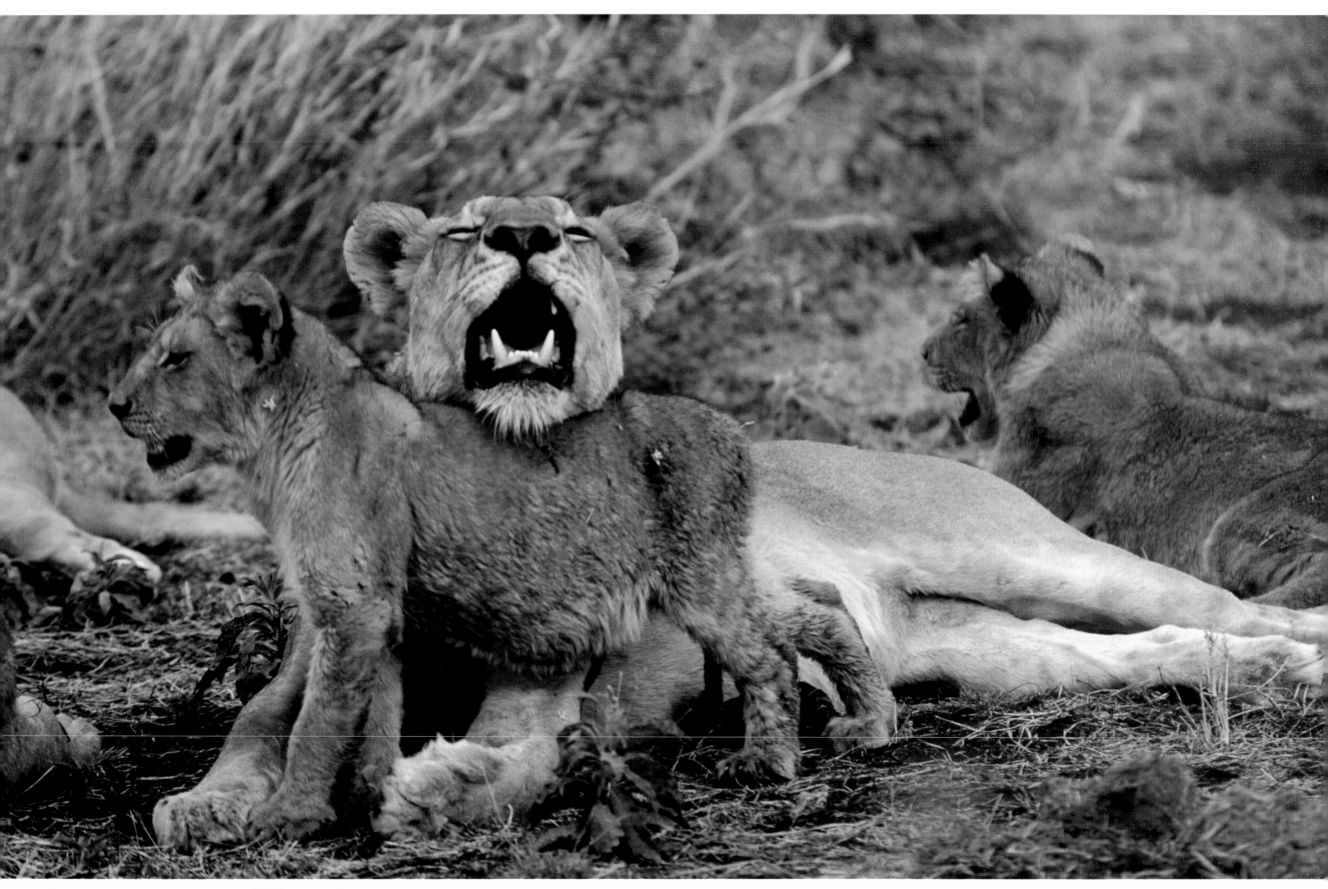

LION (*Panthera leo*), KRUGER NATIONAL PARK, SOUTH AFRICA

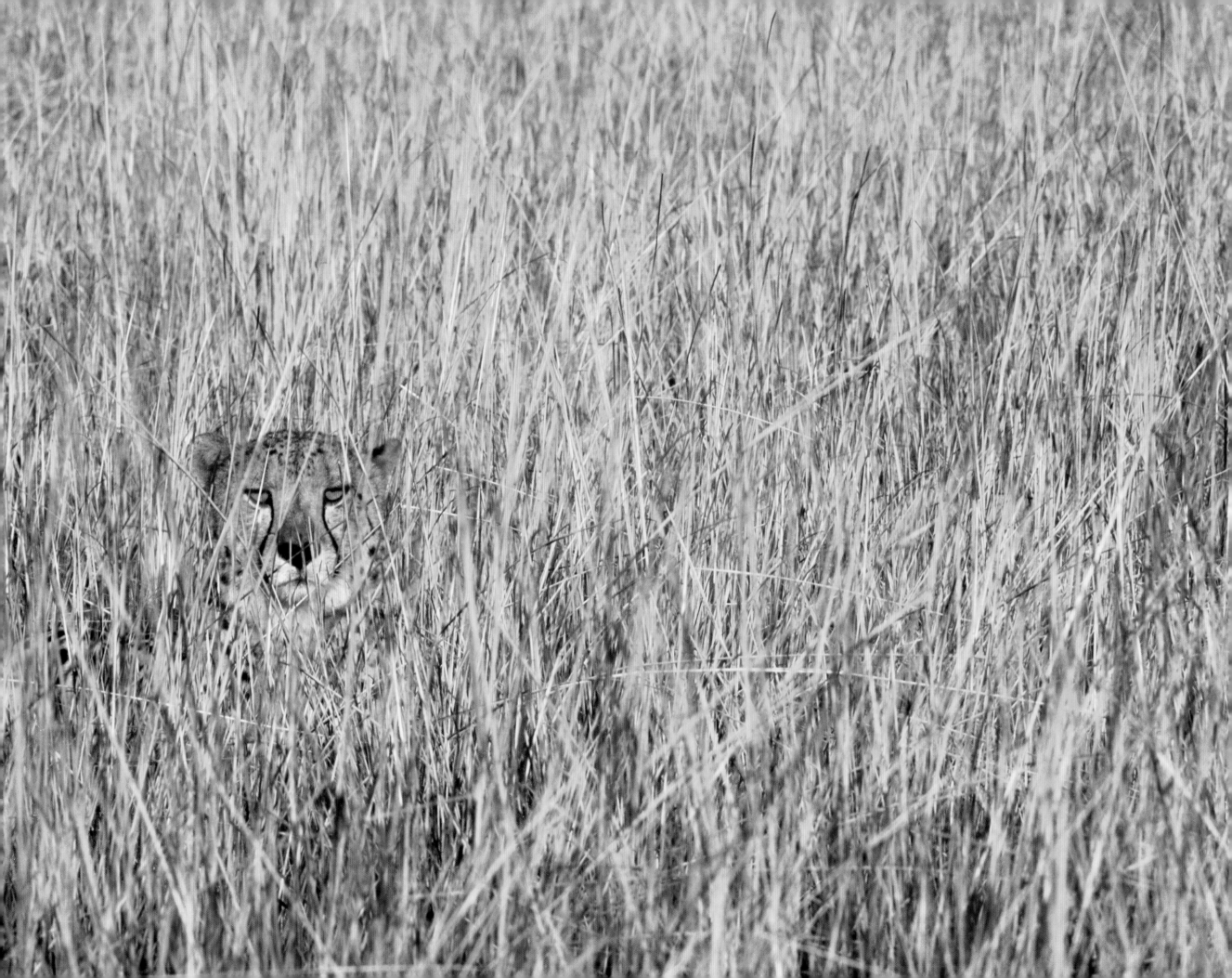

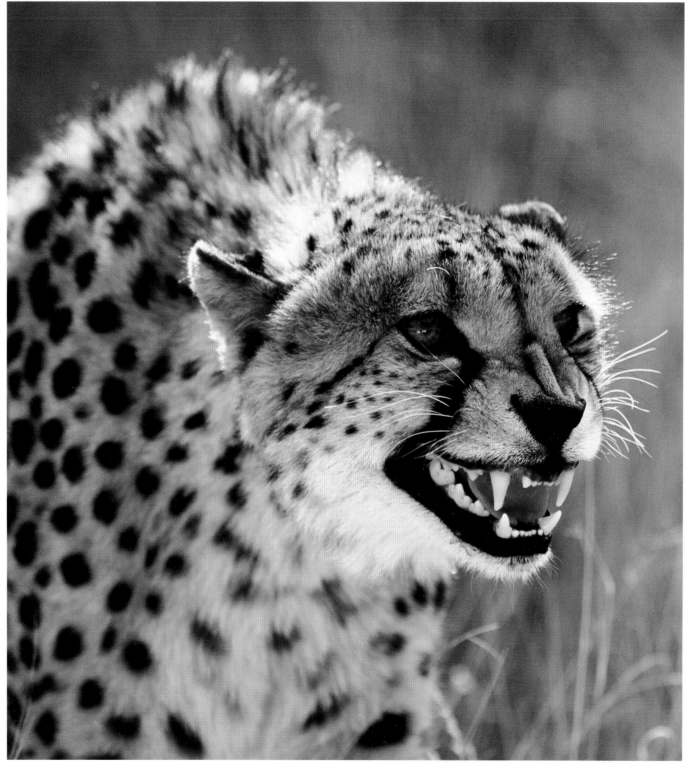

◀ CHEETAH (*Acinonyx jubatus*), Phinda Reserve, South Africa ▲ CHEETAH (*Acinonyx jubatus*), Okavango delta, Botswana

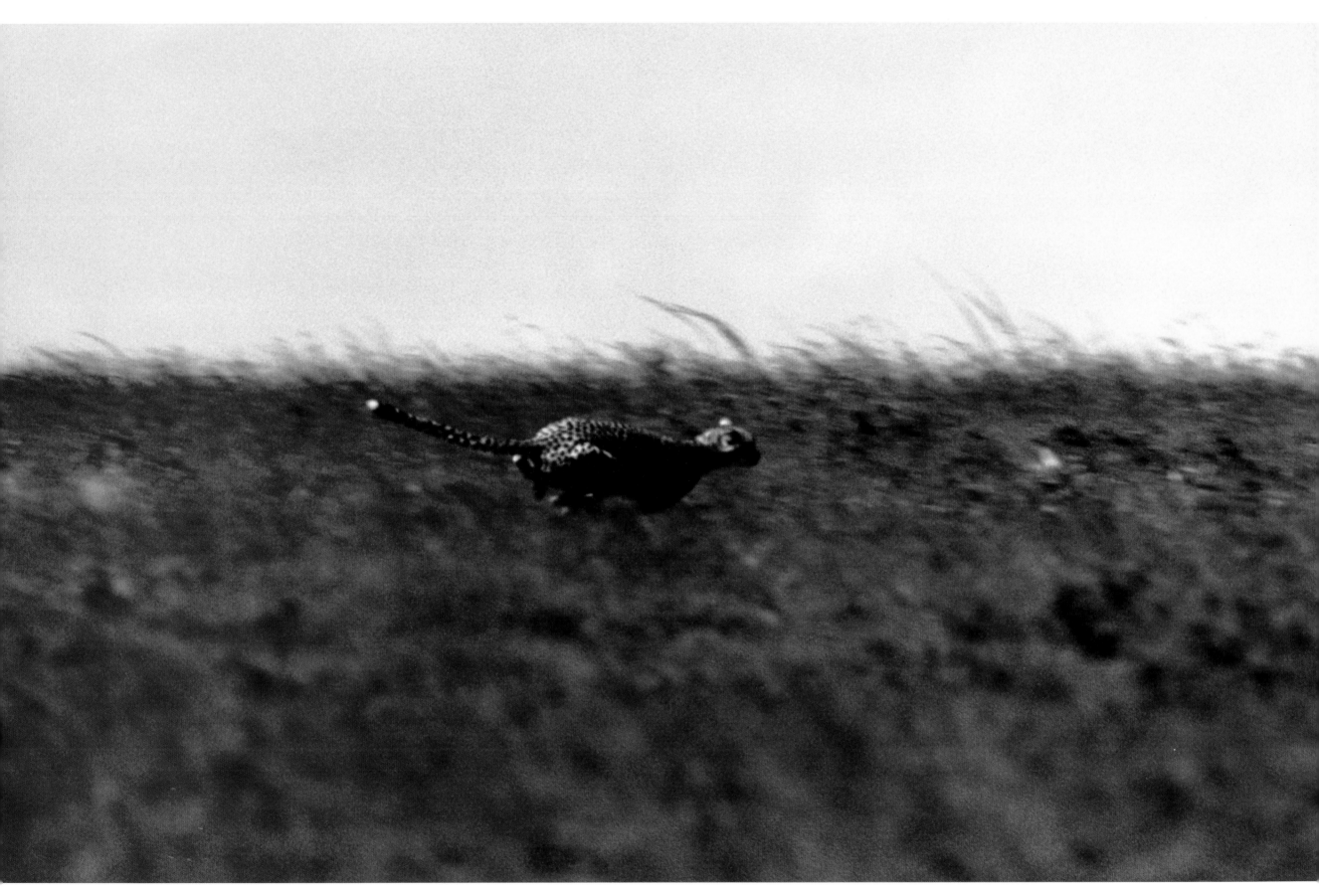

CHEETAH (*Acinonyx jubatus*) AND THOMSON'S GAZELLE (*Gazella thomsonii*), MARA RIVER REGION, KENYA

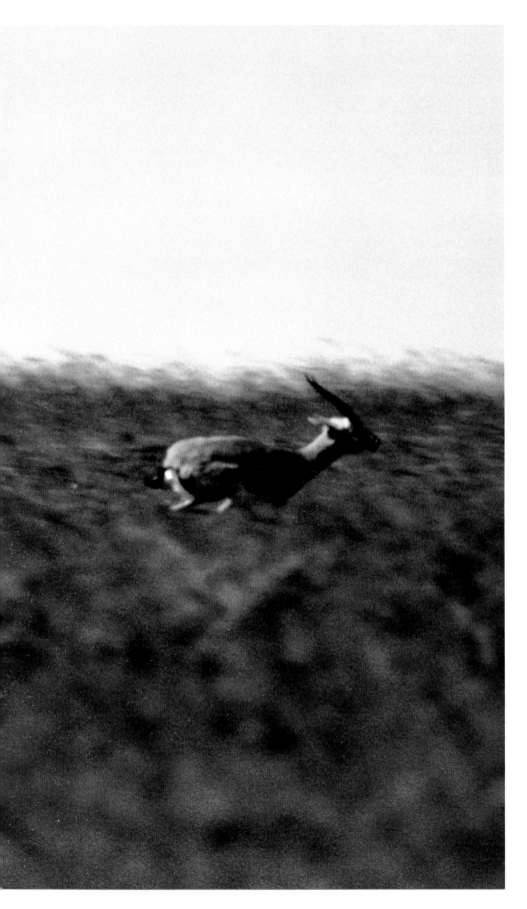

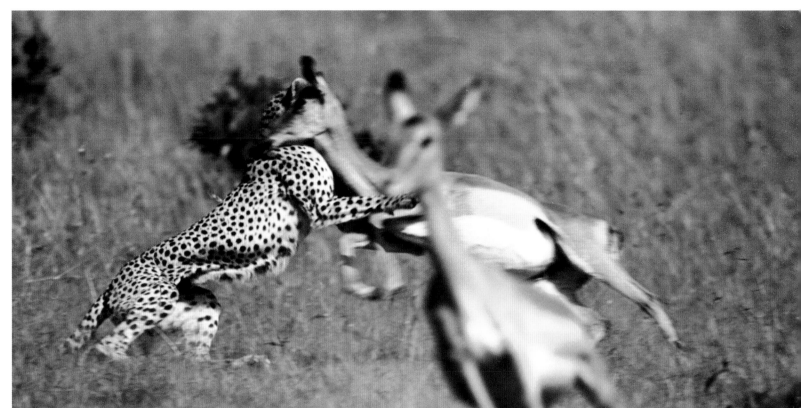

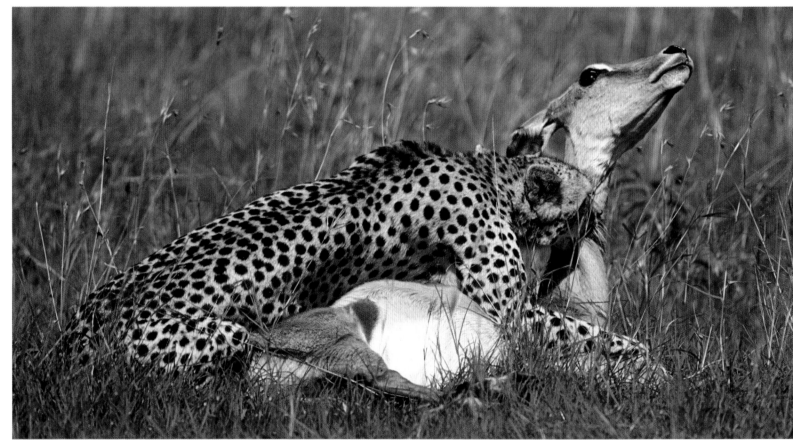

▲▲ AND ▲ CHEETAH (*Acinonyx jubatus*) AND IMPALA (*Aepyceros melampus*), MARA RIVER REGION, KENYA

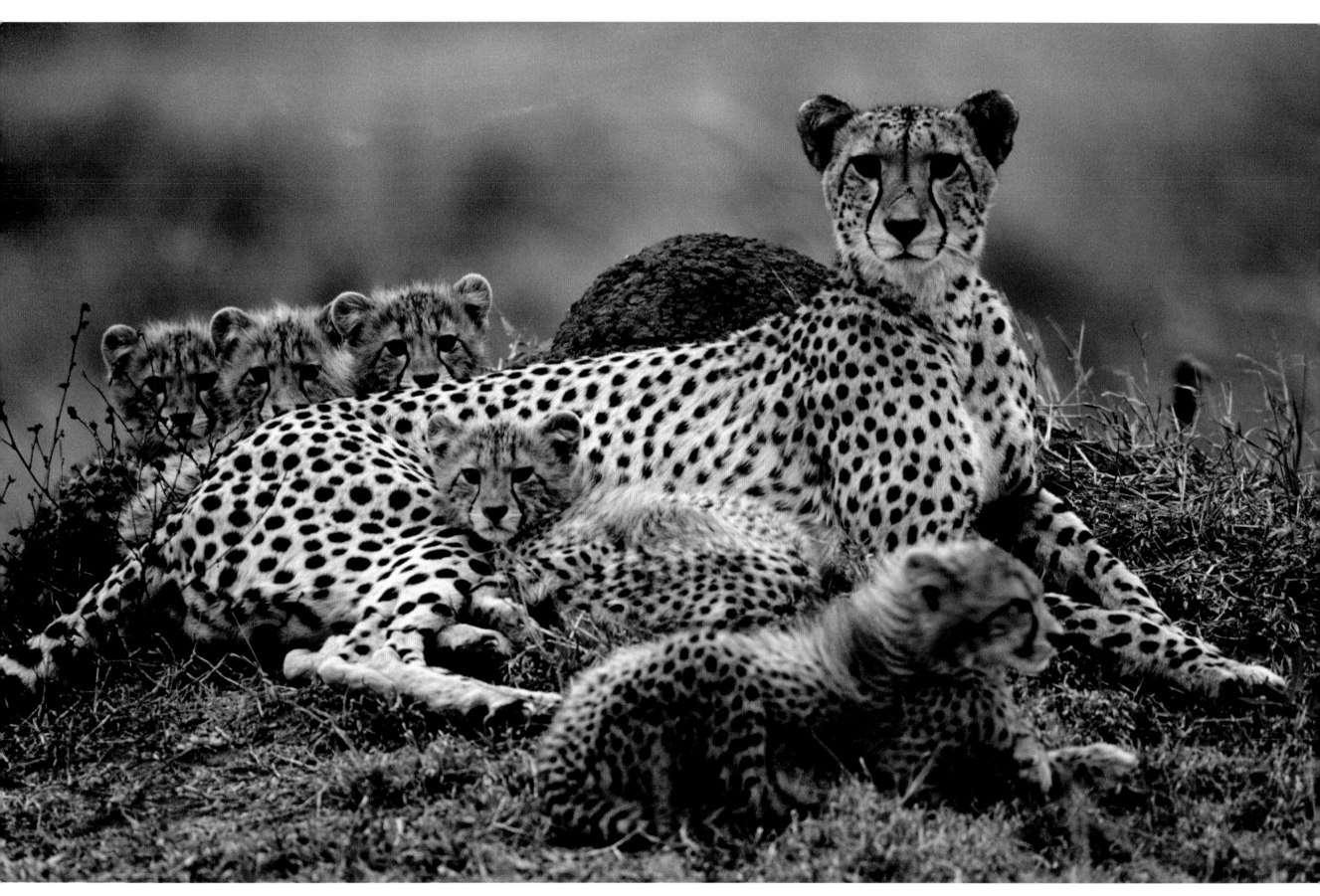

CHEETAH (*Acinonyx jubatus*), PHINDA RESERVE, SOUTH AFRICA

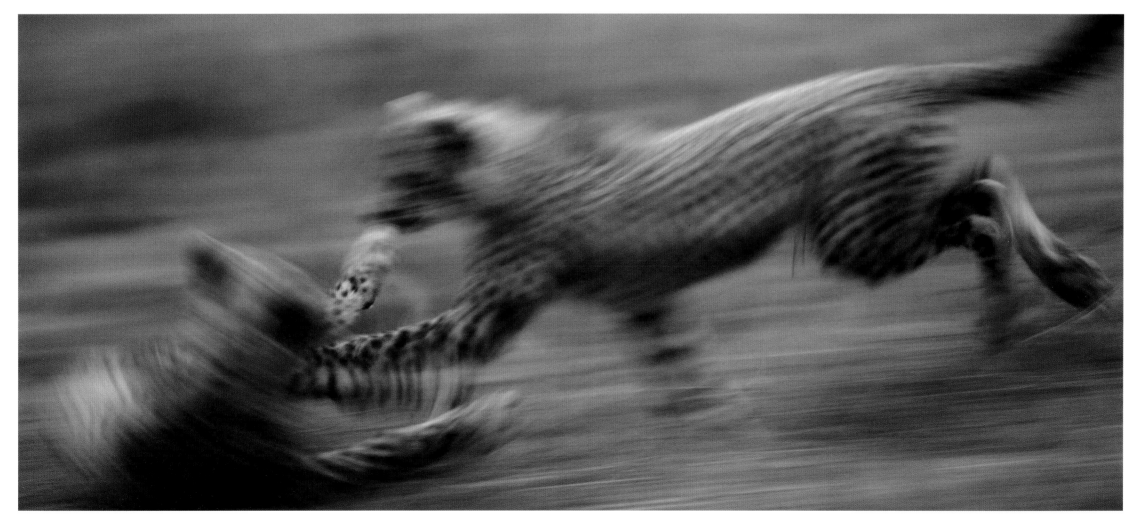

▲▲, ▲▶ AND ▲ CHEETAH (*Acinonyx jubatus*), MATETSI RESERVE, ZIMBABWE

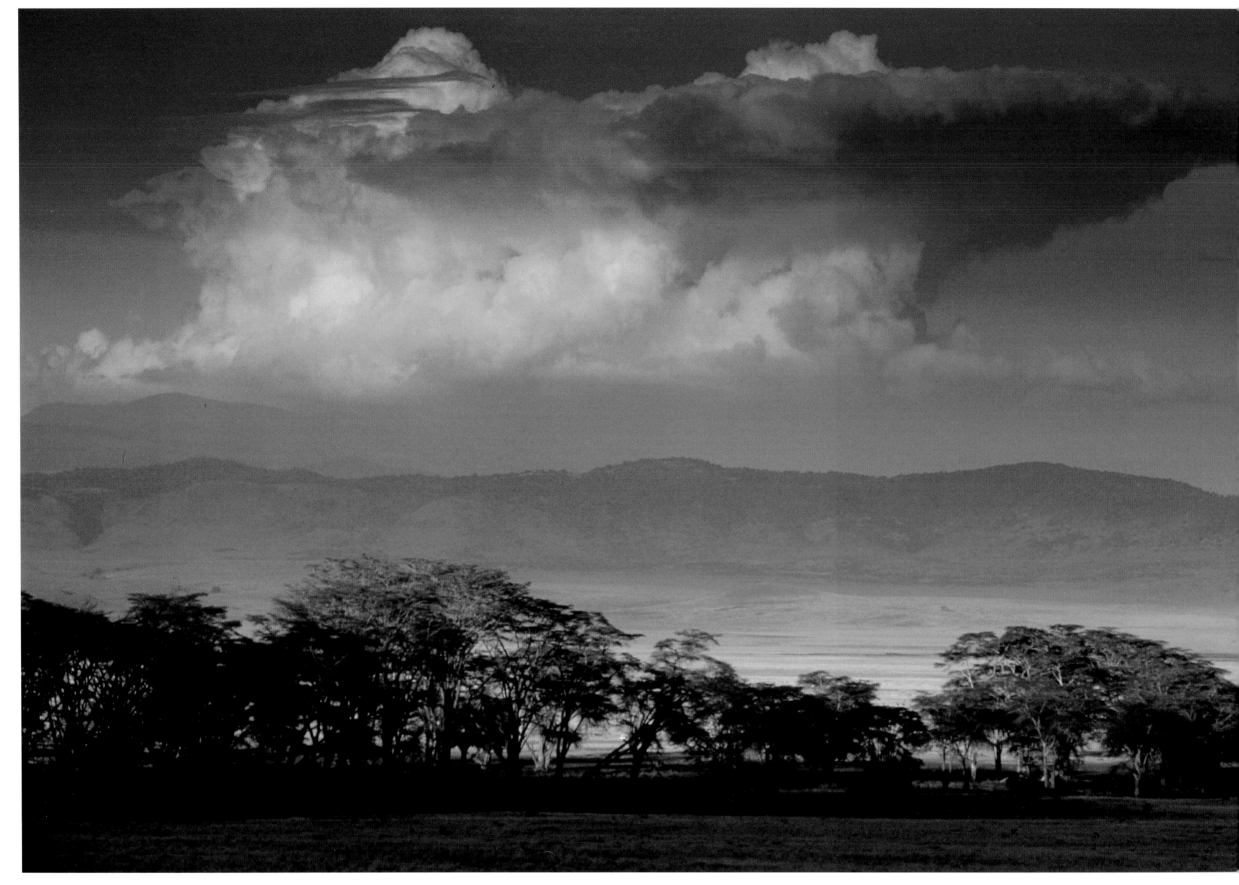

NGORONGORO CRATER, Ngorongoro Conservation Area, Tanzania

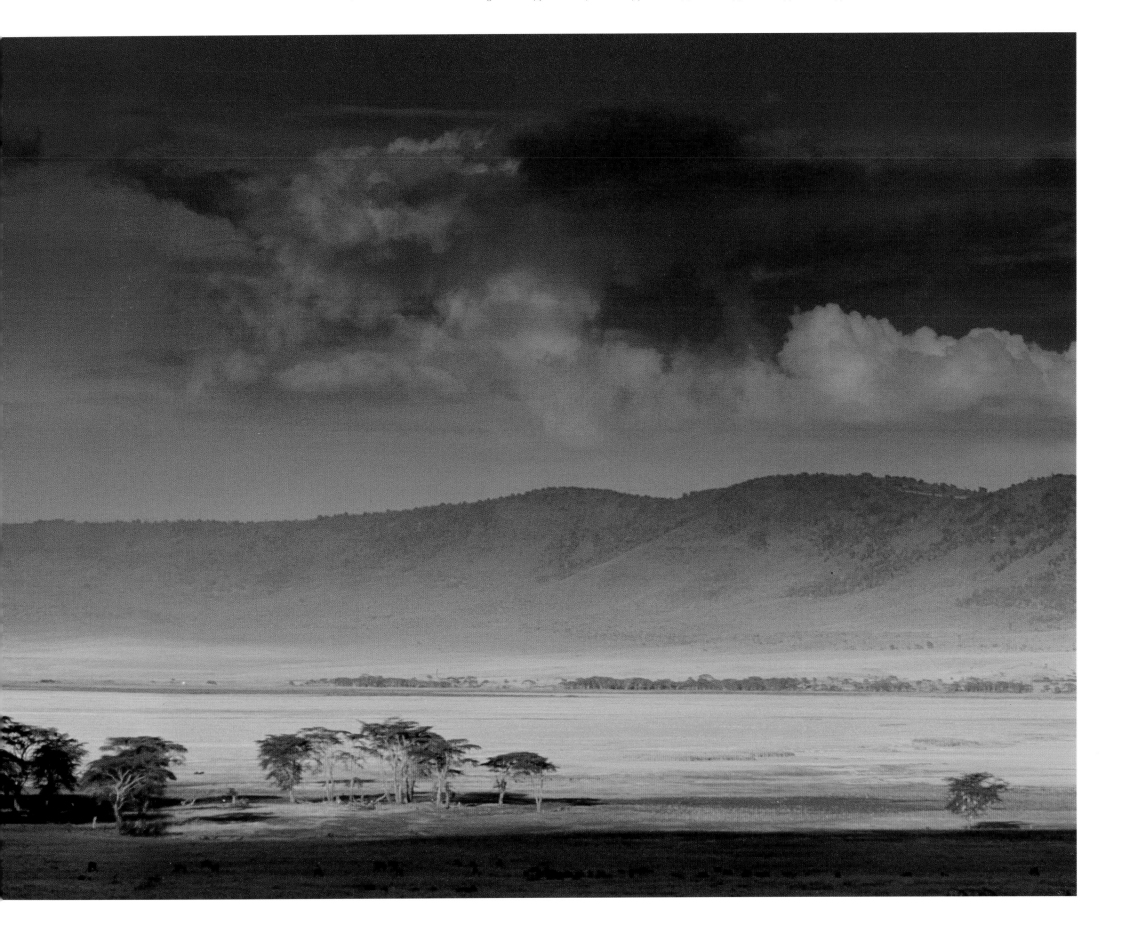

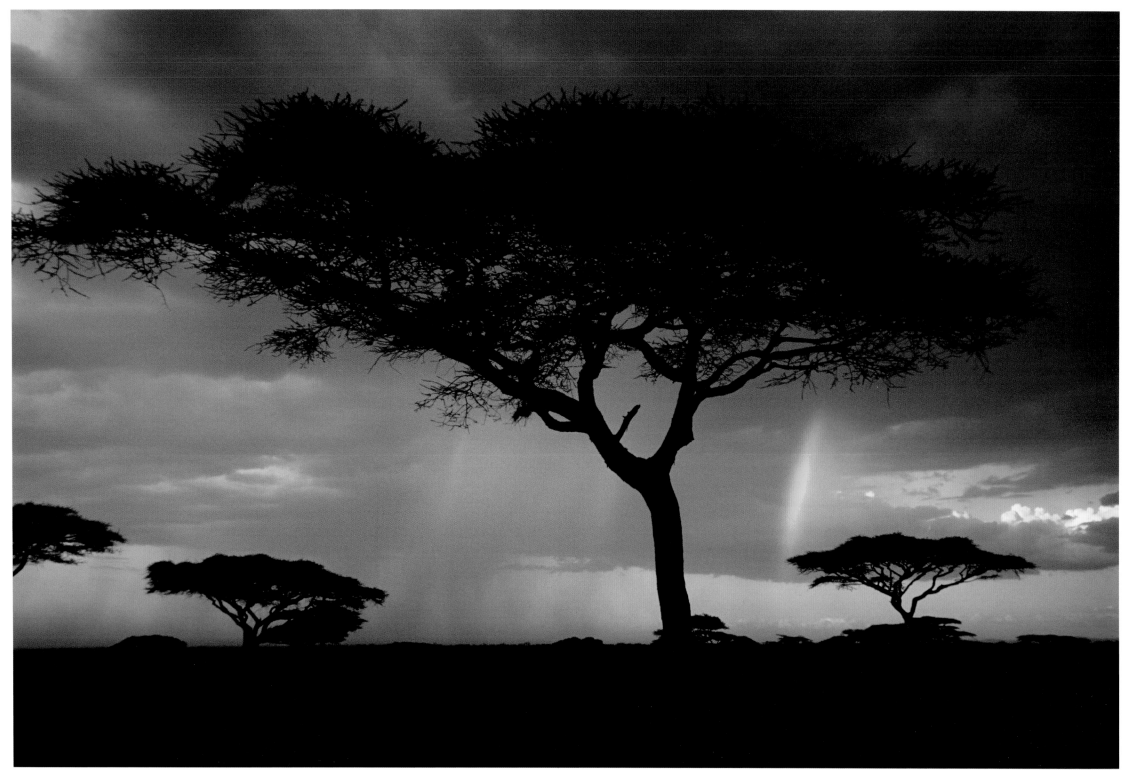

▲ RAINBOW, LAKE NDUTU REGION, TANZANIA ▶ MAWENZI PEAK, 16,893 feet (5,149 meters), TANZANIA

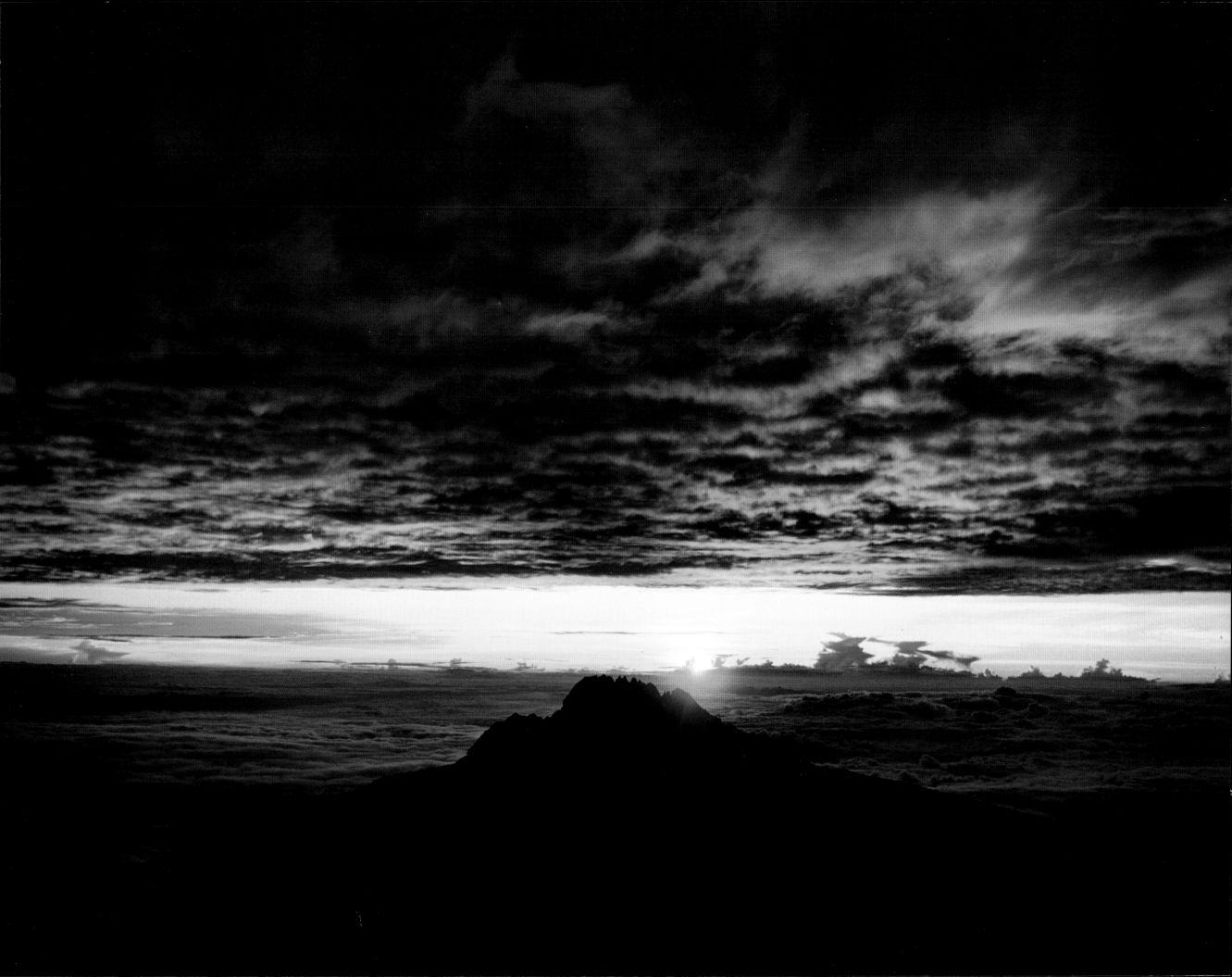

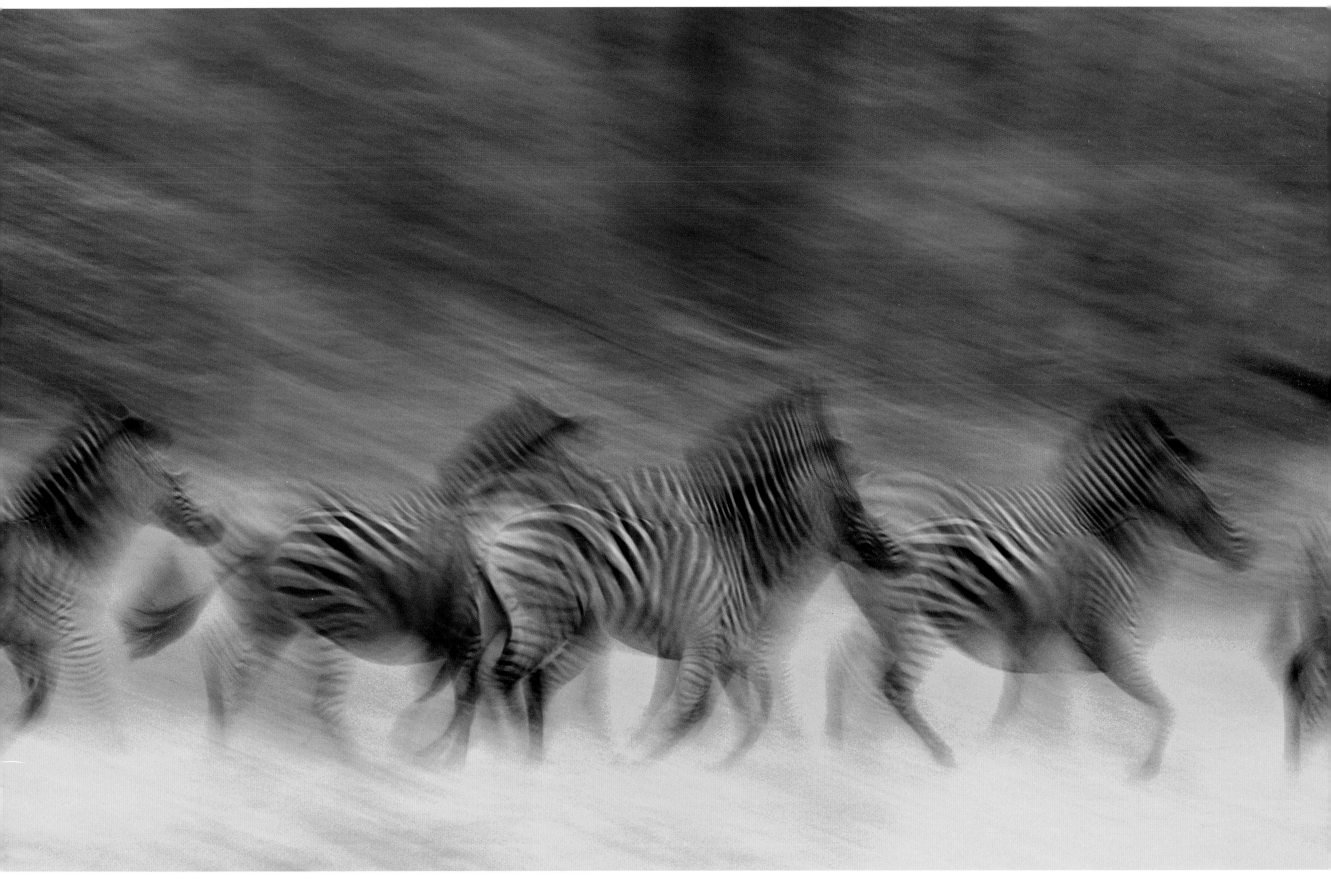

BURCHELL'S ZEBRA (*Equus burchellii*), MATETSI RESERVE, ZIMBABWE

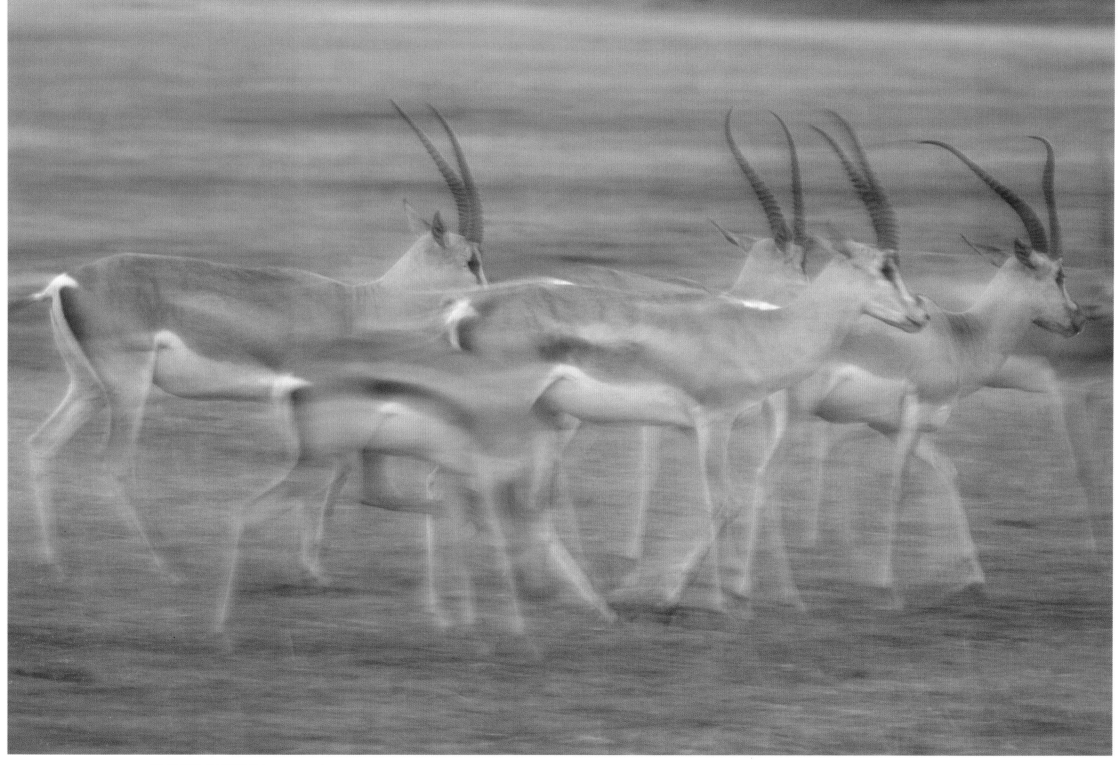

GRANT'S GAZELLE (*Gazella granti*), MARA RIVER REGION, KENYA

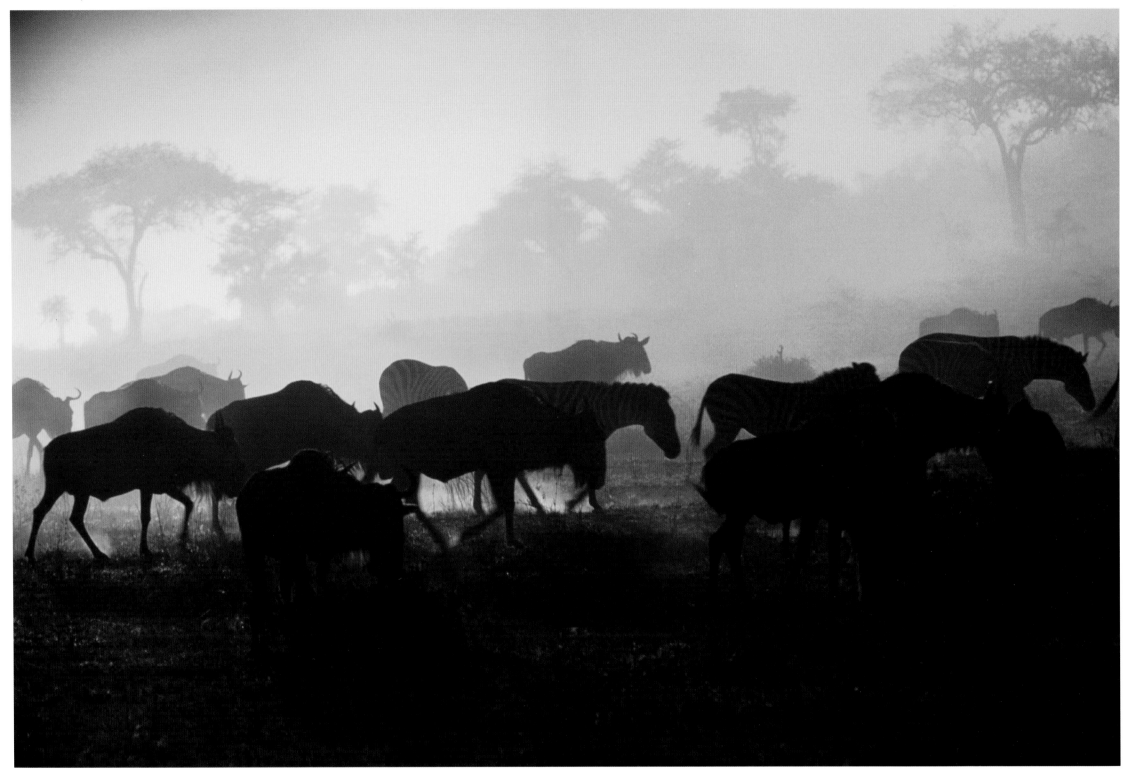

BURCHELL'S ZEBRA (*Equus burchellii*) AND COMMON WILDEBEEST (*Connochaetes taurinus*), SERENGETI NATIONAL PARK, TANZANIA

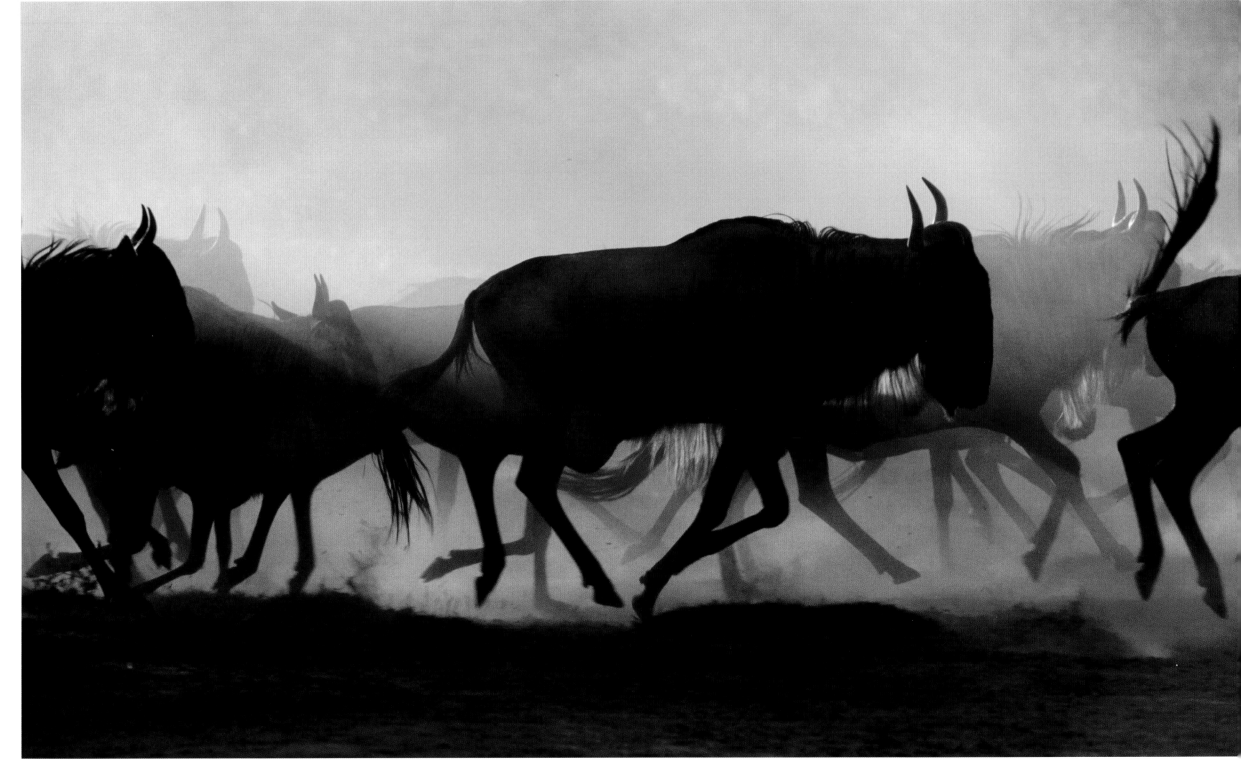

COMMON WILDEBEEST (*Connochaetes taurinus*), LAKE NDUTU REGION, TANZANIA

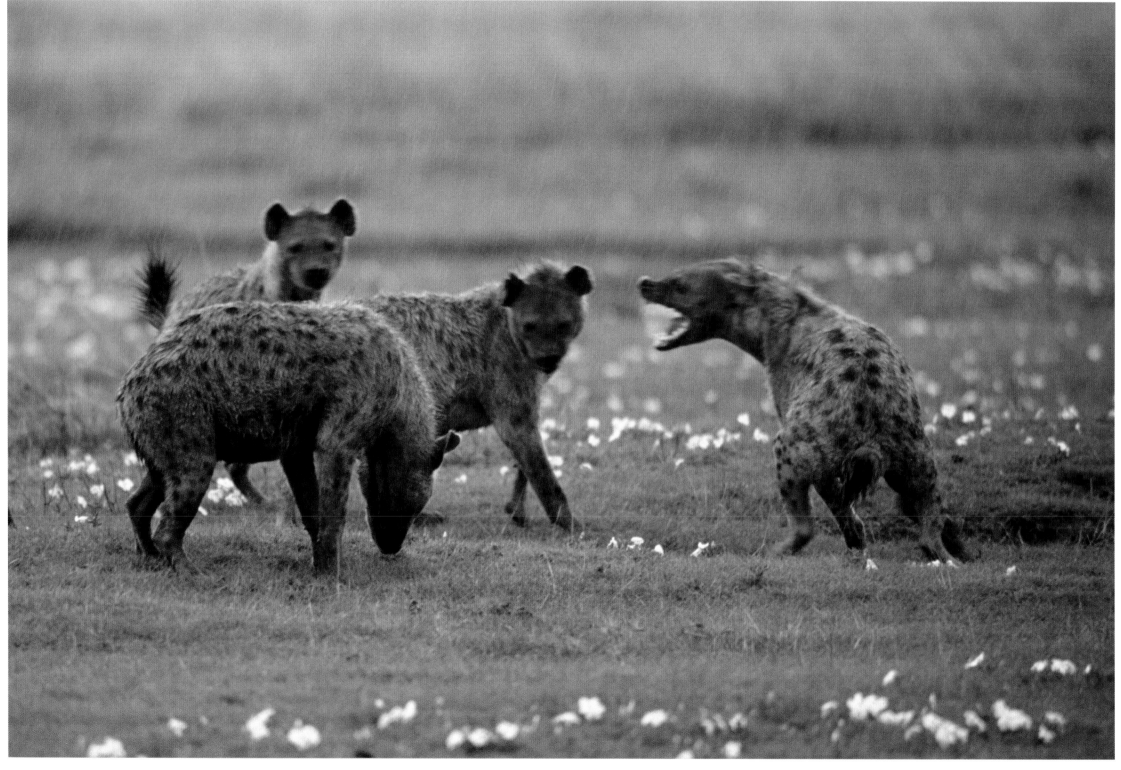

SPOTTED HYENA (*Crocuta crocuta*), SERENGETI NATIONAL PARK, TANZANIA

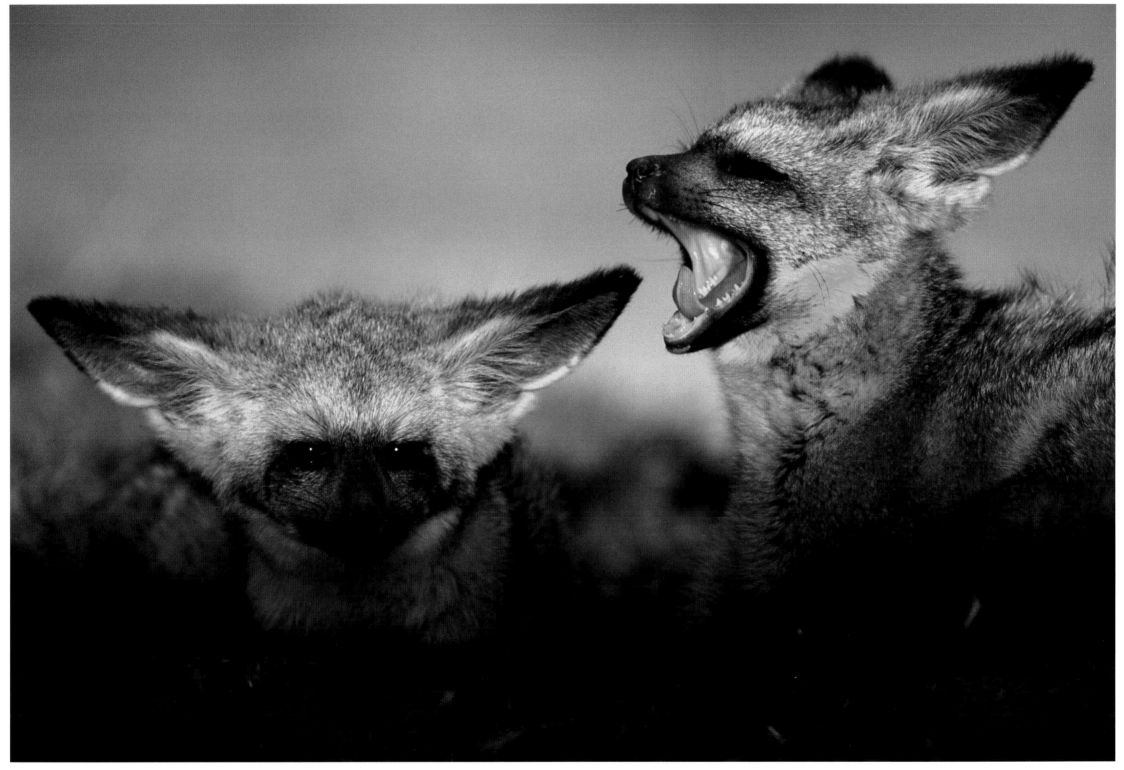

BAT-EARED FOX (*Otocyon megalotis*), NGORONGORO CONSERVATION AREA, TANZANIA

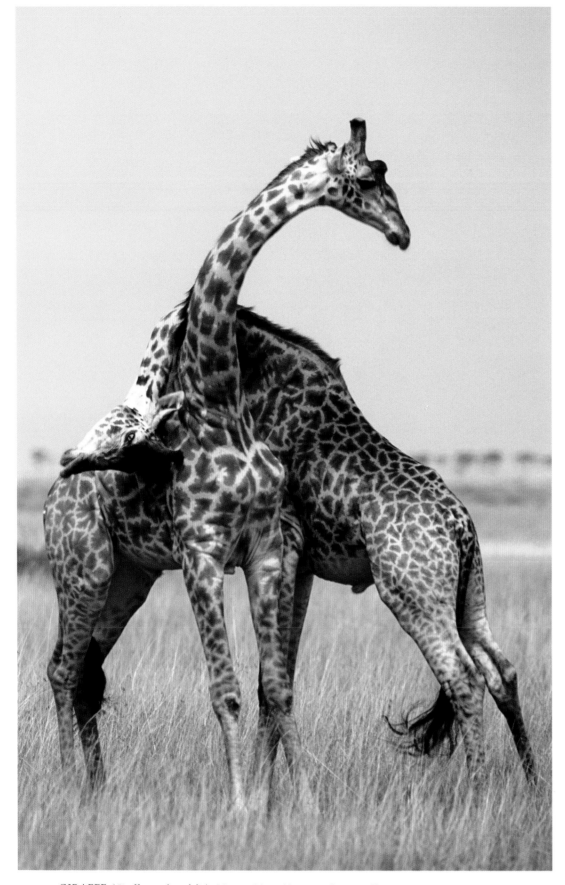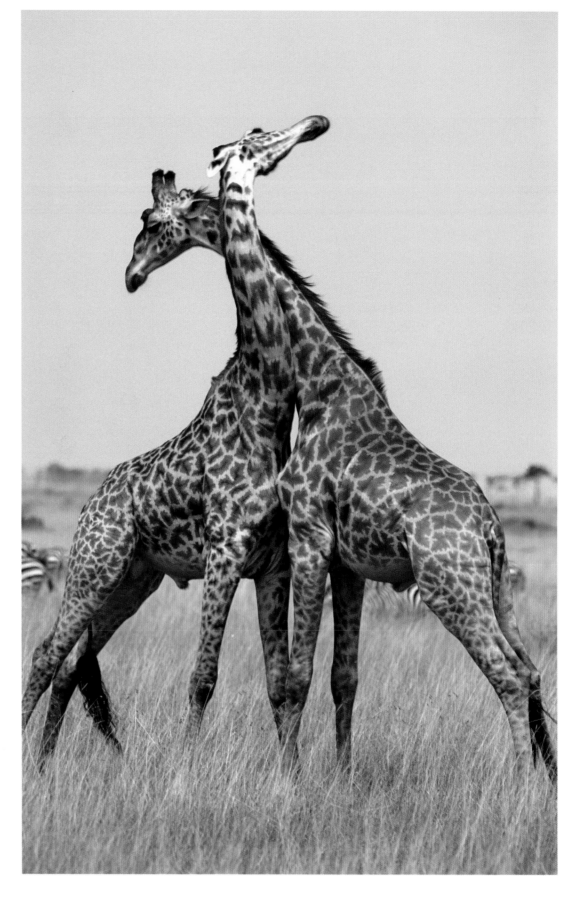

▲ AND ► GIRAFFE (*Giraffa camelopardalis*), Maasai Mara National Reserve, Kenya

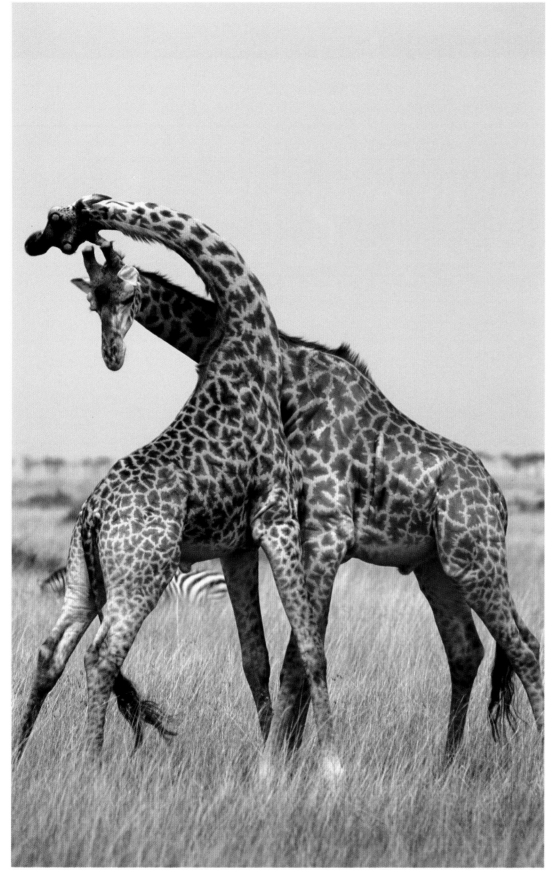

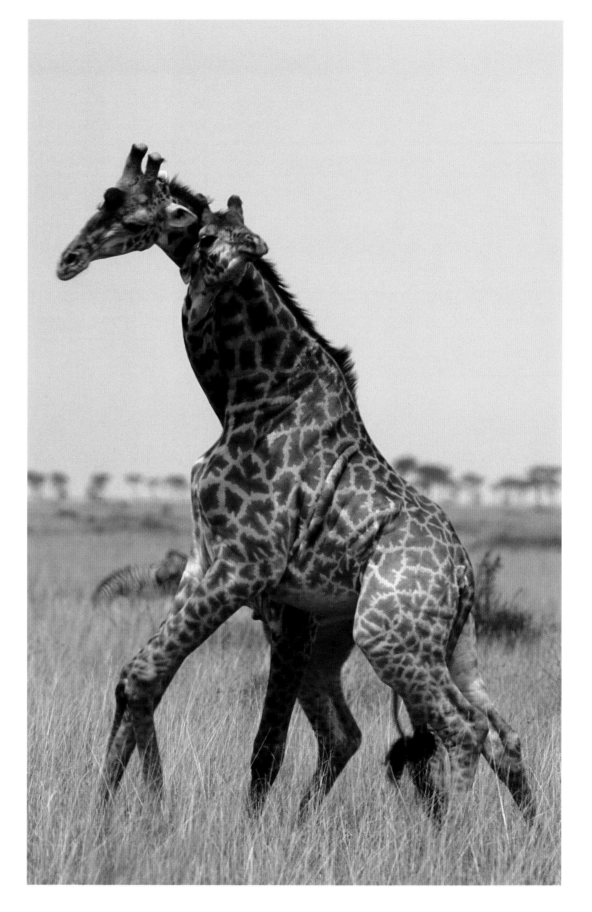

▲ AND ▶ GIRAFFE (*Giraffa camelopardalis*), MAASAI MARA NATIONAL RESERVE, KENYA

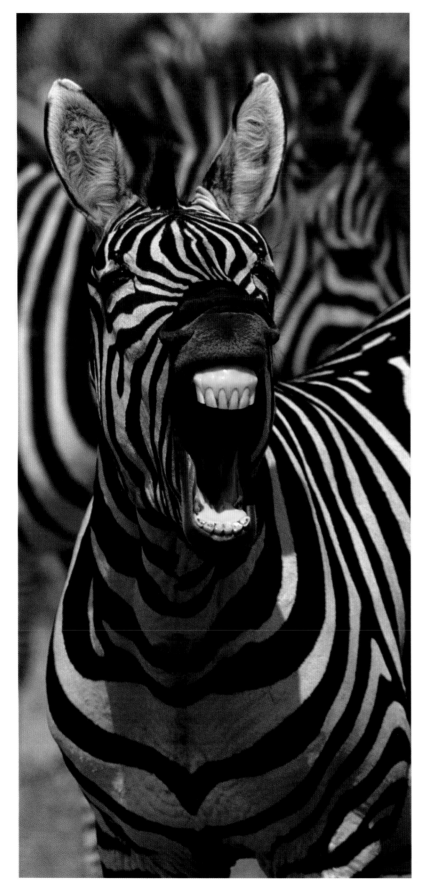

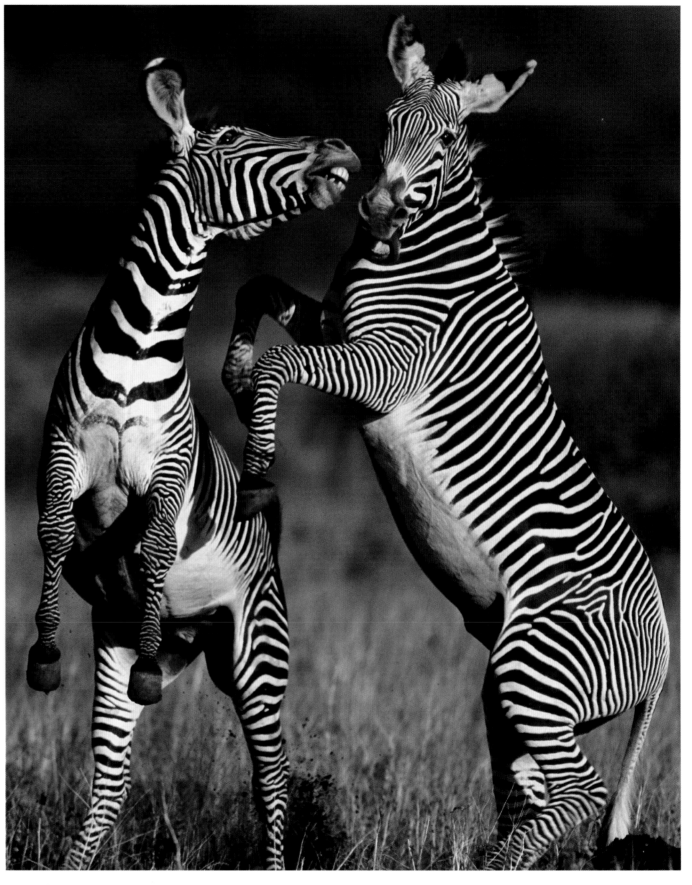

BURCHELL'S ZEBRA (Equus burchellii), MAASAI MARA NATIONAL RESERVE, KENYA

GREVY'S ZEBRA (Equus grevyi), SAMBURU NATIONAL RESERVE, KENYA

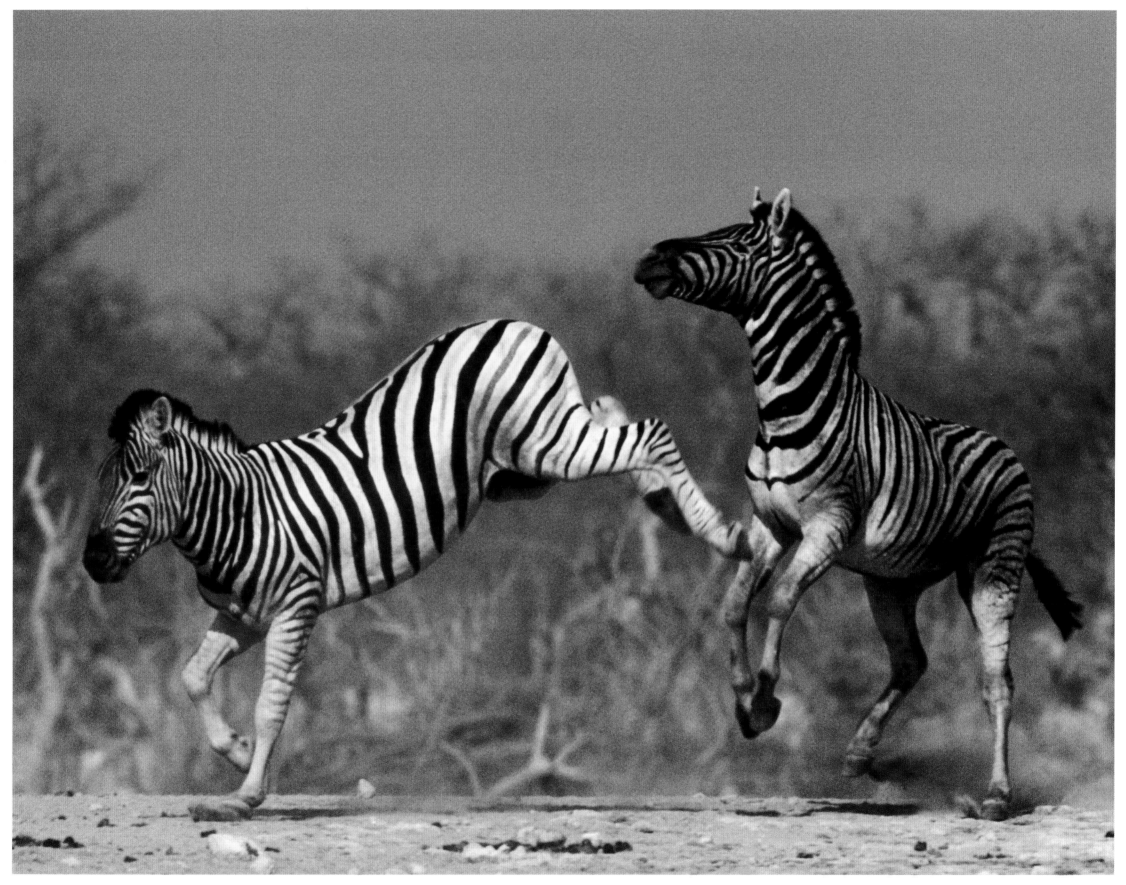

BURCHELL'S ZEBRA (*Equus burchellii*), ETOSHA NATIONAL PARK, NAMIBIA

W O O D

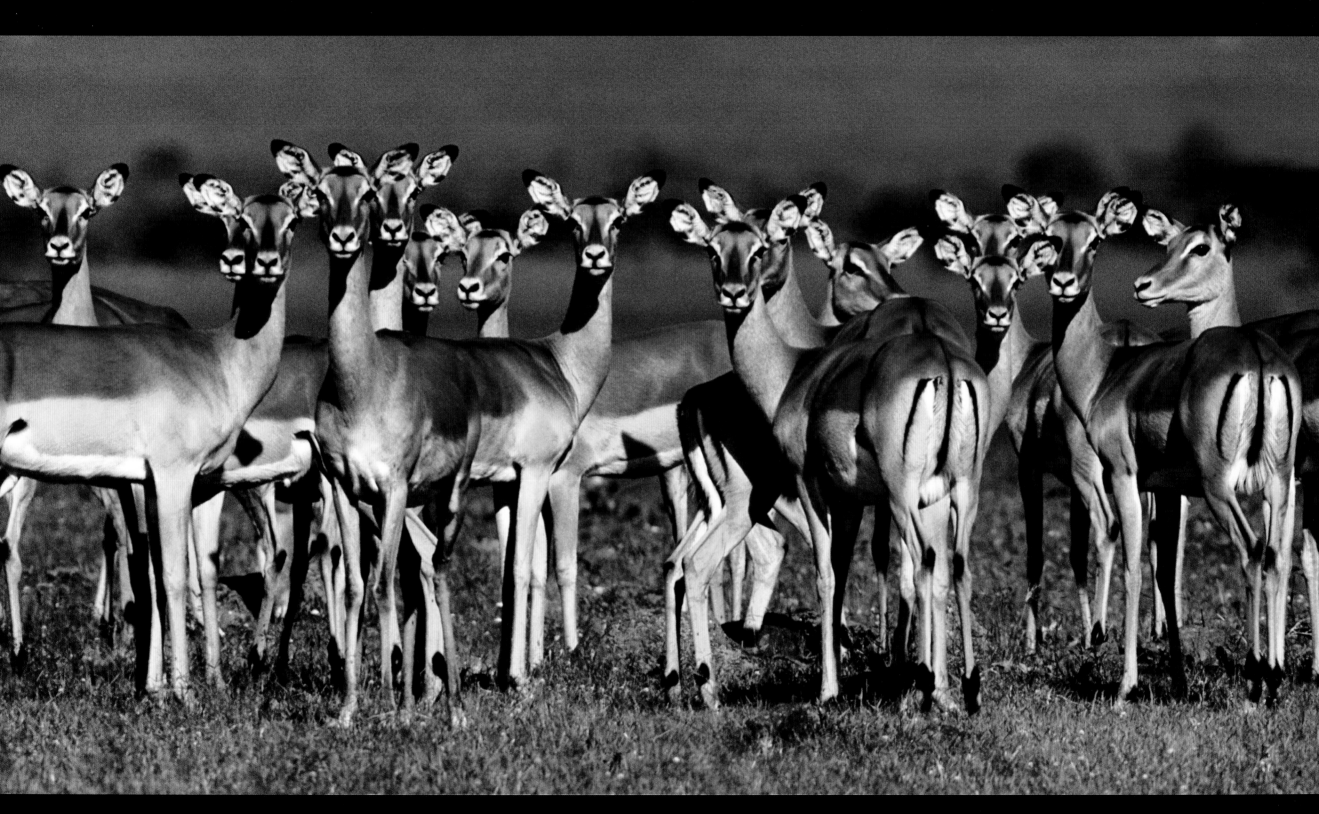

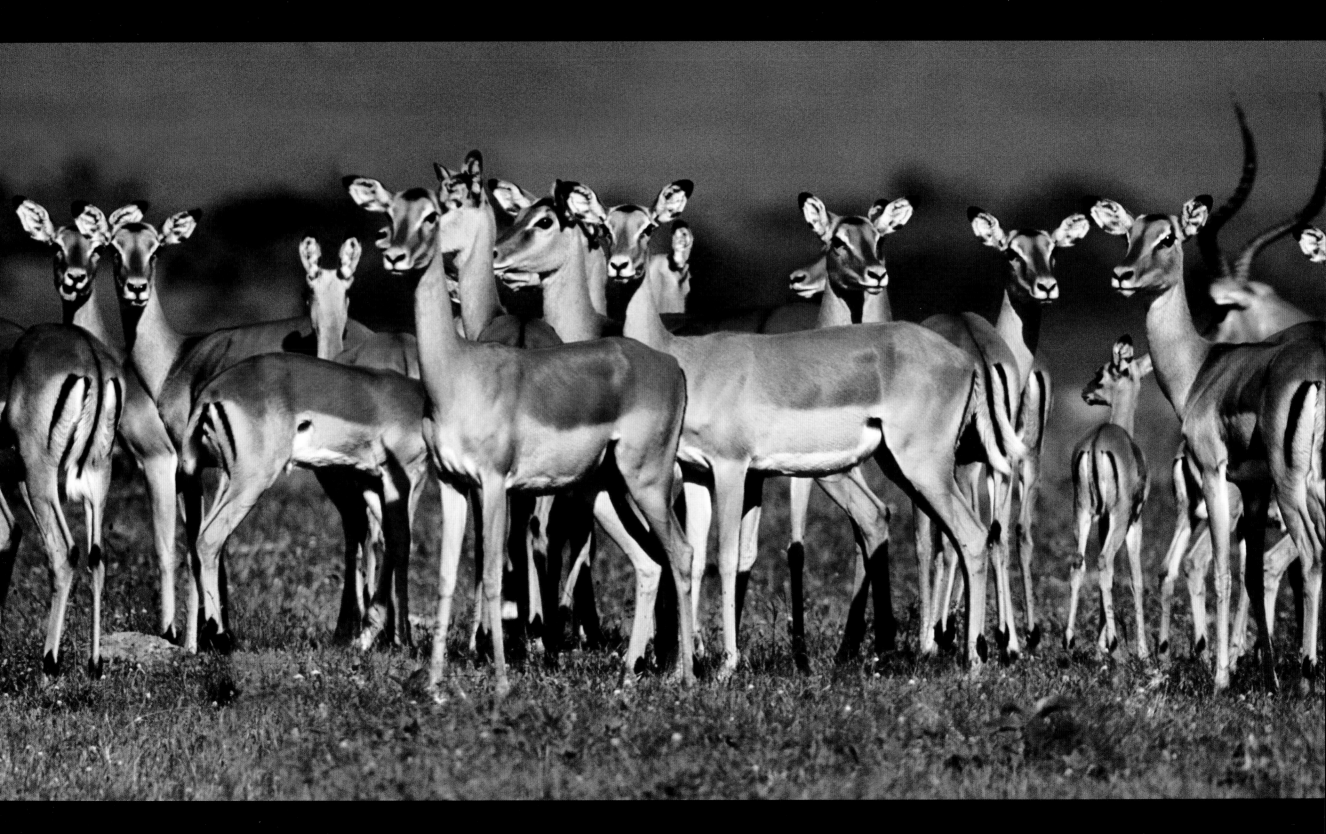

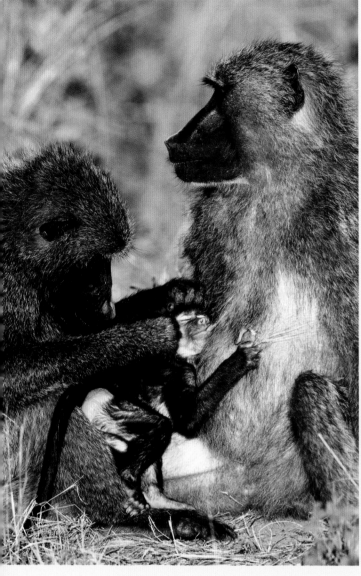

◄ IMPALA (*Aepyceros melampus*),
MAASAI MARA NATIONAL RESERVE, KENYA
▲ OLIVE BABOON (*Papio anubis*),
MAASAI MARA NATIONAL RESERVE, KENYA

A warm wind lifts the small leaves of *Brachystegia* and *Julbernardia* trees, setting up a barely audible whistling under the forest canopy. This is the *miombo*, the most extensive ecological community in Africa, stretching from Mozambique in the east to Angola in the west, and north into Malawi and southern Tanzania. The trees of the miombo concentrate along the valley ridges, forming a mosaic of habitats to the north and west with acacias, *Themeda* grasses, and wooded grasslands. The drought-deciduous trees will lose their leaves in the dry season, but when the season is still young, the delicate leaflets give the impression of feathers adorning vast wings.

The wind shifts again, funneling around narrow tree trunks to rustle the herbaceous understory. A herd of female impalas (*Aepyceros melampus*) accompanied by their young start at the noise, lifting their heads from browsing fallen seedpods. A couple of juveniles leap upward in a high jump that startles others and begins a ripple flight effect among the herd. But it is just the wind, and within minutes they are quiet again. Adults begin to browse the remaining leaves of the shrubs, and several groom each other, closely combing the fur of their partners' head and neck with incisors and canines. Juveniles copy them, taking turns until the grooming is done.

A low rumbling fills the air, felt more than heard. It is a sound, audible to just a few, that resonates through bone. The impalas move off slowly, grazing as they do so. There is no fear in their movements, just polite avoidance. Several of the small saplings break as a colossal gray mass emerges from the thicket. The ground vibrates with each well-placed footfall. Elephants emerge from the trees, surprisingly well hidden until they enter the clearing.

There are eight in this African elephant (*Loxodonta africana*) family. The matriarch is the first to emerge. She sniffs the air with her trunk, then rumbles a gathering call. Her two sisters follow at a sedate pace, but are out-maneuvered by their calves. The first youngster, a five-year-old male, runs ahead, his trunk flailing from side to side. His cousin, a seven-year-old female, hurries after him, eager to join in his exploits. The third calf, sibling to the male, stands so close to her mother that she is all but hidden from view. She was born at the height of the last rains and is just a few months old. Her mother touches her often with the tip of her trunk and rumbles reassuringly.

Another male emerges from behind the cow and calf. He is thirteen years old and has been spending progressively less time with the group; he will soon leave to join a bachelor herd, but will not breed until his thirties or forties. In his right ear, he bears a distinctive wound that he wipes with grass. It is from a spear, the young elephant's first lesson on the dangers of people. The eighth animal is the matriarch's youngest surviving female calf. She is ten years old and has yet to breed. She is attentive to the baby, rarely allowing herself to be more than a few yards away. She takes being an "aunt" seriously.

The matriarch is heading for a place she knows well. She has been coming here for nearly half a century. The trees open up ahead of them and the air feels damp, almost musty. A depression in the center of a clearing holds a puddle of water, and around the edges, white crystals glisten in the sunlight.

She knew the others were there long before they were visible. She could hear their rumblings from 6 miles (10 km) away. The families greet each other exuberantly. The temporal (scent) glands behind the matriarch's eyes begin to stream, as do those of the other elephants. The two families are closely related. The matriarch of the second family is the eldest daughter of the first. Trunks entwine and calves cavort as only elephant calves can. One of the elephants trumpets, and the clearing reverberates with the sound as it bounces off the surrounding trees. The teenage male rubs his tusks up and down the trunk of an acacia, gouging deep trenches in the bark. In time his strength will grow, and with no small effort he will be able to fell trees considerably larger than this one. The acacia shudders at the force being exerted against it, and a red-billed hornbill (*Tockus erythrorhynchus*) at rest in the canopy takes wing to find a more stable perch.

Elephants and trees have become one of the most contentious of African conservation issues. Although it is clear that elephants can have a major impact on vegetation, particularly trees, it is far from clear whether interfering with that impact is in the best interests of conservation, or even how any active management should be conducted. Two parks are often cited to demonstrate the destructive power of elephants: Murchison Falls National Park in Uganda and Tsavo National Park in Kenya.

Elephants are predominantly grazers, eating up to 370–660 pounds (170–300 kg) of grass each day. However, they also browse trees in the dry season. In both Murchison Falls and Tsavo, elephants transformed the landscape from closed woodland to open grassland, as they had done in Kenya's Maasai Mara and in the northern woodlands of the Serengeti. Myrrh trees, acacias, and baobab trees all fall prey to browsing elephants. Some tree species are felled by animals trying to reach the highest leaves during the spartan dry season. Others, such as the baobab, are killed by elephants trying to get at the water stored in the tree's bulbous trunk. Still others are felled by animals that are reacting to social pressures, or by bulls in the aggressive mating fever of musth. Of all the age and sex groups, it is the adult bulls who do the most damage.

To some, the solution of the "elephant-tree dilemma" is to kill the elephants, or relocate them to areas with a lower population density. The stated objective is

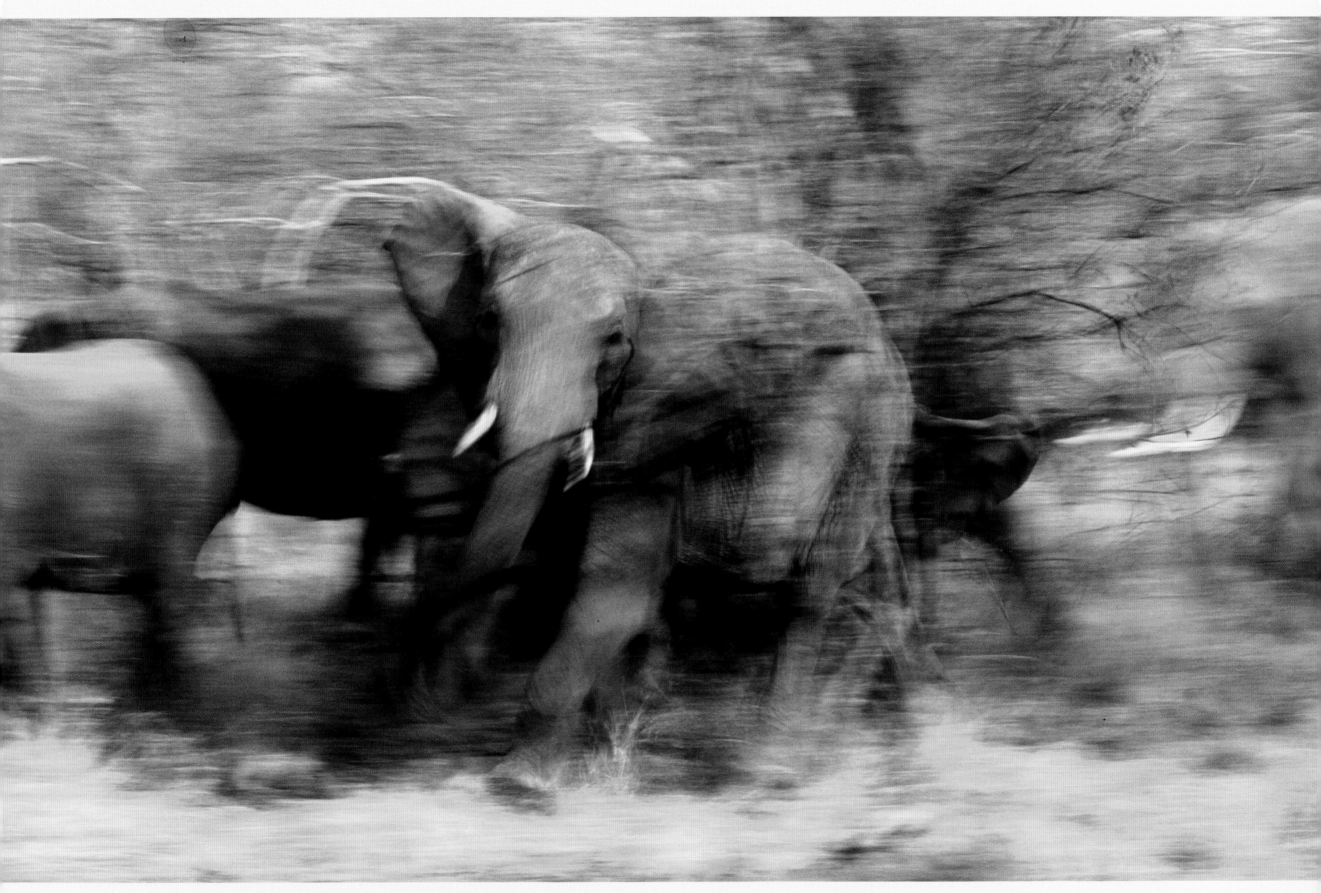

AFRICAN ELEPHANT (*Loxodonta africana*), Matetsi Reserve, Zimbabwe

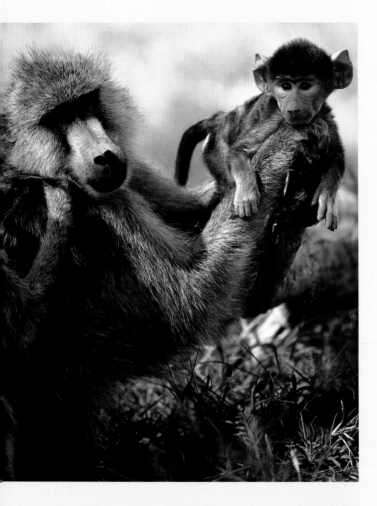

▲▲ AND ▲ OLIVE BABOON (*Papio anubis*),
MAASAI MARA NATIONAL RESERVE, KENYA

to prevent the elephants from destroying their own habitat. The solution is rarely so simple; elephants are not the sole arbiters of the forest's fate. Ecology is a web far more complex than a single cause and effect.

Just as fires sweep across savannah grasslands, recycling nutrients, clearing dead grass, and stimulating lush new plant growth, fires that rage through woodlands favor the growth of fire-resistant tree species. Elephants actually lessen the fervor of the flames by removing the grass beneath the trees, and thus reducing the available fuel (and reducing competition between the trees and grasses). Elephants are also not the only animals to directly kill saplings. Wildebeests reduce the number of small trees within their range by trampling; they also crop the grass too short for elephants, forcing them to browse elsewhere.

Where elephants do knock down trees, they open up trails, enabling other large herbivores to penetrate the forest, and providing them with access to vegetation from the upper strata. They also create gaps in the canopy, facilitating forest regeneration and the development of a multi-age and multilevel woodland. Elephants create mineral licks by excavating termite mounds; by feeding and defecating throughout the woodlands, they spread seeds far and wide, each deposited with its own individual supply of fertilizer.

Too often conservation measures view change as a threat to the system. This may be the case if the conservation areas are too small to weather even minor perturbations. But where areas are large enough to allow animals to avoid drought, flames, or their competitors, change becomes fodder for natural selection, and that is what has given us such an incredible array of species in Africa in the first place.

Grasslands give way to woodlands where rainfall increases and where soil conditions allow tree roots to penetrate to the water table. The eastern Serengeti grasslands receive just 20 inches (500 mm) of precipitation a year. However, the western and northern woodlands may receive twice that. The transition from grassland to woodland can be a gradual one, with trees encroaching on the plains until they fill the horizon with a loose canopy. In the Serengeti, the woodlands maintain coverage of between 2 and 30 percent, with closed canopies occurring only along watercourses. In areas where the soil conditions bar deep root penetration, trees may never become established, no matter how much rain falls.

When European colonialists made their way into the kingdoms of East Africa in the latter part of the nineteenth century, they were greeted by vast grasslands filled with herds of game that were unrivaled by anything they had seen before. The woodlands were limited in their range by fire, grazing, rainfall, and soils. In 1889, an Italian military expedition to Ethiopia accidentally introduced something that would dramatically change the dynamics of the ecosystem. The expedition traveled with livestock, and the livestock were infected with *rinderpest*.

Rinderpest, or cattle plague, is a highly infectious, often fatal, viral disease of ruminants (mammals with complex stomachs that chew cud). Common in the Middle East and the Indian subcontinent, rinderpest was introduced to Africa by the Italian expedition, with devastating results. The virus, although primarily a disease of cattle, once in Africa spread rapidly through populations of wild ruminants that had no natural immunity, including African buffalos (*Syncerus caffer*), giraffes (*Giraffa camelopardalis*), wildebeests, and other antelopes. The disease causes a loss of appetite, mouth ulcers, dehydration, diarrhea, coma, and, ultimately, death.

The herds of East Africa crashed under the disease, and without their grazing pressure to maintain the grasslands, the woodlands expanded (some single-aged stands of acacias still present today date to the 1889 outbreak). Coincidentally with the outbreak of disease, the ivory trade expanded, and with the elimination of the elephants, the woodlands encroached even further.

Rinderpest continued to be prevalent until the early 1960s, with two outbreaks reported even within the last decade. An effective vaccine has now brought the virus under control, and wildlife populations have rebounded. The wildebeest population increased sixfold between 1963 and 1977, and other species made similarly dramatic recoveries. The return of the grazers pushed the woodlands back to those areas best suited to their survival. Other factors, such as a drying climate, may also have contributed to the change.

As our knowledge of population dynamics increases, we can move away from the desire to attach a single cause to an effect. Elephants were always a visible and easy target, particularly during times of drought, when a single hungry family of elephants could completely destroy a tree grove. Today burning, climate changes, and other grazers have become the focus of interest. This is not to suggest that elephants are unimportant; they probably do help to maintain a grassland state. But fire (which itself is closely related to an increasing human population) and drought are probably responsible for initiating any changes to woodlands.

Few sights can match that of a herd of elephants making their way peacefully across the landscape. In their stoic grandeur, they add an aura to the land that is both primeval and profoundly intelligent. The problem of elephants and trees, if indeed there is a problem, is a human one.

Tsavo National Park supported 42,000 elephants in 1970, giving rise to numerous calls to cull the population. However, by 1994 ivory poachers had cut that population to just 6,200. The tragic decline in Tsavo was exacerbated by a severe drought between 1970 and 1974 that killed 9,000 animals. The Serengeti elephants declined by 81 percent, from 2,460 in 1970 to just 467 in 1986. With the implementation of severe poaching penalties, armed guards, and a ban on ivory sales, Serengeti numbers increased to 1,300 by 1995.

If poachers had not ravaged the Tsavo and Serengeti populations, it is likely that a stable situation between elephants and trees would have developed. Drought, lack of forage, and a lack of shade will all reduce elephant numbers, and family groups may even stop reproducing for several years if conditions are particularly poor. The loss of woodlands in the northern Serengeti and the Mara that has been attributed to elephants may now be reversed with the loss of so many animals from poaching (such a reversal has already occurred at Murchison Falls National Park).

In the early nineteenth century, an estimated 27 million elephants likely roamed Africa. By the mid-nineteenth century, that number had been cut to 10 million. In 1979, the Africa-wide population was about 1.3 million animals, and a decade later it was estimated at 625,000. Today the African elephant numbers between 300,000 and 600,000 animals. Some researchers believe that elephants will have vanished from all but a few protected areas by 2010. If Africa once rumbled under the footsteps of 27 million elephants, surely we can find a place for the few that remain.

Populations of all wildlife species are not static; they fluctuate up and down, even without any direct intervention by humans. The population debate then turns to whether the natural highs and lows that a wild population experiences are necessary, and whether culling them is better than allowing them to starve. From a human perspective, intense management can appear the kinder of the options, but management is not a short-term solution. It requires constant intervention, and with many facets of ecosystem dynamics still a mystery, human intervention can be both costly and damaging.

Elephants evolved under the pressures of their environment: They were shaped by it. We may like to believe that management can save the elephant from extinction, but by placing ourselves in the role of selector, we alter Darwin's paradigms and become the protectors of some artificial view of what we think an elephant should be. Culling the largest and oldest bulls (who inflict most of the tree damage) eliminates the best adapted from the population, and wiping out an entire family group robs the larger bond group of a matriarch's leadership.

Ivory poaching is known to have had a significant effect on elephant genetics. In South Luangwa National Park and the Lupande Game Management Area in Zambia's eastern province, the number of adult female elephants without tusks increased from 10.5 percent in 1969 to 38.2 percent in 1989. A certain number of females in any elephant population are likely to be tuskless, as this trait is sex-linked. With ivory poachers selectively killing animals with marketable tusks, the population becomes skewed in the direction of tusklessness. The tragedy is that the African elephant we manage to save may not look much like, or function as well as, the African elephant we have come to admire.

While it is true that some countries have seen their elephant numbers grow rapidly (the elephant population in Zimbabwe grew from 30,000 in 1960 to 76,600 in 1991), culling, management, and selective marketing of ivory sends a disturbing and highly utilitarian message when it comes to conservation. Perhaps elephants will not survive unless we find an economic "purpose" for them in a human-run world, but perhaps it is that purpose itself that is at fault. After all, if we conserve only those species for which there exists a trade market (however meaningless or trivial), what does that say about our ability to conserve other "non-useful" species? And what does it say about us? Equally, how do we justify the massive expense of conserving viable wildlife populations when people also need land and food? It is a debate that will undoubtedly continue, and an issue that may never be resolved.

The woodlands of Africa, from the scattered acacias of Kenya to the miombo of Tanzania and Zimbabwe and the *mopane* woodlands of central Zambia, represent habitats where the density of trees and undergrowth vary widely. It is the edge habitats that support the greatest diversity, the transition point between habitats where animals can exploit parts of both. While gazelles, wildebeests, zebras, cheetahs, and spotted hyenas are true animals of the plains, elands (*Taurotragus oryx*), greater kudus (*Tragelaphus strepsiceros*), sable antelopes (*Hippotragus niger*), roans (*Hippotragus equinus*), buffalos, giraffes, impalas, rhinos, elephants, and leopards (*Panthera pardus*) favor areas where woodlands offer shade and cover. The denser woodlands are home to the smaller and more specialized browsers, including dik-diks (*Madoqua* sp.), gray duikers (*Silvicapra grimmia*), sunis (*Neotragus moschatus*), and Sharpe's grysboks (*Raphicerus sharpei*). Many of these species are nocturnal and elusive, and as such, are poorly known.

Woodlands have tended to favor different adaptations compared to the plains. When the global climate was wetter, forests were the primary habitat. It was only with the drying trend thirty-four million years ago that the grasslands spread, encouraging evolution of larger plains herbivores. Those species that remained among the trees took a different evolutionary course.

Forest dwellers are generally small. The forest buffalo (*Syncerus caffer nanus*), a subspecies of the African buffalo, is half the size of its grassland relative, and the forest elephant (*Loxodonta africa cyclotis*) of central Africa is almost half the size of elephants living on the savannah (both might be classified as separate species if they did not interbreed).

Woodland species such as reedbucks (*Redunca arundinum*), impalas, and topis tend to be at their most vigilant in wooded habitats that provide more hiding places for predators. These species also form smaller groups in the woodlands than on the plains (topis form herds of six hundred to seven hundred in open habitats, but woodland herds are usually fewer than twenty). Grassland species are gregarious, finding security among the masses, while bovids in closed habitats are often solitary and will hide rather than flee from danger.

GERENUK (*Litocranius walleri*),
Samburu National Reserve, Kenya

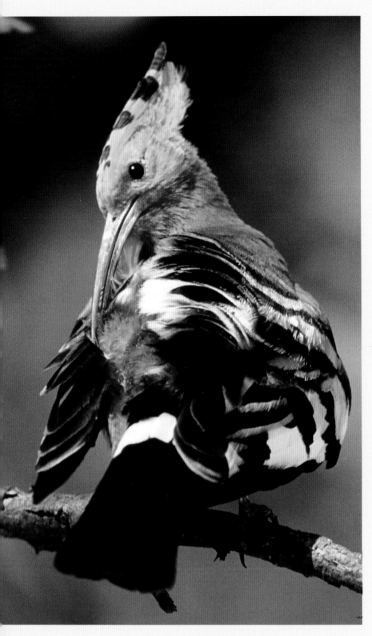

CRESTED HOOPOE (*Upupa epops*),

TARANGIRE NATIONAL PARK, TANZANIA

True woodland mammals do not migrate extensively. A more stable, year-round residence has led to the evolution of sedentary and territorial behavior among some of the woodlands' smallest bovids: the dwarf antelope (*Neotragus* spp.) and the duikers.

The dwarf antelopes are just that, antelopes in miniature, with delicate features and large eyes. Sunis stand just 12 to 16 inches (30 to 41 cm) at the shoulder, Sharpe's grysbok 18 to 20 inches (45 to 50 cm), and dik-diks average 14 to 16 inches (35 to 40 cm). Both the oribis (*Ourebia ourebi*) and duikers are larger: 20 to 25 inches (51 to 63 cm) for the oribi and 18 to 28 inches (45 to 70 cm) for the common duiker. With sunis weighing in at 8.8 to 19.8 pounds (4 to 9 kg) and duikers at 33 to 55 pounds (15 to 25 kg), these small animals are well adapted for hiding in the undergrowth, often emerging at night to graze fallen leaves, fruits, and flowers. Only the male dwarf antelopes support short, pointed horns (whereas both sexes of the duikers do), and most maintain small territories of just a few acres.

Surprising among bovids, the dwarf antelopes are largely monogamous, often marking and defending their territories together by dunging or scent-marking along the boundaries. Monogamy in antelopes is closely correlated with sexual monomorphism (barely any size difference between the sexes), male participation in the raising of offspring, the use of specialized vocalizations, and the active defense of a territory. Of the plains antelopes, none is truly monogamous, suggesting that among the mobile, gregarious animals of the plains, monogamy holds little evolutionary advantage. It would seem that a scattered, low-density food source (such as fruits or new shoots) favors the evolution of territories and pair bonding in the woodlands.

While the dwarf antelopes browse the lower levels of the forest, other woodland inhabitants reach to greater heights. Elephants take advantage of that wonder of adaptation, the prehensile trunk, to reach into the canopy, occasionally standing on their hind legs to reach the highest browse (of course they also have the strength to bring the branches down to them). It is the giraffe, though, that has gone to the most extreme heights to reach its food.

Giraffes evolved in the late Miocene, ten to twelve million years ago, when savannah woodlands were widespread. Any animal that can exploit a resource that is not being used by others gains an advantage through reduced competition. At 14 to 17.5 feet (4.3 to 5.3 m), the giraffe is the tallest living terrestrial animal, and its long neck allows it to browse 18.6 feet (5.7 m) above the ground, clearly well out of reach of even the most determined of terrestrial competitors.

In addition to its long neck (which still contains the seven neck vertebrae typical of most mammals), giraffes have a prehensile tongue 18 inches (45 cm) long that is used to pluck leaves from even the most thorny of acacias. Despite the fierce protection that some acacias have evolved, they do benefit from the giraffes'

attentions. Acacia seedpods are attacked by bruchid beetles that usually kill between 60 and 90 percent of the seeds they penetrate. Infested seeds eaten by ungulates and passed with the dung have a much greater chance of germinating than those that simply fall to the ground. Thus, although they may suffer sometimes severe pruning by giraffes, acacias actually benefit in the long term through improved germination of their seeds.

With their extremely tall stance, giraffes have a wide field of vision and probably the keenest eyesight of any of the big-game species. They are always alert and are generally timid. Although they can run at speeds of 35 miles per hour (56 km per hour) and deliver swift kicks with their forefeet, giraffes are still vulnerable to attack. It is when they have their forelegs spread to reach the ground or a watering hole that giraffes are most ungainly and exposed. To minimize their vulnerability, females with young avoid habitats with dense vegetation, and they approach water with the utmost caution.

Woodlands provide predators with welcome cover. On the open savannah, the lack of cover has favored strategies such as coursing, in which the predator chases by sight rather than scent. Woodland habitats allow approach by stealth, at the same time making prolonged chases impossible. Lions that live along the savannah-woodland edge can approach their prey to within 100 to 180 feet (30 to 50 m) before rushing in for the kill; those on the plains may have to slowly approach herds for a mile or more, an exercise that is prone to failure.

The leopard is the premier ambush predator. Found across sub-Saharan Africa, from the rainforests to the deserts, leopards favor the riverine forests, shrubs, and thickets that both attract herbivores and provide concealment. Within ranges of 3.2 to 104 square miles (8 to 260 sq km), a solitary leopard concentrates on medium-sized prey between 44 to 154 pounds (20 to 70 kg). They also eat carrion and will even take small carnivores such as jackals.

Leopards pounce on their prey, approaching as close as 16.5 feet (5 m) before launching an attack, rarely pursuing farther than 165 feet (50 m) if the initial attack fails. Invariably hunting at night, this mythic "supreme watcher" (so-named for the ever-open "eyes" on its coat), retreats to a tree branch during the day, caching its kill out of reach of other predators. In South Africa's Kruger National Park, 78 percent of leopard kills are impalas.

The impala is the perfect antelope, and has become the staple for many woodland-savannah predators. Impalas are highly gregarious, with females living in breeding herds that may range from fewer than thirty to more than eighty. Males form bachelor herds of their own. Common in mosaic habitats, impalas are both grazers and browsers. They are reasonably sedentary, and live within ranges averaging 130 acres (52 hectares).

Impala are the only ungulates to employ a highly reciprocal allogrooming system whereby unrelated adults and juveniles (as young as two weeks old)

will groom the head and neck of others (the only areas that an individual cannot groom on its own). This cooperative grooming system, not associated with kinship or dominance, is one of the few examples of such cooperation in a non-primate mammal. Grooming partners will take turns until one partner ceases to reciprocate. Ticks are common in the woodland habitats used by impala, and allogrooming successfully removes them. Because ticks can transmit disease and reduce the fitness of a carrier, the evolution of a grooming relationship based on reciprocity has a direct and immediate benefit for survival.

The one drawback associated with allogrooming is that it reduces vigilance. Animals that are busy grooming cannot keep an eye out for predators. This is mitigated somewhat by relying on the overall vigilance of the herd. When startled, impalas will leap upward with jumps up to 10 feet (3 m) high and 36 feet (11 m) long. These huge leaps make it harder for a leopard or lion to select and focus on a single animal. In addition, impalas zigzag as they run, cutting in front of each other and creating a sudden, explosive mass of antelopes that confuses any would-be predator.

Woodland primates, such as the chacma baboons (*Papio ursinus*), rely on the safety of the troop, much as impalas rely on the herd. Among baboons, the higher-ranking females are able to monopolize the less-vulnerable positions in the center of these kinship-based groups, leaving the lower-ranking individuals in the more-exposed peripheral positions. The result is that female mortality is closely related to rank, with lower-ranking individuals more likely to be picked off by leopards.

Vervet monkeys (*Cercopithecus aethiops*), found throughout much of the miombo, have developed a series of vocalizations that deal with specific predators, enabling them to quickly communicate the presence of danger to other members of their troop. Researchers have identified at least thirty-six distinct sounds and sixty gestures used by vervets to communicate a wide variety of messages. Different alarm calls warn of avian predators, snakes, leopards, or even trespassing vervets from a "foreign" troop. The monkeys recognize the different meaning of each call and react accordingly, descending from the treetops to avoid an eagle, running away from thickets or into the trees in response to the snake call, and fleeing en masse to avoid a leopard.

In the woodlands, shadows play beneath branches and leaves, antelopes hide their young, and predators search for a meal to feed their own hunger. Elephants mill among the trees, tearing sturdy limbs from quaking trunks, and monkeys flee from toppled trees as their landscape changes around them. The woodlands expand and recede as the climate grows drier or wetter and its inhabitants evolve in concert, or are replaced. The palette of colors shift with the seasons and the balance is forever in motion.

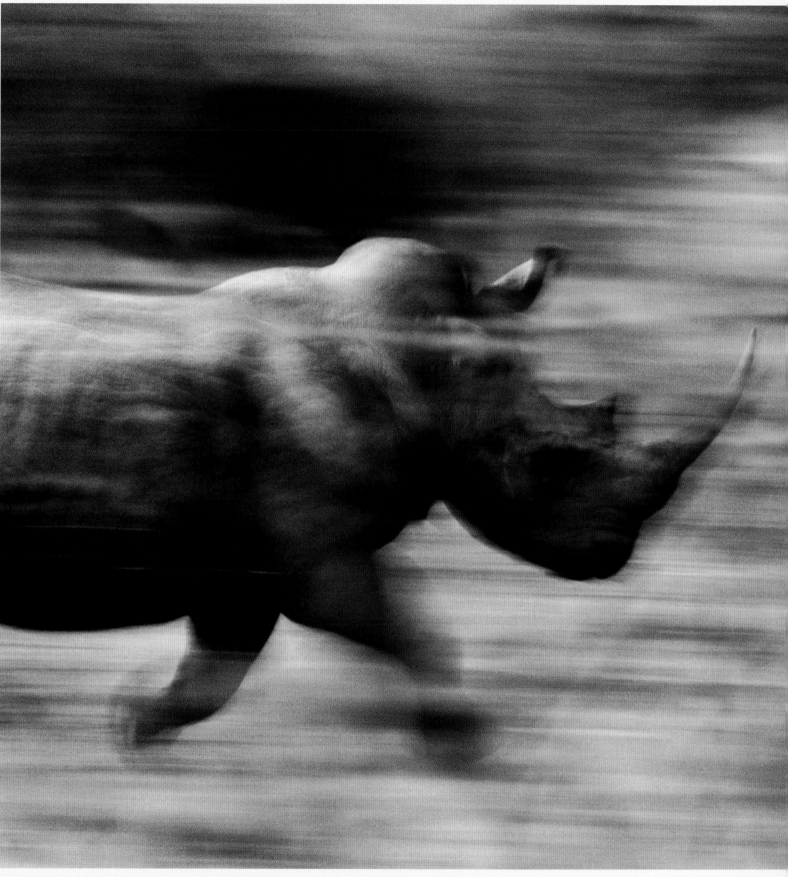

WHITE RHINOCEROS (*Ceratotherium simum*), PHINDA RESERVE, SOUTH AFRICA

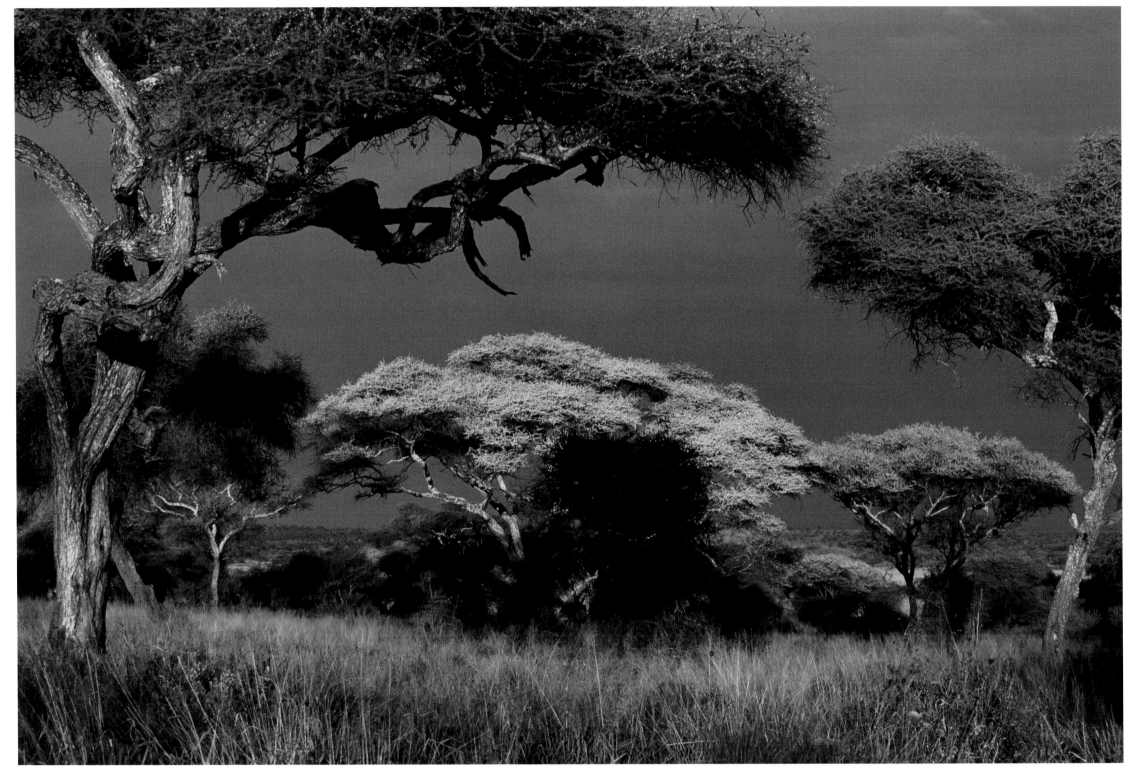

UMBRELLA THORN (*Acacia tortilis*), TARANGIRE NATIONAL PARK, TANZANIA

TERMITE MOUND, Tarangire National Park, Tanzania

AFRICAN ELEPHANT (*Loxodonta africana*), Ngorongoro Conservation Area, Tanzania

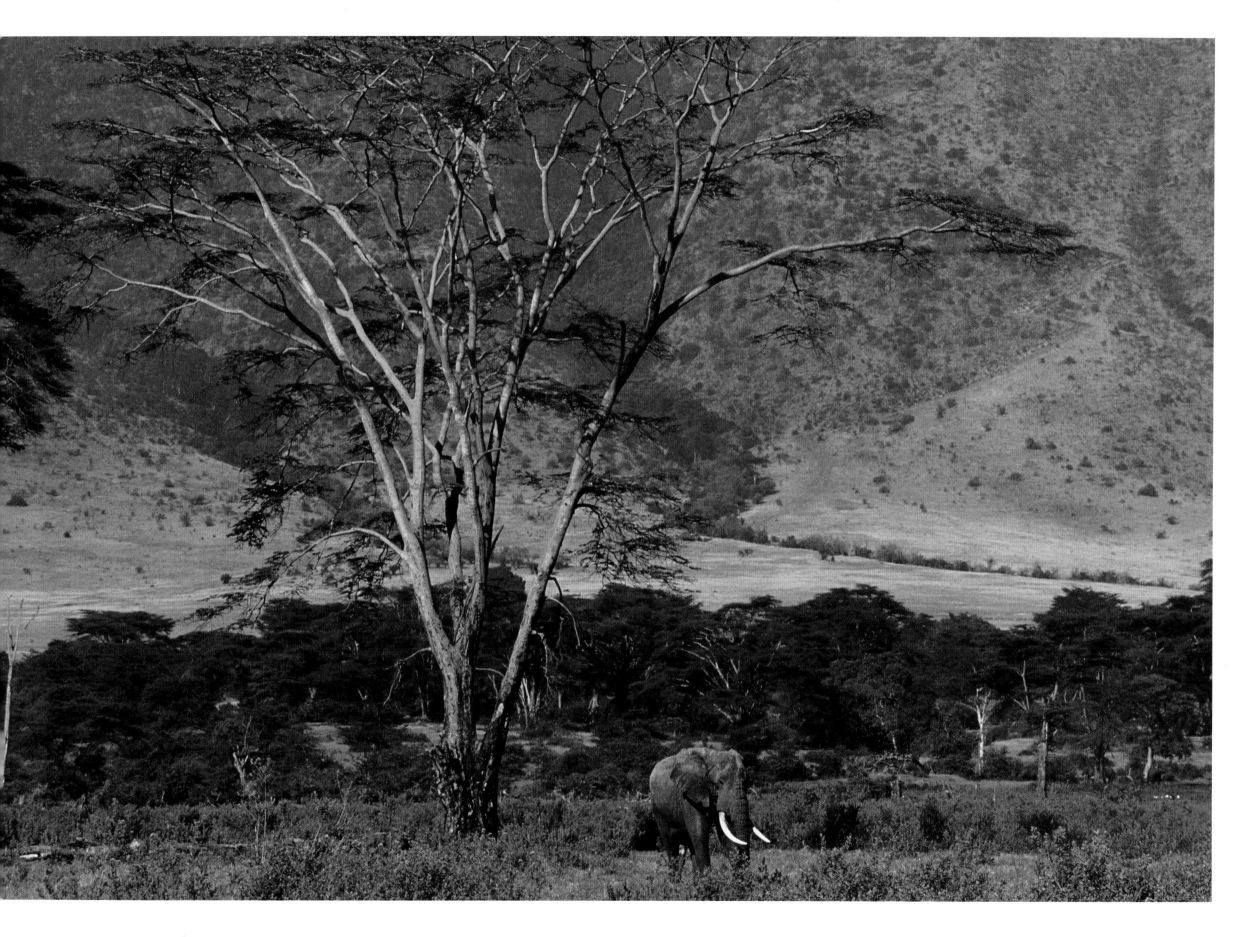

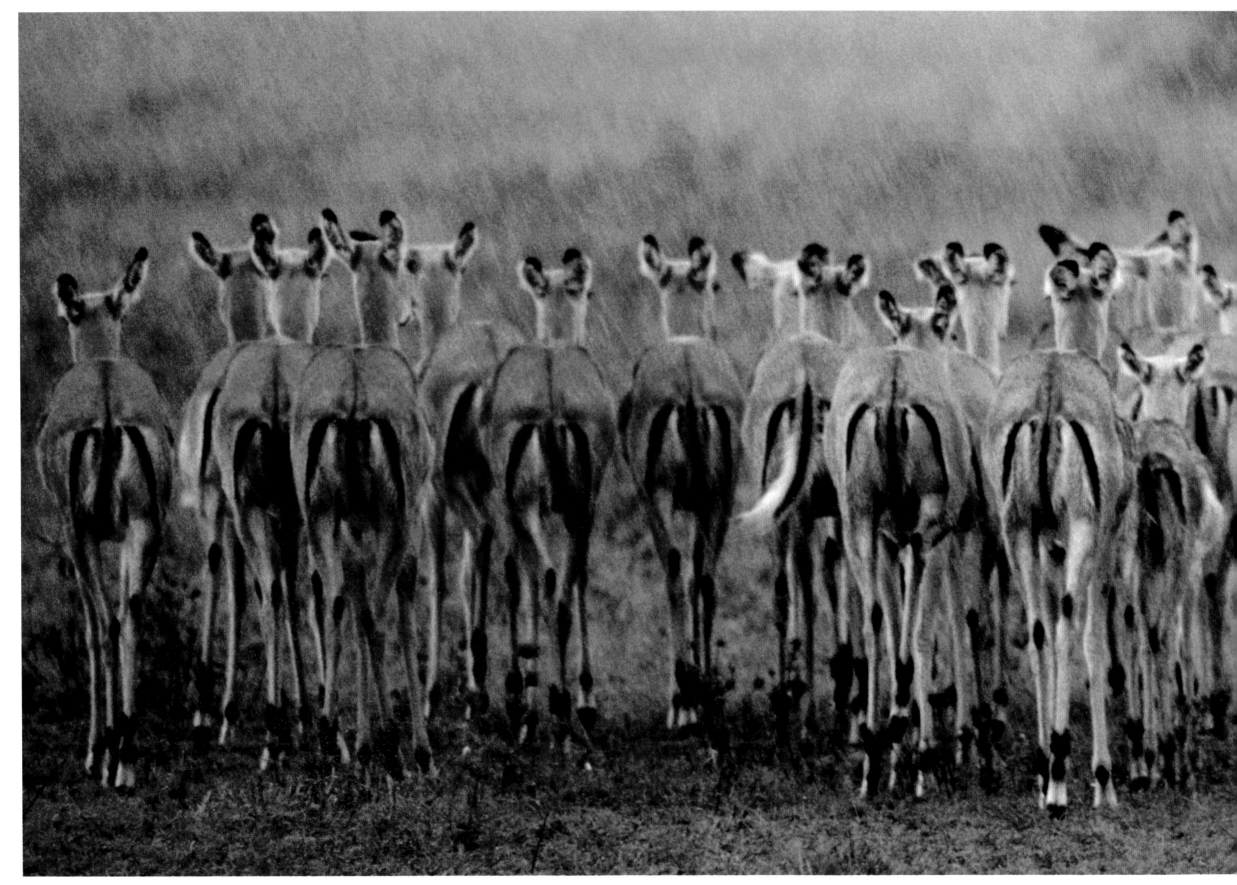

IMPALA (*Aepyceros melampus*), LAKE NAKURU, KENYA

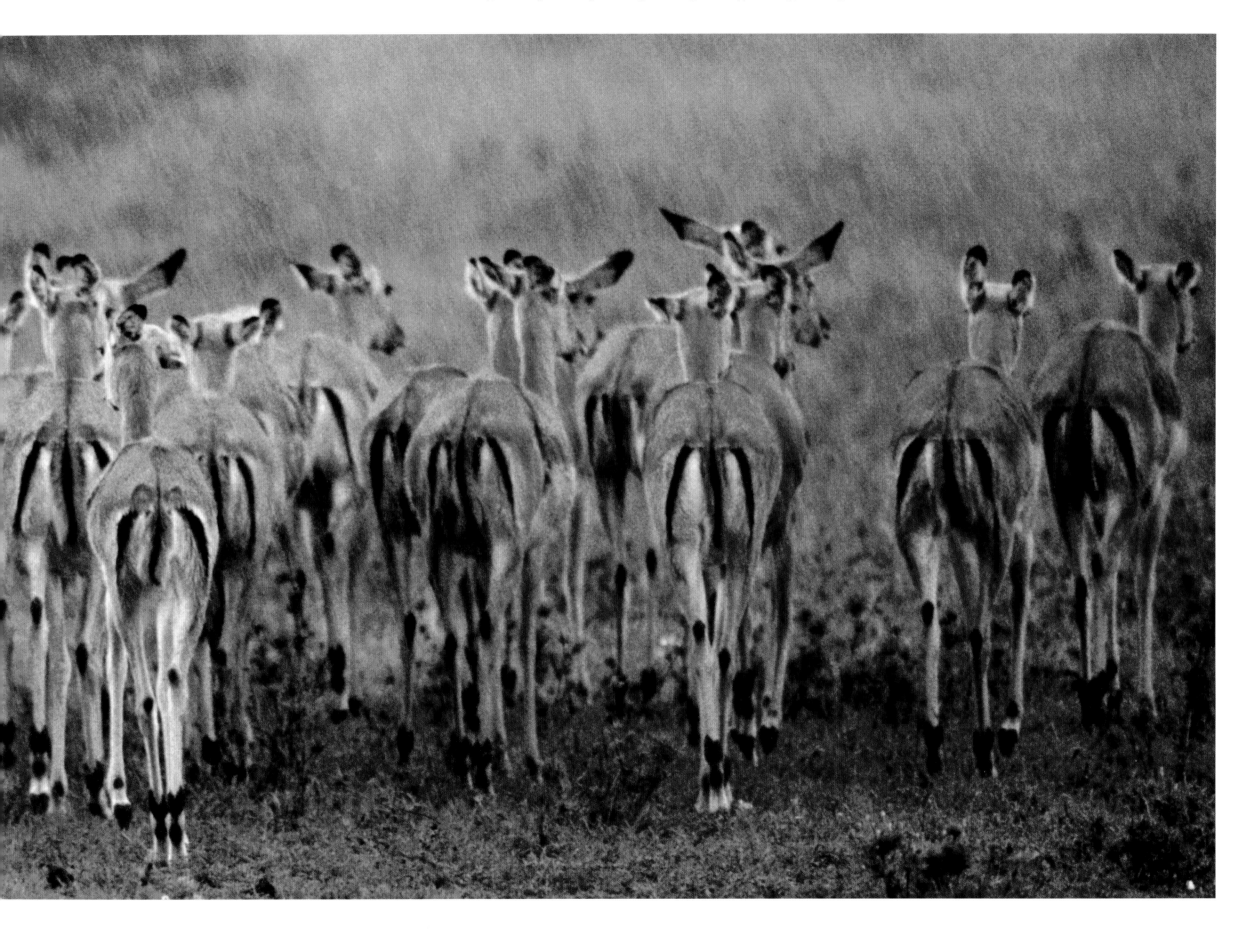

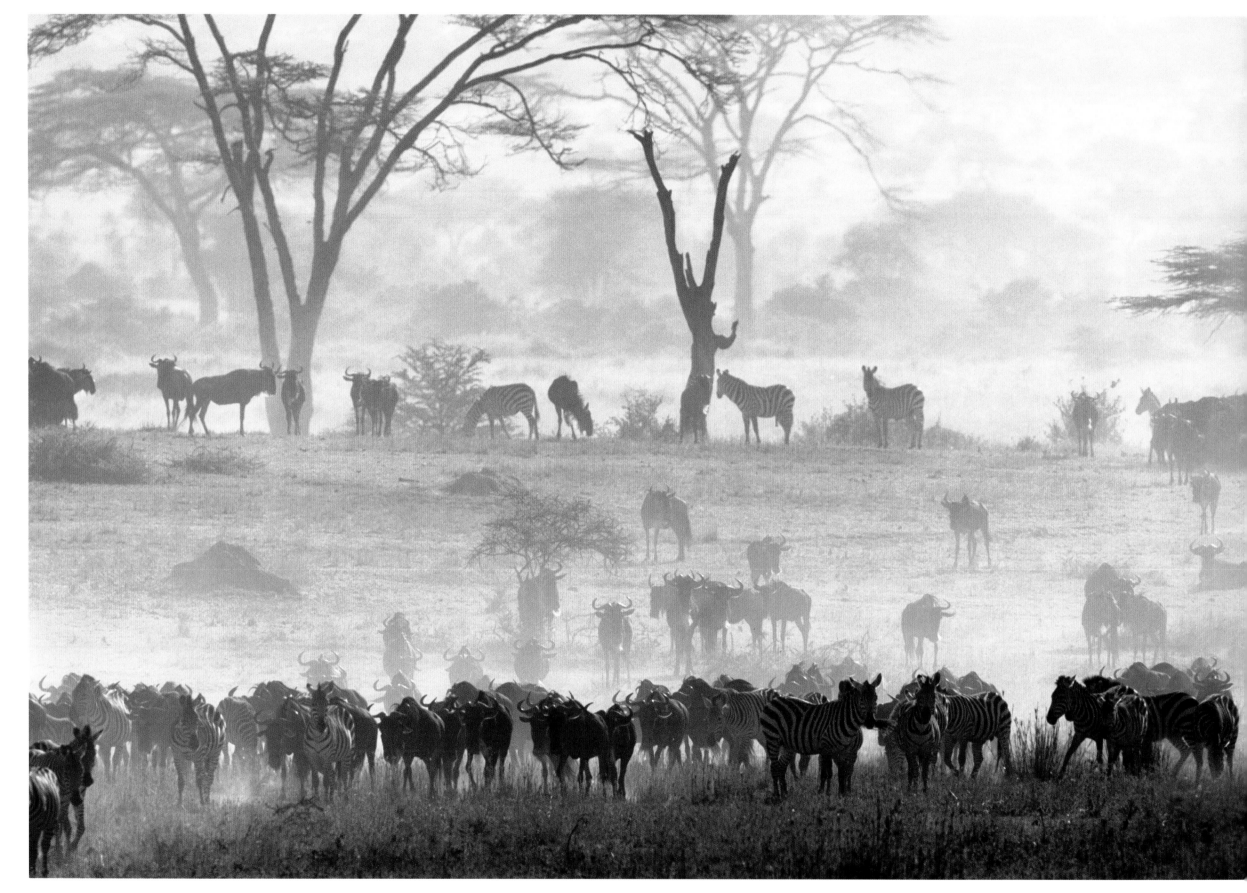

COMMON WILDEBEEST (*Connochaetes taurinus*) AND BURCHELL'S ZEBRA (*Equus burchellii*), SERENGETI NATIONAL PARK, TANZANIA

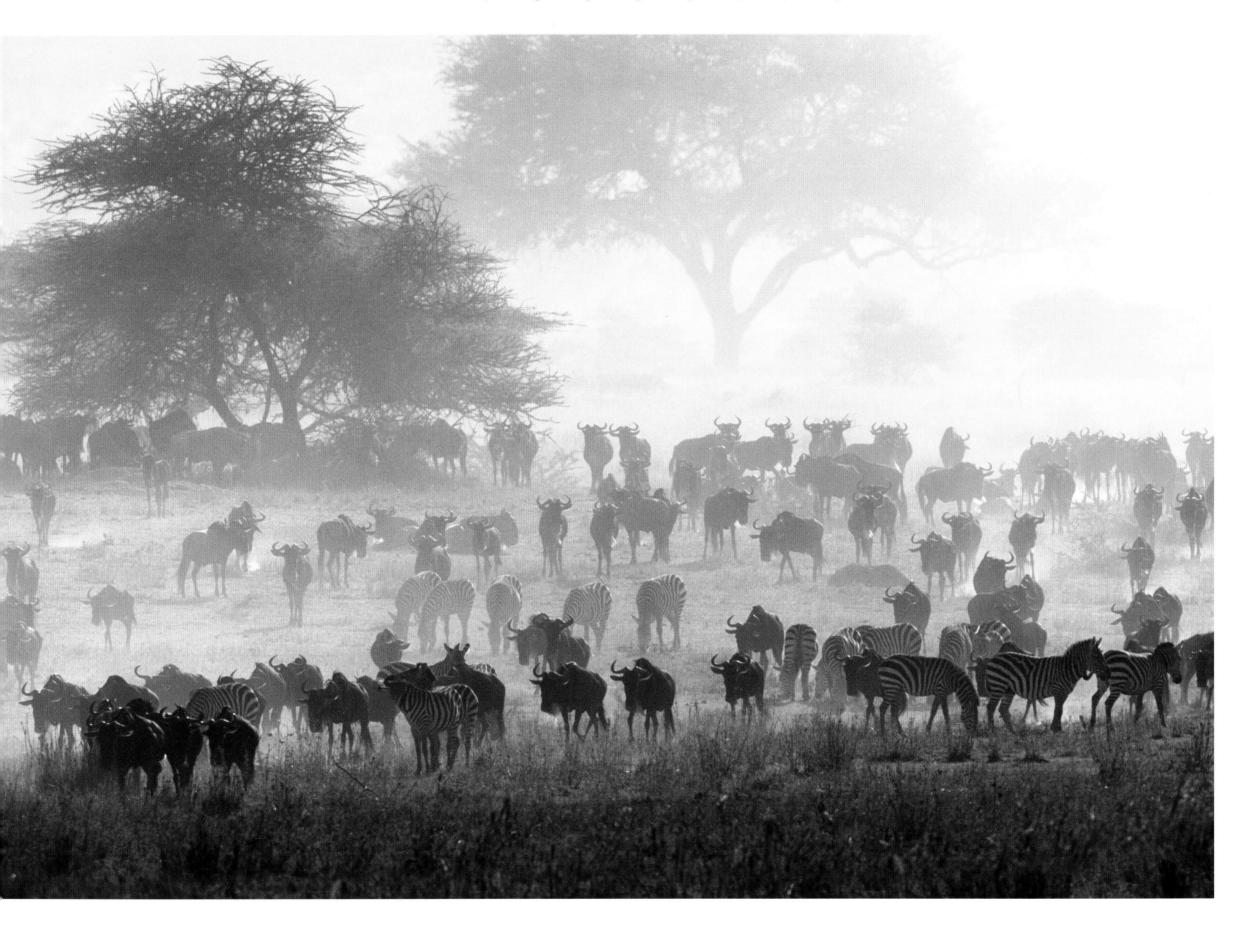

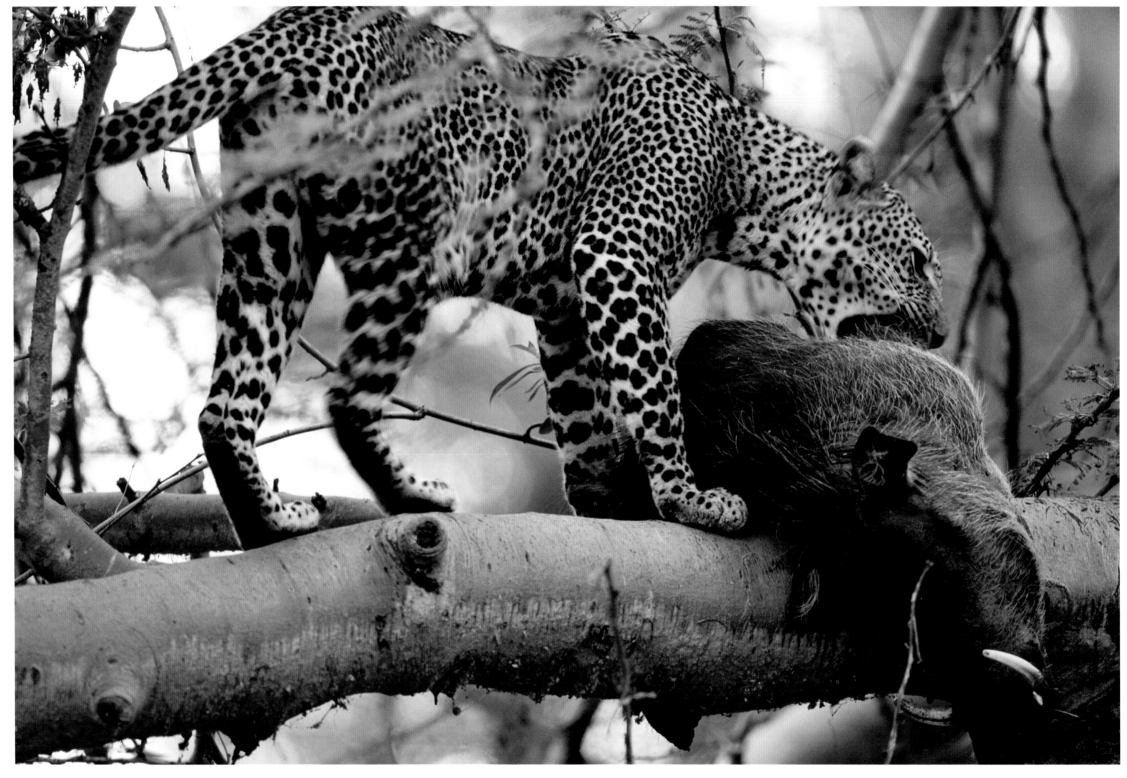

LEOPARD (*Panthera pardus*) AND WARTHOG (*Phacochoerus africanus*), LAKE NAKURU, KENYA

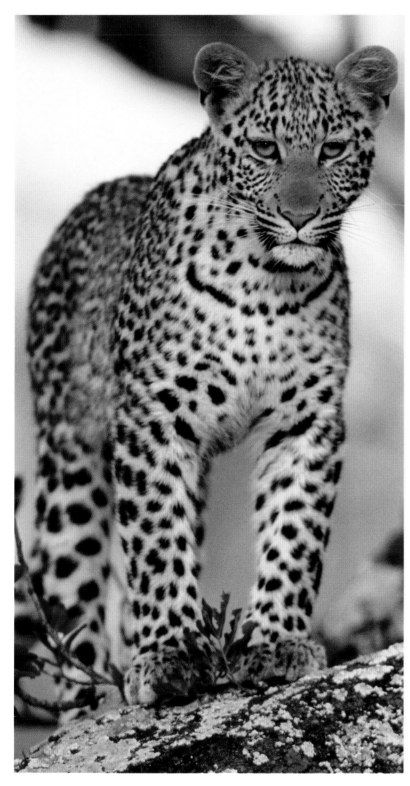

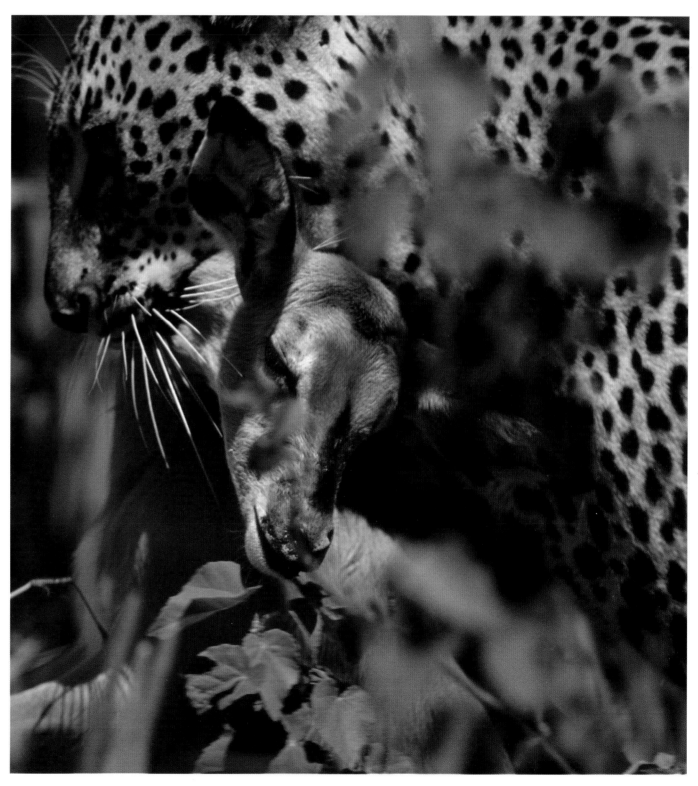

LEOPARD (*Panthera pardus*), KRUGER NATIONAL PARK, SOUTH AFRICA

LEOPARD (*Panthera pardus*) AND IMPALA (*Aepyceros melampus*), SAMBURU NATIONAL RESERVE, KENYA

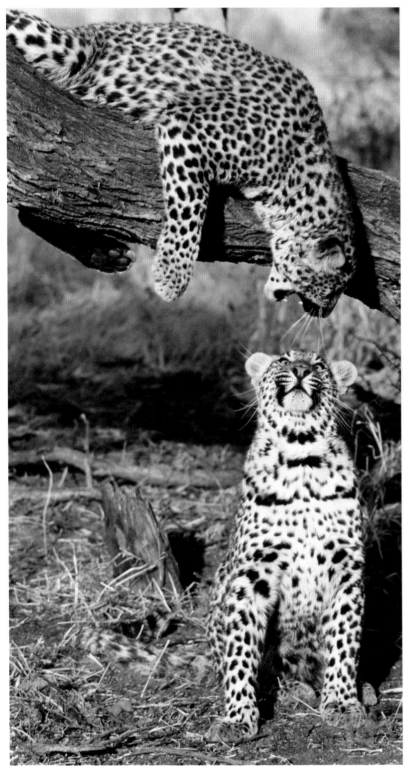

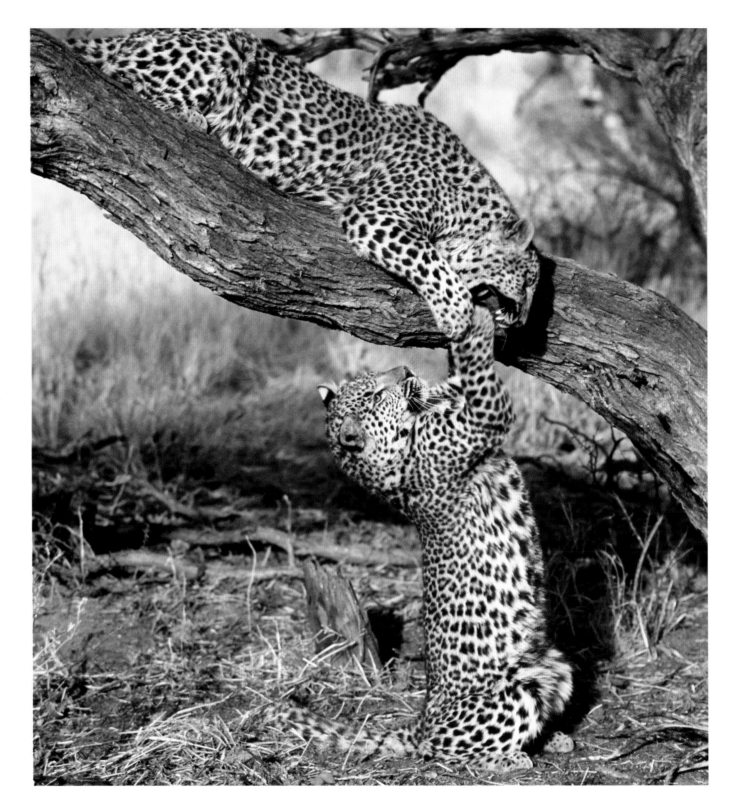

▲ AND ▶ LEOPARD (*Panthera pardus*), SABI SANDS GAME RESERVE, SOUTH AFRICA

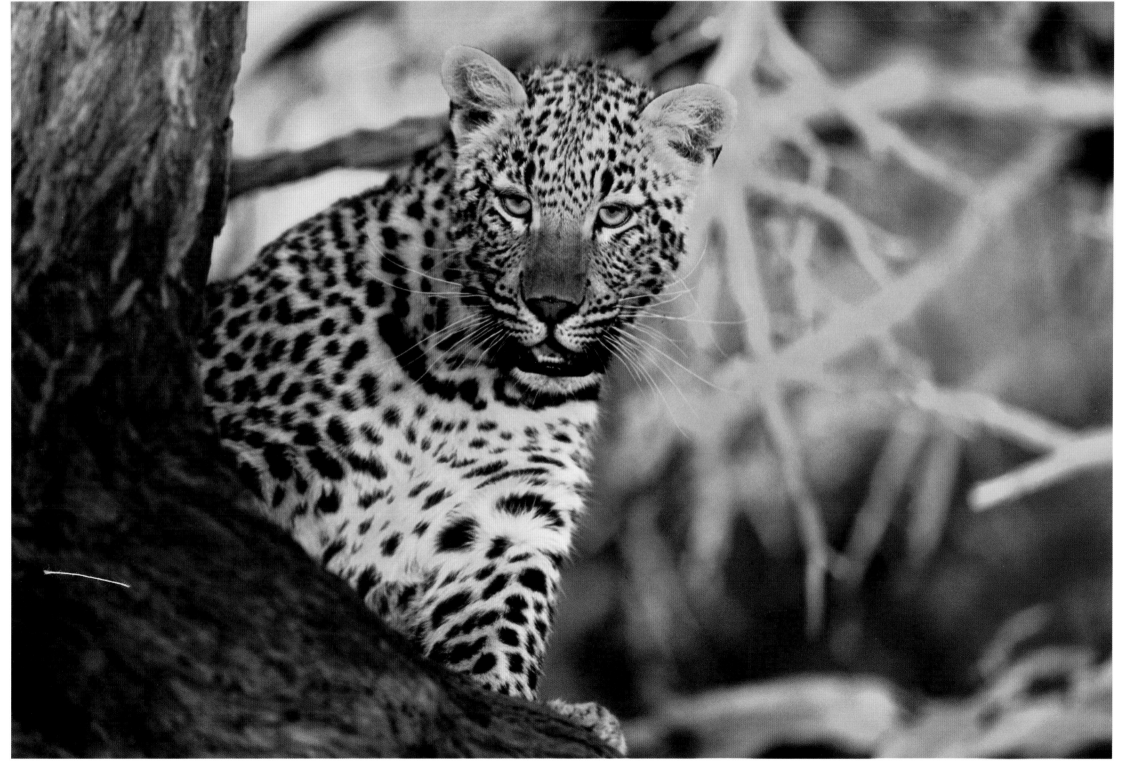

LEOPARD (*Panthera pardus*), KALAHARI DESERT, SOUTH AFRICA

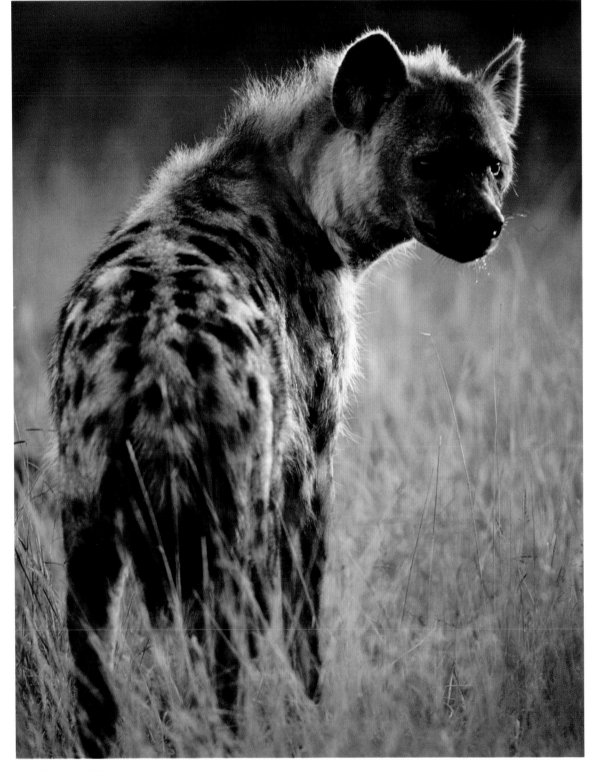

SPOTTED HYENA (*Crocuta crocuta*), KWANDO, BOTSWANA

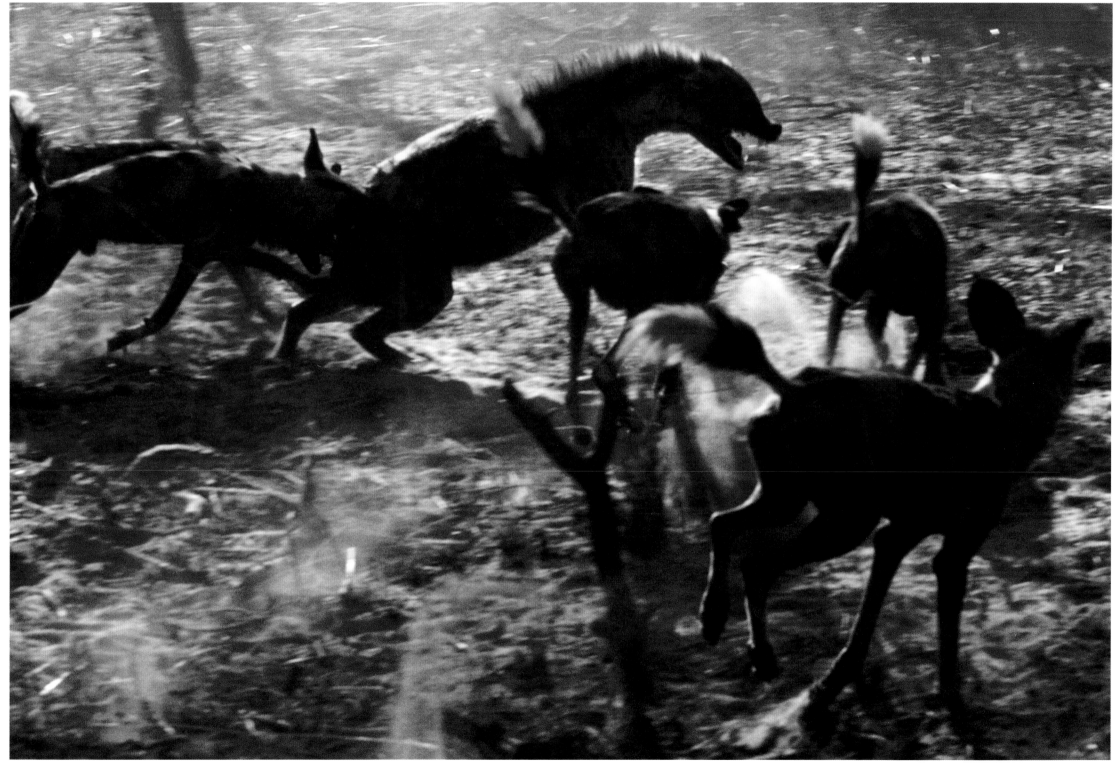

WILD DOG (*Lycaon pictus*) AND SPOTTED HYENA (*Crocuta crocuta*), KWANDO, BOTSWANA

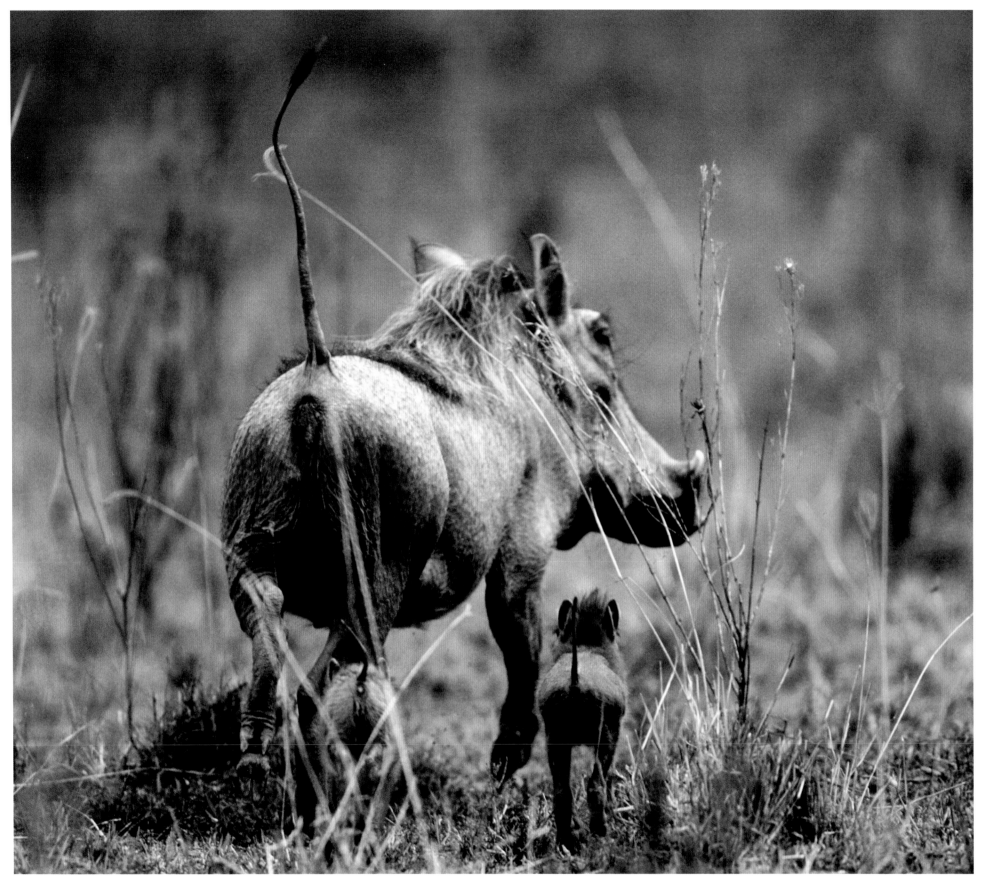

WARTHOG (*Phacochoerus africanus*), KWANDO, BOTSWANA

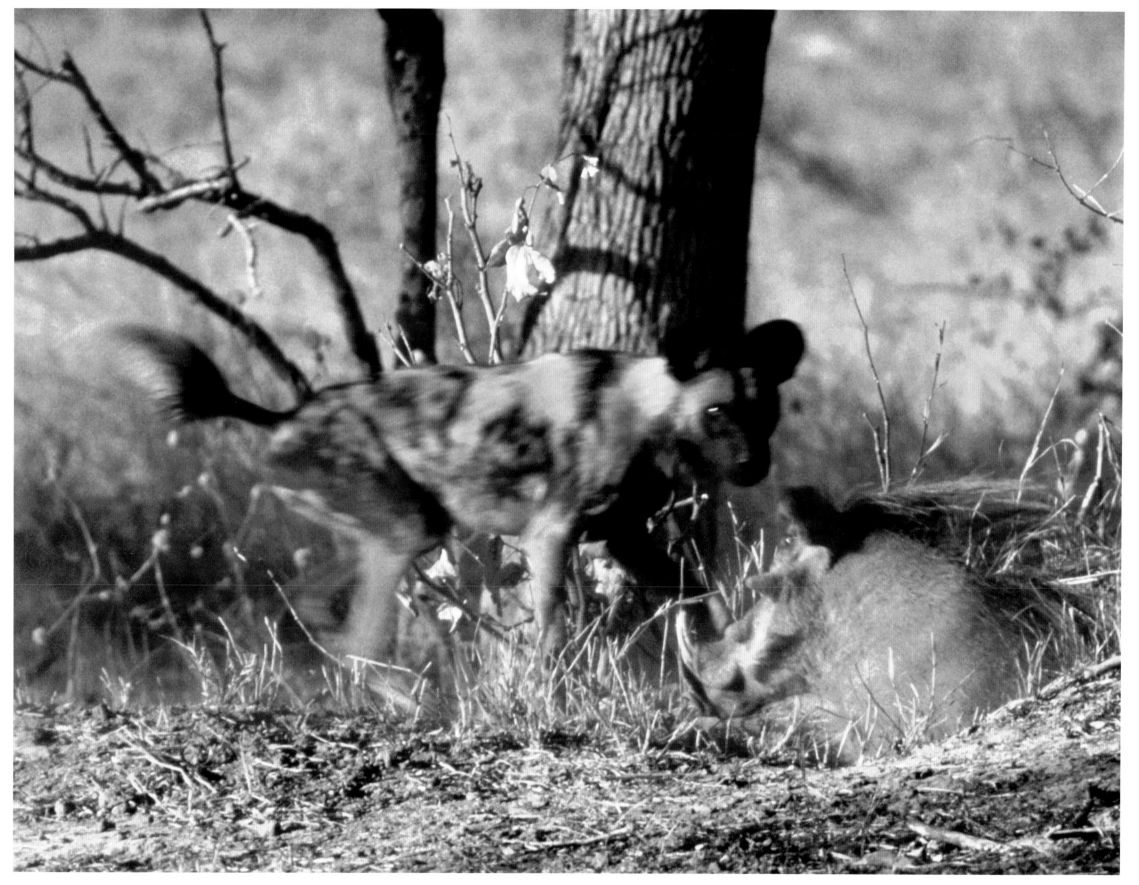

WILD DOG (*Lycaon pictus*) AND WARTHOG (*Phacochoerus africanus*), KWANDO, BOTSWANA

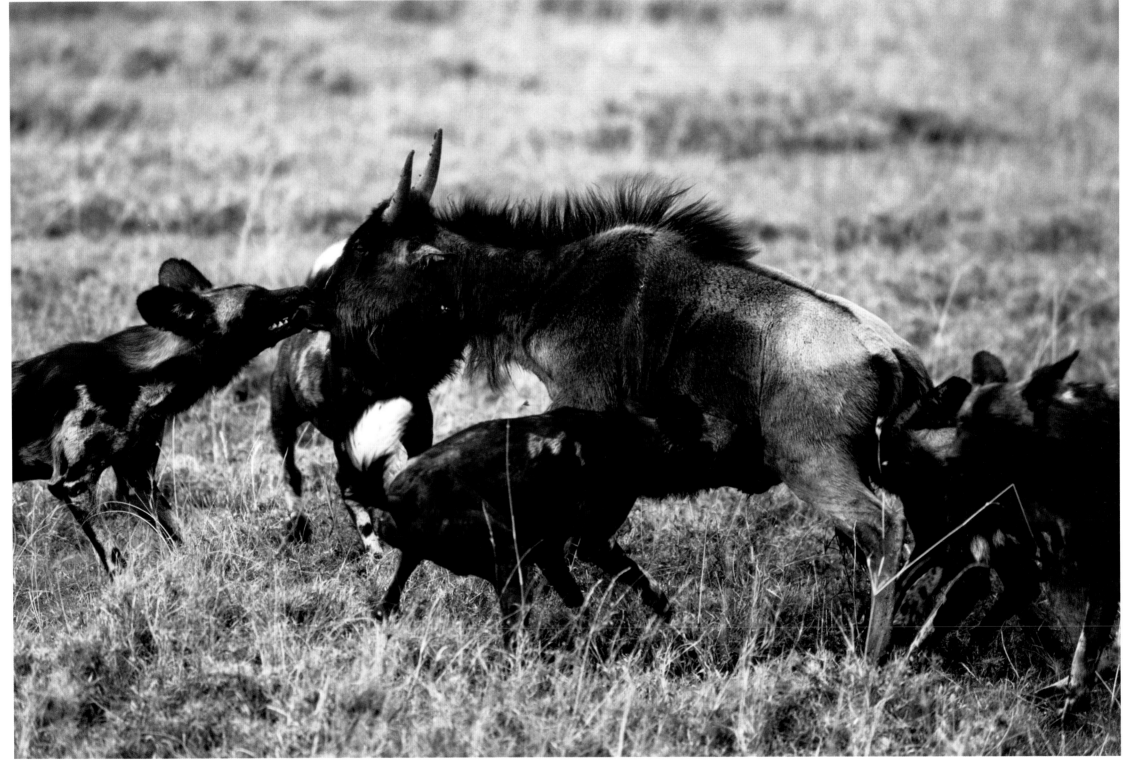

WILD DOG (*Lycaon pictus*) AND COMMON WILDEBEEST (*Connochaetes taurinus*), MARA RIVER REGION, KENYA

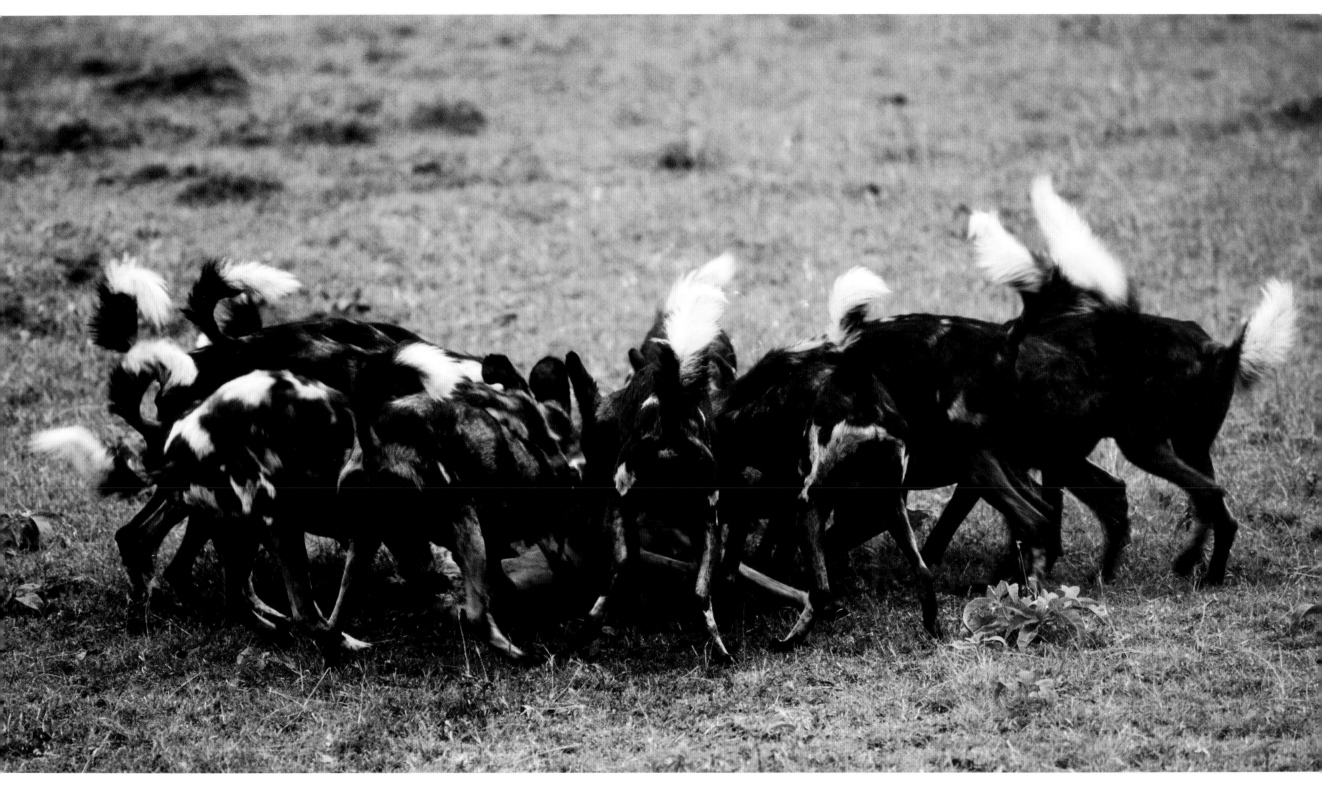

WILD DOG (*Lycaon pictus*), MARA RIVER REGION, KENYA

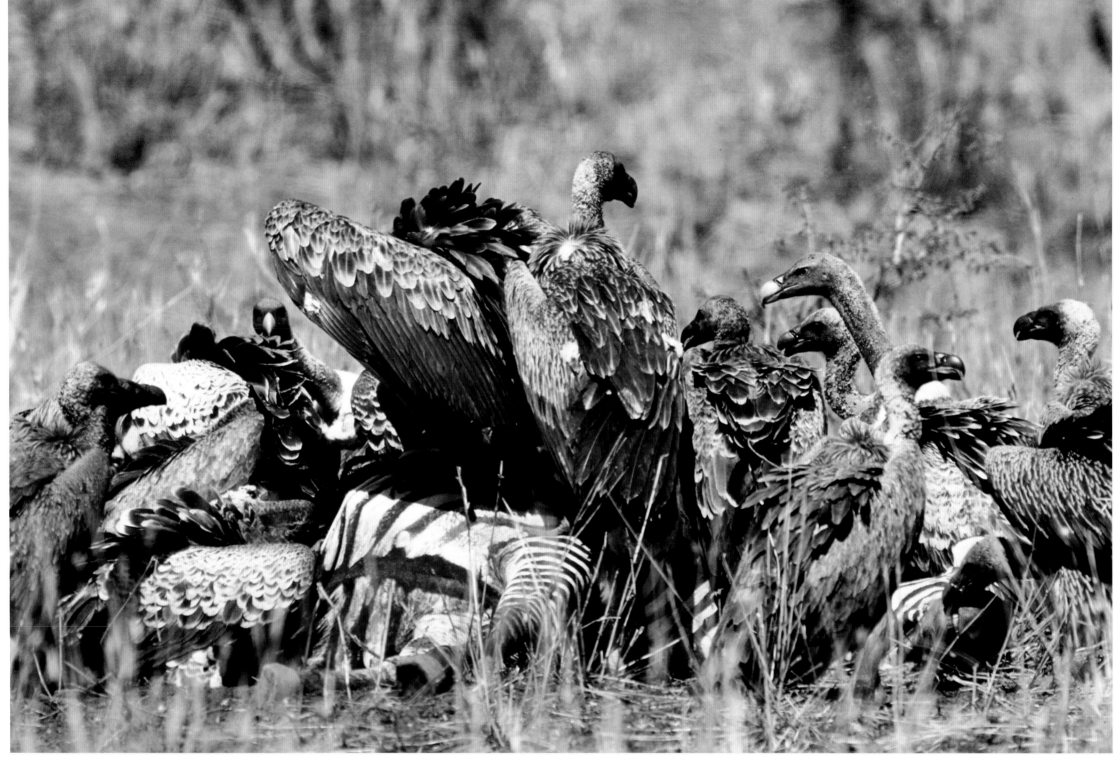

WHITE-BACKED VULTURE (*Gyps africanus*), MARA RIVER REGION, KENYA

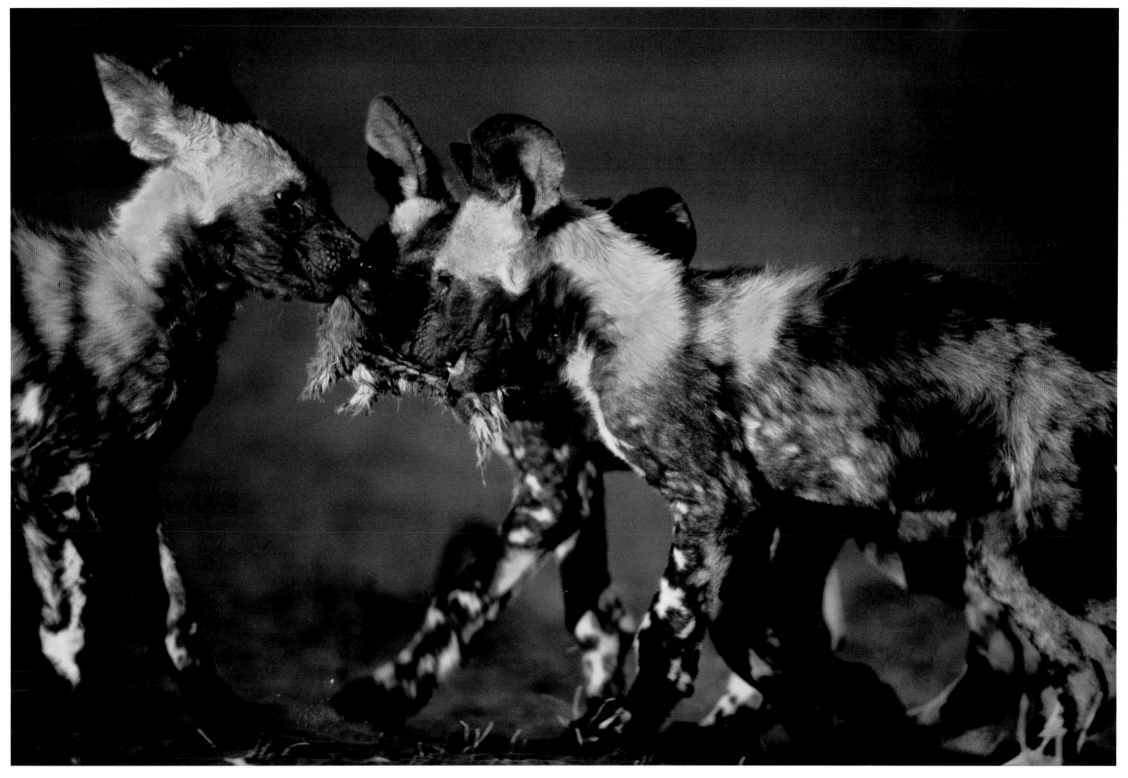

WILD DOG (*Lycaon pictus*), KWANDO, BOTSWANA

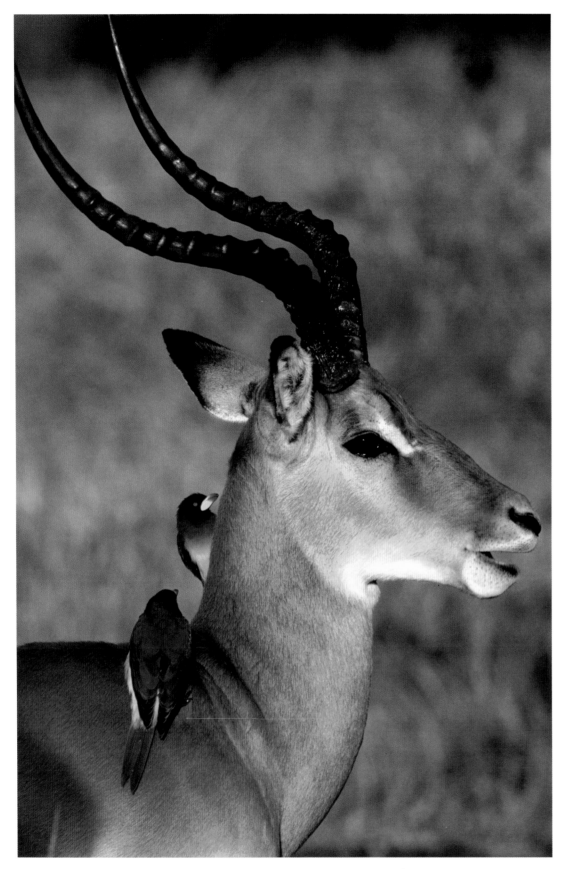

YELLOW-BILLED OXPECKER (*Buphagus a. africanus*) AND

IMPALA (*Aepyceros melampus*), MAASAI MARA NATIONAL RESERVE, KENYA

YELLOW-BILLED OXPECKER (*Buphagus a. africanus*) AND

GREATER KUDU (*Tragelaphus strepsiceros*), SABI SANDS GAME RESERVE, SOUTH AFRICA

▲▲ YELLOW-BILLED OXPECKER

(*Buphagus a. africanus*) AND

BURCHELL'S ZEBRA (*Equus burchellii*),

NGORONGORO CONSERVATION AREA, TANZANIA

▲ RED-BILLED OXPECKER

(*Buphagus erythrorhynchus*) AND

GIRAFFE (*Giraffa camelopardalis*),

SAMBURU NATIONAL RESERVE, KENYA

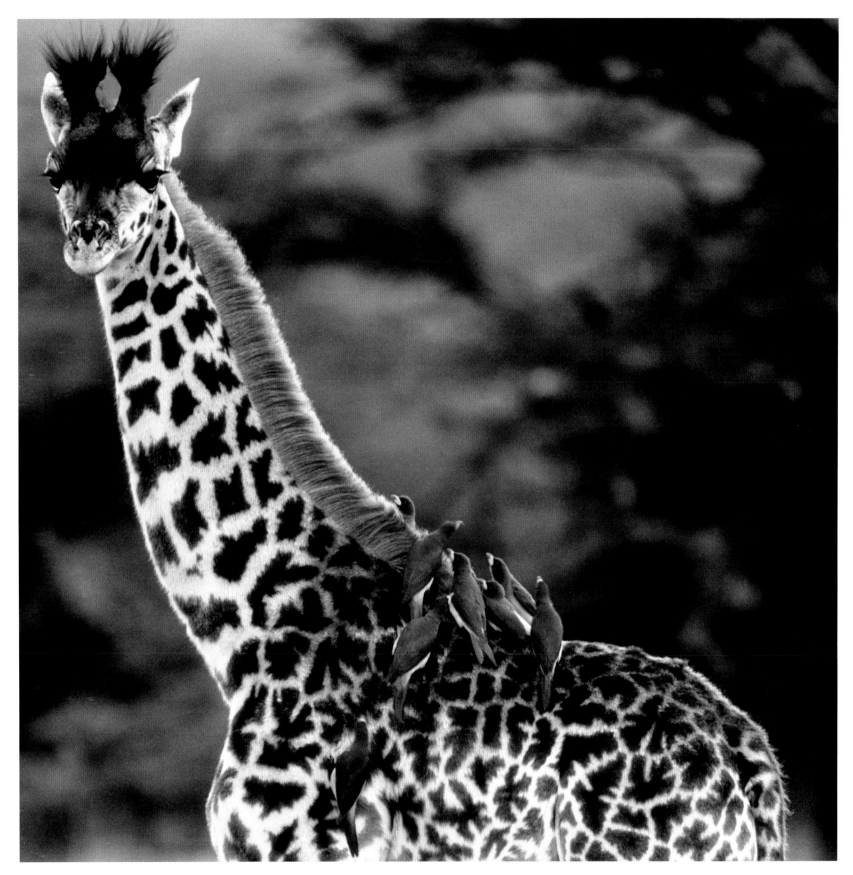

GIRAFFE (*Giraffa camelopardalis*), AND YELLOW-BILLED OXPECKER (*Buphagus a. africans*)

MAASAI MARA NATIONAL RESERVE, KENYA

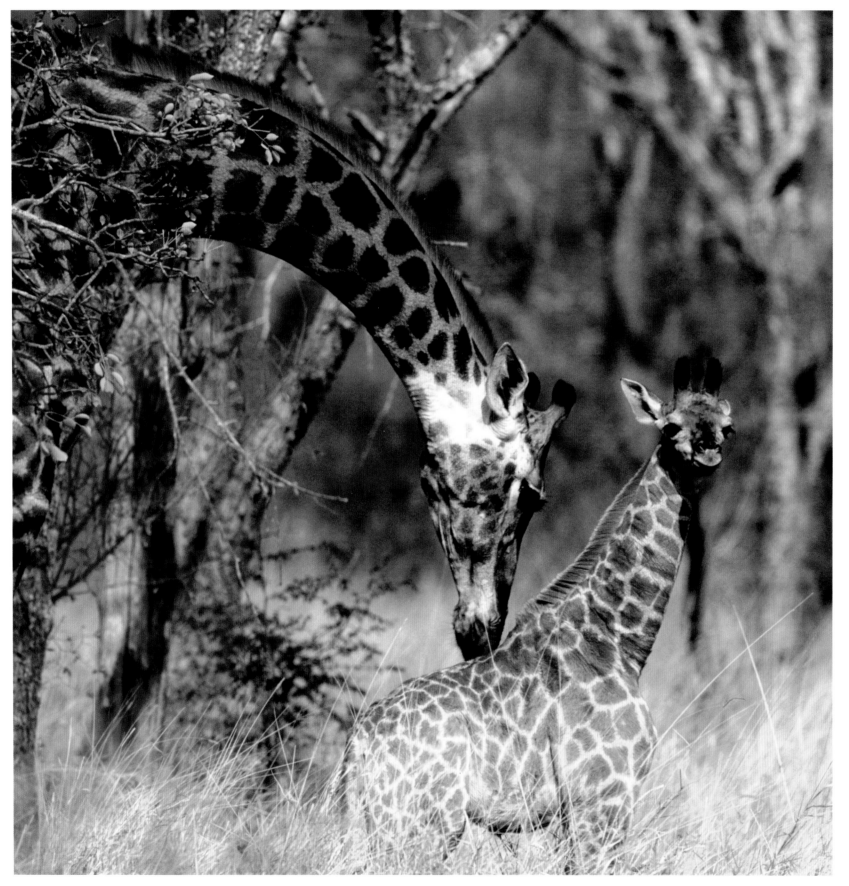

GIRAFFE (*Giraffa camelopardalis*), SABI SANDS GAME RESERVE, SOUTH AFRICA

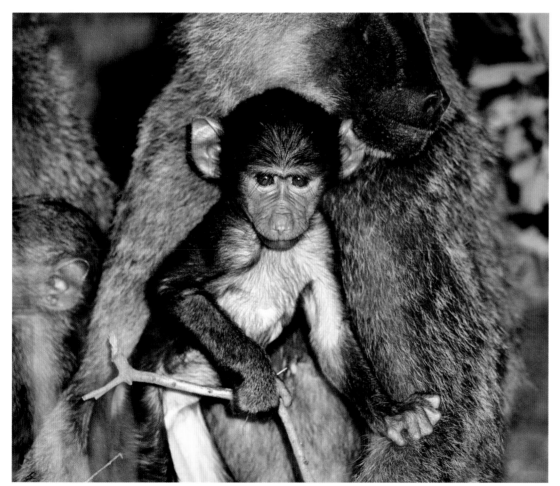

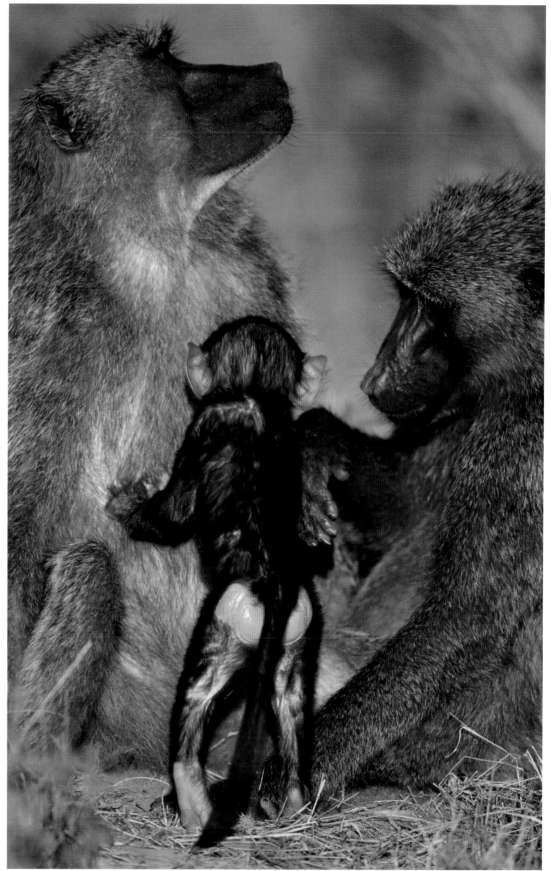

▲▲ OLIVE BABOON (*Papio anubis*), SAMBURU NATIONAL RESERVE, KENYA

◄ AND ▲ OLIVE BABOON (*Papio anubis*), MAASAI MARA NATIONAL RESERVE, KENYA

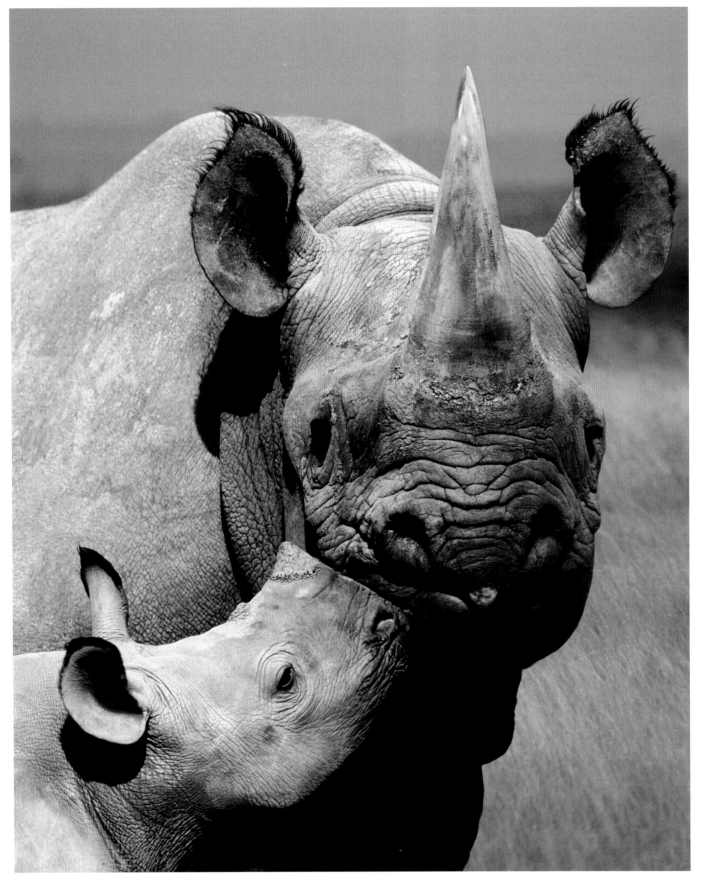

BLACK RHINOCEROS (*Diceros bicornis*), NGORONGORO CONSERVATION AREA, TANZANIA

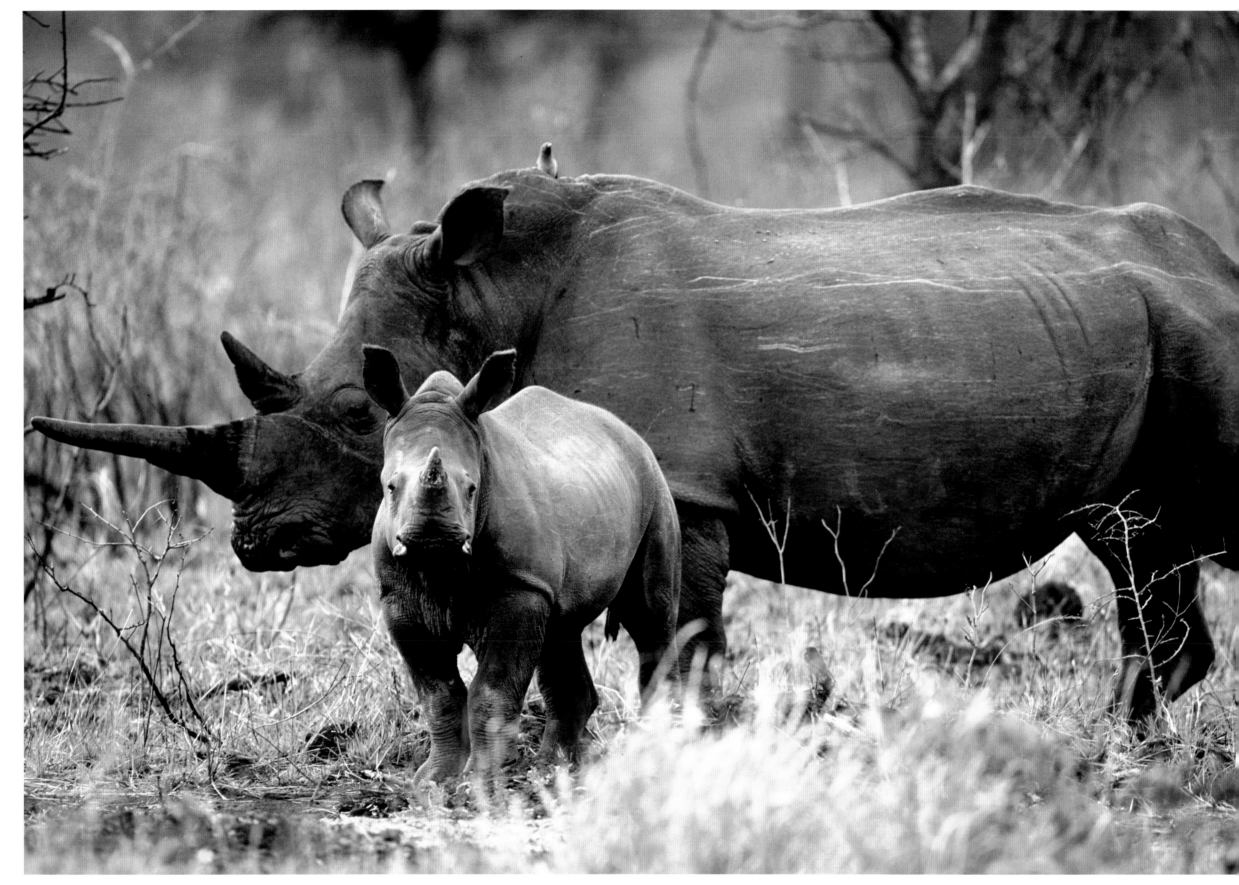

WHITE RHINOCEROS (*Ceratotherium simum*), PHINDA RESERVE, SOUTH AFRICA

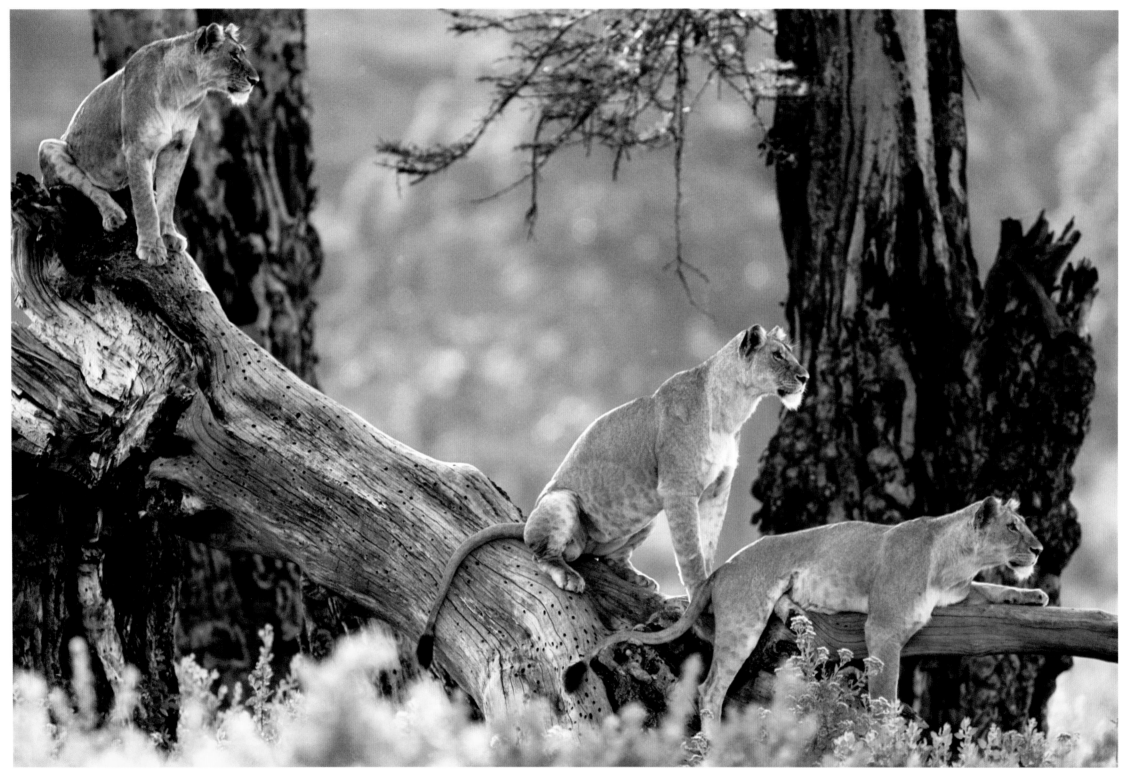

LION (Panthera leo), NGORONGORO CONSERVATION AREA, TANZANIA

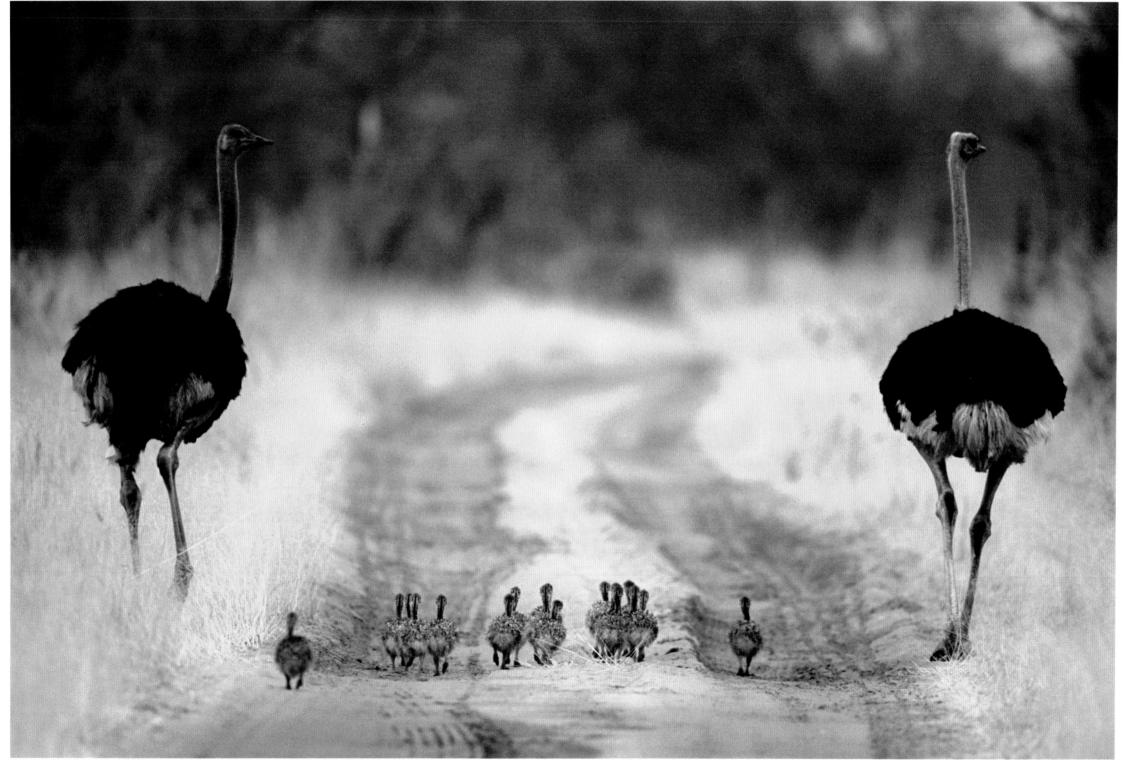

OSTRICH (*Struthio camelus*), CHOBE NATIONAL PARK, BOTSWANA

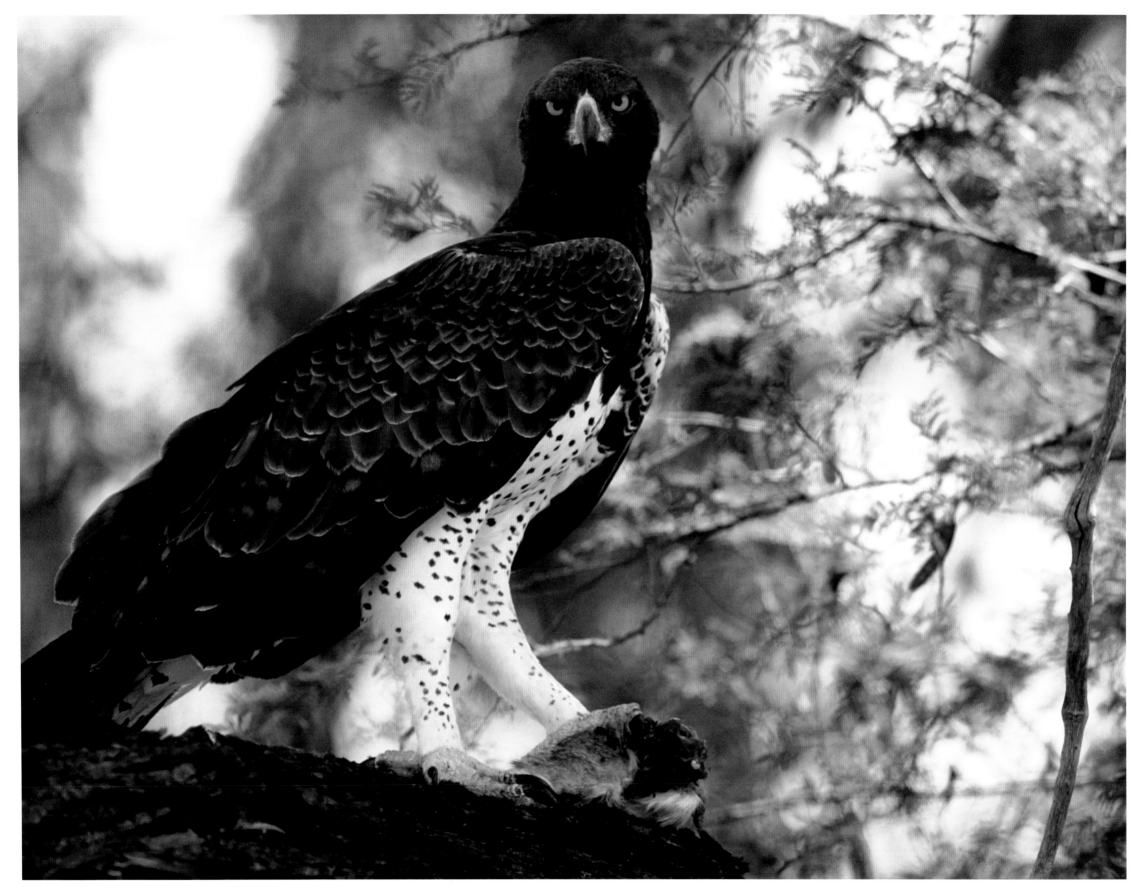

MARTIAL EAGLE (*Polemaetus bellicosus*), SAMBURU NATIONAL RESERVE, KENYA

ABYSSINIAN BLACK-AND-WHITE COLOBUS MONKEY (*Colobus guereza*), LAKE NAKURU NATIONAL PARK, KENYA

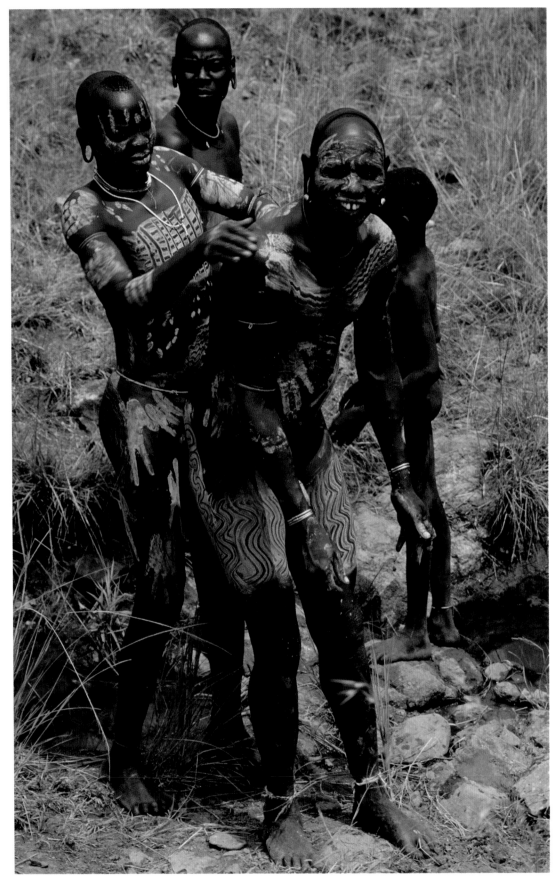

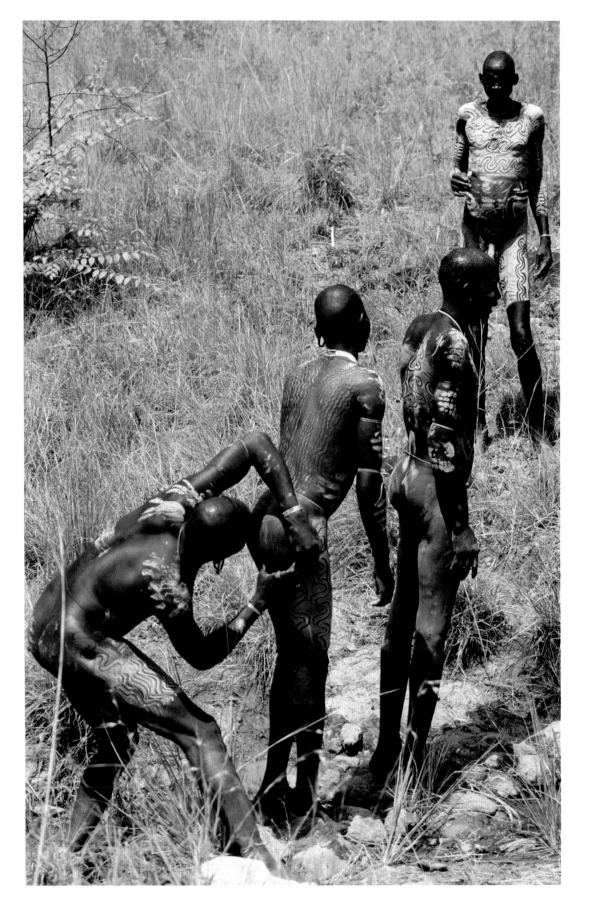

▲ AND ▶ SURMA TRIBE, LOWER OMO RIVER, ETHIOPIA

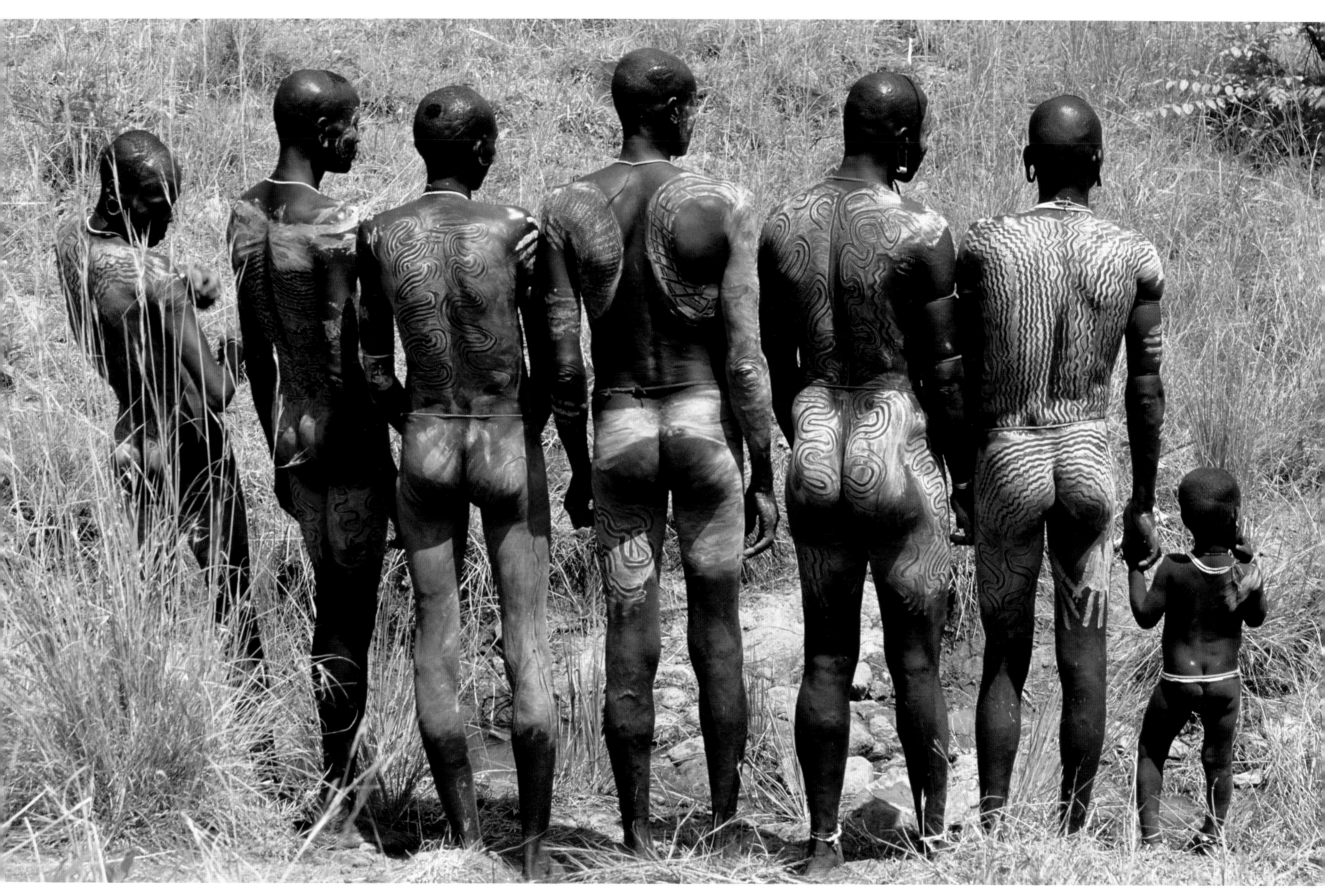

SURMA TRIBE, Lower Omo River, Ethiopia

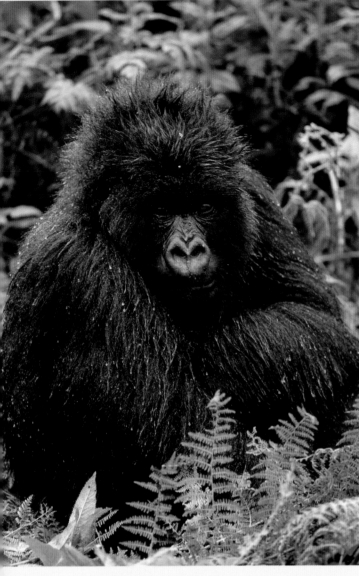

◄ CHIMPANZEE (*Pan troglodytes*),
Mahale Mountains National Park, Tanzania
▲ MOUNTAIN GORILLA (*Gorilla beringei beringei*),
Parcs National des Volcans, Rwanda

I saw before me some thirty yards off, busily employed in pulling down plantains, and other depredations, five gorillas: one old male, one young male, and three females," recalled Mary Kingsley of an 1893 journey into West Africa. "One of these had clinging to her a young fellow, with beautiful wavy black hair with just a kink in it. The big male was crouching on his haunches, with his long arms hanging down on either side . . . the backs of his hands on the ground. . . .

"They kept up a sort of a whinnying, chattering noise. . . . I noticed that their reach of arm was immense, and that when they went from one tree to another, they squattered across the open ground in a most inelegant style, dragging their long arms with the knuckles downwards. I should think the big male and female were over six feet each. . . . " As the gorillas moved off, Kingsley noted, "I have . . . never . . . seen anything to equal gorillas going through bush; it is a graceful, powerful, superbly perfect hand-trapeze performance."

Despite an apparent admiration for the gorilla (*Gorilla gorilla*), Kingsley later added: "I have no hesitation in saying that the gorilla is the most horrible wild animal I have seen. . . . (A)lthough elephants, leopards, and pythons give you a feeling of alarm, they do not give that feeling of horrible disgust that an old gorilla gives on account of its hideousness of appearance."

It would take another seventy or eighty years for "disgust" to be transformed into awe, following the groundbreaking work of biologists such as George Schaller and Dian Fossey. "I shall never forget my first encounter with gorillas," wrote Fossey in her 1983 book *Gorillas in the Mist*.

Sound preceded sight. Odor preceded sound in the form of an overwhelming musky-barnyard, humanlike scent. The air was suddenly rent by a high-pitched series of screams followed by the rhythmic rondo of sharp *pok-pok* chestbeats from a great silverback male obscured behind what seemed an impenetrable wall of vegetation. . . . Peeking through the vegetation, we could distinguish an equally curious phalanx of black, leather-countenanced, furry-headed primates peering back at us. . . . I was struck by the physical magnificence of the huge jet-black bodies against the green palette wash of the thick forest foliage. . . . I left . . . with never a doubt that I would, somehow, return to learn more about the gorillas of the misted mountains.

Fossey's patience paid off with an intimate and personal understanding of gorillas:

"Two years after our exchange of glances, Peanuts became the first gorilla ever to touch me. . . . I had just settled down on a comfortable moss-cushioned *Hagenia* tree trunk when Peanuts . . . left his feeding group to meander inquisitively toward us. . . . Since he appeared totally relaxed, I lay back in the foliage, slowly extended my hand, palm upward, then rested it on the leaves. After looking intently at my hand, Peanuts stood up and extended his hand to touch his fingers against my own for a brief instant. . . . The contact was among the most memorable of my life among the gorillas."

To the explorers of the nineteenth century, equatorial Africa was impenetrable, unfathomable, hostile, and unknown. It embodied Conrad's *Heart of Darkness*. But in just one hundred years, Africa was opened up: its rivers run, its mountains measured, and its resources exploited. Not until the latter part of the twentieth century, however, was the true bounty of Africa revealed. For here, amid greens that exist in a thousand shades and variations is a twelve-story-tall-cathedral of vegetation that owes nothing to the ingenuity or thought of humans. It is a cathedral populated by the innumerable species that form the living essence of the tropical rainforest; German explorer and naturalist Alexander von Humboldt referred to it as "forest piled upon forest."

Two and a half acres (1 hectare) in Ghana may contain 275 species of plants, half of which are trees (the same size of temperate deciduous forest typically supports 10 to 30 species of trees, and a northern coniferous forest may contain fewer than 5 species). Fourteen percent of the world's (known) flowering plants, approximately 35,000 species, are found in tropical Africa.

Surveys conducted in Korup, Cameroon, as recently as the mid-1980s revealed 17 new species of trees. In 1988 a new species of primate, a type of guenon (*Cercopithecus sp.*) was discovered in Gabon, and 10 new species of fish were identified in Cameroon's Ndian River. The 314,750-acre (125,900-hectare) Korup National Park supports 140 species of fish, more than the total number found along the entire length of the Nile or the Zambezi.

Just under 11 square feet (1 sq m) of soil under a Nigerian rainforest supports 38,000 micro-arthropods, and in the Congo basin, 870 termite colonies exist in every 2.5 acres (1 hectare) of forest. In Makaikou, Gabon, an area of 800 square miles (2,000 sq km) supports 199 species of mammals (14 of which are primates), 342 species of birds, 63 species of reptiles, and 38 species of amphibians. Global estimates of the total number of species in tropical forests range from a low of two million to a high of thirty million (some estimates go as high as eighty million); the vast majority are insects, and with only a fraction identified, most remain unknown to science.

Tropical forests are not immutable. As the climate shifted and changed over

MOUNTAIN GORILLA (*Gorilla beringei bwindi*), BWINDI IMPENETRABLE NATIONAL PARK, UGANDA

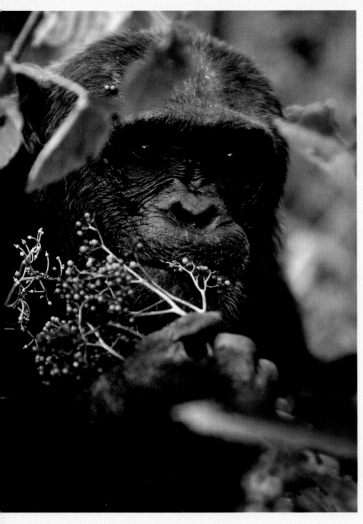

CHIMPANZEE (*Pan troglodytes*),

MAHALE MOUNTAINS NATIONAL PARK, TANZANIA

the eons, they waxed and waned in response. Sixty-three million years ago, rainforests dominated Africa, with the exception of its extreme northern and southern reaches. Fifty million years ago, rainforest covered the entire continent. A cooling and drying trend thirty-five million years ago restricted the rainforests to the equator, and by the beginning of the Plio-Pleistocene, five to ten million years ago, the rainforests were located much as they are now, confined to the Congo basin and West Africa.

During our current geological epoch, the world has cycled between glacial and interglacial periods. During the ice ages, tropical forests were almost eradicated, pushed into relatively small land areas, called glacial refugia, from which they were later able to expand when the climate warmed. During the last severe ice age, eighteen thousand years ago (and up until a general warming occurred approximately twelve thousand years ago), African rainforests were restricted to three sites that are known today for their incredible species richness and high rates of endemism: Upper Guinea, Cameroon and Gabon, and the eastern rim of the Congo basin. Although tropical rainforest ecosystems first evolved 150 million years ago, most of Africa's forests are only ten thousand to twelve thousand years old.

Today, the last remaining rainforests cover approximately 740,000 square miles (1.85 million sq km) of Africa, with a little more than 680,000 square miles (1.7 million sq km) centered on the Congo basin, and the remainder in the west. These diverse and highly productive ecosystems, generating more than 2,750 tons (2,500 metric tons) of growth per year in every 320 acres, or approximately half a square mile (128 hectares), are the most complex on Earth. Reliant on abundant rainfall—typically, more than 80 inches (2,000 mm) a year—and warm temperatures—with the mean temperature of the coldest month still above 64.4°F (18°C)—the rainforest supports the greatest amount of biomass of any ecosystem on the planet.

The heavy rainfall in the tropics has a particularly dramatic effect on the soil, leaching out most of the nutrients. The red color of many tropical soils is due to the high iron content. Only about 0.12 inch (3 mm) of the rainfall is retained in the forest canopy, with more than 80 percent making its way to the ground, soaking into the soil and contributing to more leaching. The warm temperatures also lead to rapid decomposition of vegetative litter. In some forests, nutrient cycling has been found to be more than 99 percent efficient, although the more typical range is 60 to 80 percent, aided in large part by the mycorrhizal fungi that form a symbiotic association with tree roots.

The leaching from heavy rainfall and rapid recycling of nutrients create a relatively infertile soil. Where people have attempted to clear the forest to plant crops, the enterprise has invariably failed. With natural vegetation no longer present, rainfall erodes the soil, washing away the minimal topsoil present, and with no vegetation to litter the ground, nutrients are neither added nor recycled.

The natural, untouched rainforest is a truly three-dimensional habitat, where the vertical plane can stretch 148 feet (45 m) aboveground. However, even trees of that stature have 90 percent of their roots concentrated in the top 12 inches (30 cm) of soil; few roots penetrate to the bedrock. The tallest trees are supported more by the surrounding vegetation of the forest and their broad buttresses than they are by their own roots.

The upper-canopy trees are very diverse, with two-thirds or more of the species contributing less than 1 percent to the total number of individuals. Giant emergents, such as *Cynometra*, stand high above the other trees, while the main stratum forms a continuous canopy 78 to 120 feet (24 to 36 m) above ground. Curiously, the crowns of the trees do not overlap, a characteristic known as "crown shyness." Below the canopy live the shade-dwellers. With less than 2 percent of the photosynthetically active radiation reaching the forest floor, only about 10 percent of the ground is covered with herbaceous plants and ferns.

The forests of coastal West Africa, including Guinea, Liberia, Cameroon, and Gabon, are evergreen, while those of the Congo basin are classified as semi-evergreen, with deciduous species making up as much as a third of the taller trees. Emergent trees are more common in West Africa than in the Congo basin, as are both cauliflory and ramiflory trees (in which the flowers are borne directly on the trunk, branches, or twigs); the reverse is true for epiphytes and lianas.

Epiphytes use their host tree as an anchor point, solely for a place to live, while parasites actually take nourishment from their hosts. The so-called *holoparasites* are epiphytes that are completely devoid of chlorophyll, and must steal all of the carbohydrates necessary for growth. Studies in West Africa have documented as many as sixty-five species of epiphytes on a single tree, with one particularly heavily infested 46-foot (14-m) individual carrying 416 separate epiphytic plants. In a Liberian forest, 40 to 62 percent of the trees higher than 33 feet (10 m) carried epiphytes, compared with just 15 percent of the trees in a secondary forest. Because the weight and actions of epiphytes can kill branches and even bring down a tree (one-third of the total weight of a tree may be due to epiphytes), many trees defend themselves by secreting toxic compounds or growing a smooth-barked trunk that impedes growth of such hangers-on.

Epiphytes that do become established create microcosms amid the branches. Because many are susceptible to drought, they have developed special structures to catch water. These structures encourage visits from insects and other animals. Ants often colonize epiphytes, gathering material around them and creating aerial gardens high above the ground. Just as epiphytes colonize trees, so are epiphytes colonized by epiphylls: mosses, lichens, and algae. Forest piled upon forest becomes life piled upon life.

Some of the most dramatic epiphytes are the woody climbers, or lianas.

These long, ropelike plants connect trees in the canopy, acting as useful highways for primates and others. By connecting trees, lianas also act as a secondary support for their hosts, allowing the weight of the tree to be distributed to some of its neighbors. The nutritional limitations of vegetative life located so far from the soil has led to some plants becoming insectivorous. *Triphyophyllum peltatum* is a carnivorous liana that reaches lengths of 132 feet (40 m), making it the largest carnivorous plant in the world. Fortunately this particular liana feeds only on insects that it catches with the aid of glandular leaves. It has digestive glands complete with hydrolytic enzymes, the most elaborate of all known angiosperm (flowering plant) glands. With plants such as *T. peltatum* in the wilds of Africa, early explorers had little need to exaggerate their discoveries.

While the crowns of canopy trees are exposed to the weather, they are also the main photosynthetic organs of the tree. Many have articulated leaves that can track the sun as it moves overhead. The canopy is so complete that little sunlight penetrates to the forest floor. However, because the crowns of neighboring trees avoid overlapping, sun flecks make it through, dappling the forest in speckles of light. For those plants attempting life in the shade, these sun flecks are their sole, vital connection to the world above. Farther under the canopy, the microclimate changes even more. Wind speed is low, and few species rely on wind to spread their pollen or seeds. It is cooler here, as much as 44° to 50°F (7° to 10°C) cooler than above. Sun flecks offer little continuous illumination, and carbon dioxide levels are high as the plants respire. It is cool, humid, and dark in the heart of the forest.

Traditional ecology views plant communities as a series of successional stages, moving toward a "climax community." Opportunistic pioneer species are the first to invade a barren site or gap in the forest. The pioneers grow rapidly: the kapok (*Ceiba pentrandra*) can grow 40 feet (12 m) in three years, and *Trema orientalis*, a secondary species from West Africa, can grow 56 feet (17 m) in five years (because rainforest trees grow year-round, their age cannot be determined from wood rings). As time passes, climax species begin to grow up under the pioneers. Pioneers are usually shade-intolerant, and so cannot grow beneath their own kind, but climax species can. This succession may take many decades, with an intermediate secondary forest establishing itself before the final climax community.

In reality, rainforest succession is rarely so orderly. Gaps occur throughout the forest, caused by trees felled by the wind or animals, trees dying of old age or disease, trees struck by lightning, or trees toppled by the weight of their epiphytes. Large gaps may be created by mudflows, landslides, volcanic eruptions, or floods. Where a single tree falls, the gap is small and the tree is usually replaced by a sapling (often a climax species) that has already established under the canopy. Where the gap is large, the fast-growing pioneers have the advantage.

Pioneers grow rapidly, flowering several times a year, producing large numbers of persistent seeds, and dying relatively young (true pioneer communities endure for only one to three years). As many as 6,000 to 9,500 viable seeds of pioneers have been found in the top 8 inches (20 cm) of 10.8 square feet (1 sq m) of soil, just waiting for the right moment to germinate. Climax species tend to be just the opposite: growing slowly; flowering just once a year; producing fewer, non-persistent seeds; and living a long time (often more than one hundred years).

The interrelationships between pioneers and climax species create a dynamic forest mosaic that exists in cycles rather than as a straightforward linear succession. The richest rainforest habitats, in terms of species diversity, contain a mixture of pioneer, secondary, and climax communities.

Plants compete with each other for light, water, nutrients, and space, but they also have to contend with other inhabitants of the rainforest: animals. Terrestrial plants existed for about seventy million years before herbivorous animals evolved. Most plant material is not particularly nutritious and most is fairly indigestible, locked behind cellulose cell walls. Many animals prefer fruits, seeds, and flowers to leaves, because they contain higher concentrations of sugars and complex carbohydrates and therefore provide a more nutritious diet.

Herbivores that do rely heavily on green matter have developed a close, symbiotic relationship with bacteria that can break down cellulose. Without a rich microbial stomach fauna of their own, animals such as the red colobus monkey (*Colobus badius*) would not be able to digest their food. As such symbiotic associations evolved, plants were forced to develop further defenses. In the rainforest, only about 10 percent of leaves lack significant amounts of tannins or alkaloids.

Alkaloids (nitrogenous basic compounds such as morphine, strychnine, and quinine), phenols (acidic derivatives of benzene), and terpenes (unsaturated hydrocarbons in plant oils and resins) have made many tropical plants virtual laboratories. As plants developed toxins to combat herbivores, the herbivores developed ways to circumvent the plants' defenses. Red colobus monkeys are able to detoxify alkaloids in their foregut, but where tannin levels are particularly high, they avoid the canopy trees, instead feeding selectively on pioneer species that lack the tannins, and they supplement their diet with seeds.

Although plants try to discourage browsers, they must actually encourage the attentions of animals at other times. Because the forest canopy limits the opportunities for dispersal of pollen and seeds by wind, plants need the help of animals to pollinate their flowers and disperse their seeds.

Using nectar and fruits as the reward, plants "bribe" insects, birds, and mammals to visit their blooms, trusting that the visitors will brush pollen against the stigmas and fertilize their seeds. Some plants have become highly specialized at attracting just the right visitor. Trees that rely on bats often bear their flowers on their trunks, or on the outside of the crown, because bats cannot easily penetrate dense foliage. These flowers open at night, when bats are feeding, and they are often a dull cream or white color. Flowers that attract moths are also nocturnal,

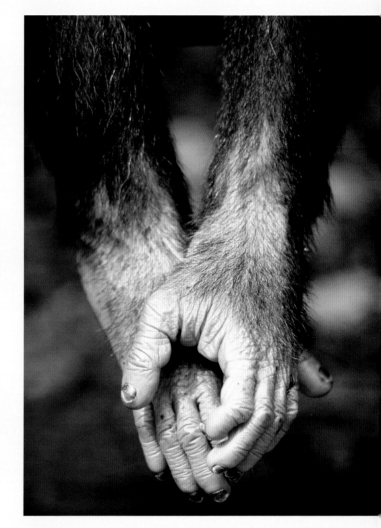

CHIMPANZEE (*Pan troglodytes*),

MAHALE MOUNTAINS NATIONAL PARK, TANZANIA

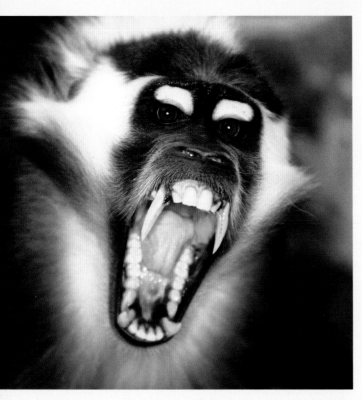

RED-CROWNED MANGABEY

(*Cercocebus torquatus*), CENTRAL WEST AFRICA

whereas flowers designed for beetles often appear as dishes or bowls among the leaves. Some flowers mimic the smell of decomposing flesh to attract flies. In the rainforest, beauty is in the eye of the pollinator.

One of the most elaborate plant-insect relationships is that between figs and wasps. Almost all of the 750 *Ficus* species are pollinated by their own species of agonine wasp. Adult female wasps, laden with pollen, search out a flowering fig, aided in part by pheromones (chemicals released into the air, often as sexual attractants) that are emitted by the tree. The females enter the gall part of the fig and lay their eggs, pollinating the stigmas as they do so. The wasp then dies. With the eggs safely inside the fig, the plant's ovules are stimulated to produce endosperm upon which the larvae feed. When the young wasps mature, the wingless males mate with the females, and the fertilized females, their pollen pockets filled from the plant's anthers, leave the fig through a hole cut by the males to begin the cycle all over again. Without the wasp to transfer pollen between flowers, the fig would not produce fertile seeds, and were it not for the fig tree, the wasp would not breed. Such a relationship of mutual aid is termed *symbiosis*.

Once a plant has fertilized seeds, it must find a way to disperse them. For many, this means wrapping them in a tasty fruit and waiting for an animal to find them. Not all animals, however, are equally attractive from the point of view of the plant. In West Africa, squirrels actively disperse seeds in less than 20 percent of the species they feed on, compared with birds, which disperse seeds for 88 percent, and monkeys, which disperse seeds for 96 percent.

Birds act as particularly good seed dispersers because they typically feed for a short period of time and then fly off. This means the seeds may be dispersed some distance from the parent tree. Such a strategy is particularly favorable for pioneer species seeking a wide dispersal to increase the chances of germination in a newly created gap in the canopy.

Recent studies indicate that many tropical trees rely on the same agent of dispersal: the forest elephant. In Taï National Park, Ivory Coast, elephants are considered the principal dispersal agent for 30 percent of the large trees (and up to 40 percent of the canopy trees), and in Gabon 44 percent of plant species are primarily dispersed by elephants.

In Western Ghana, elephants browse more than 138 species, including 35 different types of fruit. Plants such as *Balanites wilsoniana*, *Omphalocarpum mortenhani*, *Antrocaryon nannanii*, *Autranella congolensis*, *Klainedoxa gabonensis*, and *Mammea africana* rely principally, if not exclusively, on elephants for dispersal. The forest elephant is also the only animal capable of cracking the fruit of the liana *Strychnos aculeata*; without elephants, this species of liana would vanish, as would *Panda oleosa*, whose seeds will only germinate if passed through the digestive system of an elephant.

The scarcity or absence of regeneration in some tree species has been linked to the precipitous decline in elephant numbers across tropical Africa. While the savannah elephant has taken the brunt of poaching, the forest elephant population in Central Africa has also been hit hard, although accurate population numbers are hard to come by. In Congo/Zaire, only about 64,000 elephants remain, compared to 208,000 found there as recently as the 1980s. Population estimates in Cameroon, Congo, and Equatorial Guinea have also been halved, and it is feared that elephants may vanish from equatorial Africa by about 2006. With a resumption in limited ivory trading by certain nations, conspicuous consumption may once again place the elephant in imminent danger.

The plight of the African elephant has done a great deal to highlight the loss of habitat and biodiversity across the continent. Despite this increased awareness, less than 7 percent of tropical rainforests are protected worldwide. Since 1950, Central Africa has lost more than 35 percent of its rainforest. More than 80 percent of the West African rainforest has already been destroyed, and the Ivory Coast is facing the complete loss of its forests; across Africa an additional 5 percent is being lost annually. Nigeria, the most densely populated country in Africa, was once a major exporter of raw timber. Today, more than 90 percent of its rainforest has been converted to farmland or is being actively logged, and the nation must now import timber.

In the rainforest, timber is not a renewable resource. When a climax rainforest is logged, the habitat is destroyed. The time required to allow a climax forest to return is too great to sustain a forestry rotation of even seventy or eighty years. A logged climax forest becomes a secondary forest, considerably less diverse than the original. The only way to preserve the integrity of the rainforest is to preserve it intact, particularly the glacial refugia areas.

Projections of extinction rates in the tropics are sobering. Based on current rates of forest destruction, the next twenty-five years may see losses of 4 to 8 percent of species in closed canopy tropical forests. If deforestation rates accelerate, 17 to 35 percent of tropical forest species could be lost by 2040.

But what do such projections really mean? Does the loss of so much diversity mean that our own hold on survival is made more tenuous?

Around the world, some three thousand different plant species have been used at some time in history as a food source. Today, most people rely on fewer than twenty. With the advent of "industrial farming," many species have become genetically uniform and susceptible to pests and diseases. Who knows what potential food crop could dwell in the jungles of Cameroon or deep in the Congo basin, or what genes could be excised from a yet-to-be discovered species to enhance the yield of our staple crops?

Although our foods continue to be dominated by the grasses (including all of our cereal crops), our medicines owe much to the forest. More than one-quarter of all drugs prescribed in the United States are derived from the tropical

rainforest; yet less than 7 percent of known tropical plants have been screened for medicinal use, and many more await discovery. The rosy periwinkle of Madagascar has already yielded alkaloids to treat Hodgkin's disease and childhood leukemia, and the tubers of wild yams provided the precursor molecule for oral contraceptives and cortisone.

The world's rainforests may hold the best chance for cures to countless human diseases. The study of tropical ecosystems is not an academic luxury; however, global funding of it is roughly just $30 million U.S. a year, equivalent to what the world spends on armaments every ten minutes.

In a continent facing social, economic, and political turmoil, it can be hard to find a place for wildlife. The ultimate argument for conservation may be a moral one that recognizes the intrinsic value of all living things. However, humans have a tendency to be utilitarian beings, and in a utilitarian world, wildlife must pay its way.

Before Rwanda's 1994 civil war that cost half a million lives and displaced more than a million people, tourists from around the world were paying $10 million U.S. a year to see mountain gorillas (*Gorilla beringei beringei*). Three hundred gorillas were effectively Rwanda's third-largest earner of foreign income. In a nation where the average annual income is $1,300 U.S. and the human population is projected to double in twenty-five years, mountain gorillas (which inhabit just 0.5 percent of Rwanda's land) are a significant and vital part of the economy and of Rwanda's national identity.

During the recent Rwandan civil war, both sides recognized the long-term value of the gorilla to their country, and only one gorilla was killed in the course of the war. Unfortunately, continuing conflict in the region, including Congo/Zaire, has resulted in the loss of significant numbers of gorillas. In the years following the turmoil in Rwanda the plight of the *bonobo* (*Pan paniscus*), found only in Congo/Zaire, is equally perilous. In 1999, four habituated groups of gorillas in Congo/Zaire's Kahuzi-Biega National Park were wiped out, and the future for the remaining gorillas looks bleak. All of this comes at a time when the classification of gorillas has been revised to reveal new subspecies in dire straits.

There are an estimated 300 mountain gorillas surviving in the Virunga volcanoes region. The 300 or so gorillas that inhabit Uganda's Bwindi Impenetrable Forest have been designated a distinct subspecies, tentatively named *Gorilla beringei bwindi*, while Grauer's or eastern lowland gorillas (*Gorilla beringei graueri*) number fewer than 5,000 and are restricted to the far eastern reaches

of Congo/Zaire. The western lowland gorilla (*Gorilla gorilla gorilla*) is the most abundant of the gorillas, with as many as 100,000 surviving; another newly designated subspecies, the Cross River gorilla (*Gorilla gorilla diehli*), found only along the Nigeria-Cameroon border, now has the dubious distinction of being the rarest primate in the world with only 100 to 150 remaining.

Africa has more primate species than any other continent. The chimpanzee (*Pan troglodytes*) is our closest living relative in the animal kingdom. In West Africa, chimpanzees use stones and anvils to break open nuts, carefully selecting just the right tools for the job, sometimes carrying them long distances for later use. In East Africa and the Congo basin, other chimpanzee populations use fishing probes and brush-sticks to get at termites. There is even evidence that chimpanzees use plants as medicines. In the forests of Africa, our ape kin are showing us how culture may have developed among the hominids. All this could be lost with the demise of the rainforest.

We cannot pick and choose to which species we will afford protection. The loss of a single species may be deemed tragic but inevitable, and even forgivable when placed against the scale of human suffering. But consider a species of agonine wasp. It becomes extinct following the logging of its West African home. What about the fig tree that relied on the wasp for pollination? Now it follows the wasp into oblivion. What of the population of colobus monkeys that fed on the figs during times of food scarcity? Do we lose a subspecies of primate as well? What of the numerous trees that relied on the colobus to disperse their fruits? Or the eagle that fed on the monkeys? And if the forest elephant is lost to satisfy our hunger for ivory, do we risk losing 30 to 40 percent of the canopy trees?

The complex web of interconnections between plant, invertebrate, reptile, bird, and mammal may never be fully understood. We have no idea how the loss of a single insect species will affect the forest as a whole. With many rainforest trees surviving for centuries, the loss of pollinators or dispersers may not be revealed until it is too late. If we do not control our activities, we may be left with a rainforest filled with the living dead, unable to reproduce or adapt. Earth's magnificent cathedral may be left vacant.

Felix Houphouët-Boigny, former president of the Ivory Coast, put the dilemma most eloquently: "Man has gone to the moon but he does not yet know how to make a flame tree or a bird song. Let us keep our dear countries free from irreversible mistakes which could lead us in the future to long for those same birds and trees."

JEWEL CHAMELEON (*Furcifer lateralis*),
MADAGASCAR

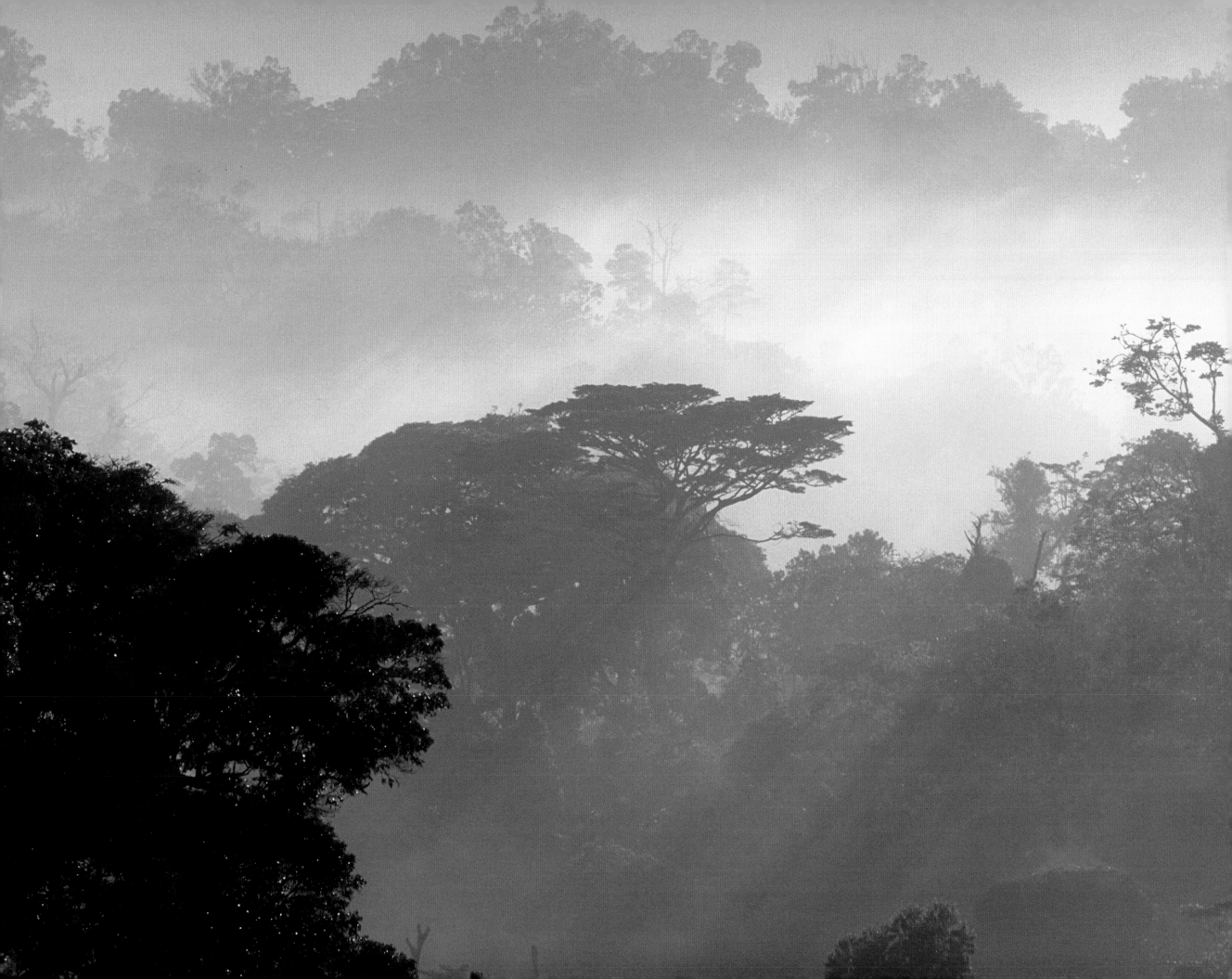

◄ AND ▲ RAINFOREST, BWINDI IMPENETRABLE NATIONAL PARK, UGANDA

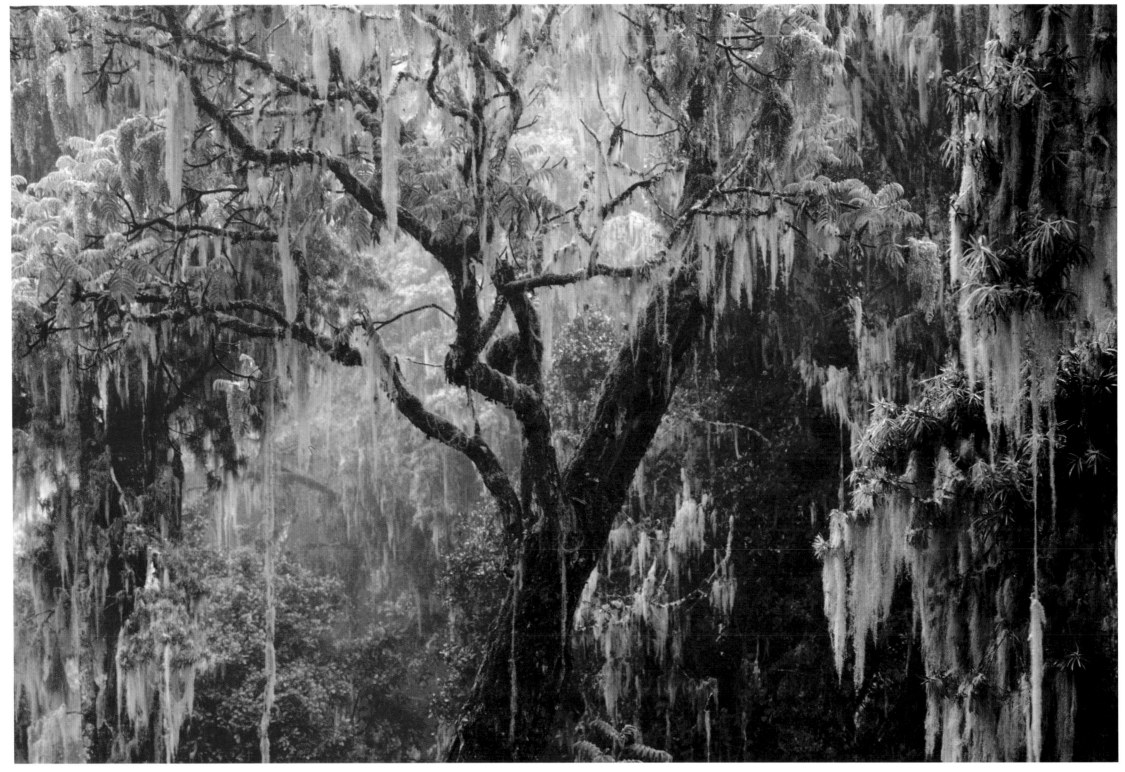

RAINFOREST, Mount Kilimanjaro, Tanzania

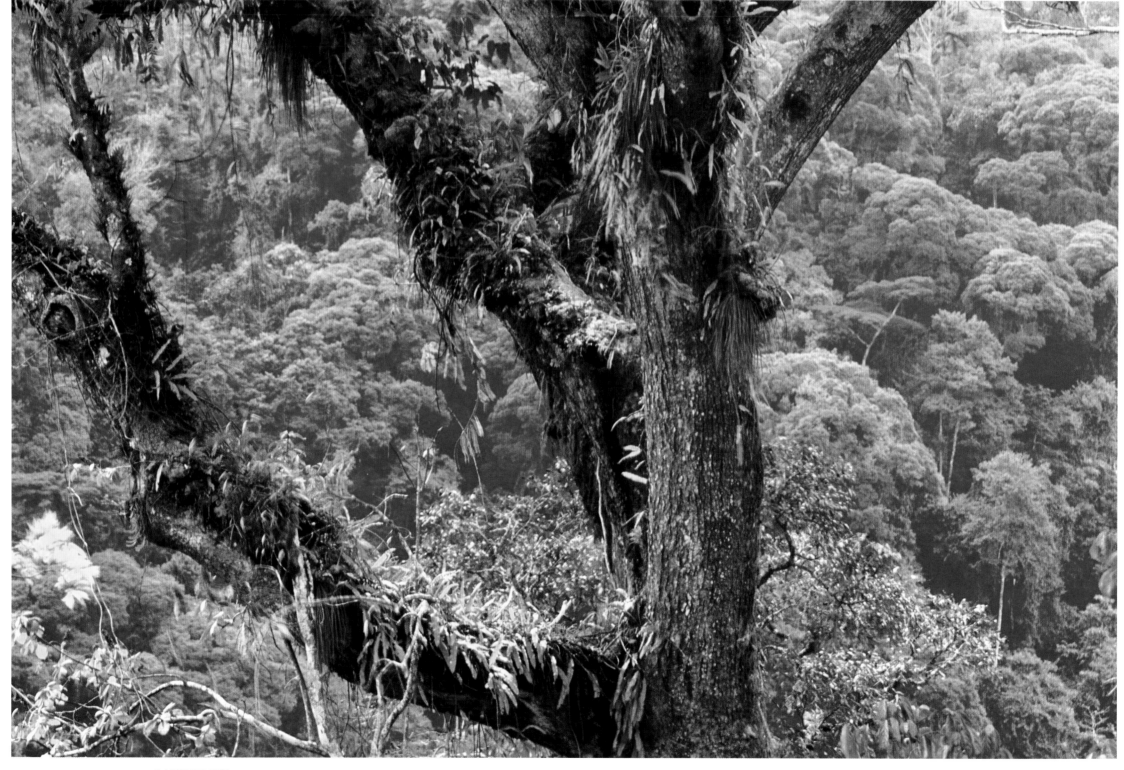

RAINFOREST, Bwindi Impenetrable National Park, Uganda

BLOSSOM AND LICHEN ON FALLEN LEAVES, KIBALE FOREST NATIONAL PARK, UGANDA

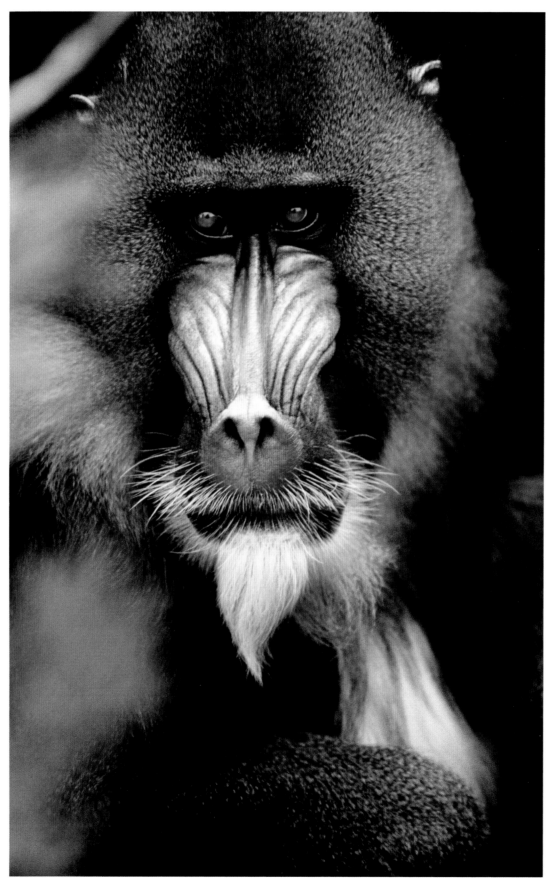

MANDRILL (*Mandrillus sphinx*), CAMEROON

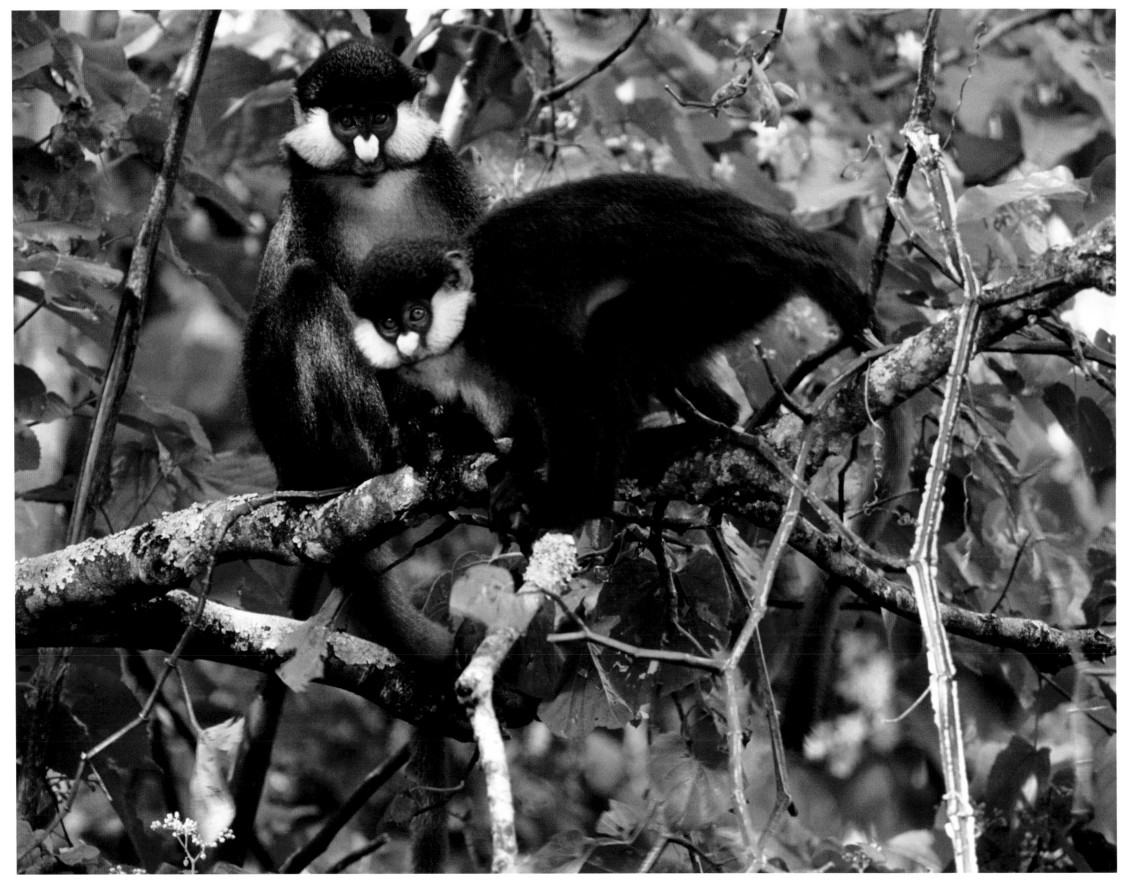

RED-TAILED GUENON (*Cercopithecus ascanius*), KIBALE FOREST NATIONAL PARK, UGANDA

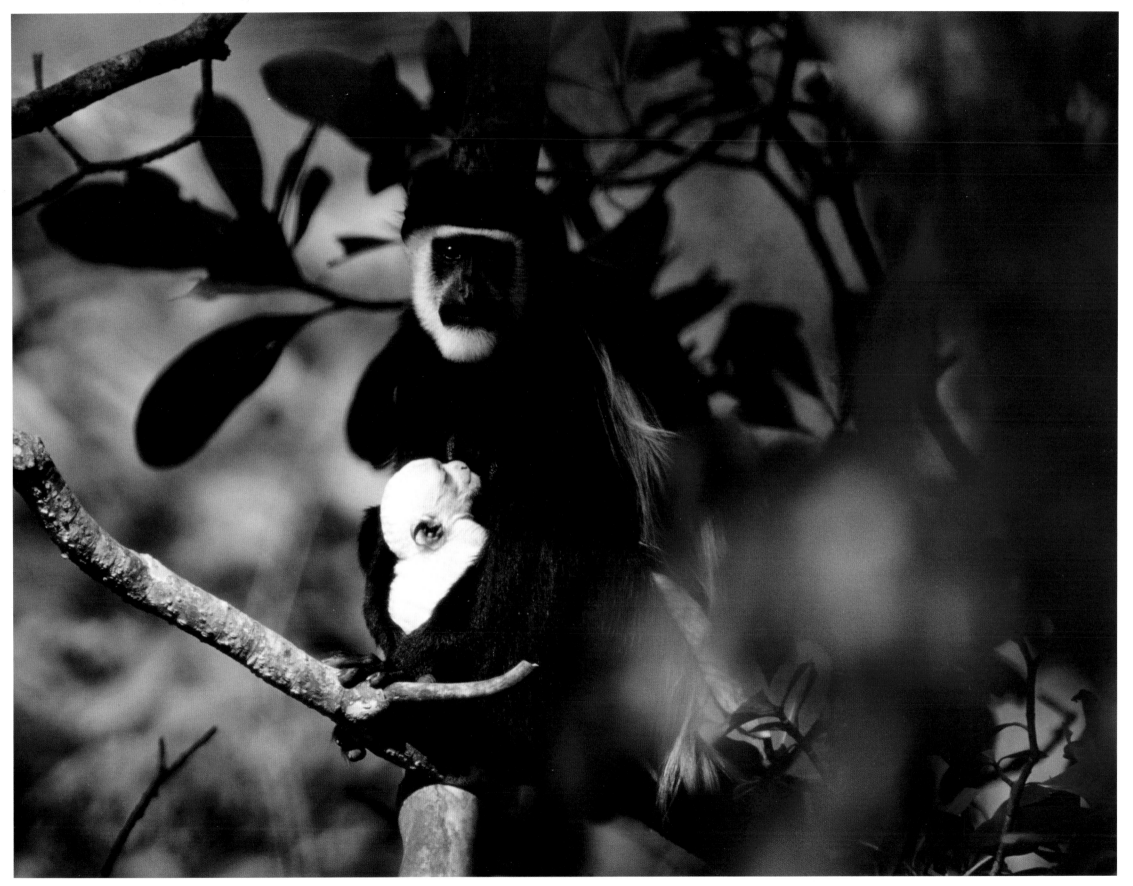

ABYSSINIAN BLACK-AND-WHITE COLOBUS MONKEY (*Colobus guereza*), KIBALE FOREST NATIONAL PARK, UGANDA

CHIMPANZEE (*Pan troglodytes*), MAHALE MOUNTAINS NATIONAL PARK, TANZANIA

CHIMPANZEE (*Pan troglodytes*), Mahale Mountains National Park, Tanzania

◄◄, ◄ AND ▲ CHIMPANZEE (*Pan troglodytes*), MAHALE MOUNTAINS NATIONAL PARK, TANZANIA

▲ AND ▶ MOUNTAIN GORILLA (*Gorilla beringei beringei*), PARCS NATIONAL DES VOLCANS, RWANDA

MOUNTAIN GORILLA (*Gorilla beringei bwindi*), BWINDI IMPENETRABLE NATIONAL PARK, UGANDA

MOUNTAIN GORILLA (*Gorilla beringei beringei*), Parcs National des Volcans, Rwanda

MOUNTAIN GORILLA (*Gorilla beringei beringei*), Parcs National des Volcans, Rwanda

FLAT-TAILED LEAF GECKO (*Uroplatus sikorae*), MADAGASCAR

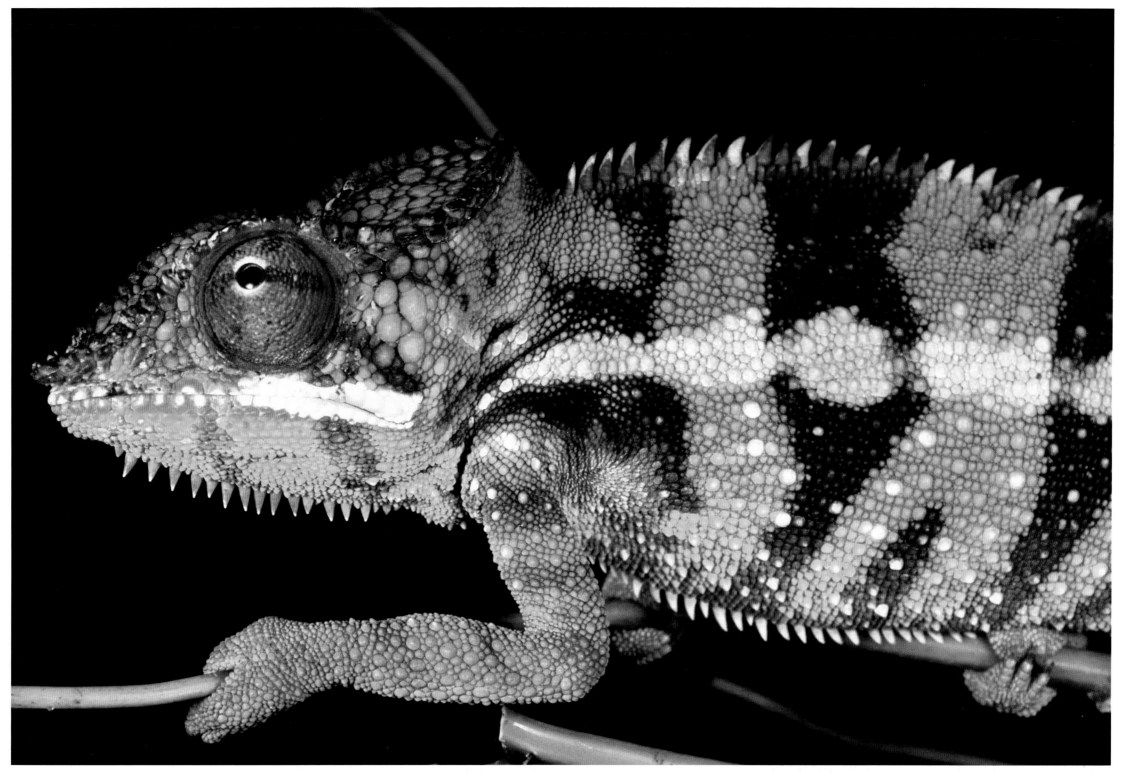

JUNGLE PANTHER CHAMELEON (*Furcifer pardalis*), NOSY BE, MADAGASCAR

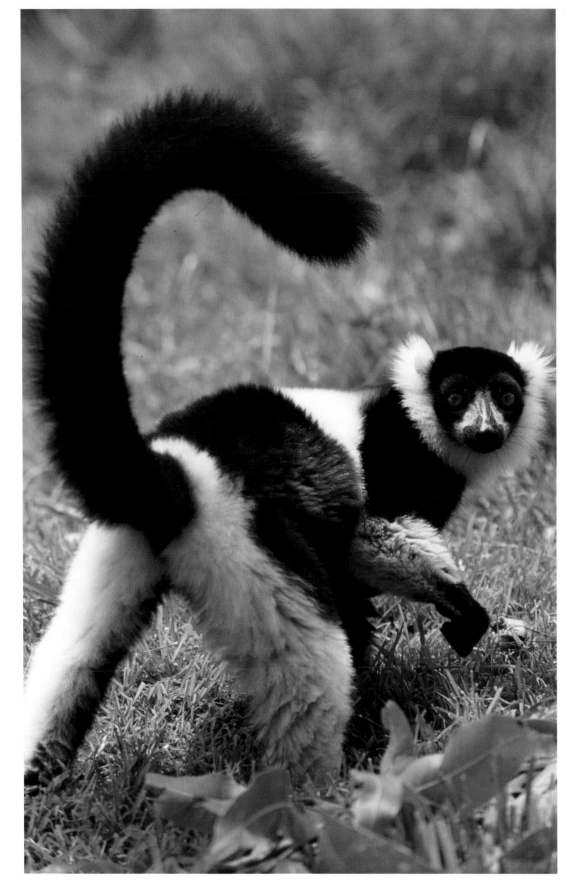

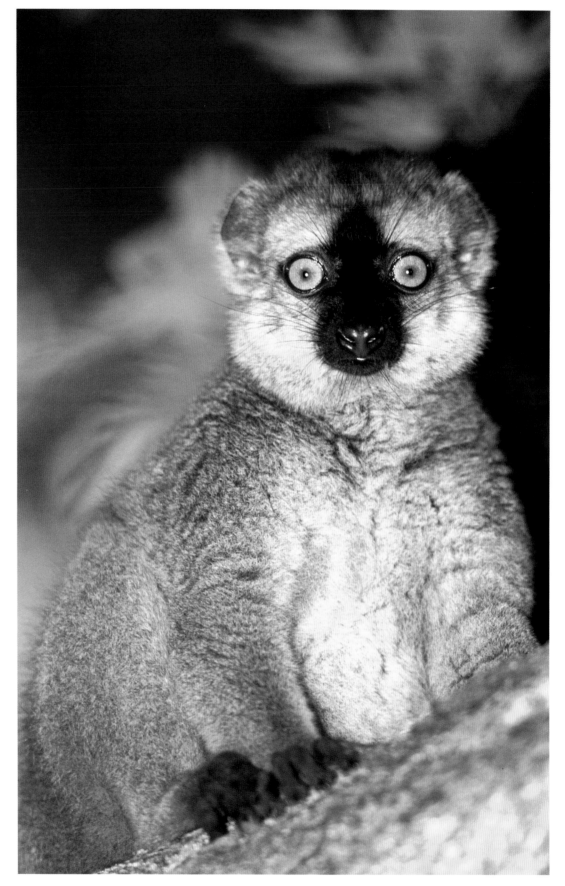

BLACK-AND-WHITE RUFFED LEMUR (*Varecia variegata variegata*), MADAGASCAR

RED-FRONTED BROWN LEMUR, (*Eulemur fulvus rufus*), MADAGASCAR

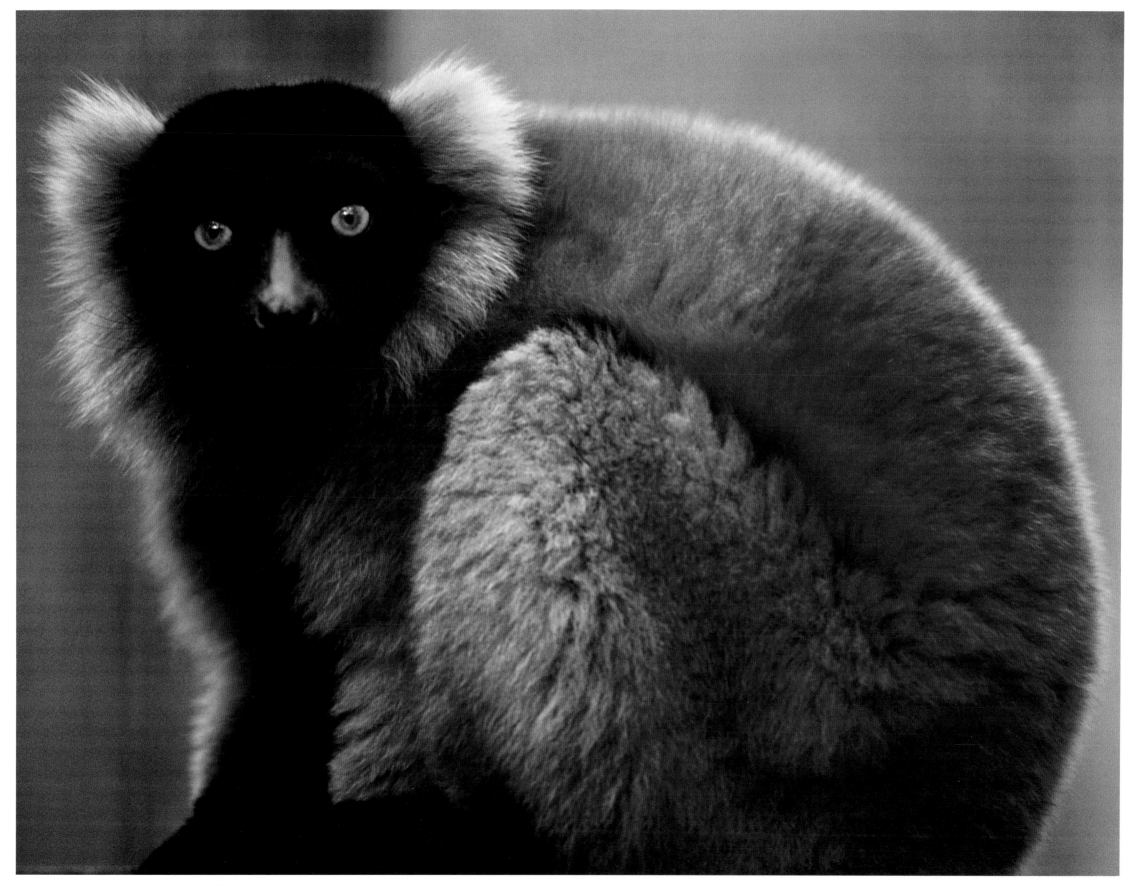

RED-RUFFED LEMUR (*Varecia variegata rubra*), MASOALA PENINSULA, MADAGASCAR

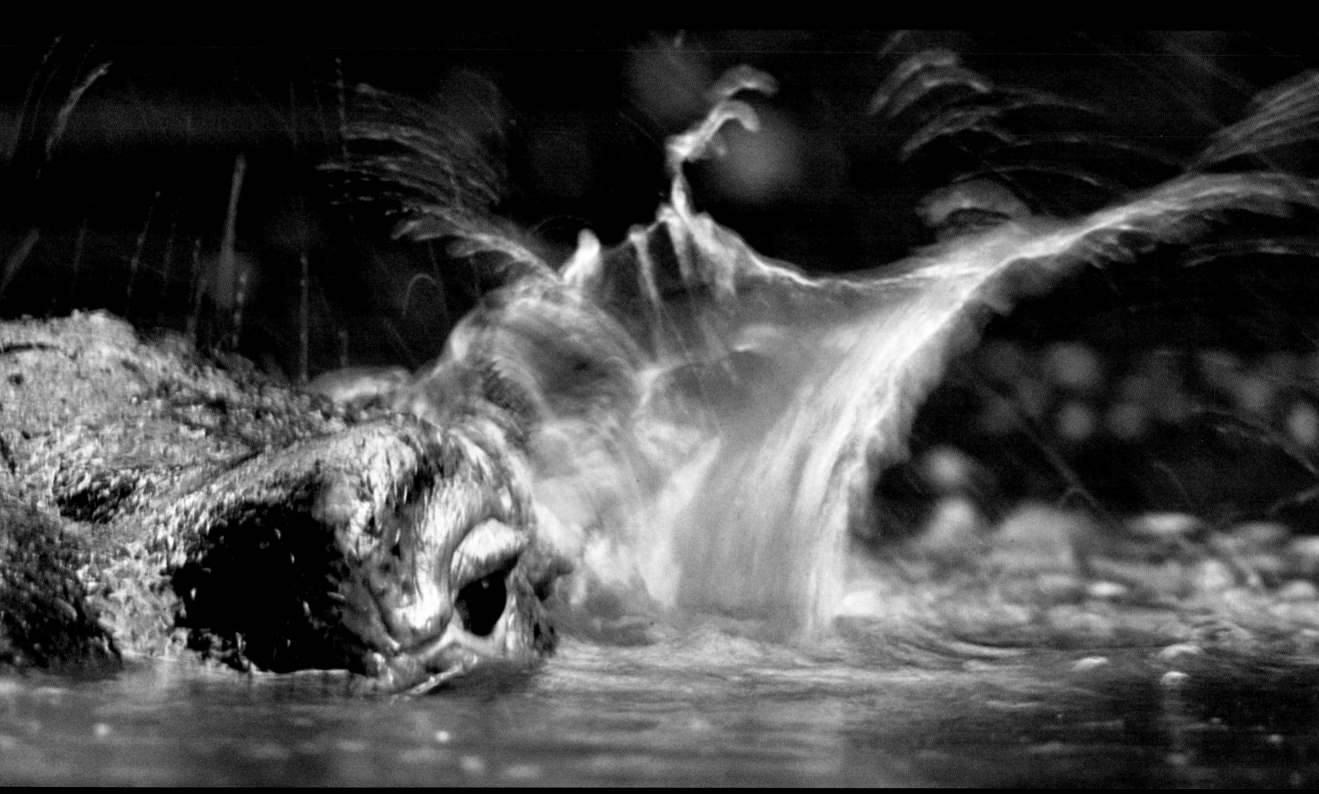

L A N D

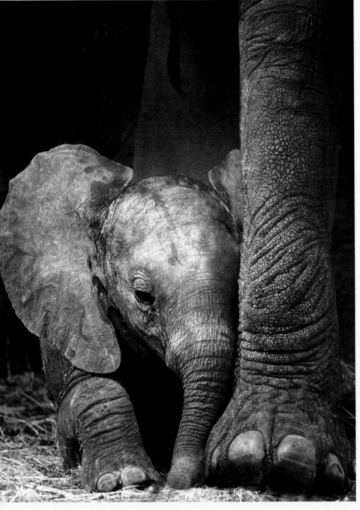

◄ HIPPOPOTAMUS (*Hippopotamus amphibius*),
Grumeti River, Tanzania

▲ AFRICAN ELEPHANT (*Loxodonta africana*),
Tarangire National Park, Tanzania

Dark, humus-rich waters meander across the floodplain. Papyrus and reeds edge the river, and acacias, fig trees, and grasslands thrive beyond the banks. A waterbuck (*Kobus ellipsiprymnus*) lowers its head to drink at the river's edge, then jumps back warily as it sights a Nile crocodile (*Crocodiylus niloticus*) idling in the current nearby. With a powerful sideswipe of its tail, the reptile swims off and hauls out on the opposite bank; it has been hunting for much of the night and is ready to rest. The day is warming and the 20-foot- (6-m-) long animal, perhaps many decades old, leaves its tail submerged in water that is a tributary to the great Zambezi. The crocodile opens its mouth in an aggressive-looking gape, but it is simply cooling itself. The waterbuck calms and takes a long drink.

The river has recently flooded. Black waters, rich in silt, poured over the banks, depositing sediment across the floodplain and adding new water to the stagnant swamp. A group of African elephants stand in the cooling water, their gray skins stained a shiny black. One of the family raises a trunk full of muddy water and sprays it over her back, flapping her ears with enjoyment. The youngsters blow bubbles under water and stamp their feet in the mud.

Lechwes (*Kobus leche*) jump through the marshes, sending up splashes of water as their splayed hooves strike the waterlogged sedges. A female stands deep in the water, pulling at aquatic grasses. Back toward the river, kobs (*Kobus kob*) graze and reedbucks hide among the taller vegetation.

The river flows languidly, its steady stream gently eroding the riverbank. Clearly defined paths mark a route from the river to the adjacent grassland; they are deeply eroded and well used. Dark boulders punctuate the surface of the water, and currents swirl around them. An African jacana (*Actophilornus africanus*) jumps from boulder to boulder, picking at invertebrates with its pale blue bill. Then one of the boulders shifts and splits open to reveal ivory-white canines and a cavernous maw.

At up to 7,000 pounds (3,200 kg), the barrel-shaped hippopotamus (*Hippopotamus amphibius*) is not the most graceful of animals except when viewed underwater, where its bulk is weightless. To view hippos dancing across the river bottom is like watching the scene with the hippo ballerinas in *Fantasia*.

During the day, hippos lounge in the water, the males defending small territories with open-mouthed defiance that can escalate into fatal conflicts (even other species, including crocodiles and people, sometimes fall prey to their attacks). At night, they leave the water to walk their well-worn trails several hundred yards inland to graze more than 88 pounds (40 kg) of grass a session. If grazing is poor, hippos will eat the feces of elephants, digesting what the elephants did not; and under conditions of extreme nutritional stress they will drive carnivores from their kills or kill prey of their own. Under conditions

of plenty, however, the hippos move grass from the savannah to the wetlands, fertilizing the water with their own ample deposits of dung.

An African fish eagle (*Haliaeetus vocifer*) sweeps down from its perch, snagging a tilapia with its talons, and returns to its tree to pick scales from its catch. A yellow-billed oxpecker (*Buphagus a. africanus*) alights on the head of one of the hippos, and the animal obligingly opens its mouth and allows the bird inside to clean food from between its teeth. Beneath the water, a fish that has so far eluded the eagle's grasp picks its own meal from the hippo's skin.

The sky darkens in the distance and storm clouds build over the mountains. Several weeks after the torrential rains in the highlands, the water will reach the lower river to flood over the plains once again. The river steadily erodes the land, moving pieces of the mountains to the river basin, and then travels onward, aiming for the ocean and a reunion with the salty source of the original rain cloud.

Wetland habitats include fast-running white-water rivers and slow-moving dark ones filled with silt and humus. They include deep lakes that form along rifts in the fabric of the Earth's crust and shallow lakes that sit in soft depressions, gradually filling with sediments deposited by their rivers. Ancient lakes have left behind salt pans that glisten in the heat, tempting animals to a barren death, while soda lakes swirl with red algae, caustic alkali, and invertebrates by the billion. Following the rains, rivers break their banks to inundate forests and reedbeds, creating vast swamps. Marshes border deltas and sand dunes. Salt-tolerant mangrove trees capture debris between their elevated roots and build up the land around them, creating islands where none had been before. Subterranean springs flowing through porous volcanic rock feed swamps and lakes from below, directing water from mountain peaks far in the distance.

In the wetlands, water is not transitory or ephemeral; it is the defining physical feature of the land. Terrestrial wetlands cover a little more than 160,000 square miles (400,000 sq km) of the African continent, or just over 1 percent of the landmass. Rivers incise their valleys into the land and meander across the plains. Lakes punctuate the landscape. Some are truly vast, inland seas in their own right: Lake Victoria has an area of 26,828 square miles (69,484 sq km), Lake Tanganyika covers 12,700 square miles (33,020 sq km), and Lake Nyasa covers 11,430 square miles (29,718 sq km). The fourth-largest lake in Africa, Lake Chad, averages 6,875 square miles (17,800 sq km), although at its maximum extent, several thousand years ago, it covered twenty-two times that area, an incredible 160,000 square miles (400,000 sq km). In comparison, the state of Maryland covers 10,460 square miles (27,091 sq km), and Switzerland covers 15,940 square miles (41,284 sq km).

The longest river in the world, the Nile, arises south of the equator in the

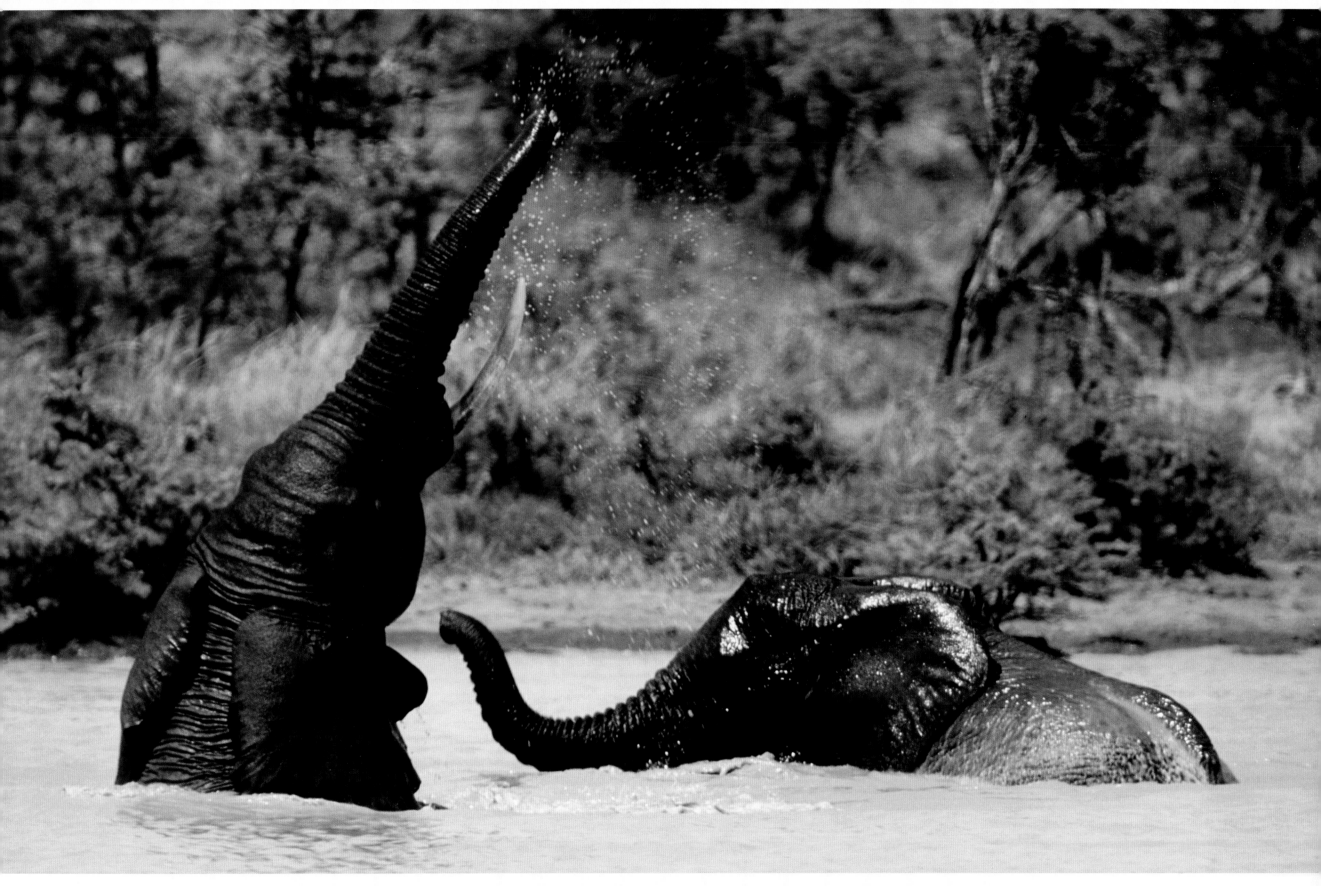

AFRICAN ELEPHANT (*Loxodonta africana*), Mpala Research Centre, Nanyuki, Kenya

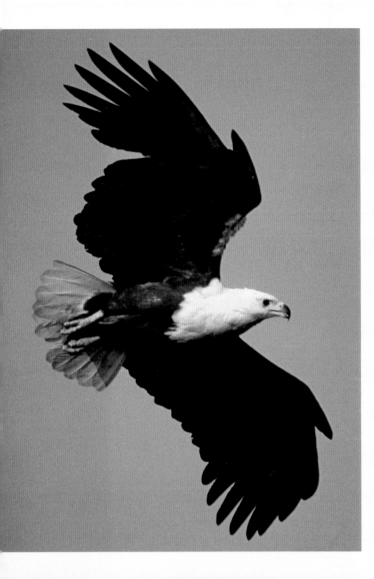

▲▲ AFRICAN FISH-EAGLE (*Haliaeetus vocifer*),
AMBOSELI NATIONAL PARK, KENYA

▲ HIPPOPOTAMUS (*Hippopotamus amphibious*) AND
RED-BILLED OXPECKER (*Buphagus erythrorhynchus*),
LAKE MANYARA, TANZANIA

fabled Mountains of the Moon, and stretches for 4,132 miles (6,650 km) to reach the Mediterranean, draining 1.29 million square miles (3.35 million sq km) of northeast Africa. The other great rivers are similarly vast in extent: the Congo at 2,900 miles (4,700 km) drains a basin of 1.33 million square miles (3.7 million sq km), the 2,600-mile (4,200-km) Niger drains 730,000 square miles (1.89 million sq km) with a delta that extends more than 14,000 square miles (36,000 sq km), and the Zambezi runs for 2,200 miles (3,540 km) and has a 500,000-square-mile (1.3 million-sq-km) drainage basin. Of these great rivers, the Nile, Congo, and Zambezi all have their birth in highlands associated with the Great Rift Valley.

True wetlands are among the most threatened of ecosystems because of their highly seasonal nature, their variable size, and the fact that the waters that feed them are increasingly polluted or diverted to meet irrigation needs and demands for power and drinking water. Many rivers, most notably the Nile and the Zambezi, have had their flow dramatically altered by huge dams that provide hydroelectric power for growing populations. But such dams also deny the river the annual cycle of flood and retreat that has sustained so many ecosystems and, in the case of the Nile, that once fed the ancient civilizations of North Africa.

When Europeans reached the mouths of these rivers, they were captivated. Many gave their lives to find the mythical sources or great landlocked seas that they imagined filled the interior. Livingstone, who first traveled the Zambezi in 1853, called it "God's Highway." (The word *Zambezi* actually translates to "great river" in the language of the Tonga.) He believed that it would serve as a fluid road into the "dark heart of the continent," taking trade and missionaries wherever it flowed. As the river became better known, such beliefs gave way to a reality punctuated by shifting sandbars, rapids, and spectacular waterfalls.

Livingstone recorded the sight of one such waterfall in 1856: "I resolved on the following day to visit the falls . . . called by the natives Mosioatunya. . . . (O)ne of the questions asked . . . was, 'Have you smoke that sounds in your country?' They did not go near enough to examine them, but . . . said, in reference to the vapour and noise, 'Mosi oa tunya' (smoke does sound there). . . ." Livingstone renamed the great Zambezi cataract after his monarch, and Mosioatunya became Victoria Falls.

Taken individually, the amount of water flowing through these rivers is impressive. The Congo discharges more than 1,450,000 cubic feet of water per second (41,000 cu m), a rate that can double during the floods. Only the Amazon has a greater rate of discharge. Even so, the total volume of river flow for the continent is fairly small. During the dry season, flow may be reduced more than 50 percent, and some rivers completely cease to flow. Although most rivers ultimately reach the sea, several, including the Okavango, die in the desert; the Okavango forms a vast 10,000-square-mile (25,000-sq-km) landlocked river delta

(the world's largest) that serves as an oasis amid the Kalahari sands of Botswana.

River flow is dependent on the rainfall, both at its source and along its length. Equatorial regions receive 80 to 120 inches (2,000 to 3,000 mm) annually, while some regions even exceed 160 inches (4,000 mm)—one area at the base of Mount Cameroon in West Africa receives more than 400 inches (10,000 mm) annually. When the rains do come, the floods inundate vast stretches of the plains, sometimes beginning as an ominous wall of water bearing down the channel. The summer floods of the Nile confused the ancient Egyptians and Greeks, because they occurred during the warmest time of year when rainfall was at its lowest. The answer lay far to the south and high on the Ethiopian plateau, which receives its heaviest rainfall during the northern summer, feeding the Nile with white water off its heavily weathered rocks.

When rains fall high in the mountains, the water already contains a rich supply of sodium and chloride ions, a reminder of its evaporation from some distant ocean. Rainwater also provides all of the ammonium, nitrate, and much of the potassium that end up in rivers and lakes. Other minerals and elements, including silicates, phosphates, and iron, are leached from the soil and bedrock over which waters flow, imparting a distinctive and individual chemical signature to each river.

Rivers typically move water along the length of their channels in a matter of days (a few weeks at the most), whereas lakes often have turnover times that can run into years. (Lake Victoria takes at least one hundred years to exchange its volume.) This means that lakes tend to be much richer in terms of free-floating phytoplankton and zooplankton communities, although particularly slow-moving rivers may also carry significant numbers of these life-forms.

Tropical lakes accumulate sediments deposited by their rivers, and, because of the high temperatures, tend to undergo eutrophication (a process whereby a body of water becomes overrich in organic and mineral nutrients) at a much faster rate than comparable temperate lakes. Since lake waters also form layers or stratify, with cold water sinking to the bottom and warm water remaining at the surface, nutrients locked in the bottom sediments are released only if winds or currents disturb the depths. Oxygen levels and light penetration are greatest near the lake's surface, and it is here that plankton concentrates.

The geographically isolated and distinct drainage basins that cover the African continent have had a profound effect on species diversity. Of the 112 species of fish in the Nile, 16 are endemics (species unique to a specific region). In the Congo River basin, 83 percent of the fish species are endemic (573 out of 690), and in two-million-year-old Lake Tanganyika, the figure is 80 percent (198 species out of 247). Lake Malawi has more than 245 species of fish, 93 percent of which originated in the lake, and Lake Nabugabo, separated from neighboring Lake Victoria just 3,700 years ago, already has five unique species of cichlids (*Oreochromis* sp.) in its waters.

Cichlids are plankton-feeders that dominate the fish populations of many East African lakes. Although they are found in rivers, they prefer quiet lake waters. Many are rock- and bottom-dwelling species, a lifestyle that allows the frequent isolation of small populations, which in turn promotes evolution and speciation. Several cichlid species are mouth-brooders that produce relatively few eggs. They hold these eggs in their mouths for protection, releasing the fry only after they hatch, when they have a much greater chance of survival on their own.

As people exploit fish populations, they often stock rivers and lakes with species that have a commercial use, but that are not native to the original body of water. The results can be disastrous for indigenous species. In Lake Victoria, Lake Kyoga, and Lake Nabugabo, Nile perch have been blamed for the extinction or decline of some two hundred of the more than three hundred endemic species of cichlids. Similarly, in lakes and rivers where Nile crocodiles have been severely reduced or eliminated, catfish populations have exploded at the expense of other species. Captive breeding and reintroduction of crocodiles may offer hope to restore the balance.

Once found in most of Africa's lakes and rivers, crocodiles are superbly adapted to their environment, as befits an animal that evolved more than 150 million years ago and that has remained largely unchanged since. Today, they have the distinction of being a last living link with the dinosaurs, and the nearest living relative of birds. Crocodiles are nocturnal hunters and primarily fish-eaters. However, large crocodiles, particularly the now-rare 20-foot (6-m) animals—the oldest animals may once have reached almost 30 feet (9 m) in length—will attack swimming mammals, and even those close to the water's edge. Such attacks have instilled a high level of fear in humans that, combined with overhunting for hides, has resulted in nearly total elimination of the species from many areas.

Riverbanks support lush vegetation, fed both by rainfall and the flow of water in the river itself. In the shallow margins of both rivers and lakes, papyrus and reedbeds form nearly impenetrable, closed habitats. Vegetation takes root and blurs the dividing line between land and water. The reedbeds capture sediment, build up land around them, and eventually fill in lakes and block slow-moving rivers.

The primary productivity of equatorial wetlands is astounding: The below-ground biomass in reed swamps is one to three times higher than the above-ground biomass in the same swamp, and even significantly higher than biomass of high-intensity agriculture.

Wetland plants have to contend with two main difficulties: oxygen deficiency and nutrient leaching. Submergence in water and extensive decomposition both reduce the amount of oxygen available. Most wetland plants are no more resistant to a lack of oxygen than their terrestrial counterparts, but several have developed specialized tissues to transport oxygen internally to tissues that cannot absorb enough to meet respiration demands. These air-space tissues extend from the roots to the porelike openings (stomata) in the leaves. Terrestrial plants typically have tissues with an oxygen porosity of about 3 percent; wetland plant tissues have a porosity as high as 60 percent, allowing oxygen to be conducted from the leaves all the way to the roots.

The constant presence of water leaches essential nutrients from the soil and decomposing litter. For some species, the loss of leaves at the end of their functional life represents too great a nutrient loss, and many have evolved mechanisms for reabsorbing the nitrogen and potassium in their leaves before shedding them. Other species reduce their nutrient requirements at the end of the growing season by dying back and storing carbohydrates in belowground rhizomes that are then used to jump-start the next season's growth. Still others deal with the lack of nitrogen by becoming insectivorous, such as bladderworts, whose air-filled bladders trap small invertebrates that are then digested and absorbed by the plant.

The low-oxygen environment and acidic conditions in wetlands tend to result in a short food chain, with most of the plant litter remaining uneaten and decomposing only slowly. Few large herbivores or carnivores live exclusively in the wetlands, although many make temporary use of them during the dry seasons. Even hippos, which rely on ample water to avoid dehydration, feed on grasses outside of the wetlands. Two of the rarest and most specialized wetland mammals are the lechwes and sitatungas (*Tragelaphus spekeii*).

Lechwes are medium-sized antelopes that have evolved along the floodplains of the Zambezi and Kafue Rivers. With their splayed hooves, these antelopes are well adapted to the wet, spongy ground. The Kafue lechwes once numbered close to a half million animals. However, construction of hydroelectric dams and the subsequent permanent flooding of much of their habitat by the Kafue Gorge and Itezhi-Tezhi Reservoirs have caused their population to decline dramatically. A low count of 16,000 has since recovered to more than 30,000, with illegal poaching apparently preventing any further recovery.

The lechwes share their habitat along stretches of the Zambezi and Kafue with the sitatunga, an antelope that is comparable in both size and weight, and that shares the characteristic splayed hooves that ease passage across the swamps. Sitatungas have pale vertical stripes that camouflage them among the reed grass, and although they can appear slow and clumsy when running on land, they are in their element in the water, swimming with proficiency and even grazing in deep water. To avoid predators, they have been known to submerge with just their nostrils and eyes showing above the surface.

Although mammals may be relatively scarce in the wetlands, invertebrates are abundant, both above the water and below it. Spiders and beetles are among the most numerous of the wetland predators, and amphibians such as the African clawed frog (*Xenopus laevis*) and painted reed frogs (*Hyperolius* sp.) add noise and color to the vegetation. The female African clawed frog has a particularly

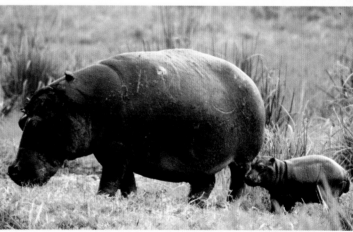

▲▲ GRAY-CROWNED CRANE
(*Balearica regulorum gibbericeps*),
Lake Manyara, Tanzania
▲ HIPPOPOTAMUS (*Hippopotamus amphibius*),
Maasai Mara National Reserve, Kenya

▲▲ AND ▲ LITTLE BEE-EATER (*Merops pusillus cyanostictus*), OKAVANGO DELTA, BOTSWANA

ingenious method of securing food for her offspring. These incredibly slippery creatures (the males bear the claws that give the species its name, using them to hold onto the females during copulation) each lay some ten thousand eggs per year. The tadpoles show an extremely high mutation rate, far above what would be considered normal, and researchers hypothesize that the mutations are actually an adaptation, providing the healthy tadpoles with an immediate, easily accessible food source: their deformed siblings.

Birds are plentiful in the wetlands, feeding on the bounty of fish, amphibians, and insects and nesting on isolated islands or prominent trees. Even so, competition can be fierce. Immature fish eagles are often excluded from the prime wetland habitats by adults, forced instead to survive on the margins of the wetlands or even to migrate to dry land where they subsist on remains of lion or leopard kills.

Specialized birds such as the black crake (*Amaurornis flavirostris*) and the African jacana walk easily across floating vegetation (the jacana is also known as the lily-trotter). Great white pelicans (*Pelecanus onocrotalus*) congregate on lakes and estuaries, plummeting into the water to catch fish, and heron species ply the shallows looking for frogs, fish, and rodents. Among the herons found in Botswana's Okavango delta are the 59-inch- (1.5-m-) tall goliath heron (*Ardea goliath*) and the considerably smaller squacco heron (*Ardeola ralloides*). Stalking the water with them are saddle-billed storks (*Ephipplorhynchus senegalensis*) and the rare shoebill (*Balaeniceps rex*), which uses its heavy bill to catch lungfish and catfish hiding in the mud of papyrus swamps.

Among the browns and greens of southern African swamps, a number of distinctively colored birds stand out, including blacksmith plovers (*Vanellus armatus*), with their distinctive piebald plumage; red bishops (*Euplectes orix*); and the stunning malachite kingfisher (*Alcedo cristata galerita*), with its bright red bill, rust and white plumage, and shining violet and cerulean head and back.

At night, as most of the avian inhabitants of the swamps and marshes roost, Pel's fishing owl (*Scotopelia peli*) emerges to strike at fish in the dark. With uncanny ability, the owl skims the water's surface, catching its meal with sharply curved talons.

Most inland wetland habitats are freshwater. They are fed by rains, rivers, and lakes. They exist because of the outpourings of freshwater over banks and levees. These seasonal inundations dilute and cleanse, killing those plants that cannot survive a regular drowning and encouraging the spread of those that can. But there is another type of wetland in Africa, also landlocked, but far from fresh: the soda lakes.

Tropical rivers are usually in the neutral to slightly acidic pH range. Since most lakes get their water from rivers, their pH is often similar. However, lakes lose water by evaporation and seepage. If a lake is "closed," with little or no inflow, and it continues to lose water by evaporation, it can become increasingly saline. Many lakes in Africa's Great Rift Valley are moderately saline due to high levels of evaporation, but some of these lakes are truly exceptional. Lake Manyara in northern Tanzania is twice as saline as seawater, while Lake Nakuru in Kenya has a salt content more than three times that of normal seawater.

These so-called soda lakes are a product of recent volcanism. Volcanic ash is rich in sodium carbonate, and it floods the lakes, dissolving in the water and bubbling up through hot springs as concentrated and caustic soda. Some thirty active or semiactive volcanoes run the length of the Great Rift Valley, occasionally venting molten magma aboveground in dramatic visual displays, but also quietly transforming tranquil-looking lakes into alkali infernos.

Lake Natron and Lake Magadi, both close to the Kenya-Tanzania border, are two of the most hellish soda lakes on Earth. Lake Natron covers 520 square miles (1,300 sq km); Magadi is considerably smaller at about 38 square miles (96 sq km). Both lakes are long and narrow—Lake Magadi is just 1.86 miles (3 km) wide—lying in deep depressions in the rift. The lakes are surreal. Daytime temperatures can top 149°F (65°C), and hot springs spew forth boiling water and a continuous supply of sodium carbonate. At Lake Natron, water is evaporated eight times faster than it is replenished by rainfall. By all accounts these lakes should be lifeless. They are far from it. Life, of a weird and wonderful sort, flourishes here.

Fish survive in the hot springs of Magadi, at temperatures that would boil others alive. The alkali waters are a brilliant red, colored by blooming algae that would look at home on some alien world. Literally millions of flamingos flock to Natron. Lesser flamingos (*Phoenicopterus minor*) come to feed on the blue-green algae that thrive here, and greater flamingos (*Phoenicopterus ruber*) feed on the multitude of brine shrimp and other crustaceans that proliferate in the noxious liquids.

The flamingos form a moving crimson tide across the lakes. They are grace personified in the air, sweeping across the mirrored, glistening soda lakes with coordinated wingbeats. Flamingos perform a highly ritualized courtship that can last for months. Once paired, they build evenly spaced, conical nests out of the mud, forming colonies of tens of thousands of birds, protected from predators by the expansive salt flats that surround the lakes. When these "firebirds" were first seen emerging from the cauldron lakes, they gave rise to the myth of the phoenix rising from the ashes.

The soda lakes are not without their perils for these ancient birds. The soda is lethal to them, and they have to strain their food carefully through the fine filaments in their bills to avoid ingesting any liquid. The young flamingo chicks cannot feed themselves, so the parents secrete a fluid that has a nutritional value similar to milk; when the adults need water, they must find fresh springs to drink from, away from any contaminating soda.

In southern Africa, both species of flamingos are in trouble. They breed, or, rather, attempt to breed, at two locations: the Makgakikgadi Pans in Botswana,

near the Okavango delta, and the Etosha Pan in Namibia. These pans are the remnants of ancient lakes that have dried, leaving salt flats in their place.

During the rains, salt flats are transformed into shallow sheets of saline water that swarm with brine shrimp and bloom with algae. Flamingos flock to these sites in good years when the rains offer promise. But the phenomenal sight of hundreds of thousands of birds preparing to raise the next generation is a tragic illusion. Flamingos have had few successful breeding events on the Etosha Pan in the last few decades, and both species have shown population declines of an estimated 40 percent during the last fifteen years.

The problem is that after the rains, the waters evaporate rapidly and, more often than not, the pans dry before the chicks have fledged. In some years as many as one hundred thousand flightless flamingo chicks starve to death or become trapped in the drying sediments. With few other suitable sites available to the birds, they keep returning to the drying pans, and with little or no recruitment of young birds being added to the population, numbers are falling. The

future for flamingos in southern Africa is uncertain, and both species have been listed in Namibia's Red Data Book for Threatened and Endangered Species.

Water is forever in motion, sustaining the ecosystems through which it passes. At times, too little or too much water can transform an ecosystem, changing it dramatically and threatening the survival of previously well-adapted species, but at the same time creating conditions that allow other species to become established and to flourish. Usually the change is a temporary one, and conditions soon return to normal. But sometimes the change is permanent, and what was normal once becomes something different, requiring different adaptations and favoring different species.

Wetlands represent a union between water, land, plant, and animal. Within that union there is an array of diverse and unrivaled habitats: dark rivers that hide electric fish and crocodiles, clear lakes filled with endemic cichlids, and red and white soda lakes trimmed with pink flamingos. We have no way of knowing how the wetlands of the future will look, but they will surely be wondrous.

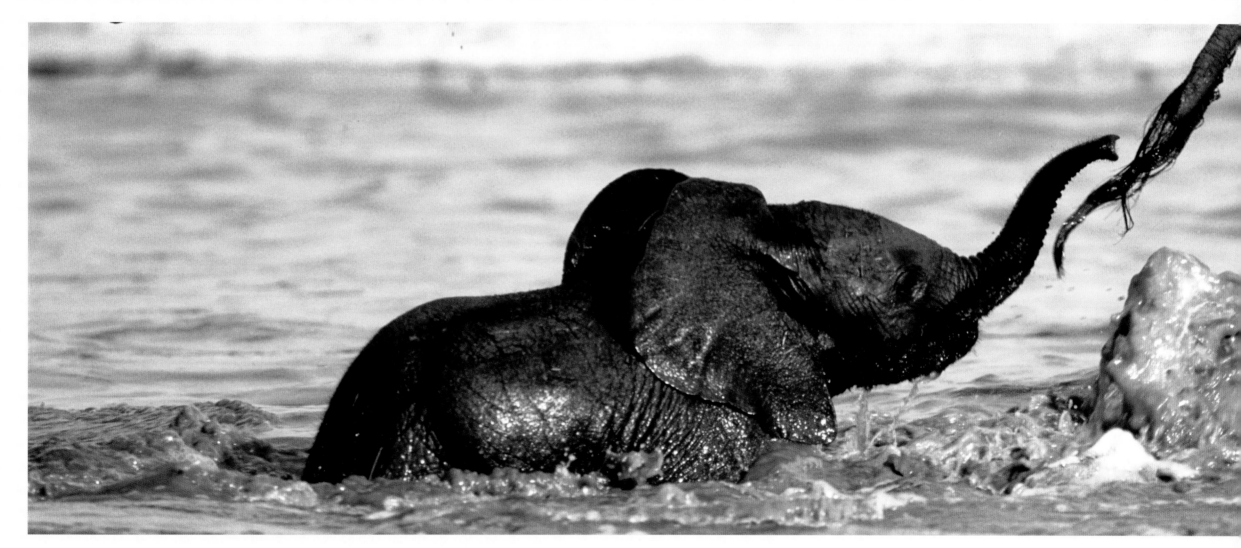

AFRICAN ELEPHANT (*Loxodonta africana*), SAMBURU NATIONAL RESERVE, KENYA

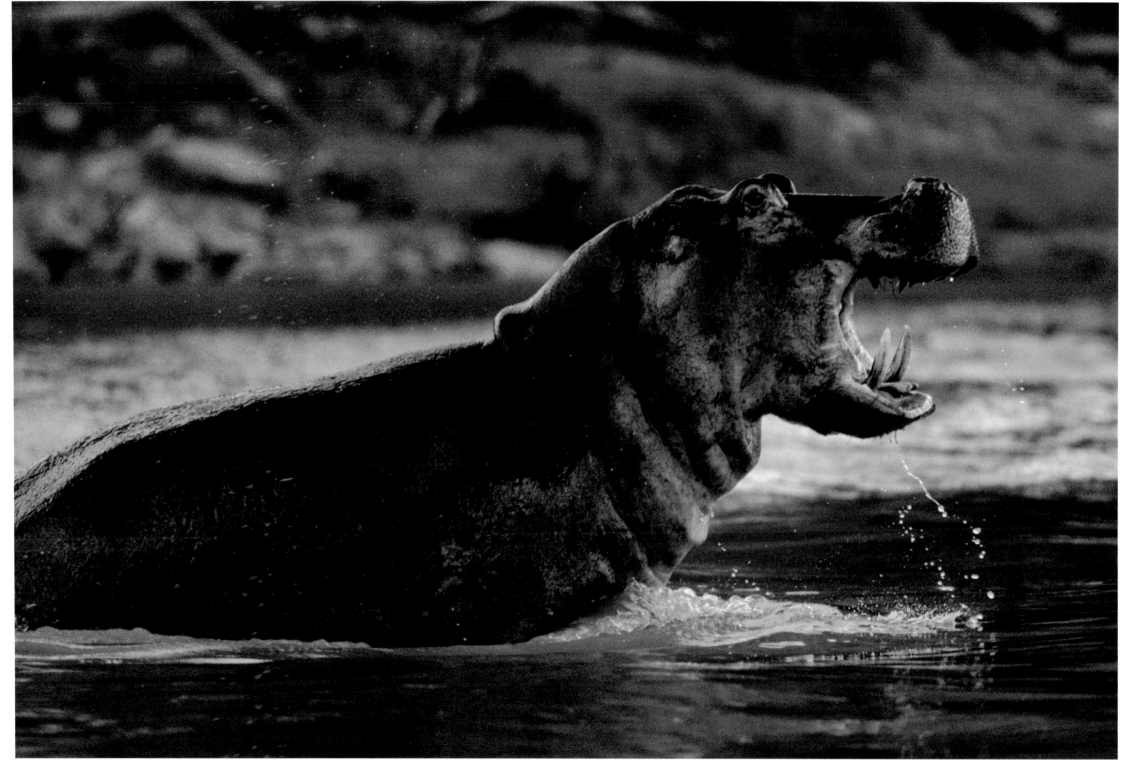

HIPPOPOTAMUS (*Hippopotamus amphibius*), SELOUS GAME RESERVE, TANZANIA

HIPPOPOTAMUS (*Hippopotamus amphibius*), LAKE MANYARA, TANZANIA

HIPPOPOTAMUS (Hippopotamus amphibius), Grumeti River, Tanzania

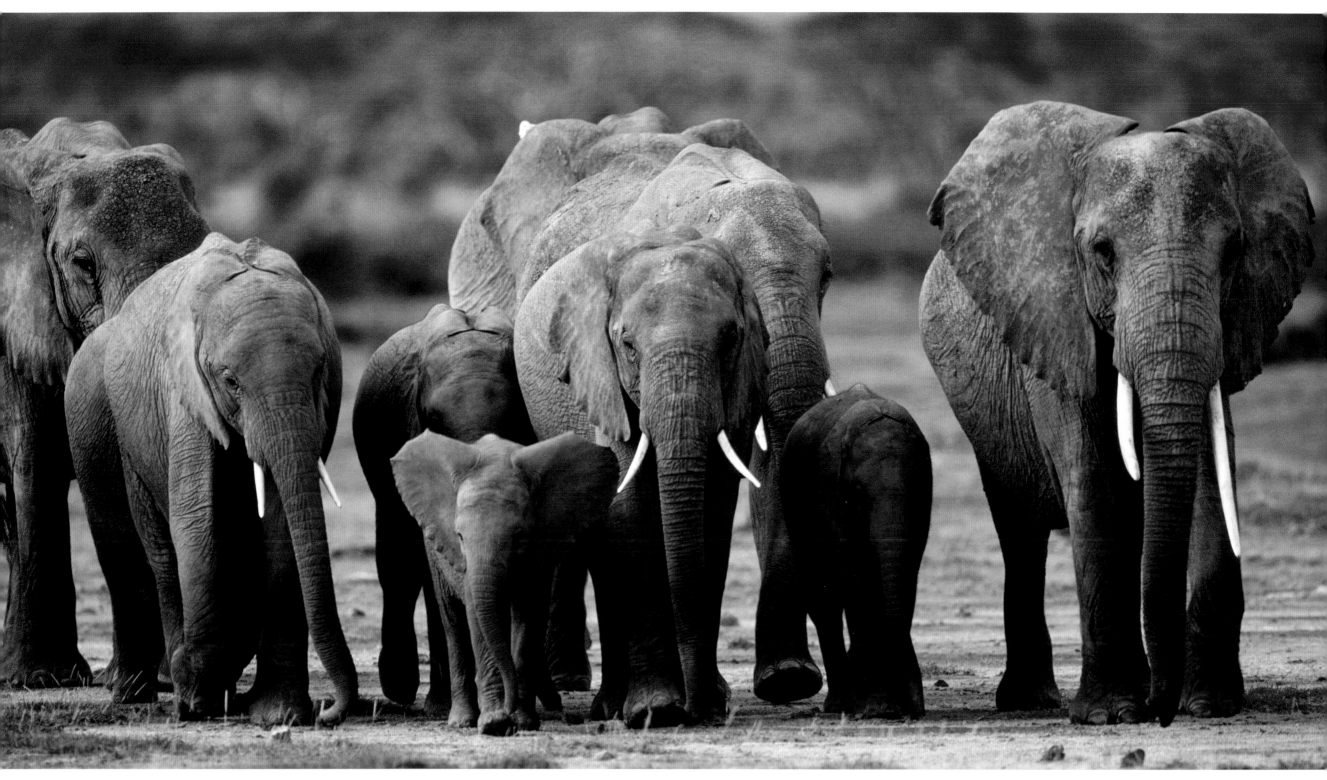

AFRICAN ELEPHANT (*Loxodonta africana*), AMBOSELI NATIONAL PARK, KENYA

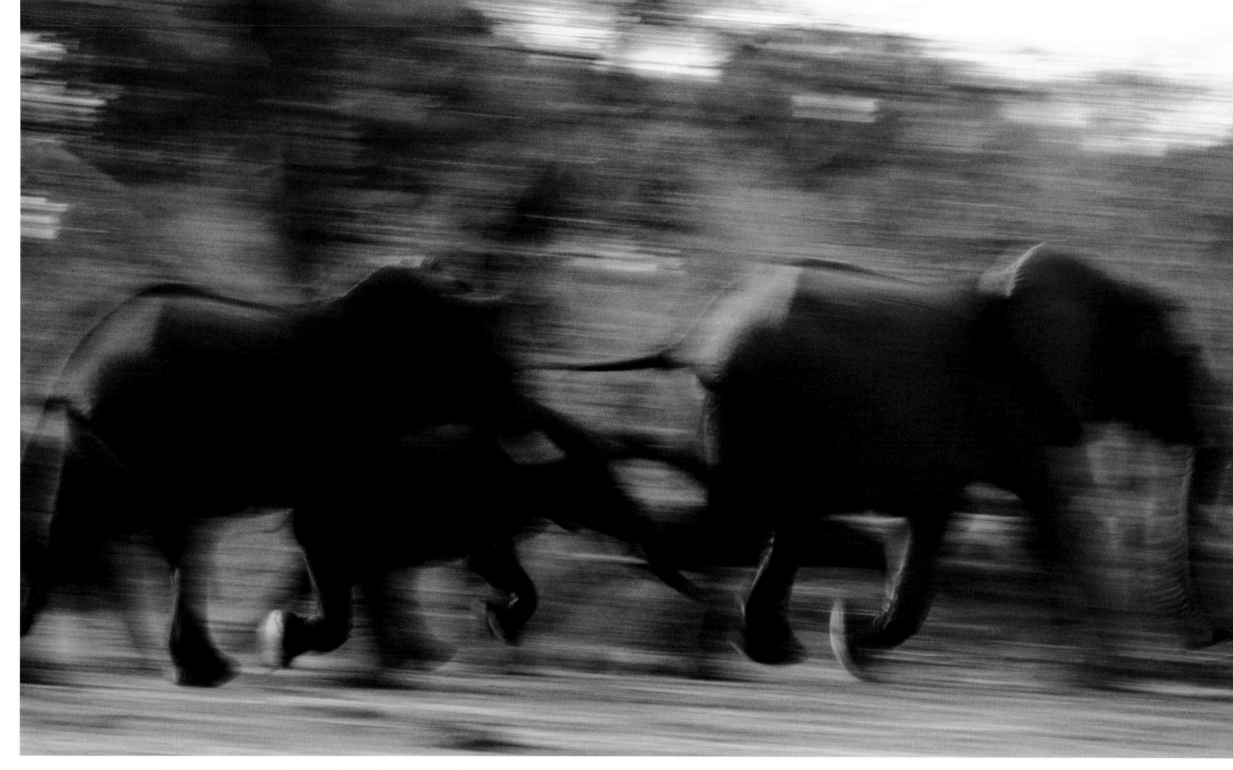

AFRICAN ELEPHANT (*Loxodonta africana*), MATETSI RESERVE, ZIMBABWE

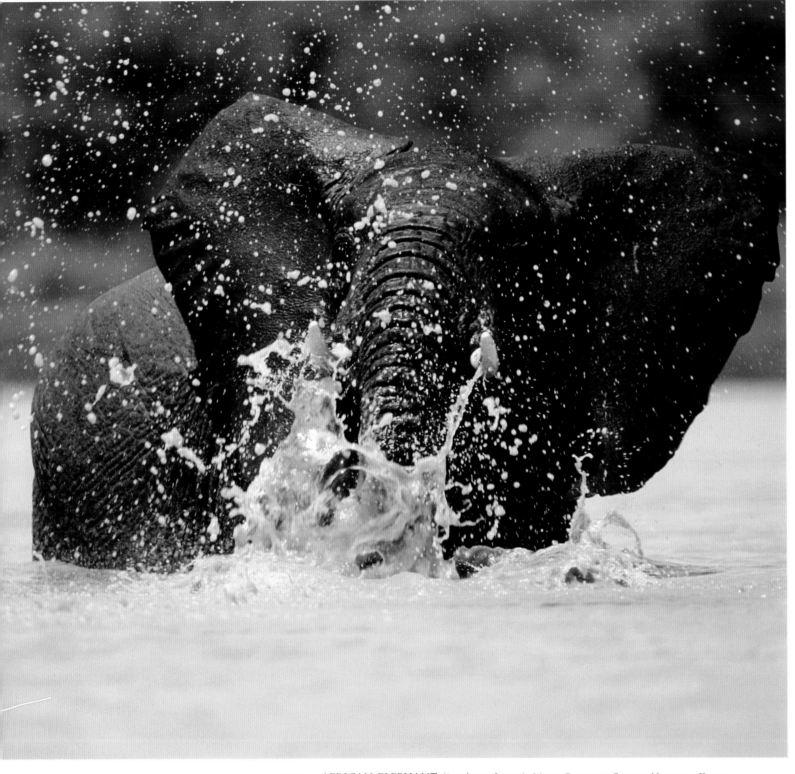

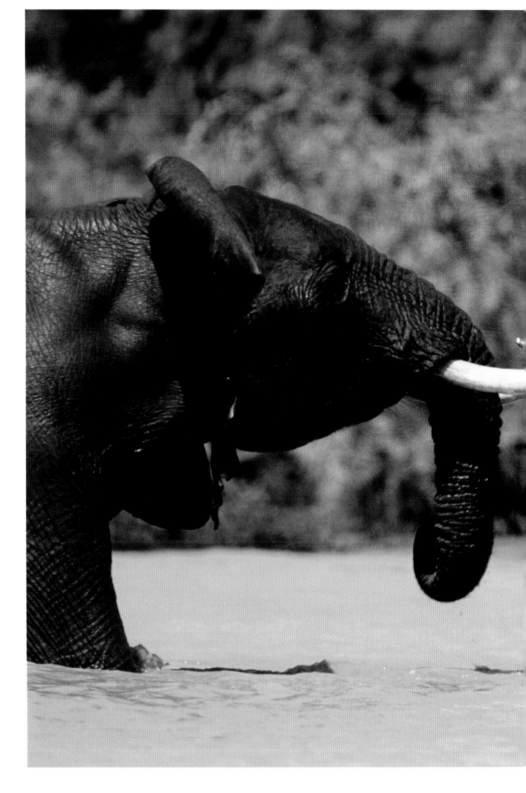

▲, ► AND ►► AFRICAN ELEPHANT (*Loxodonta africana*), MPALA RESEARCH CENTRE, NANYUKI, KENYA

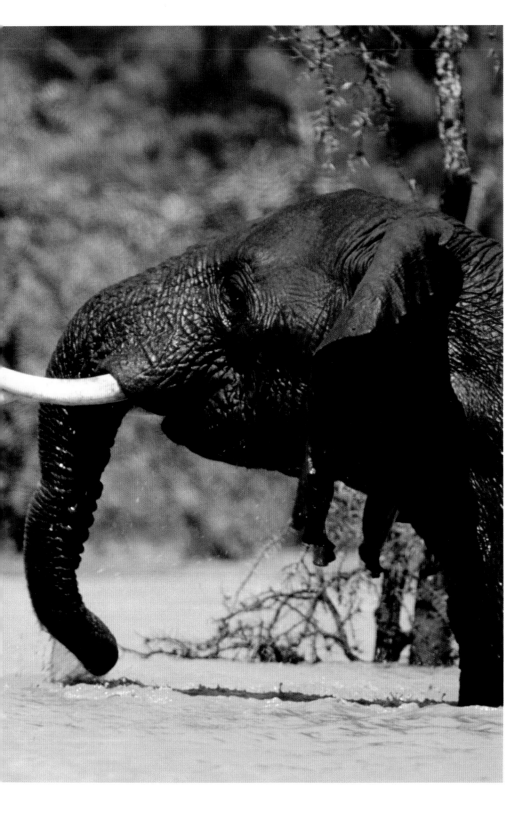

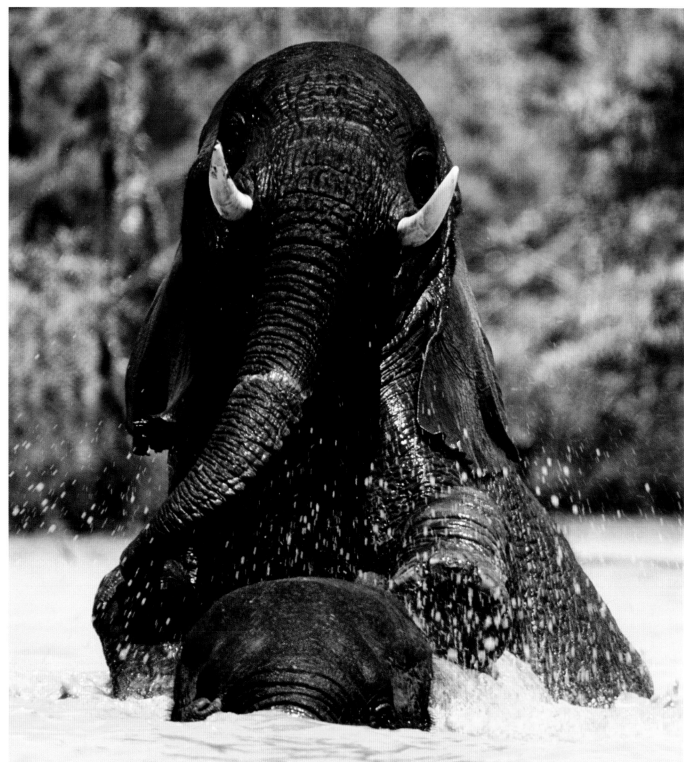

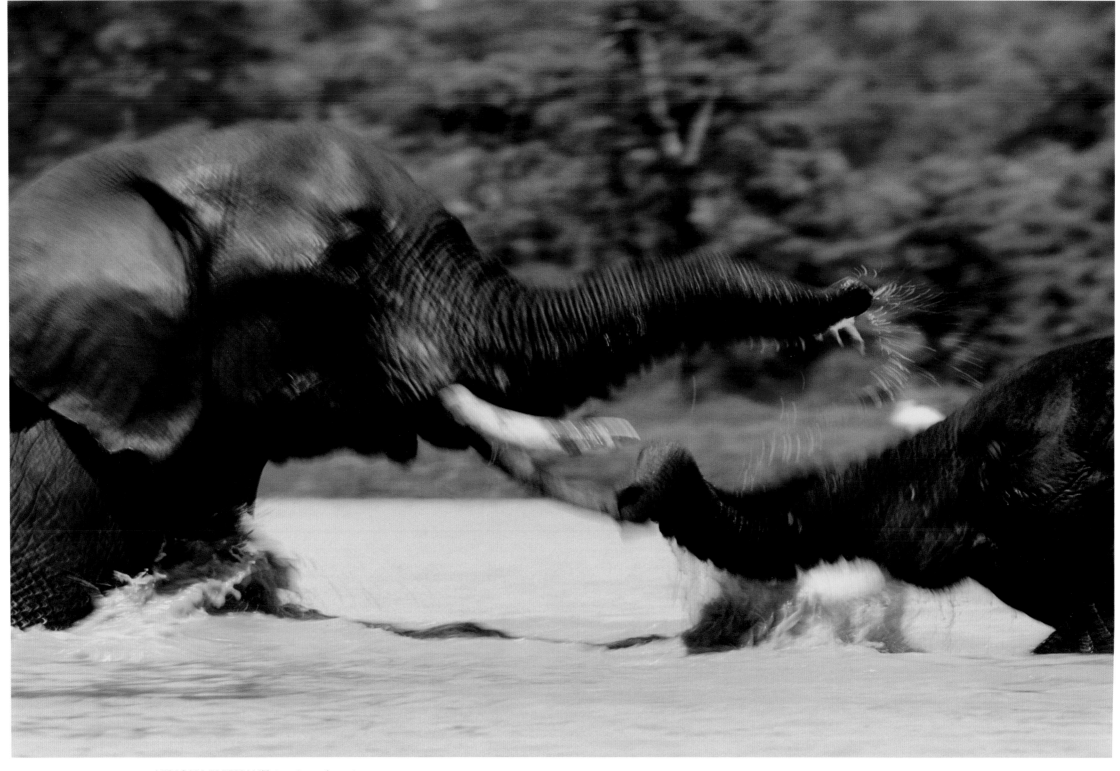

AFRICAN ELEPHANT (*Loxodonta africana*), Mpala Research Centre, Nanyuki, Kenya

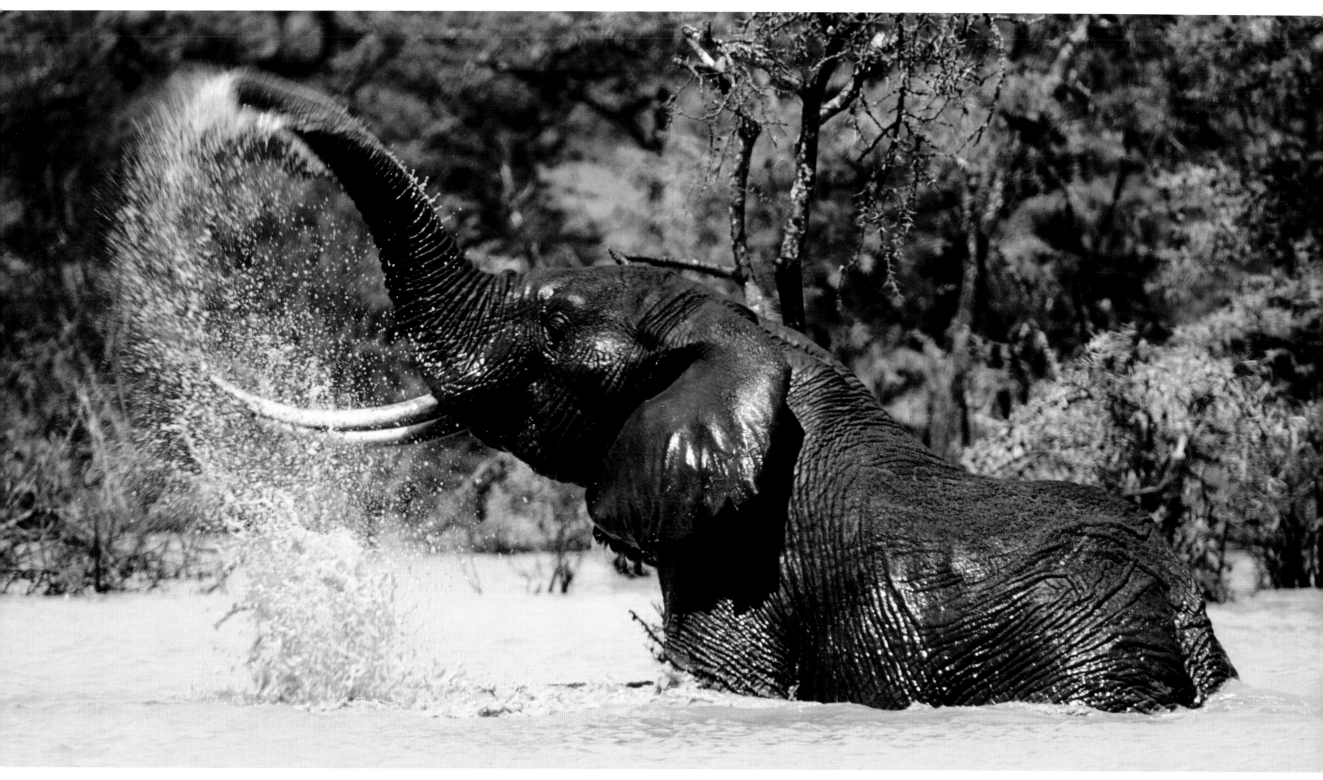

AFRICAN ELEPHANT (*Loxodonta africana*), MPALA RESEARCH CENTRE, NANYUKI, KENYA

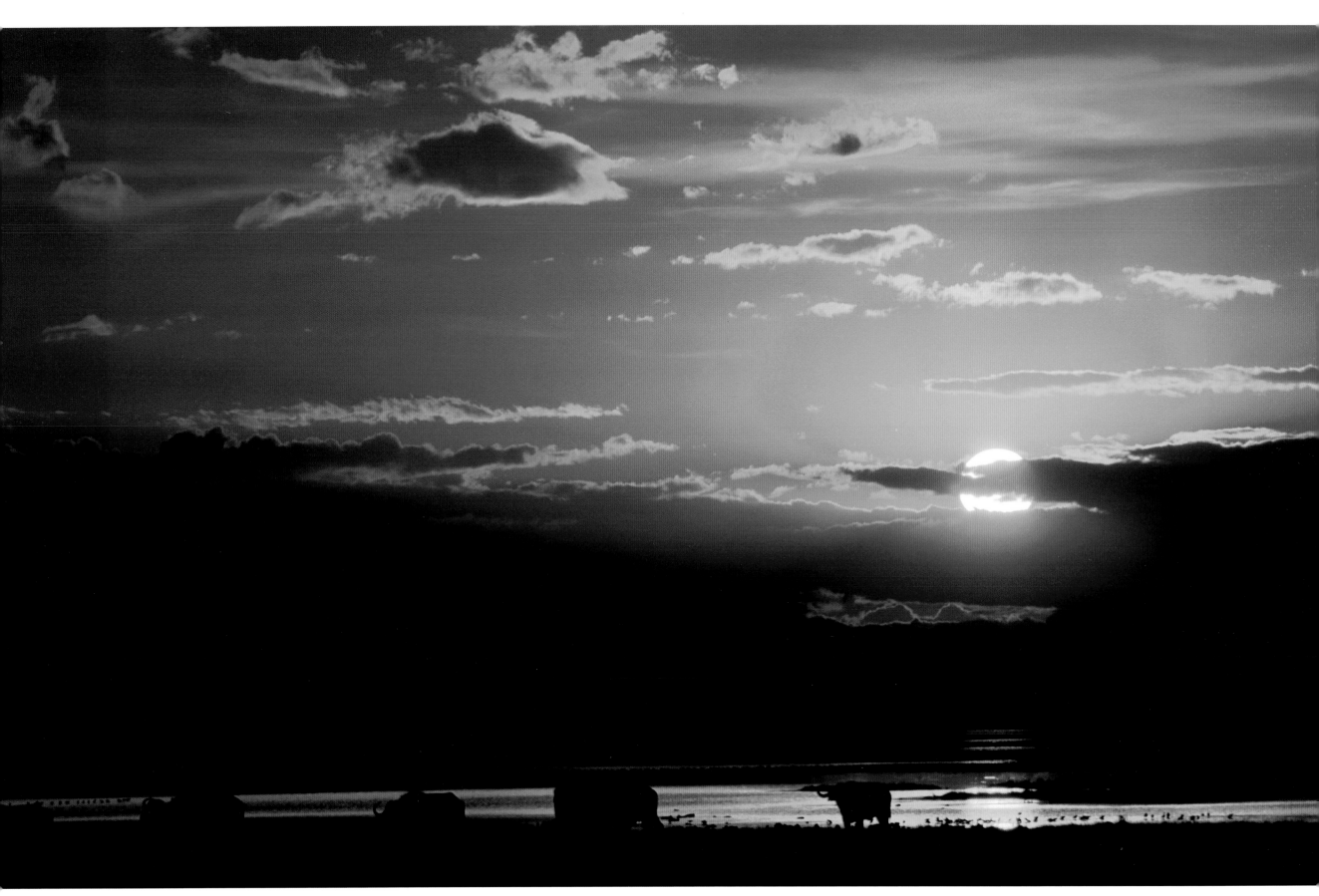

SUNRISE, Lake Manyara, Tanzania

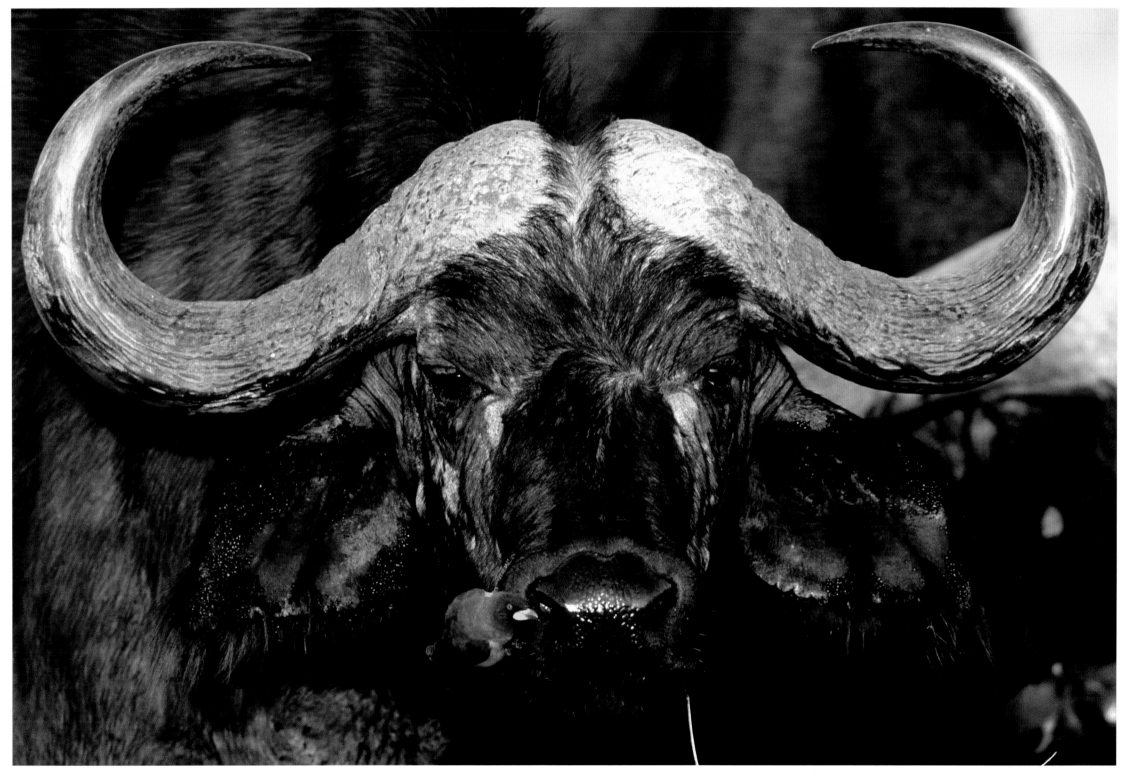

AFRICAN BUFFALO (*Syncerus caffer*) AND YELLOW-BILLED OXPECKER (*Buphagus a. africanus*), LAKE MANYARA, TANZANIA

AFRICAN BUFFALO (*Syncerus caffer*), KRUGER NATIONAL PARK, SOUTH AFRICA

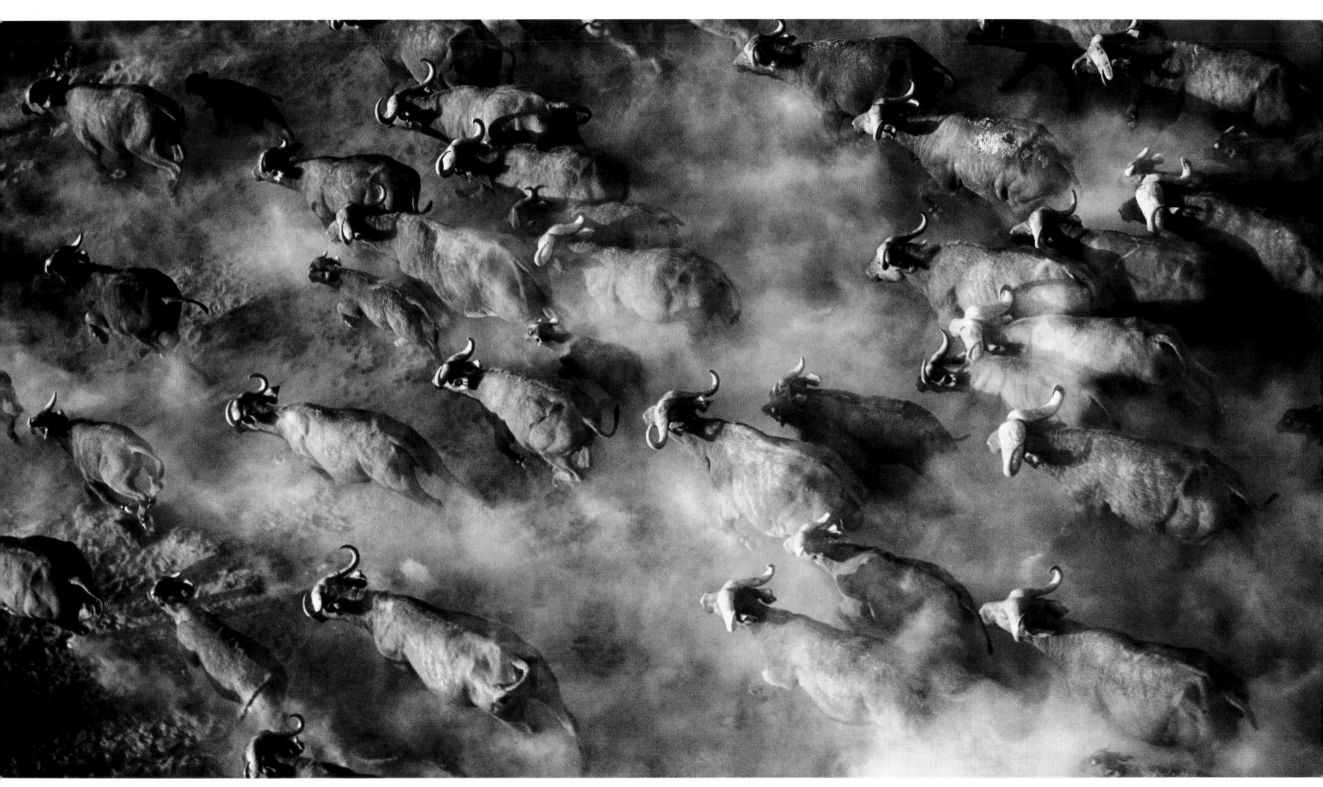

AFRICAN BUFFALO (Syncerus caffer), AMBOSELI NATIONAL PARK, KENYA

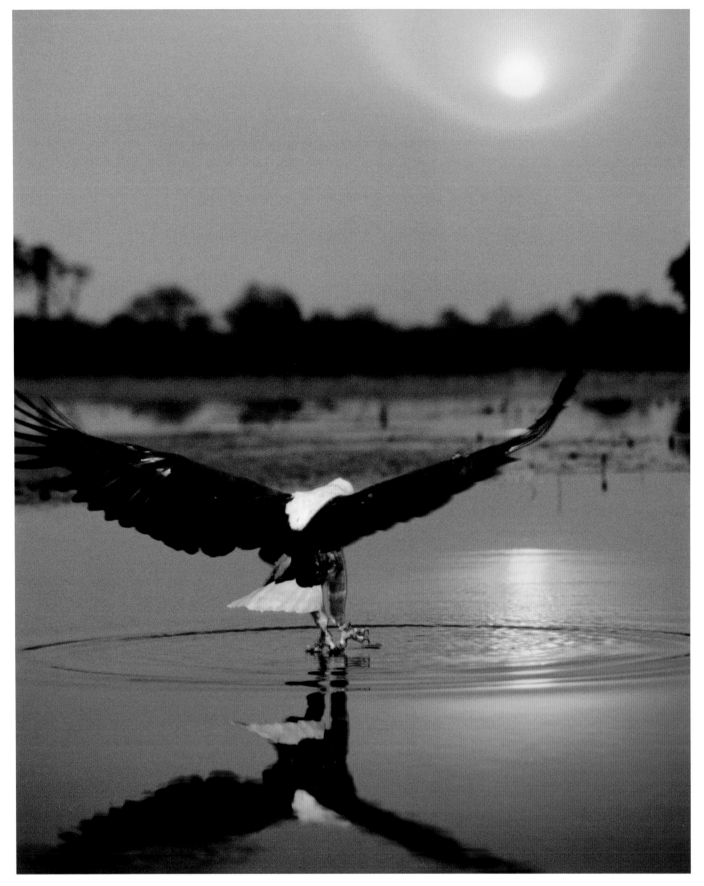

AFRICAN FISH-EAGLE (*Haliaeetus vocifer*), OKAVANGO DELTA, BOTSWANA

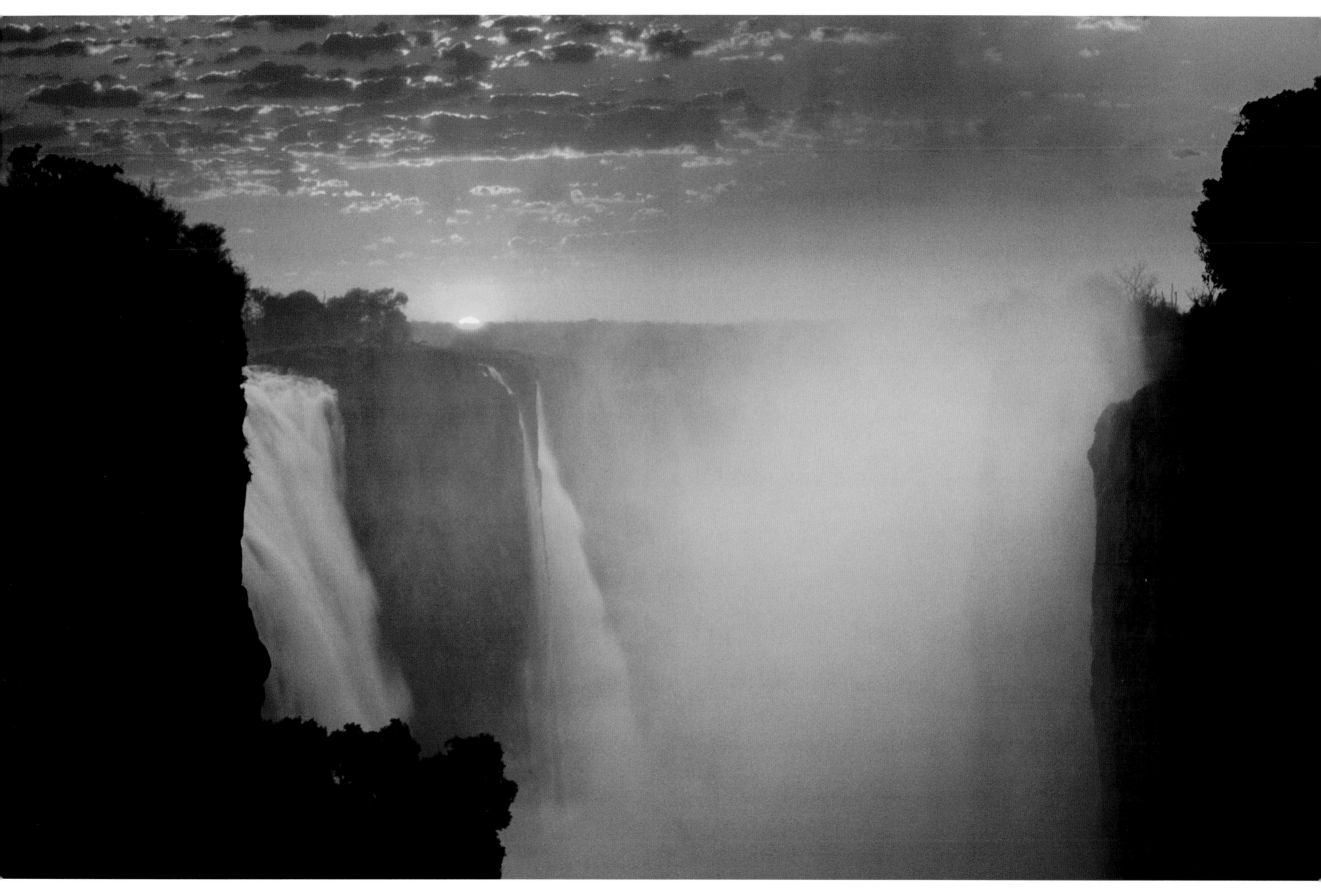

SUNRISE, Victoria Falls, Zimbabwe

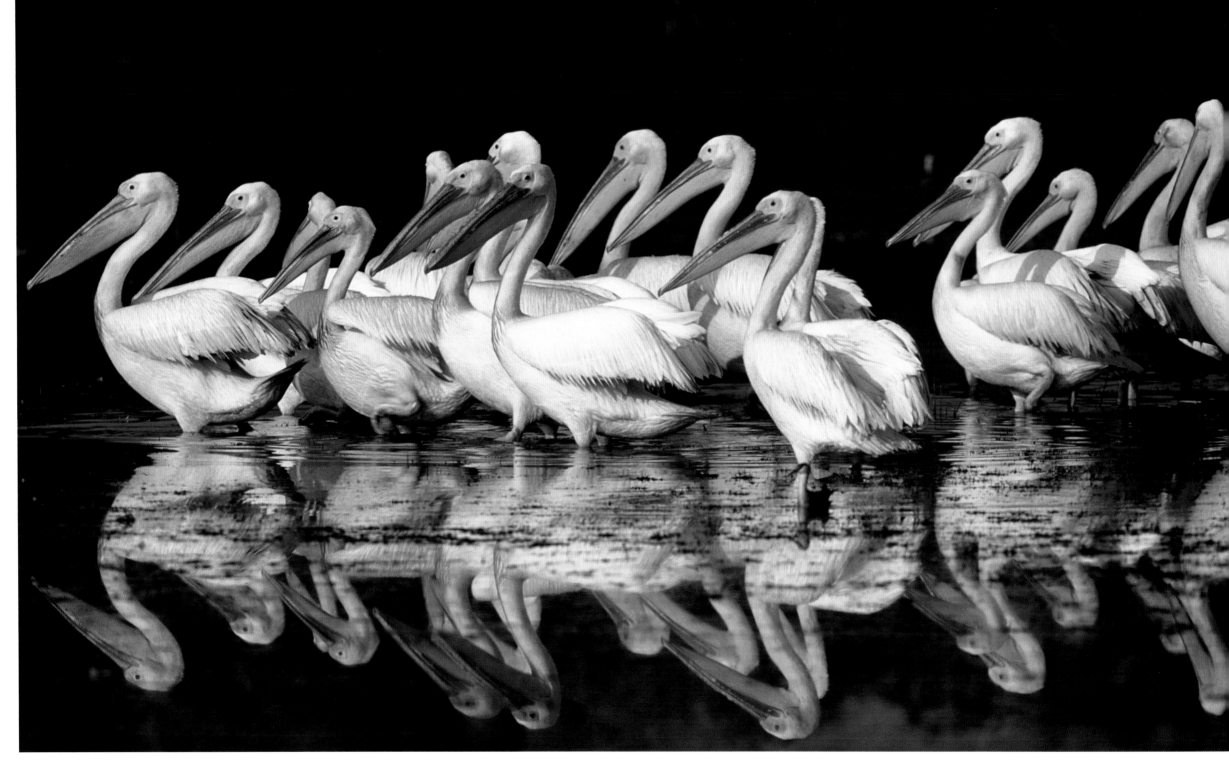

GREAT WHITE PELICAN (*Pelecanus onocrotalus*), Lake Nakuru, Kenya

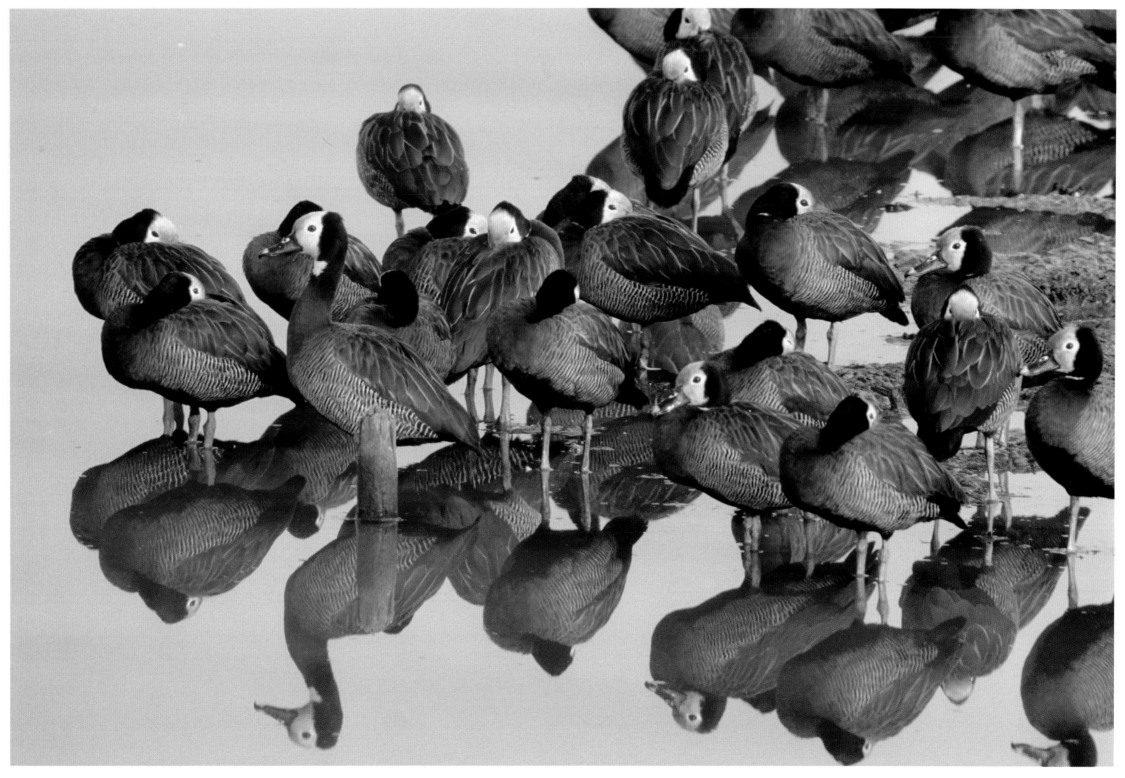

WHITE-FACED WHISTLING DUCK (*Dendrocygna viduata*), PHINDA RESERVE, SOUTH AFRICA

MALACHITE KINGFISHER (*Alcedo cristata*), OKAVANGO DELTA, BOTSWANA

EGYPTIAN GOOSE (*Alopochen aegyptiacus*), OKAVANGO DELTA, BOTSWANA

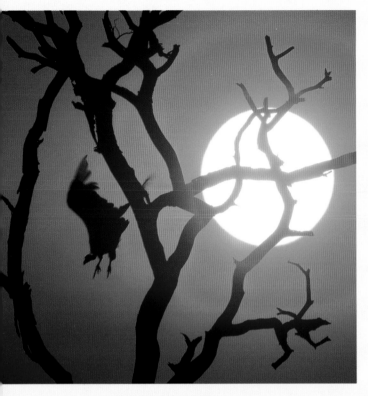

◄ COMMON ELAND (*Taurotagus oryx*),
SERENGETI NATIONAL PARK, TANZANIA

▲ WHITE-BACKED VULTURE (*Gyps africanus*),
ETOSHA NATIONAL PARK, NAMIBIA

As the sun rises over the Namib, shadows are chased behind dunes that tower 330 feet (100 m) above dry wadis carved by vanished rainstorms. The wind accelerates as it funnels around linear dunes, blowing smokelike wisps from their crests.

Patterns crisscross the sand; beetles, bat-eared foxes (*Otocyon megalotis*), and sand vipers leave evidence of their passage in the night. Fog rolls in off the sea and brown hyenas (*Hyaena brunnea*) scavenge along the coast looking for seal carcasses. Tenebrionid beetles engage in "fog basking," drinking the dew that condenses on their bodies, while another species of beetle digs a trench to capture the precious liquid.

At midday, gemsboks (*Oryx gazella*) climb the dunes and stand facing into the wind, savoring a brief respite from the heat. Brooding ostriches (*Struthio camelus*) orient themselves toward the breeze, allowing their eggs to cool convectively. When the wind picks up, the dunes begin to sing as quartz grains vibrate against each other, and scavenging beetles emerge to feed on detritus deposited across the sand. Vipers lie in wait, their bodies hidden, with only their eyes poking through the camouflaging sand. Birds seek shade in burrows, the lee of dunes, or the interior of a rare shrub. Blanketed by oppressive heat, the desert is quiet.

As the sun sets, turning the desert blood red on its descent, the land cools, and the sand shifts to release skink lizards and blesmoles (*Cryptomys* sp.). Hairy-footed gerbils (*Gerbillurus* sp.) dash between islands of vegetation surrounded by a sea of sand. Jackals sniff the night air, and bat-eared foxes listen for termites. An elephant-shrew family (Macroscelididae) drums out a warning with its hind feet. The full moon illuminates the desert and the animals are cautious. Well before dawn, birds begin to sing, finishing the dawn chorus before the sun's return. As the sun heats the air, animals seek shelter again. Gerbils block the entrances to their burrows. Sociable weavers (*Philetairus socius*) return to communal nests. All life either retreats or endures.

To outsiders, the desert is the harshest of places. Deserts are defined by what they lack: water, soil, vegetation, clouds, shade, life. They are inimical and yet hauntingly beautiful, hostile but radiant. In the desert, the physical environment shapes the biological one with a blind indifference. There is no deliberate design here, despite mathematically perfect shapes and hypnotic patterns that dot the landscape.

Africa's deserts and semiarid areas dominate significant portions of the continent. The Sahara, the largest desert in the world, stretches across 3.44 million square miles (8.6 million sq km) of northern Africa from the Atlas Mountains of Morocco to the Red Sea. To the south, the Kalahari, Namib, and Karoo fill another 640,000 square miles (1.6 million sq km).

For many, their first thoughts of Africa are accompanied by visions of sweeping sands and famine-stricken villages. Rarely are deserts appreciated for what they are. Even the word "desert" is a synonym for "barren, desolate, useless, and sterile." To be deserted is to be alone and neglected. But there is another side to the desert; it is the desert of ancient cultures, of exquisite adaptation, and of survival against the odds. Deserts are only deserted if you don't know where to look.

Most deserts occur in the two warm subtropical belts of descending air that straddle the equator between 20 and 30 degrees latitude. Many receive less than 4 inches (100 mm) of precipitation a year; some just 0.02 inch (0.5 mm). Evaporation significantly exceeds precipitation, and there is a chronic water deficit. Annual rainfall can also deviate dramatically from the average. In the Namib, consistent annual rainfall of 0.5 inch (13 mm) can be interrupted by a single year with 5 inches (125 mm).

It is the unpredictable nature of rainfall that presents such phenomenal problems of adaptation for the desert's inhabitants, and that wreaks havoc on human attempts to live in arid regions. Wetter-than-normal years result in population increases among plants, animals, and people alike. When the rainfall pattern returns to "normal," the desert can become a site of devastation.

Despite the lack of it, water actually dominates landform processes here. This may seem contradictory, but the explanation lies in the fact that deserts were not always deserts, and a little water can go a long way.

In 1981, the U.S. space shuttle *Columbia* focused its radar on the Selima sand sheet in the Sahara. Previous satellite images had shown an even, uninteresting sea of sand. But dry sand is invisible to radar, and *Columbia* returned images that mapped what lay 10 feet (3 m) beneath the sand sheet: a thirty-five-million-year-old landscape of ancient rivers, some the size of the Nile.

Two hundred and fifty million years ago, the Sahara was a sea. One hundred million years ago, it was a forest, home to dinosaurs. As recently as six thousand years ago, it was a land of lakes, and people hunted giraffe and antelope. Cattle were domesticated five thousand years ago, and three thousand years later, people were raising camels (*Camelus dromedarius*). Lions were once common in Algeria and elephants in Nubia. The land of the early pharaohs was not the same land that surrounds the pyramids today.

The Kalahari was once a subtropical forest, with vast lakes dominating its interior. But as the ancient supercontinent of Gondwanaland broke up and Africa drifted southward, the land grew drier. Thirty million years ago, volcanoes formed along the great rift valleys, raising the land and interfering with moist air movements. Even the continent of Antarctica had an influence here, drying the air over southern Africa by drawing moisture to its own icy heart.

QUIVER TREE (*Aloe dichotoma*), SOSSUSVLEI, NAMIB-NAUKLUFT PARK, NAMIBIA

KARO TRIBE, Lower Omo River, Ethiopia

Today, constant winds lift sand into the air, coloring sunsets a rich, brilliant red, at times depositing sand as far afield as England and Florida. Silica grains moved by the wind form rivers of sand that are shaped into curves, stars, lines, and spirals. Dominant winds create repetitive patterns among the dunes. Wherever sand is absent, erosion picks out the regular weaknesses in the rock, creating patterns of abstraction that seem calculating in their content. Abrasion carves deep grooves into rock and cuts pillars and pinnacles out of mountains. Gradually the landscape is transformed into a gallery of sculpture and architecture. In the desert, nature is both mathematician and artist.

As the wind provides the mechanism for abrasion, heat provides the mechanism for insolation weathering. Daytime temperatures can top 176°F (80°C), but at night, with no vegetation or cloud cover, temperatures plummet. Daily temperature cycles may exceed 122°F (50°C), establishing steep temperature gradients in the rocks, and creating stresses that can fracture solid-looking boulders. As the rocks shatter under the blazing sun, they fire pistol-like retorts.

The heat can be suffocating. James Bruce, who reached the headwaters of the Blue Nile in 1770, recounted a particularly eloquent description to an eager Georgian public:

> I call it hot, when a man sweats at rest, and excessively on moderate motion. I call it very hot, when a man, with thin or little clothing, sweats much, though at rest. I call it excessive hot, when a man in his shirt, at rest, sweats excessively, when all motion is painful, and the knees feel feeble. . . . I call it extreme hot, when the strength fails, a disposition to faint comes on . . . the voice is impaired, the skin dry, and the head seems . . . large and light. This, I apprehend, denotes death at hand.

As great as the forces of wind and heat may be, it is still water that carries sway. Flash floods can turn dry riverbeds into raging torrents, sweeping huge boulders along with monumental force. An area that usually receives 4 inches (100 mm) of rain in a year can receive twice that in a matter of hours. As quickly as the rain falls, it evaporates, and floods do little to rectify water deficits. Floods can, however, move substantial amounts of material and carve riverbeds that will soon run dry.

It is on a less dramatic scale that water erodes the desert's finer features. Water from infrequent showers or dew penetrates rock fractures. At night, when temperatures dip, this water may freeze, pushing the rocks apart. Water can also combine with salts or soluble minerals, swelling them by more than 300 percent. This combination of mechanical, salt, and chemical weathering continually degrades rocks, adding more debris to the ever-eroding land.

It seems incredible that life can survive here. But it does. Nature appears at its most primeval in a desert. Nothing is superfluous. Every drop of water must be saved, every morsel of food earned. Every kit, pup, chick, seed, and egg adds fuel to the evolutionary process.

Living organisms are more than three-quarters water, whether they live in the wettest or driest of habitats. Many species adapt by reducing evaporation or developing specialized organs to obtain and store water. However, the majority deal with the desert by simply fleeing from it.

Plants would seem to have rather limited options for escape. They are, after all, largely immobile. The key is ephemerality. Dying would seem to be an extreme method of avoiding the harshest of conditions, but as long as the offspring of these fleeting plants survive, the strategy works.

In the Namib, few perennials can survive the uncertainty of desert rains. Annuals, with few true desert adaptations, grow rapidly when conditions allow and put all of their energies into the next generation. One Saharan plant can produce seeds just eight days after germination. Because the metabolic rate of seeds is low, the plant is able to survive prolonged drought in a dormant, nearly ametabolic state. Some animals also survive droughts as dormant eggs, most notably shrimp and copepods and even some amphibians. Pools of water that collect after the rains literally bloom with life within days. The risk, for seeds and eggs alike, however, is that conditions will never be favorable for development.

Other animals survive the harshest conditions by estivating, a form of desert hibernation. It involves prolonged dormancy in which both metabolism and body temperature are depressed. Snails withdraw into the upper whorls of their shells, closing off the opening with an impermeable membrane; the African bull-frog (*Pyxicephalas adspersa*) burrows into the earth, surviving a 40 to 50 percent loss in body weight from dehydration; both mollusks and amphibians may survive for years in such a state.

A more active method of escape from the trials of the desert is migration. Every year, more than five billion birds leave their breeding grounds in Europe, Africa north of the Sahara, and Asia north of the Himalayas to winter in Africa. To reach their destinations, they must cross the Sahara. Many fly at night, trying to conserve their energy by resting through the hot days. It is a grueling passage, taking small perching birds more than forty hours of continuous flight. Tens of thousands never make it. For them, the Sahara is impenetrable, and the sands become littered with tiny corpses, a boon to scavenging jackals and foxes.

Animals that are not well adapted to a lack of drinking water, such as wildebeests and zebras, are tied to the rains. They are brief visitors to the southern African deserts, entering as the rains flood salt pans and fresh grasses paint the desert green. When the rains pass, these animals must leave, or face a grim desert death.

Sometimes, though, escape can be achieved by hardly moving any distance at

all. Although the desert climate is severe, most organisms do not exist in a world of averages or extremes. They exist in a world of microclimates.

A white stone may be 55°F (13°C) cooler on its underside than a gray stone. It may be 87°F (30.5°C) on the ground, but 2 inches (5 cm) belowground it is 64.4°F (18°C), and 12 inches (30 cm) down it is 54.5°F (12.5°C). The Bateleur eagle (*Terathopius escaduatus*) glides at an altitude of 990 to 1,650 feet (300 to 500 m) over the Kalahari, where the temperature is 104° to 122°F (40° to 50°C) which is cooler than at ground level. Sociable weavers build large communal nests that weigh more than a ton, keeping the birds cool in the summer and warm in the winter. For many, the key to survival becomes the ability to exploit and manipulate differences of degrees and inches through changes in behavior.

Tenebrionid beetles maintain their mean body temperature within a degree of 91.4°F (33°C) by spending thirty seconds in the shade for every ten seconds in the sun. Even desert ants are active at midday in the cool of winter, but switch to evenings in summer. The Namib sand-diving lizard (*Aporosaura anchietae*) engages in a comical "thermoregulatory dance" as it forages. The lizard emerges when the temperature rises above 86°F (30°C), and presses its body to the sand to warm up after a cool night. When it gets too hot, the lizard holds itself above the sand, raising diagonally opposed legs into the air before diving below when the temperature hits 113°F (45°C).

Small desert mammals face considerable loss of water and heat by evaporation and radiation due to their large surface area relative to their volume. Many dig burrows, emerging only at night. Gerbils block the entrances of their burrows, raising the humidity of their tunnels and trapping moisture within; African ground squirrels (*Xerus inauris*) take their shade with them, using their own tails as parasols as they feed.

Most large mammals do not have the escape options of their smaller relatives, although gazelles in the Kalahari will sometimes make use of the entrances to old aardvark burrows to avoid the sun. Baboons in the Namib watch for showers and hurry to ephemeral pools, even digging for water when they have to, as will gemboks. Jackals along the Skeleton Coast lick dew from rocks, and lions in the Kalahari hunt almost exclusively at night, concentrating in hard times on smaller animals.

Cooperative behavior in some species has even extended to reproduction. Mole-rats, slender-tailed meerkats (*Suricata suricatta*), bat-eared foxes, brown hyenas, and jackals all show a degree of sociability in which kin give up their chance to breed to assist with relations' offspring. Deserts appear to promote this sort of adaptation where it takes more than a single pair of animals to successfully raise a litter.

Unlike small mammals that face problems of heat loss due to their size, large mammals tend to absorb heat during the day, raising their body temperature to nearly lethal levels; the brain cannot usually withstand temperatures above 107.6°F (42°C). Such a heat load requires specific physiological adaptations, and few species can match those of the oryx and eland. They tolerate heat, rather than risk losing precious water by sweating or panting, instead cooling the blood that flows to the brain in a counter-current exchange that uses the cool venous blood returning from the nasal sinuses. It is an effective adaptation that allows these antelope to survive temperatures of 113°F (45°C) and exploit desert niches closed to others.

Many desert animals are pale in color, but there is still considerable debate about whether color plays a role in heat regulation. Intuitively it is logical: dark colors absorb heat, light colors reflect it. Springbok antelope (*Antidorcas marsupialis*), with their white heads and rumps, appear to orient themselves toward the sun when grazing, perhaps reflecting heat away from themselves. The Namib chameleon (*Chamaeleo namaquensis*) is almost completely black in the morning but lightens as its body temperature rises, and many small beetles are black, perhaps to absorb heat quickly after a cold night. It may be that color in the desert really is as simple as black and white.

There is a Saharan proverb: "Jackal tracks, water near. Fennec tracks, tighten your belt and keep walking." These words neatly address the ability of some animals, such as the fennec fox (*Fennecus zerda*), to survive solely on the moisture content of their food, while others need an almost daily supply of drinking water.

Whenever water is in short supply, animals try to minimize their losses or tolerate dehydration. Many amphibians and all mammals excrete urea; insects, reptiles, and birds excrete uric acid. Urea contains more water than the near-solid uric acid, and desert mammals have highly efficient kidneys to reabsorb as much water as possible before excretion. Similarly, insects and reptiles reabsorb water from their hindgut, producing concentrated waste with minimal water content.

Insects and reptiles also have a nearly impermeable outer layer, which drastically reduces their water losses by evaporation. However, insects must still breathe through spiracles (apertures in an insect's cuticle that allow air to enter). In many species the spiracles are sunken, whereas in Tenebrionid beetles, they open into a humid subelytral cavity (the region under the front wings) rather than connecting directly with the atmosphere.

The ability of some animals to tolerate dehydration is astounding and is a true testament to their resilience. The Saharan sunspider can survive a 66 percent loss in body weight; one type of gecko (*Tarentola annularis*), a 35 percent loss; and the camel can survive an incredible 30 percent loss (a 12 to 14 percent loss is critical for most mammals). Camels are able to recover quickly even after a 20 percent loss in body weight, restoring their original body weight in less than ten minutes—camels have been observed drinking 17.3 gallons (66.5 liters) of water at one time.

Once an animal is hydrated, storing the water can prove difficult. Unlike

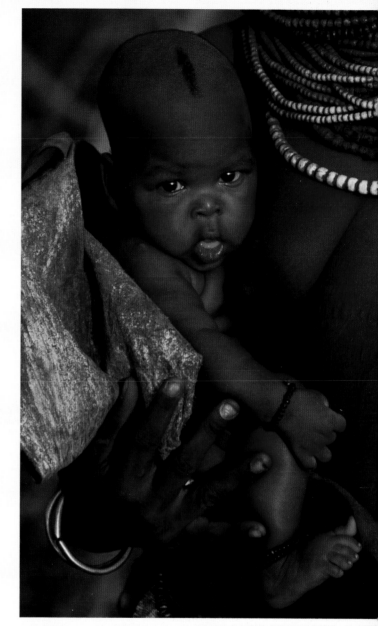

SUMI TRIBE, LOWER OMO RIVER, ETHIOPIA

SLENDER-TAILED MEERKAT (*Suricata suricatta*),
KALAHARI DESERT, SOUTH AFRICA

plants, few animals have dedicated water-storage organs. The camel's hump, contrary to popular opinion, does not store water, but it does store fat that can be metabolized to produce water. Desert frogs store very dilute urine in their bladders for later use, while the sand-diving lizard stores excess water in its lower intestine that it can draw on for weeks.

When it comes to storing water, plants are the clear winners. The tubers of *Pachypodium succulentum*, a root succulent from the Kalahari, can contain up to 950 percent of its dry weight as water. Baobab trees, which may live more than a thousand years, have swollen trunks that can hold 2,340 gallons (9,000 liters) of water—true oases in their own right.

Desert plants minimize their water losses by reducing the number and size of their leaves, or covering themselves with a waxy coating or reflective hairs. However, plants need to photosynthesize, and they obtain most of their carbon dioxide from the atmosphere through tiny pores or stomata. Every time they open the stomata during the day, they risk losing water from evaporation. Opening them at night would dramatically reduce water loss; the problem is that sunlight is also necessary for photosynthesis.

A number of plants get around this conundrum by using a photosynthetic pathway known as C4 (or a slight variant, Crassulacean Acid Metabolism, or CAM). The plant absorbs carbon dioxide at night and stores it in the form of organic acids. When exposed to sunlight, these acids break down to give carbon dioxide and the plant can then photosynthesize without opening its stomata. Among the central Namib dunes, C4 grasses comprise 41 percent of the species, but up to 99 percent of the biomass. Some species alternate between the normal photosynthetic pathway and C4, using the latter only when water availability is restricted.

Plants across Africa's deserts live a life that is both tenuous and stoic. Annuals send out short-lived roots after it rains to absorb as much water as possible, whereas perennials rely on deeply penetrating taproots; the roots of tamarisk and camelthorn acacia reach groundwater that may have been replenished ten thousand years earlier.

Harsh conditions and isolation have given rise to some unique African species. The tumboa, an ancient gymnosperm (coniferous plant), is found only in the Namib. Its roots extend down 100 feet (30 m), and it lives twenty-five years before flowering for the first time. Its two leaves grow 4 to 8 inches (10 to 20 cm) a year, rolling across the sand to be battered by the wind. It is not an attractive plant, but it may live for two millennia.

Plants are not silent, inactive participants in the desert. They are shaped by the same evolutionary pressures that shape animals. Some plants secrete toxic substances that inhibit the growth of competitors; others, such as the acacia, possess potentially damaging thorns; others, even acrid resins or oils to discourage browsers. Grasses in the Kalahari are covered with gland-tipped hairs that blister the mouths of animals that try to graze. Although some plants discourage grazers, other positively encourage them, often to disperse their fruits and seeds. The camelthorn acacia relies on giraffes, oryxes, and other animals to disperse its thick seedpods, and tsama melons encase their seeds in succulent fruits to attract animals. The grapple plant has seeds that hitch a ride on the feet or fur of passing animals.

The desert is a simple ecosystem when compared to tropical rainforests or wetlands. Deserts have a very low biomass, one hundred times less than a comparable area of temperate forest. Such characteristics, however, do not detract from the unique adaptations and beauty of a land at the margin of life.

It is the physical severity of the desert that is simultaneously a threat and a solace. Arid and semiarid ecosystems are extremely sensitive to climate change and land use. As people settle in arid regions, bringing their animals with them, the ecosystem is unable to adapt quickly enough. Recovery following disturbance is slow because plant growth is limited by rainfall, and long-lived perennials are slow to reinvade. Desertification has consumed more than 2.92 million square miles (7.3 million sq km), or 24 percent of Africa's land, and threatens even more. With an ever-increasing human population, this destruction cannot be allowed to continue indefinitely.

It is the harshness of the desert that still makes it a refuge for many embattled species. The Namib is home to the only unfenced population of black rhinoceros, more than one hundred. This is, however, still a pitifully small number, and one that is under constant threat from poachers who seek horns for the vanity of a dagger handle or the false promises of an apothecary. In Namibia, rhino home ranges are ten times larger than in other regions—often more than 800 square miles (2,000 sq km)—a graphic illustration of the desert's poverty. In the future, the ranges may grow to 1,200 square miles (3,000 sq km) or shrink to 400 square miles (1,000 sq km), depending on changing conditions. The dilemma for conservationists is to know how to plan for the unexpected.

Deserts are always entering or leaving wetter or drier periods in their history. Rainfall from earlier times fills aquifers and feeds oases. Some subsurface water resources have been aged at twenty thousand to thirty-five thousand years and are known appropriately enough as "fossil water." This "fossil water" can prove too tempting to developers, and artificial water holes have been established for cattle across southern Africa. Water holes tend to encourage overgrazing, and they tempt wildlife to remain too long in the desert after the rains have gone. The results can be devastating and all too visible.

In 1985, a six-year-long drought in the Kalahari brought death to 35 percent of the elands, 19 percent of the wildebeests, 12 percent of the hartebeests (*Alcelaphus buselaphus*), and 10 percent of the ostriches. These deaths, particularly those of the wildebeests and elands, were believed to have been exacerbated by

artificial water holes. Animals that normally would have left the desert remained and were caught by the drought later in the dry season. Migrations to other natural water sources were blocked by veterinary control fences designed to keep wildlife and cattle apart. In the desert, physiological specializations are tied to behavioral opportunism. Deserts are not isolated from their surroundings, and to forcibly isolate them and their inhabitants is to slowly strangle both out of existence.

People can live in the desert without destroying it, but it requires a culture that steps lightly on the land. The San bushmen of the Kalahari (San means "the harmless people," in their own language) have been living off the desert for thousands of years. Living in balance with arid lands is possible; it just isn't easy. However, people have long sought to alter the desert. The first dam was built in Egypt five thousand years ago. Deserts will never support large numbers of

people, and to attempt to change them leads inevitably to their destruction. It would be a loss of unimaginable magnitude.

A quarter of the spiders collected in the Sahara are still new to science. A single, strange-looking plant in the Namib may have been alive when the Roman Empire held court in North Africa. A baobab tree in the Kalahari is a veritable city, filled with bushbabies (*Galago moholi*), lizards, weaverbirds, ants, and snakes.

Life persists where we least expect it, and it does even more—it flourishes in exquisite detail. In the simplicity of the African desert, we witness the complexity, fragility, and vigor of life. Metaphorically, the setting sun could have such a different meaning for the future of this land. But as the sun sets on the desert, it comes alive. Perhaps it is fitting that the deserts of Africa are a contradiction to the very end.

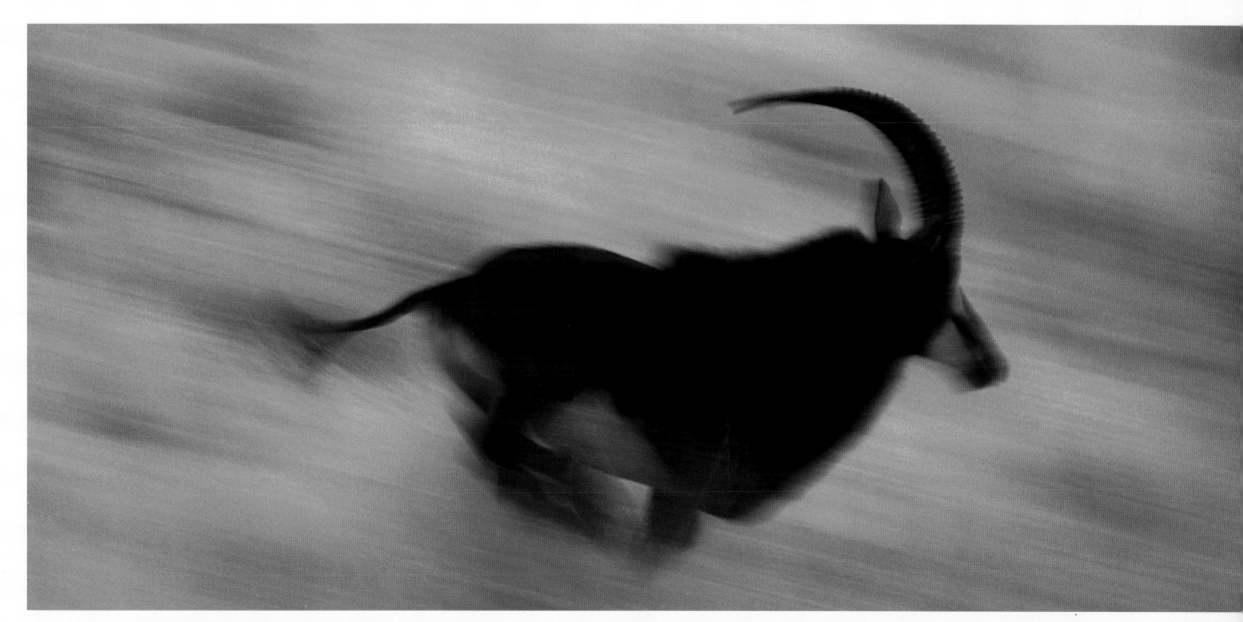

SABLE ANTELOPE (*Hippotragus niger*), KALAHARI DESERT, SOUTH AFRICA

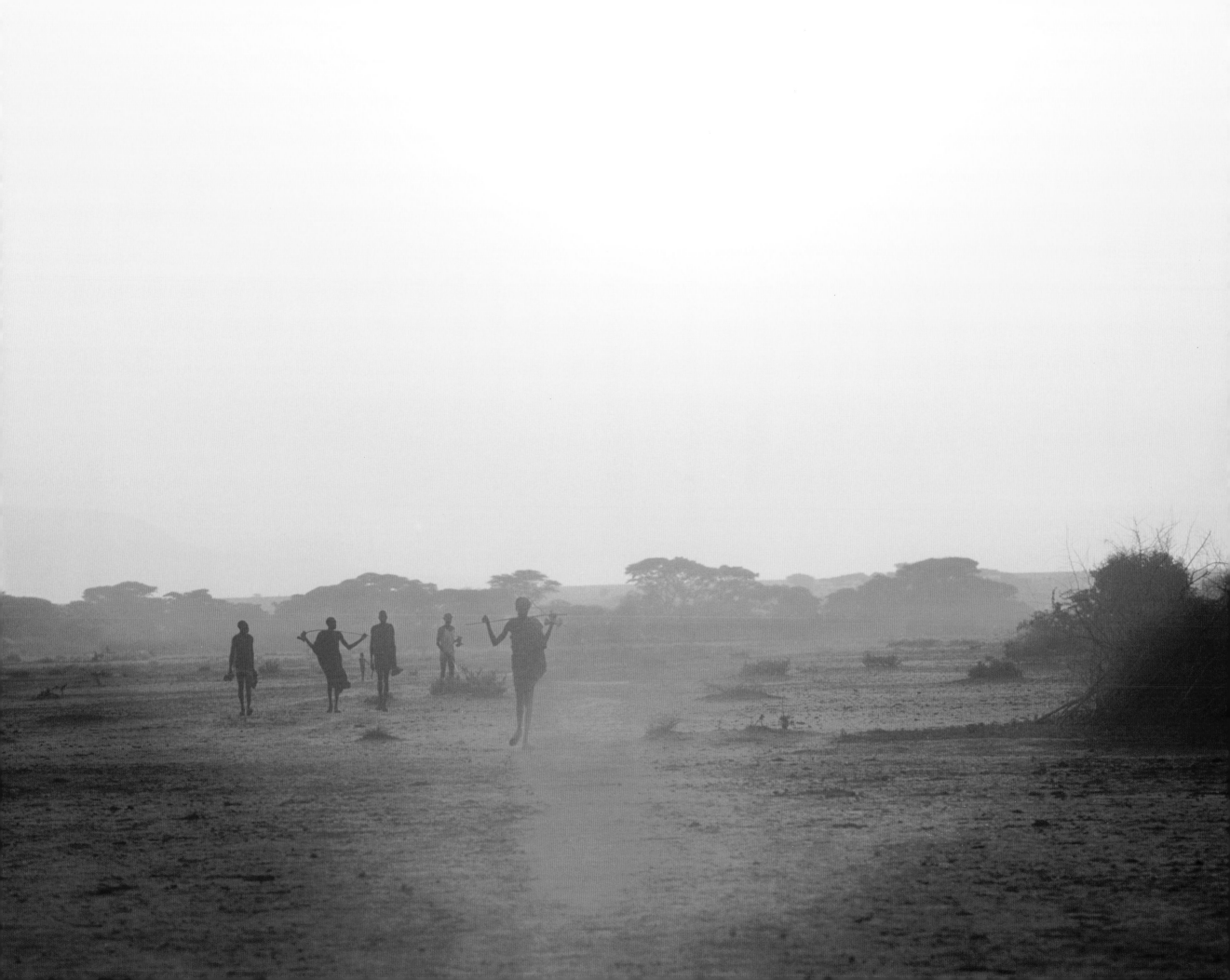

◄ AND ▲ BUMI TRIBE, LOWER OMO RIVER, ETHIOPIA

SAN TRIBE, KALAHARI DESERT, BOTSWANA

BUMI TRIBE, Lower Omo River, Ethiopia

MALE TRIBE, Lower Omo River, Ethiopia

SAN TRIBE, Kalahari Desert, Botswana

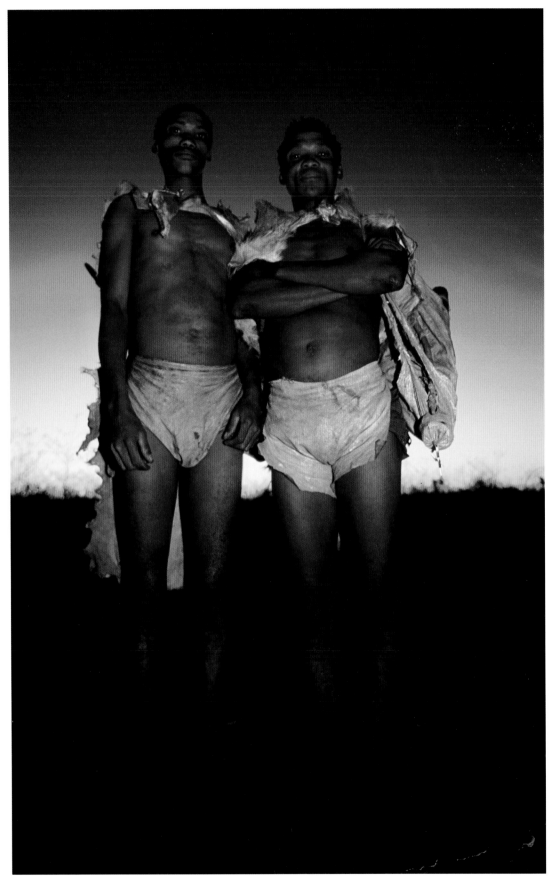

▲ AND ▶ SAN TRIBE, KALAHARI DESERT, BOTSWANA

SAN TRIBE, Kalahari Desert, Botswana

LAKEBED, Sossusvlei, Namib-Naukluft Park, Namibia

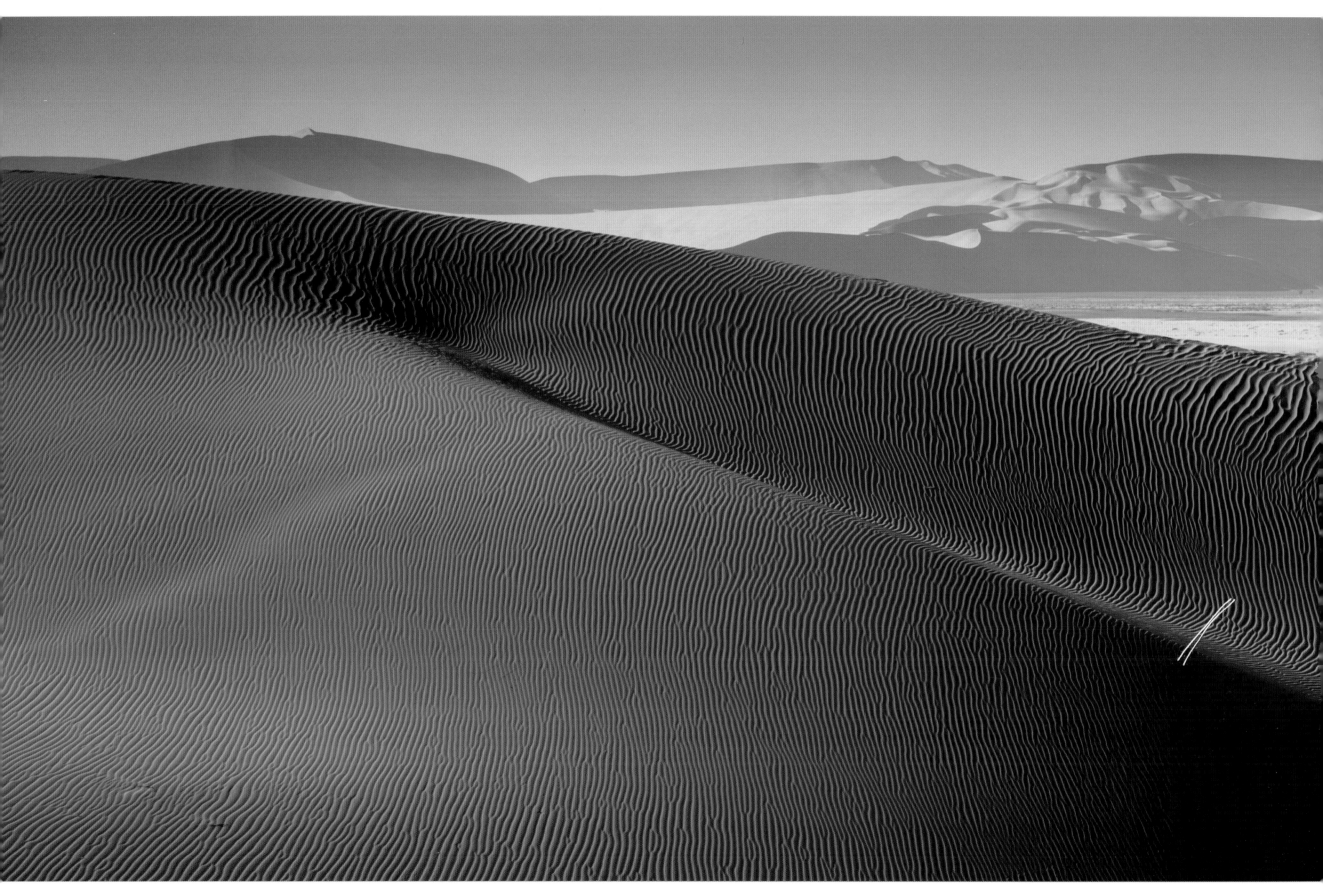

SAND DUNES, Sossusvlei, Namib-Naukluft Park, Namibia

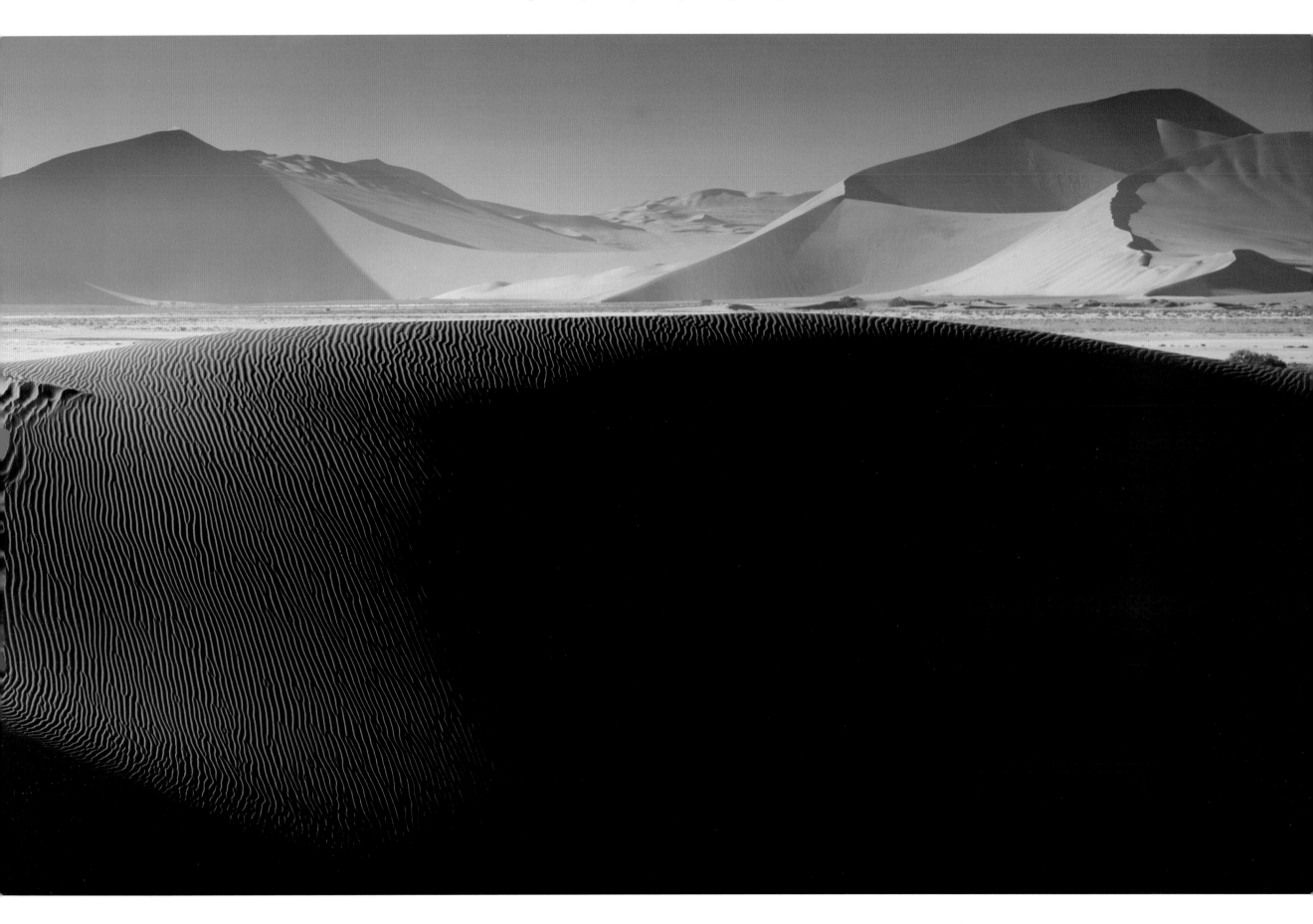

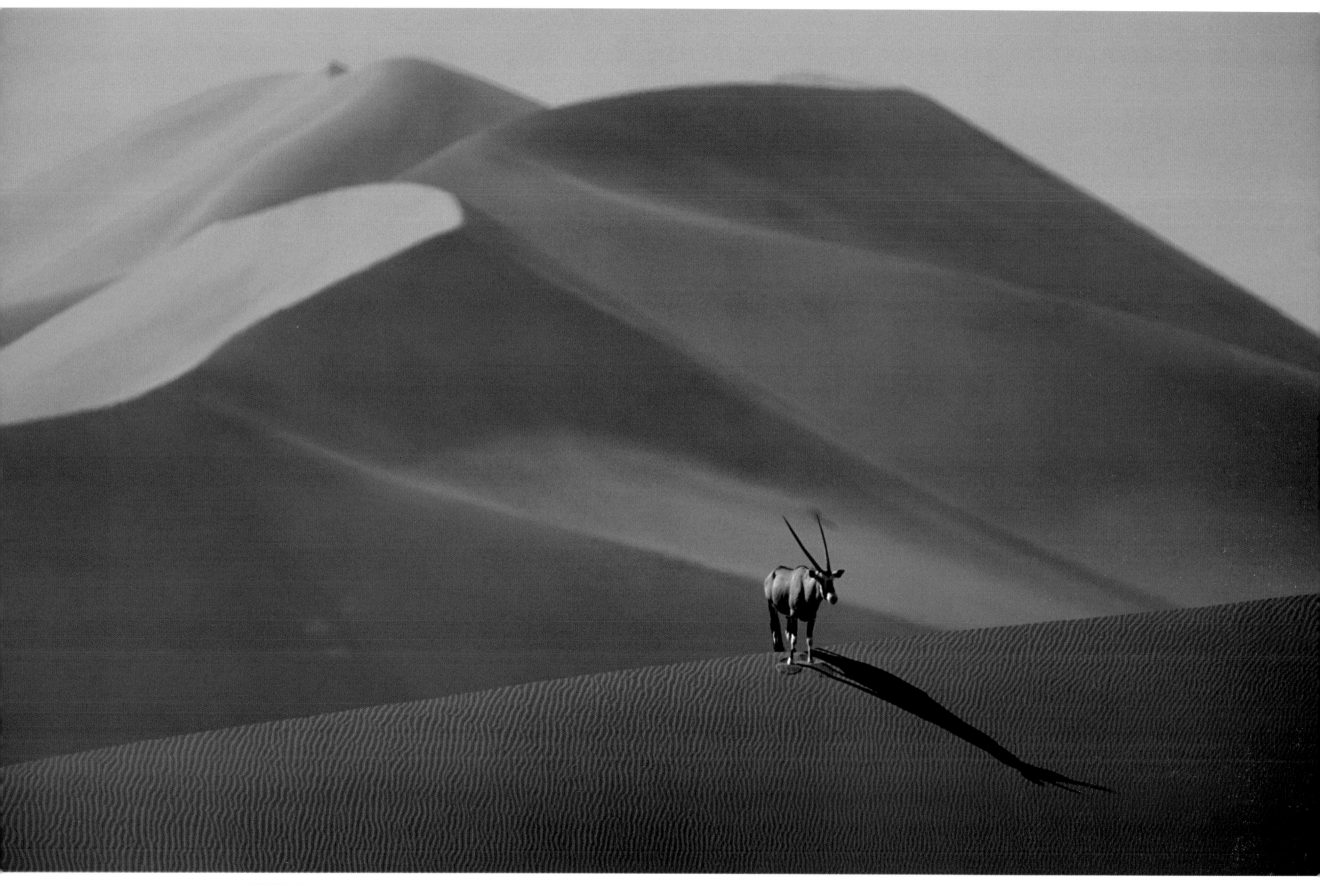

GEMSBOK (*Oryx gazella*), Sossusvlei, Namib-Naukluft Park, Namibia

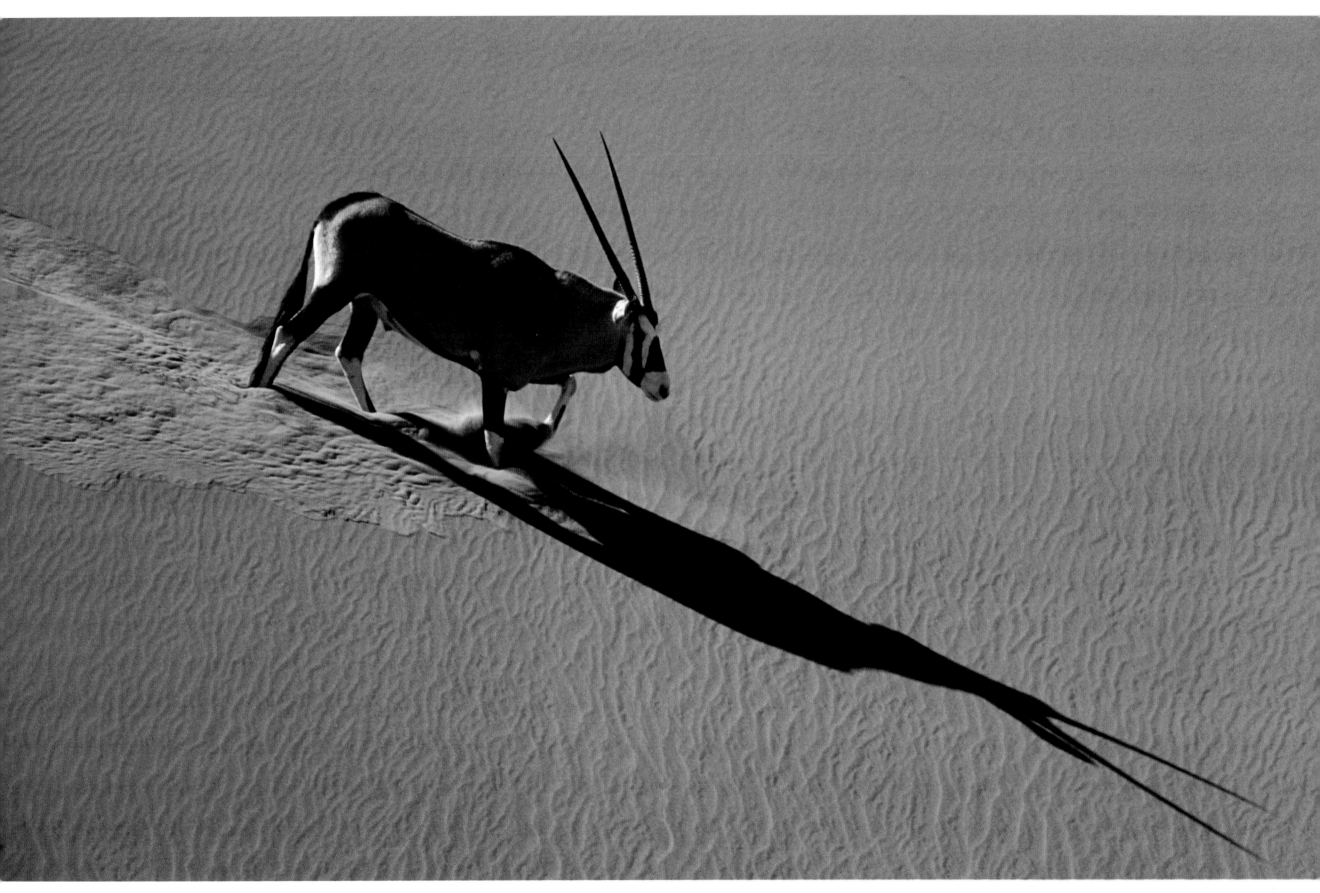

GEMSBOK (*Oryx gazella*), SOSSUSVLEI, NAMIB-NAUKLUFT PARK, NAMIBIA

TEMPORARY LAKE, Sossusvlei, Namib-Naukluft Park, Namibia

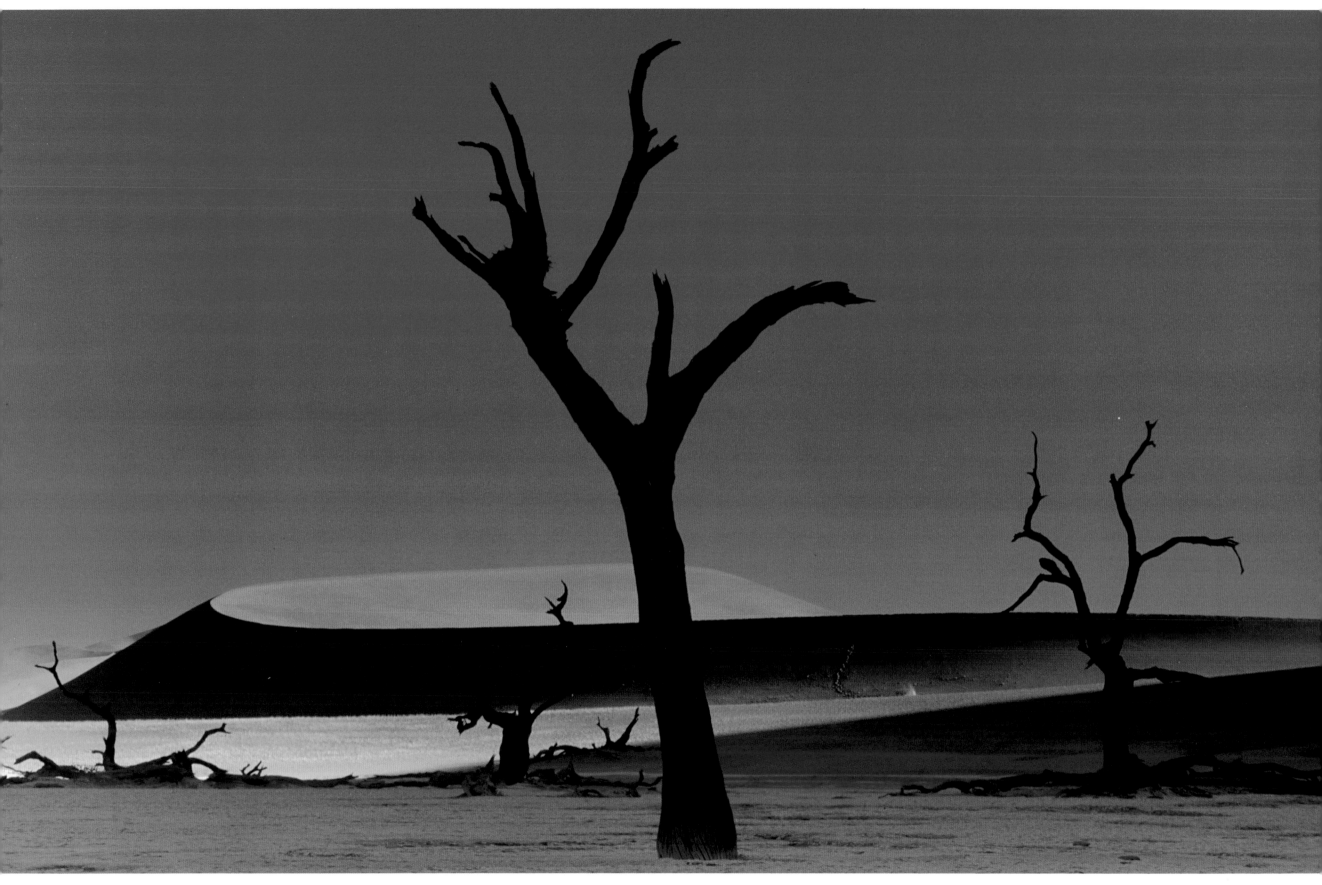

DEAD ACACIA TREE (*Acacia* sp.), Sossusvlei, Namib-Naukluft Park, Namibia

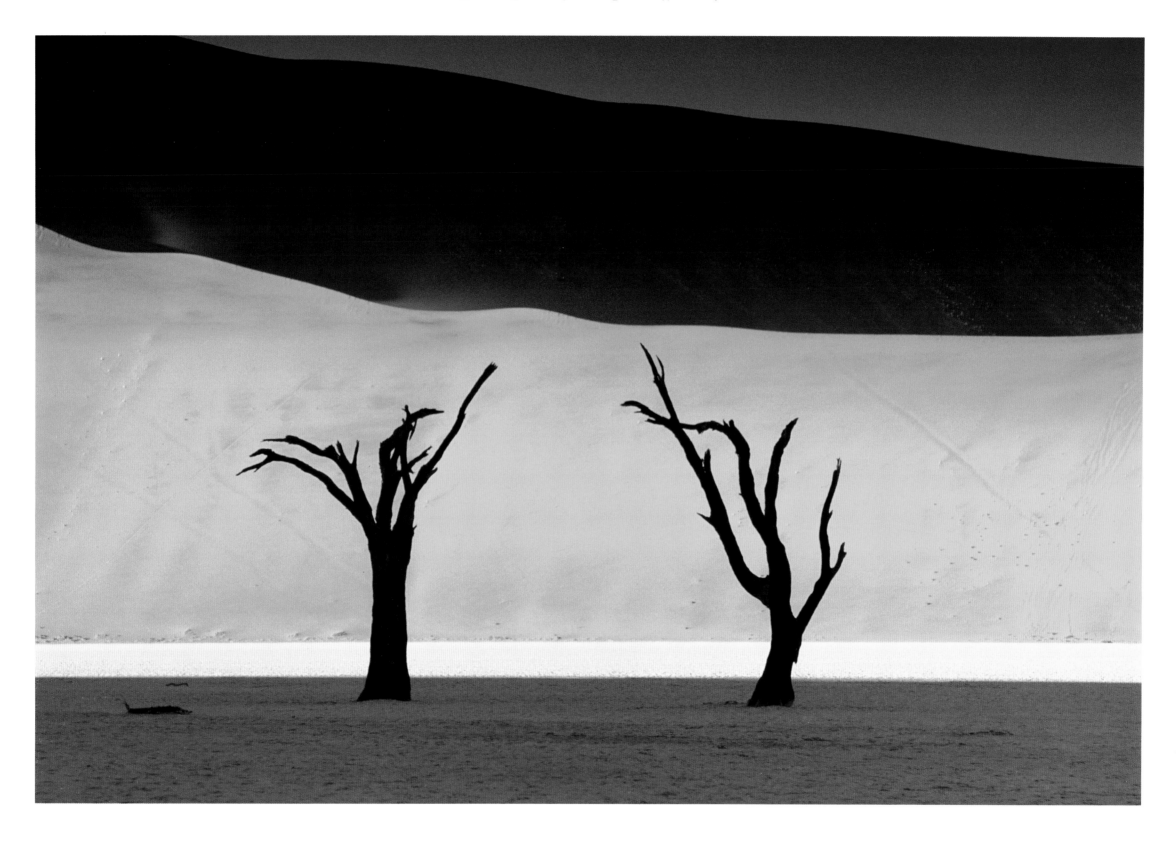

DEAD ACACIA TREE (*Acacia sp.*), Sossusvlei, Namib-Naukluft Park, Namibia

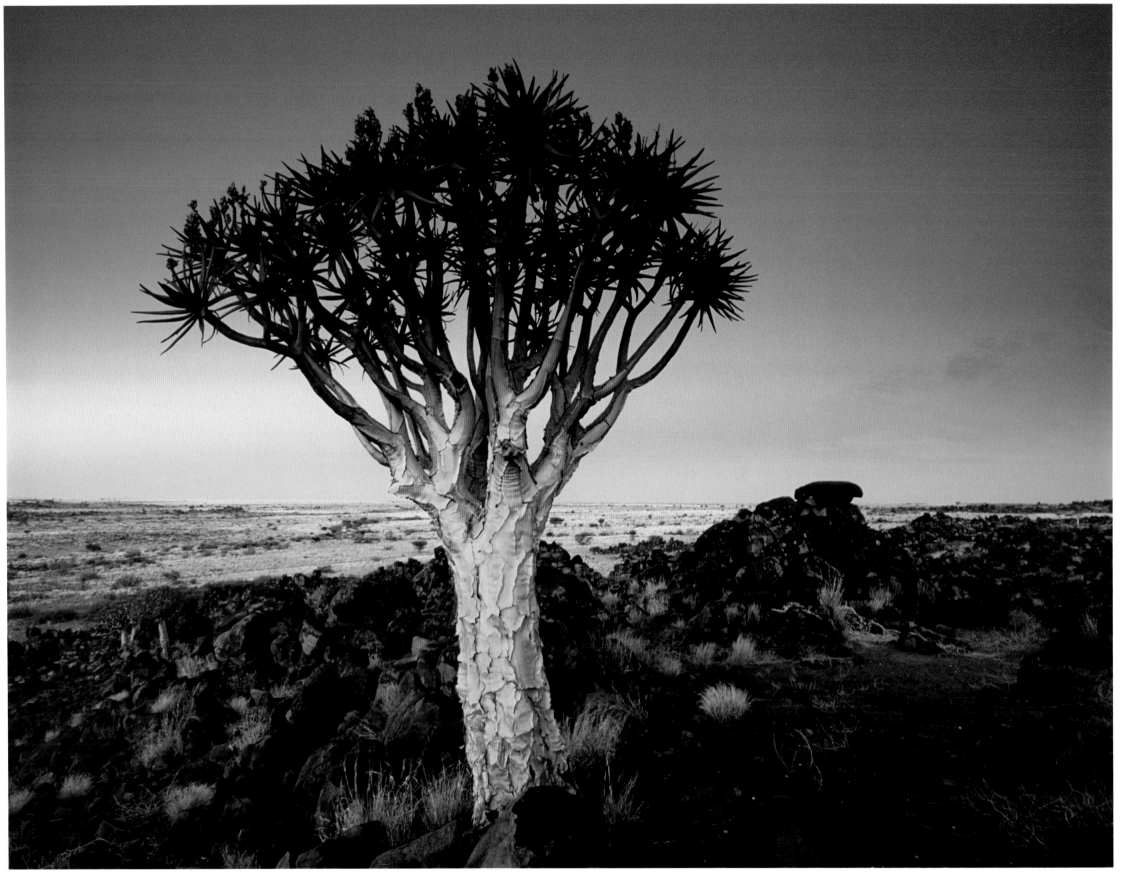

QUIVER TREE (*Aloe dichotoma*), SOSSUSVLEI, NAMIB-NAUKLUFT PARK, NAMIBIA

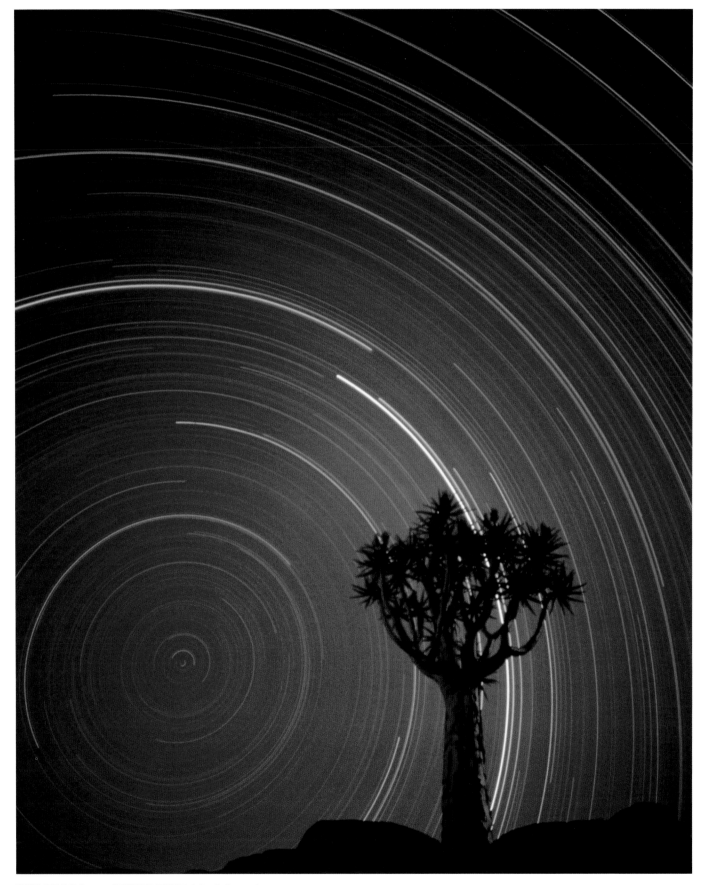

STAR TRAILS AND QUIVER TREE (*Aloe dichotoma*), SOSSUSVLEI, NAMIB-NAUKLUFT PARK, NAMIBIA

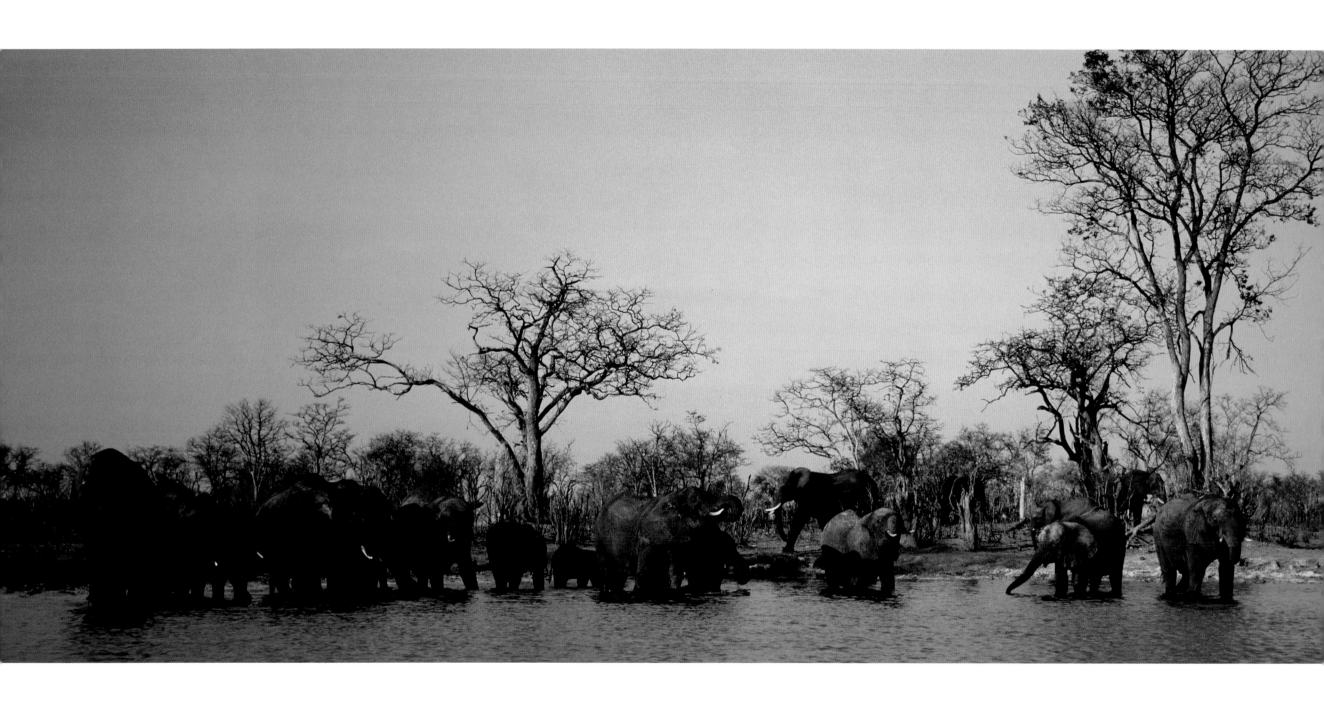

AFRICAN ELEPHANT (*Loxodonta africana*), Chobe National Park, Botswana

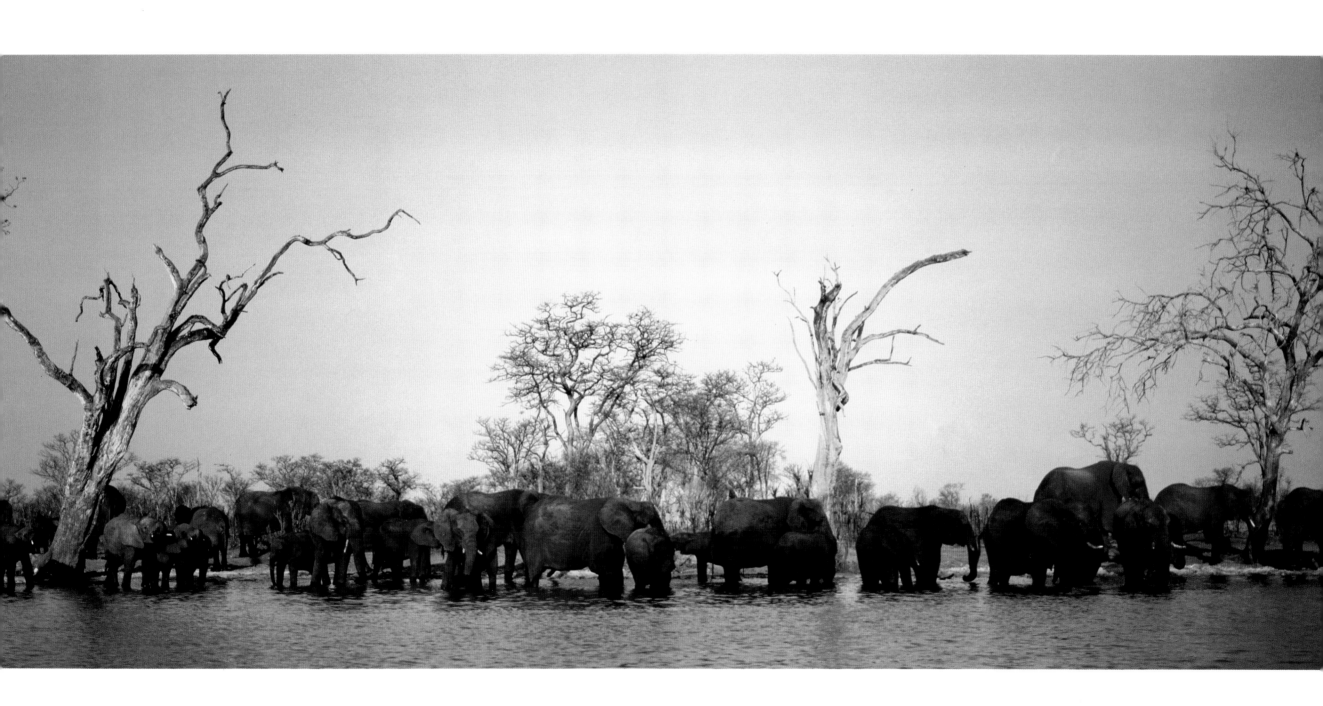

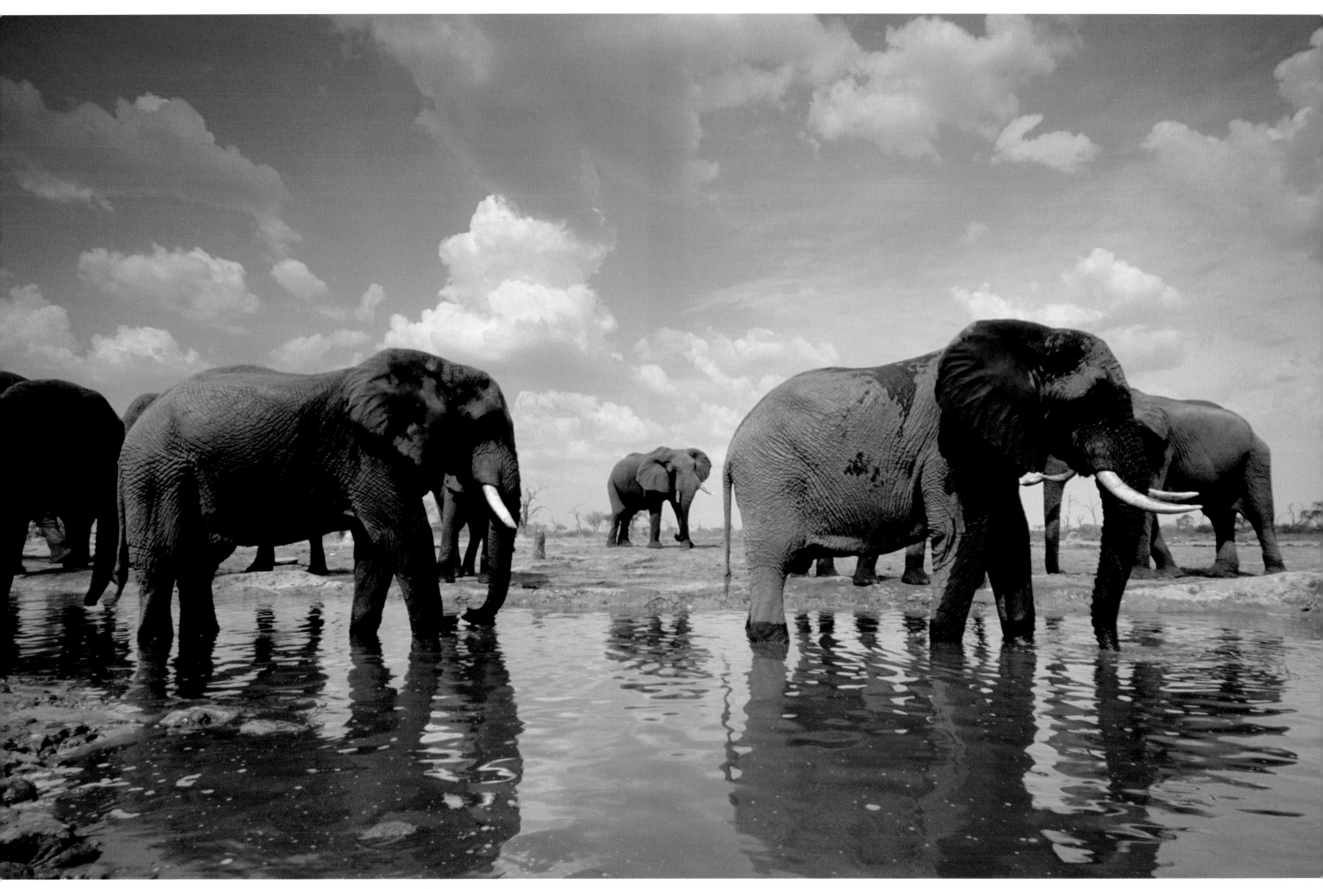

AFRICAN ELEPHANT (*Loxodonta africana*), SAVUTI, CHOBE NATIONAL PARK, BOTSWANA

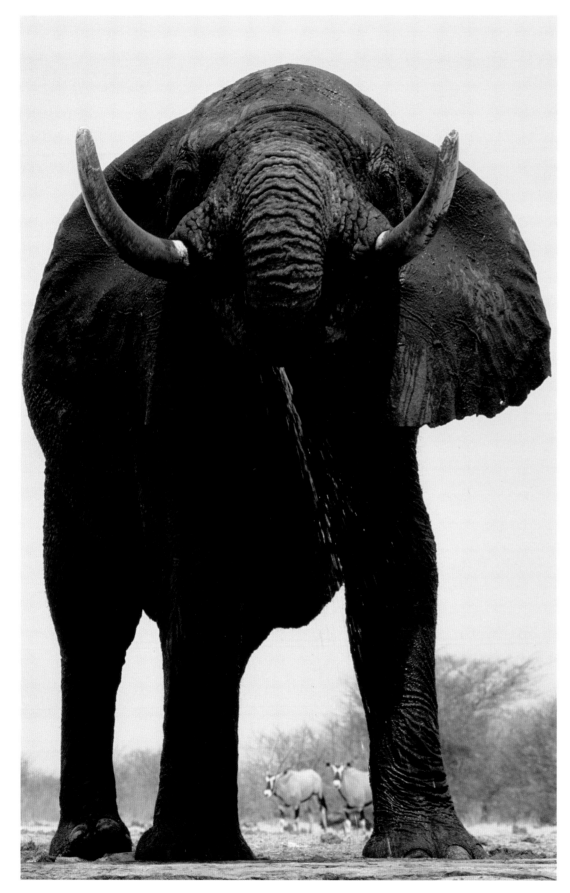

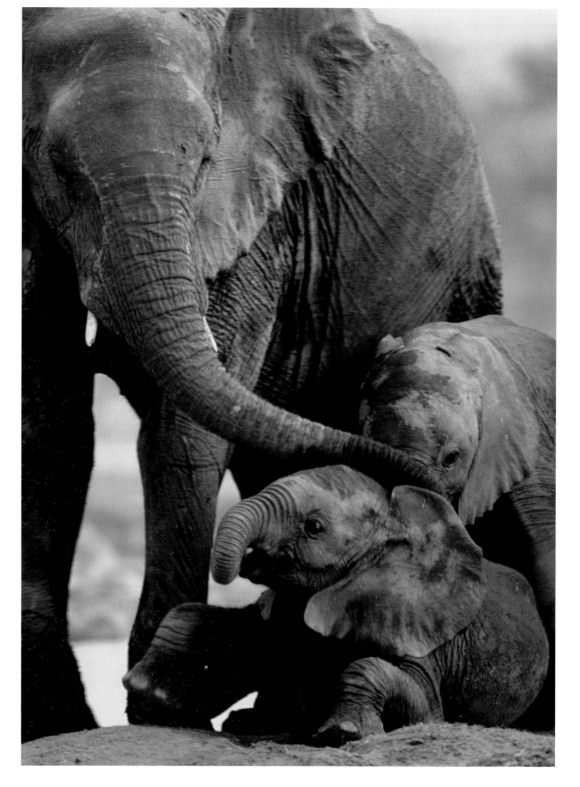

▲ AND ▶ AFRICAN ELEPHANT (*Loxodonta africana*), ETOSHA NATIONAL PARK, NAMIBIA

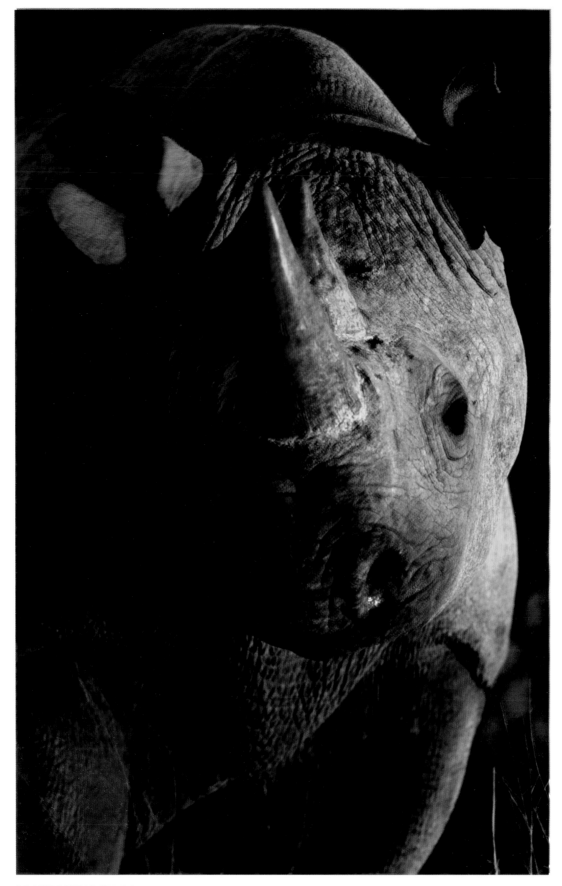

BLACK RHINOCEROS (*Diceros bicornis*), KALAHARI DESERT, SOUTH AFRICA

PETROGLYPH, Twyfelfonstein region, Namibia

BUMI TRIBE, Lower Omo River, Ethiopia

KARO TRIBE, Lower Omo River, Ethiopia

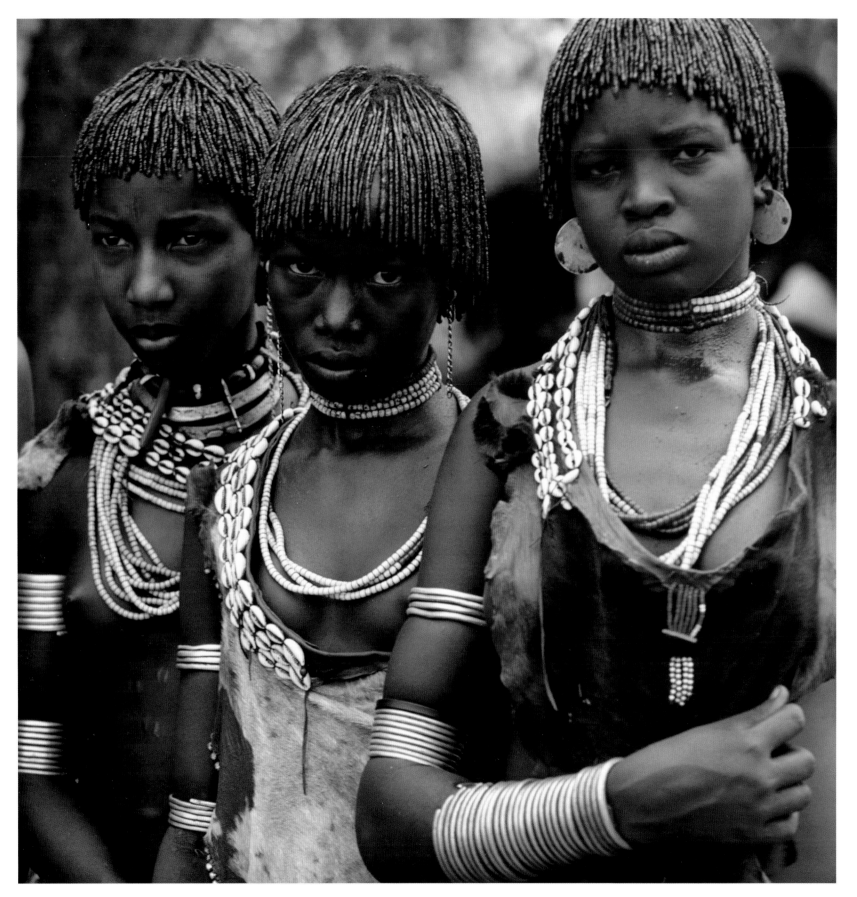

HAMAR TRIBE, Lower Omo River, Ethiopia

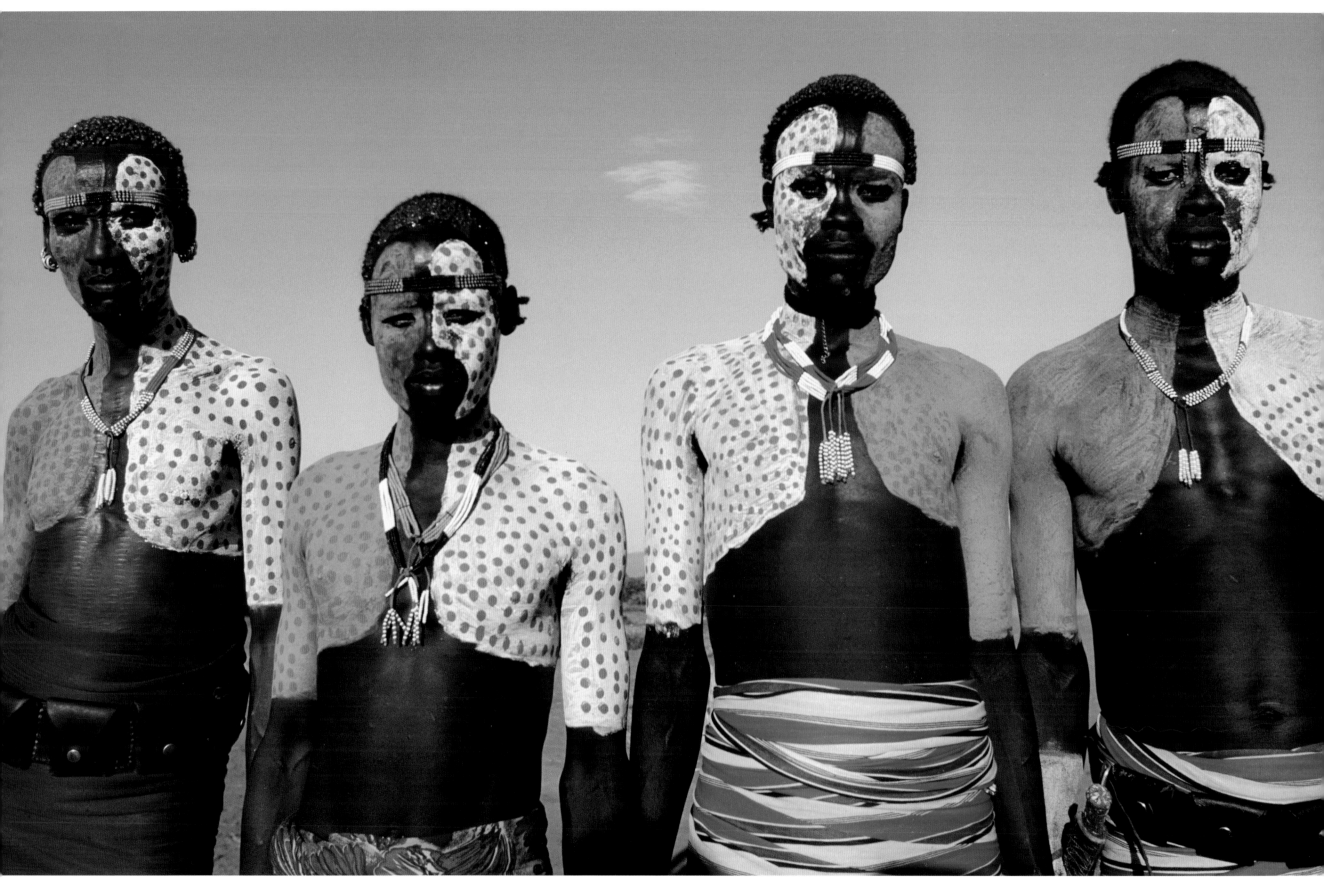

KARO TRIBE, Lower Omo River, Ethiopia

KARO TRIBE, LOWER OMO RIVER, ETHIOPIA

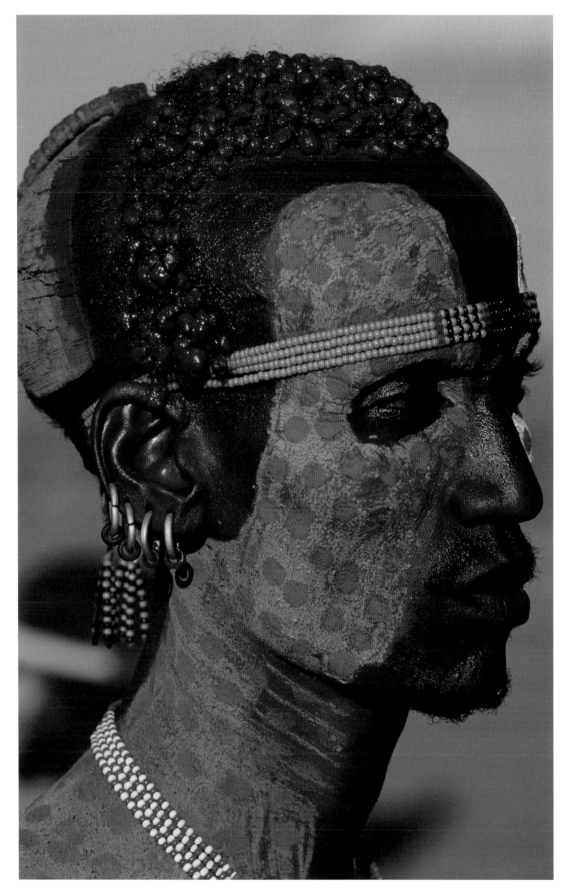 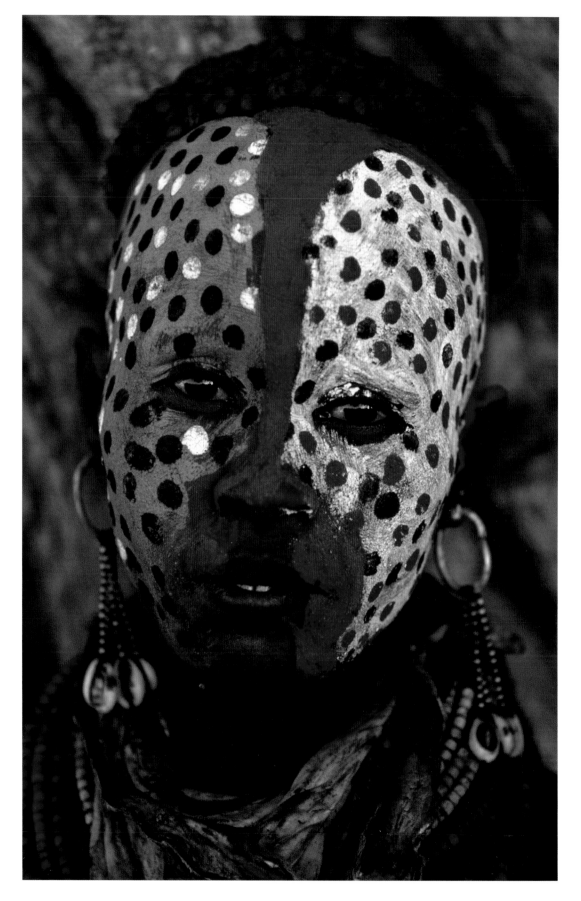

▲ AND ► KARO TRIBE, LOWER OMO RIVER, ETHIOPIA

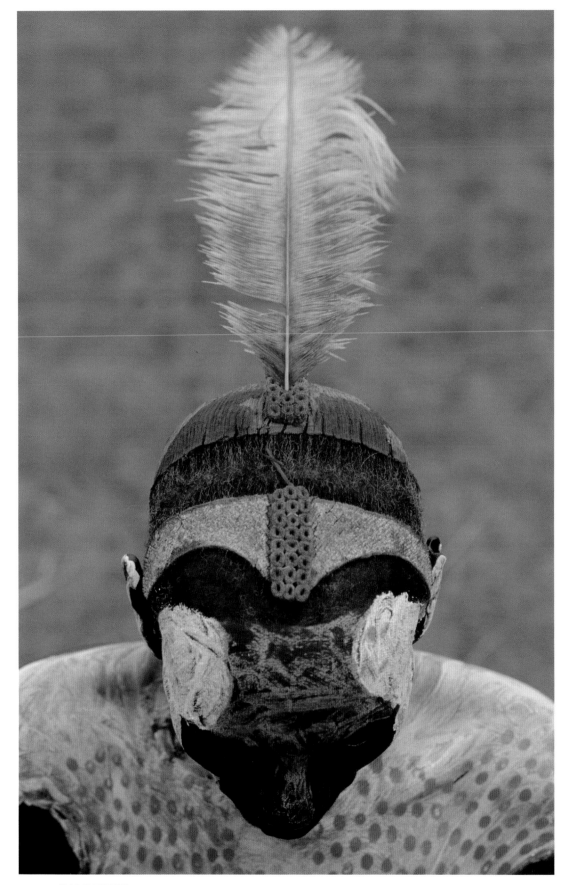

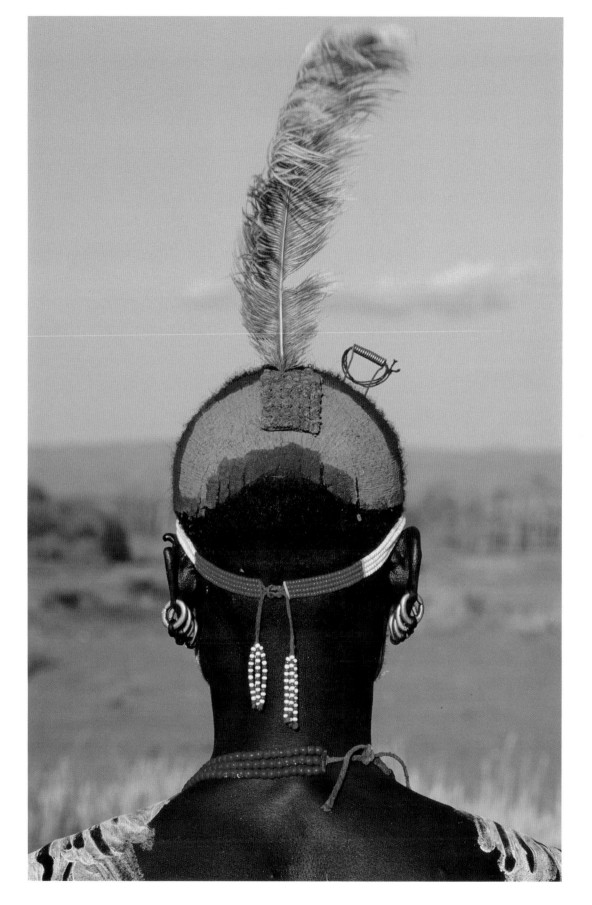

▲ AND ► KARO TRIBE, LOWER OMO RIVER, ETHIOPIA

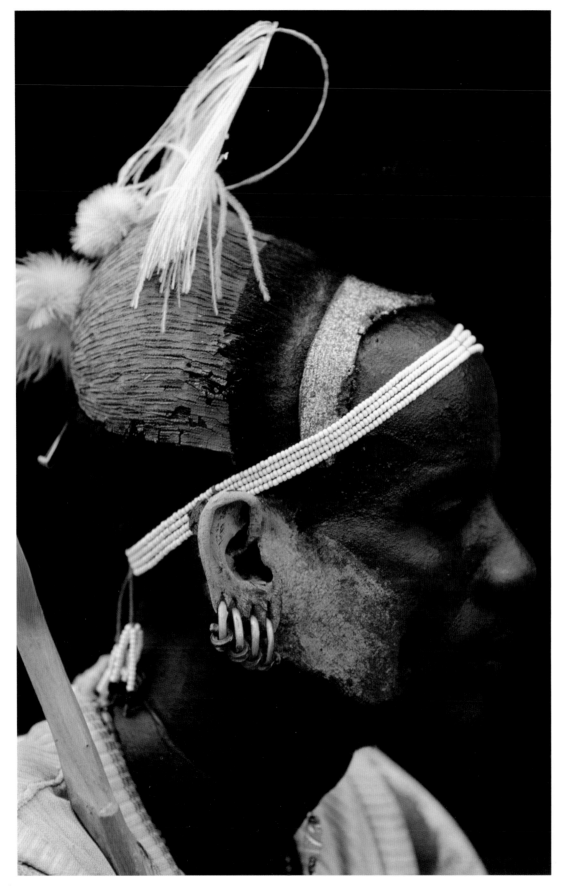

HAMAR TRIBE, Lower Omo River, Ethiopia

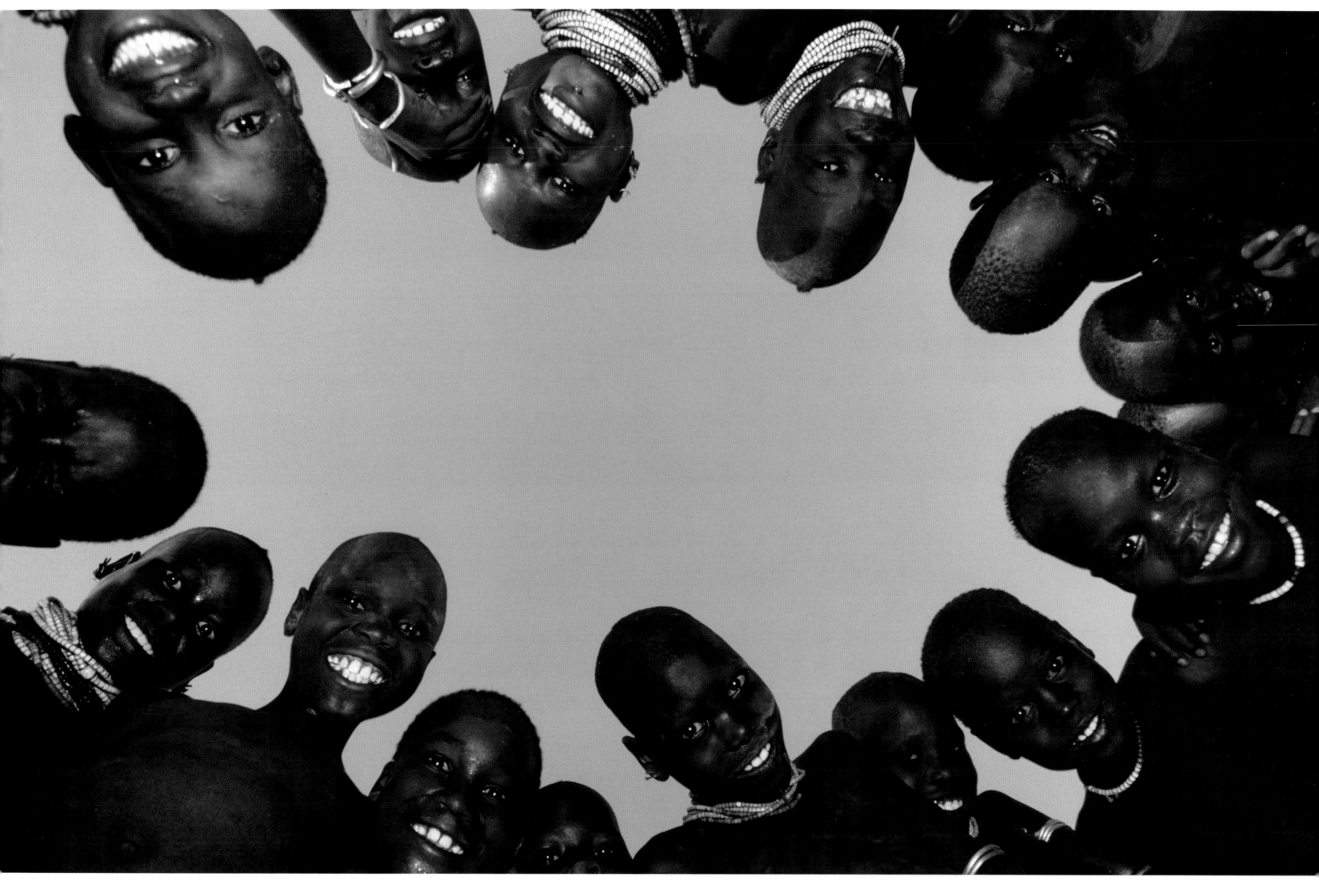

BUMI TRIBE, Lower Omo River, Ethiopia

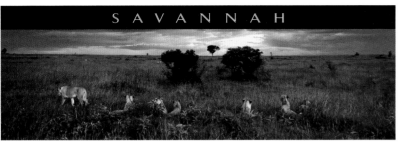

SAVANNAH

18–19 LION

In Kenya's Maasai Mara National Reserve, a pride of lions stirs in the waning light. As night falls, the lions will fan out over the surrounding plains, hunting in unison. I chose a wide-angle lens, shooting from 15 feet away. I also used a 2-stop graduated neutral density filter to slightly darken the sky.

Canon EOS-1N, Canon EF 17–35mm lens, 2-stop graduated neutral density filter, f/16 at 1/8 second, Fujichrome Provia film

21 LION

I wanted this image from Kruger National Park printed upside down as it is here to make the perspective even more ambiguous.

Canon EOS-1N/RS, Canon EF 600mm lens, f/11 at 1/60 second, Fujichrome Provia film

26–27 SERENGETI PLAIN

To convey the vast open space of the landscape of Tanzania's Tarangire Park as much as possible and as an alternative to traditional panoramic photography, I exposed side-by-side 35mm images, using a tripod.

Canon EOS-1N, Canon EF 70–200mm lens, 2-stop graduated neutral density filter, f/11 at 1/60 second, Fujichrome Velvia film

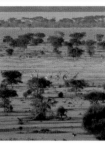

28–29 GIRAFFE

Giraffes wander among the acacia trees, which grow evenly across the plains near the Grumeti River in Serengeti National Park, Tanzania. These trees provide important forage for giraffes, which have long, tough tongues that seem to be unaffected by the trees' sharp thorns.

Canon EOS-1N, Canon EF 70–200mm lens, f/11 at 1/60 second, Fujichrome Velvia film

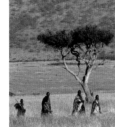

30 MAASAI TRIBE

Maasai women in Kenya cross the open savannah between the Mara River and their village. The red and orange that the Maasai wear are warning colors to the area's lions. Maasai and lions are adversaries sharing the same environment. While photographing lions, I have seen them suddenly get up and sneak into the brush at the sight of a Maasai walking across the plain.

Canon EOS-1N, Canon EF 70–200mm lens, f/8 at 1/250 second, Fujichrome Provia film

31 MAASAI VILLAGE

From an ultralight, the layout of a Maasai village in Kenya's Mara River region is clear. Known as a *boma*, the village contains several huts and livestock enclosures, all of which are surrounded by a thick fence of thorn bush. During the day, the goats and cattle are let out to graze the savannah's bountiful grasses. By late afternoon, all the livestock are brought back into the safety of the *boma*.

Canon EOS-1N, Canon EF 70–200mm lens, f/5.6 at 1/250 second, Fujichrome Provia film

32 MAASAI MORAN

A Maasai Moran in the Mara River region wears a headdress of ostrich plumes. Before the practice was outlawed by the Kenyan government, headdresses were customarily made from lions' manes. I especially like the way the light reflects off the youth's skin.

Canon EOS-1N, Canon EF 70–200mm lens, f/16 at 1/15 second, Fujichrome Velvia film

33 (both) MAASAI TRIBE

The Maasai tribe is one of the most distinctive of Africa. Maasai women customarily wear long red dresses or robes and large beaded necklaces, elaborate earrings, and headdresses. In these two photographs from the Ngorongoro Conservation Area, Tanzania, the bright equatorial sun reflects back into the shadows where the women are sitting at the entrance to their adobe-walled homes.

Canon EOS-3, Canon EF 70–200mm lens, f/11 at 1/30 second, Fujichrome Velvia film

34 LAKE NATRON

Indicating scale, animal tracks combine with the graceful lines of a small river fanning out across the dried lakebed of Lake Natron, on the Kenya-Tanzania border. This photograph was taken from an ultralight 500 feet above the land's surface.

Canon EOS-1N, Canon EF 70–200mm lens, f/5.6 at 1/250 second, Fujichrome Provia film

35 FLAMINGO

An aerial view of Lake Natron's shoreline reveals how precious freshwater is here. This small flock of lesser flamingos drink the freshwater flowing into the otherwise heavily alkaline waters of Lake Natron. Lake Natron and several other lakes are situated along the Great Rift Valley where the waters are thick with salts and minerals.

Canon EOS-1N, Canon EF 70–200mm lens, f/5.6 at 1/250 second, Fujichrome Provia film

36 FLAMINGO

It was difficult to imagine that such a dry, desolate area could support any life at all. Yet as we approached Kenya's Lake Magadi from the air, we suddenly discovered that it was teeming with colorful lesser flamingos. As we grew close they lifted in waves across the shallows of the lake.

Nikon N90S, Nikkor 80–200mm lens, f/2.8 at 1/500 second, Fujichrome Velvia film

37 FLAMINGO

I photographed these flamingos as they sprinted across shallow Lake Magadi to gain momentum for flight. Gliding above them in an ultralight, I concentrated solely on perspective. The drama of the scene was intensified by the sharp contrast between the birds' brilliant pink legs and the dark green water.

Nikon N90S, Nikkor 80–200mm lens, f/2.8 at 1/500 second, Fujichrome Velvia film

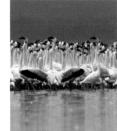

38–39 FLAMINGO

Seeking a more intimate perspective of the flamingos, I lay in the mud at the edge of Kenya's Lake Nakuru, quietly waiting for them to move closer. Sweeping back and forth in tight formation, the flamingos created a sea of perpetual pink motion.

Nikon N90S, Nikkor 800mm lens, f/11 at 1/125 second, Fujichrome Velvia film

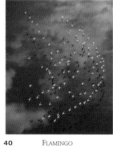

40 FLAMINGO

Flamingos migrate up and down the Rift Valley as the water levels change, creating dramatic visual patterns as they fly en masse. This shot was taken above Lake Magadi from an ultralight in the cool calm of early morning. I caught the birds as they flew over a reflection of the clouds that drifted above us. Later in the day, when the temperature soared to 100°F (38°C), thermal turbulence made flying and photography impossible.

Nikon N90S, Nikkor 80–200mm lens, f/2.8 at 1/500 second, Fujichrome Velvia film

41 FLAMINGO

A large flock of lesser flamingos were startled as an African fish-eagle swooped low over their ranks at Lake Bogoria, Kenya. Because I was using an aperture of f/22 to get all the birds in focus, I already had my camera set at 1/4 second shutter speed. The resulting image was a blur of motion, which I like.

Canon EOS 1N/RS, Canon EF 600mm lens, f/22 at 1/4 second, Fujichrome Provia film

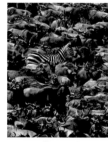

42 ZEBRA & WILDEBEEST

The lone Burchell's zebra engulfed by a sea of moving wildebeests in Kenya's Maasai Mara National Reserve caught my attention. I waited for the instant when the confused zebra turned directly into the herd, and I framed it off-center to add a sense of tension to the image. The eye is drawn straight to the zebra. The fact that the zebra is taller than the wildebeests and standing on a slight knoll accentuates the effect.

Nikon N90S, Nikkor 600mm lens, f/16 at 1/30 second, Fujichrome Velvia film

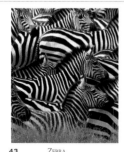

43 ZEBRA

Part of a herd numbering in the hundreds, Burchell's zebras approach the crocodile-filled Mara River. I waited until the animals had come to a standstill. Then, using a small aperture that required a corresponding slow shutter speed, I was able to bring all of the zebras into focus.

Nikon N90S, Nikkor 200–400mm lens, f/16 at 1/60 second, Fujichrome Velvia film

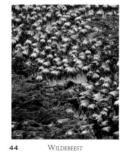

44 WILDEBEEST

A massive herd of common wildebeests resembles a plague of locusts as they head across the gently rolling hills above the Mara River. I took this photograph from an adjacent ridge slightly above the moving herd. The added elevation gave me a perspective in which individual animals are distinguished from one another.

Canon EOS-1N/RS, Canon EF 600mm lens, f/16 at 1/60 second, Fujichrome Velvia film

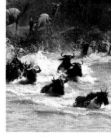

45 WILDEBEEST

A herd of common wildebeests storm the Mara River, frightened by the knowledge that enormous Nile crocodiles lie in their path. Whenever I am taking photographs that require depth of field plus sufficient speed for groups of animals on the move, I calculate my depth of field using the camera's preview button. If I decide I need a little more speed, I push my film 1 stop.

Canon EOS-1N/RS, Canon EF 600mm lens, f/11 at 1/500 second, Fujichrome Velvia film (pushed 1 stop)

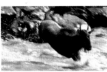
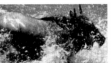

A terrified common wildebeest leaps as far from the banks of the Mara River as possible. Crocodiles often lie hidden just below the water surface along the river's edge. Once in the water, wildebeests swim with such intensity that they appear to hydroplane across the river's surface.

Canon EOS-1N/RS, Canon EF 600mm lens, f/8 at 1/1000, Fujichrome Velvia film (pushed 1 stop)

46 WILDEBEEST
47 WILDEBEEST

Once committed to crossing the Mara River, common wildebeests will do so with reckless abandon, leaping from cliffs, plunging down steep embankments, and fording turbulent rapids. Along the way thousands of wildebeests may perish from being trampled by the frenzied herd.

Canon EOS-1N/RS, Canon EF 600mm lens, f/11 at 1/125 second, Fujichrome Provia film

48 WILDEBEEST
49 WILDEBEEST

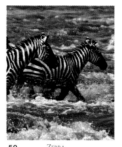

Burchell's zebras are much stronger swimmers than common wildebeests, preferring to cross the Mara River's many rapids, where they know crocodiles are less likely to be lurking.

Canon EOS-1N, Canon EF 600mm lens, f/16 at 1/250 second, Fujichrome Velvia film

50 ZEBRA

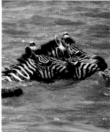

More out of reflex than hunger, a Nile crocodile approaches exhausted Burchell's zebras. By the second week of the migration, crocodiles are so full that they will not eat. In this photograph of the Mara River, the crocodile swam along with the terrified zebras but did not attack. However, you see the zebras' fear.

Canon EOS-1N, Canon EF 600mm lens, Canon Extender EF 1.4x, f/11 at 1/250 second, Fujichrome Velvia film

51 CROCODILE & ZEBRA

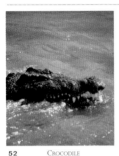

A Nile crocodile surfaces in the Mara River to scout out his next meal. Crocodiles feast only twice a year—during the river crossings of the migration. They gorge on so much meat then that it sustains them for many months.

Canon EOS-1N, Canon EF 600mm lens, Canon Extender EF 1.4x, f/16 at 1/125 second, Fujichrome Velvia film

52 CROCODILE

Nile crocodiles explode out of the water with blinding speed. In this photograph of the Mara River, a crocodile severs the tail of a very lucky wildebeest—perhaps not so lucky, because wildebeests, like most ungulates, use their tails to swat tormenting flies.

Canon EOS-1N, Canon EF 600mm lens, Canon Extender EF 1.4x, f/8 at 1/500 second, Fujichrome Velvia film

53 CROCODILE &
 WILDEBEEST

A large impala herd runs across the open savannah in the Mara River region. I deliberately stopped my lens down to f/22. The corresponding shutter speed was slow enough to create a stream of motion that provides a pleasing contrast to the stationary, single impala.

Canon EOS-1N/RS, Canon EF 600mm lens, f/22 at 1 second, Fujichrome Velvia film

54 IMPALA

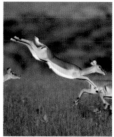

This photograph represents a turning point for me. I had always relied on manual focus with moving subjects. For this trip, I purchased an autofocus lens, suspecting that my reflexes were no match for the latest technology. When I spotted a herd of sprinting impala near the Mara River, I panned with the movement of the animals. The autofocus allowed me to get several sharply focused frames.

Canon EOS-1N/RS, Canon EF 600mm lens, f/8 at 1/500 second, Fujichrome Velvia film (pushed 1 stop)

55 IMPALA

The full moon rises above the Kenyan savannah as the post-sunset glow illuminates grazing Thomson's gazelles. Twilight is an especially dangerous time for animals such as these gazelles. The diminishing light further conceals camouflaged leopards and cheetahs, their primary predators.

Canon EOS-1N, Canon EF 70–200mm lens, f/4 at 1/8 second, Fujichrome Velvia film (pushed 1 stop)

56 GAZELLE & ZEBRA

A pride of lions slowly shake off the drowsiness of a long day's snooze in Kenya's Maasai Mara National Reserve. As nighttime falls, they will hunt in a coordinated effort, passing smaller gazelles in search of animals that will feed the entire pride. Prides have, on occasion, successfully brought down midsize elephants.

Canon EOS-1N/RS, Canon EF 20mm lens, polarizing filter, 2-stop graduated neutral density filter, f/8 at 1/8 second, Fujichrome Velvia film

57 LION

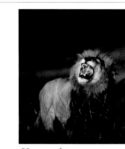

Lions such as these in Maasai Mara National Reserve are excellent subjects for photography, illustrating so many different concepts—regalness, power, and even tenderness.

Canon EOS-1N, Canon EF 70–200mm lens, f/5.6 at 1/60 second, Fujichrome Velvia film

58 LION

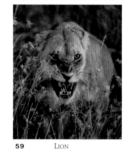

In South Africa's Kruger National Park, a lioness hisses toward an approaching amorous male. Lions are record contenders for their ability to copulate for hours. Consequently, a large pride of lions may have several lionesses with cubs.

Canon EOS-1N, Canon EF 600mm lens, f/11 at 1/125 second, Fujichrome Velvia film

59 LION

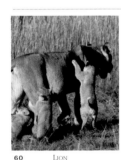

Rambunctious cubs gang-tackle their tolerant mother as she seeks the shade of a nearby tree in Kruger National Park. Young cubs such as these provide endless photo opportunities while they're awake. Unfortunately, they burn out quickly and can sleep for many hours while I impatiently wait for them to awaken.

Canon EOS-1N/RS, Canon EF 70–200mm lens, f/11 at 1/250 second, Fujichrome Provia film

60 LION

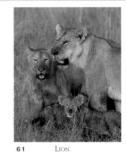

Within a lion pride, the lionesses are the primary food providers, making more kills than the males. Once a kill has been made, however, the males rush in and eat first while females and then cubs wait their turn. Here full-bellied cubs and a lioness in Maasai Mara National Reserve have just finished gorging on an African buffalo.

Canon EOS-1N, Canon EF 600mm lens, f/11 at 1/125 second, Fujichrome Velvia film

61 LION

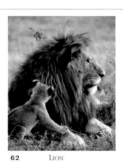

Male lions seldom interact with their offspring. In this photograph a young cub in Maasai Mara National Reserve tries to get his father's attention. I like this photograph because of the nice contrast between the young and the old.

Canon EOS-1N/RS, Canon EF 70–200mm lens, f/4 at 1/60 second, Fujichrome Velvia film

62 LION

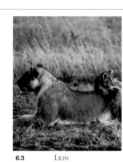

A first-year cub in Maasai Mara National Reserve seeks the comfort and safety of its mother's hindquarters. Cubs of this age frequently investigate their surroundings, but the moment something startles them, they immediately return to their mothers.

Canon EOS-1N/RS, Canon EF 600mm lens, f/11 at 1/8 second, Fujichrome Provia film

63 LION

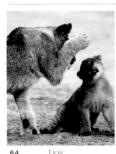

Lion cubs can be born throughout the year. In many prides, there are cubs at various ages. In this photograph in Kruger National Park, a larger cub playfully swats a small cub.

Canon EOS-1N/RS, Canon EF 600mm lens, f/5.6 at 1/250 second, Fujichrome Provia film

64 LION

When lion cubs are very small, they have a particularly tough time keeping up with the pride as it moves through tall grass. The lionesses, therefore, must ferry all of the cubs to the new location, gently picking them up one by one by the nape of the neck.

LEFT: Canon EOS-1N/RS, Canon EF 600mm lens, f/5.6 at 1/250 second, Fujichrome Provia film
RIGHT: Canon EOS-1N, Canon EF 400mm lens, f/8 at 1/125 second, Fujichrome Velvia film

65 (both) LION

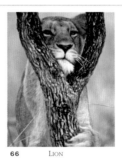

A lioness momentarily rests her chin in the crotch of a small acacia tree in South Africa's Kruger National Park. Small trees such as this might have been scent-marked earlier by other cats.

Canon EOS-1N/RS, Canon EF 600mm lens, f/8 at 1/125 second, Fujichrome Provia film

66 LION

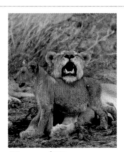

In Kruger National Park, a mother rests her head on her cub's back. Lionesses demonstrate an amazing range of behaviors, from ferocious hunter to gentle and tolerant mother.

Canon EOS-1N/RS, Canon EF 600mm lens, f/8 at 1/60 second, Fujichrome Provia film

67 LION

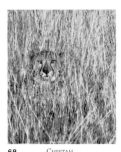

An adult cheetah in Phinda Reserve, South Africa, rests amid the savannah's tall grasses. Here not only can it conceal itself from the threat of lions, but it can also take the opportunity to pounce on a passing gazelle.

Canon EOS-1N/RS, Canon EF 70–200mm lens, f/22 at 1/15 second, Fujichrome Velvia film

68 CHEETAH

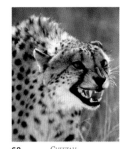

Cheetahs often have a tough time defending their kill once other predators have discovered it. Lions can easily chase the cheetah away; packs of hyenas can intimidate the outnumbered cat. Here, in the Okavango delta of Botswana, a cheetah unsuccessfully tries to ward off a hyena.

Canon EOS-1N, Canon EF 600mm lens, Canon Extender EF 1.4x, f/11 at 1/250 second, Fujichrome Provia film

69 CHEETAH

A cheetah can attain speeds of 80 miles per hour (129 km per hour), enabling it to chase down its prey. In this photograph, a cheetah outruns a Thomson's gazelle on the Kenyan savannah.

Canon EOS-1N/RS, Canon EF 600mm lens, Canon Extender EF 1.4x, f/5.6 at 1/500 second, Fujichrome Provia film

70–71 CHEETAH & GAZELLE

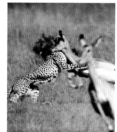

A cheetah explodes in a burst of speed and ambushes a pregnant impala in Kenya's Mara River region.

Canon EOS-1N/RS, Canon EF 600mm lens, Canon Extender EF 1.4x, f/5.6 at 1/500 second, Fujichrome Provia film

71 (top) CHEETAH & IMPALA

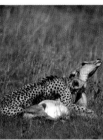

Cheetahs kill their prey by first knocking it to the ground in order to get a strangulation hold on the throat.

Canon EOS-1N/RS, Canon EF 600mm lens, Canon Extender EF 1.4x, f/5.6 at 1/500 second, Fujichrome Provia film

71 (bottom) CHEETAH & IMPALA

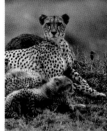

Cheetahs often rest on termite mounds, from which they are able to survey their surroundings, as here in Phinda Reserve, South Africa. This is a necessity for a mother with many cubs to keep out of harm's way.

Canon EOS-1N/RS, Canon EF 600mm lens, f/5.6 at 1/30 second, Fujichrome Provia film (pushed 1 stop)

72 CHEETAH

Rambunctious by nature, cheetah cubs such as these in Matetsi Reserve, Zimbabwe, burn off excess energy by chasing each other in circles. This age of innocence is short-lived; their mother will soon start teaching them to hunt. The maneuvering skills they develop while playing will serve them well as adults.

Canon EOS-1N/RS, Canon EF 600mm lens, f/16 at 1 second, Fujichrome Provia film

73 (all) CHEETAH

Cumulus clouds develop over the Ngorongoro Crater's rim. Formed eight million years ago, this 102-square-mile (165-sq-km) crater in Tanzania is one of the largest in the world. At 7,218 feet (2,200 m) above sea level, the crater is home to a vast variety of East African wildlife. To capture the crater's expanse, I took two exposures side by side.

Canon EOS-1N, Canon EF 70–200mm lens, 2-stop graduated neutral density filter, f/11 at 1/30 second, Fujichrome Velvia film

74–75 NGORONGORO CRATER

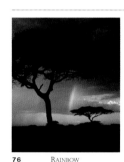

A small rainbow emerges as the sun breaks through intermittent clouds and illuminates a late-afternoon shower in Tanzania's Ndutu region. Umbrella thorns are silhouetted against the clouds.

Canon EOS-1N, Canon EF 70–200mm lens, f/11 at 1/15 second, Fujichrome Velvia film

76 RAINBOW

Tanzania's 16,893-foot (5,149-m) Mawenzi Peak is silhouetted by the rising sun as viewed from its towering neighbor, 19,340-foot (5,895-m) Mount Kilimanjaro, the highest point on the African continent.

Nikon F3, Nikkor 35mm lens, f/5.6 at 1/60 second, Kodachrome 64 film

77 MAWENZI PEAK

A herd of Burchell's zebras bound across the open savannah of Zimbabwe's Zambezi River region. I like the way longer exposures of fast-moving subjects have a way of conveying them more lyrically.

Canon EOS-1N/RS, Canon EF 600mm lens, f/22 at 1 second, Fujichrome Velvia film

78 ZEBRA

A small band of male Grant's gazelles traverse the open savannah in Kenya's Mara River region. These, along with their smaller cousins, Thomson's gazelles, prefer to graze on open savannahs where they can easily spot lions and cheetahs.

Canon EOS-1N/RS, Canon EF 600mm lens, f/22 at 1 second, Fujichrome Velvia film

79 GAZELLE

A cloud of dust rises from the southern Serengeti Plain in Tanzania as a large herd of Burchell's zebras and common wildebeests move toward a nearby waterhole. Soon March rains will transform the parched grasslands into a sea of green.

Canon EOS-1N/RS, Canon EF 70–200mm lens, f/16 at 1/60 second, Fujichrome Velvia film

80 ZEBRA & WILDEBEEST

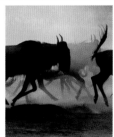

When viewed singly, common wildebeests are not the most beautiful mammals to wander the savannah. However, when the wildebeests move en masse, they take on a whole new persona. The repetition of profiles moving across the open plains epitomizes Africa to me more than any other sight.

Canon EOS-1N/RS, Canon EF 500mm IS lens, f/16 at 1/250 second, Fujichrome Provia film

81 WILDEBEEST

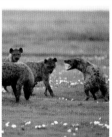

A brief altercation occurs between spotted hyenas waiting their turn at a lion kill in Serengeti National Park. Hyenas are renowned for their tenacious scavenging behavior and yet are also efficient hunters in their own right, capable of killing animals as large as zebras.

Canon EOS-1N, Canon EF 600mm lens, f/8 at 1/60 second, Fujichrome Provia film

82 HYENA

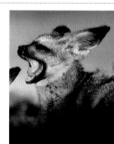

The population of bat-eared foxes rises and falls depending on the availability of insect prey. In years following those when locusts are numerous, bat-eared foxes produce large litters. This tiny carnivore, pictured here in Tanzania's Ngorongoro Conservation Area, is almost exclusively an insect eater.

Canon EOS-1N/RS, Canon EF 600mm lens, Canon Extender EF 1.4x, f/8 at 1/125 second, Fujichrome Provia film

83 FOX

In Kenya's Maasai Mara National Reserve, two male giraffes engage in a thirty-minute sparring match, delivering solid thumps to one another with powerful necks and bony heads. These battles of strength and endurance eventually determine the herd's dominant male, who will breed with the females. Giraffes are powerful animals capable of killing a lion with a single kick. However, old and weakened giraffes often fall prey to lions.

84 (both) GIRAFFE
85 (both) GIRAFFE

Canon EOS-1N/RS, Canon EF 70–200mm lens, f/8 at 1/250 second, Fujichrome Velvia film

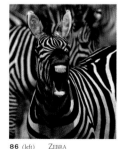

A Burchell's zebra yawns and reveals teeth perfectly designed for a lifetime of grazing the grasses of the savannah in Kenya's Maasai Mara National Reserve.

Canon EOS-1N, Canon EF 600mm lens, f/8 at 1/125 second, Fujichrome Provia film

86 (left) ZEBRA

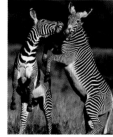

Grevy's zebras demonstrate interesting behavior in tightly packed herds. These two in Kenya's Samburu National Reserve were in a herd of about forty when one bit the other's rump. I first framed the fight horizontally, but switched to verticals as the zebras became more agitated. The driver kept moving in order to stay parallel to the zebras' ever-changing positions, while keeping the late-afternoon sun shining squarely in their faces.

Canon EOS-1N, Canon EF 600mm lens, f/8 at 1/250 second, Fujichrome Velvia film

86 (right) ZEBRA

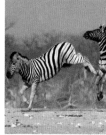

Burchell's zebras routinely engage in behavior such as biting, kicking, and chasing one another across the savannah in Etosha National Park, Namibia.

Canon EOS-1N/RS, Canon EF 600mm lens, f/11 at 1/250 second, Fujichrome Provia film

87 ZEBRA

88–89 IMPALA

There is safety in numbers as an impala herd in Kenya's Maasai Mara National Reserve attentively watches and listens with many eyes and ears, but with perhaps one mind. If one impala is startled, the entire herd reacts.

Canon EOS-1N/RS, Canon EF 600mm lens, f/16 at 1/30 second, Fujichrome Velvia film

91 ELEPHANT

In Zimbabwe's Matetsi Reserve, I pan my camera with the motion of a passing herd of breeding African elephants. The drama of a mock charge by one of the elephants is captured with a slow shutter speed.

Canon EOS-1N/RS, Canon EF 70–200mm lens, f/22 at 1/2 second, Fujichrome Provia film

96 UMBRELLA THORN

Flowering umbrella thorns glow in the afternoon light as storm clouds build on the horizon. After spring rains, the plains of Tarangire National Park, Tanzania, transforms from a dry, beige landscape into one of tall green grass and flowering trees.

Canon EOS-3, Canon EF 70–200mm lens, f/11 at 1/30 second, Fujichrome Velvia film

97 TERMITE MOUND

A termite mound rises 12 feet (3.6 m) above the ground in Tarangire National Park. The termites excavate the red soil into mounds that become striking sculptures decorating the landscape.

Canon EOS-3, Canon EF 70–200mm lens, f/11 at 1/30 second, Fujichrome Velvia film

98–99 ELEPHANT

In the Ngorongoro Crater, a small forest of yellow-barked acacia trees provide not only shade and seclusion for the unusually large bull elephants within the crater, but also a nighttime resting area for some exceptionally large black rhinoceroses.

Canon EOS-1N, Canon EF 70–200mm lens, f/16 at 1/30 second, Fujichrome Velvia film

100–101 IMPALA

In Kenya, an impala herd reacts to a sudden downpour by facing away from the angle of the rain. When I scanned across the terrain, I was amazed to see most animals standing still, facing downwind from the heavy rains. Then I saw a lion pride also seeking shelter from the storm. It appears as though predator-prey activity stops during particularly strong rainstorms.

Canon EOS-1N/RS, Canon EF 600mm lens, f/8 at 1/30 second, Fujichrome Provia film

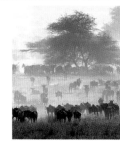

102–103 WILDEBEEST & ZEBRA

Along the migration route between the Serengeti's southern plains and Kenya's Maasai Mara River region, common wildebeests and Burchell's zebras often pass between open savannah and forested woodlands. It is interesting to see a cloud of dust rising above the forests as thousands of animals pass through, concealed by the trees.

Canon EOS-1N, Canon EF 70–200mm lens, f/11 at 1/250 second, Fujichrome Velvia film

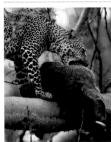

104 LEOPARD & WARTHOG

A female leopard near Kenya's Lake Nakuru begins to eat her recent kill, a warthog. Earlier in the day, the leopard ambushed and killed the potentially lethal warthog. Stout warthogs with razor-sharp tusks have mortally wounded more than one attacking predator.

Canon EOS-1N/RS, Canon EF 600mm lens, f/11 at 1/250 second, Fujichrome Velvia film

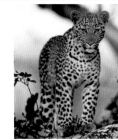

105 (left) LEOPARD

In this image in Kruger National Park, South Africa, an adolescent leopard is completely absorbed by what I am doing. In preserves, where many generations of leopards have been protected, they can become quite habituated to Landrovers and other safari vehicles.

Canon EOS-1N/RS, Canon EF 70–200mm lens, f/8 at 1/250 second, Fujichrome Velvia film

105 (right) LEOPARD & IMPALA

A leopard finds adequate cover to stalk his prey within the densely vegetated woodlands along the Samburu River in Kenya. Here, a large male leopard has just ambushed a young impala. He will quickly climb a tree, carrying the kill up and away from lions and hyenas.

Canon EOS-1N/RS, Canon EF 600mm lens, f/5.6 at 1/250 second, Fujichrome Provia film

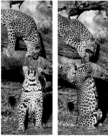

106 (both) LEOPARD

A pair of young leopards play amid the limbs of a tree in Sabi Sands Game Reserve, South Africa. During the heat of the day, the young leopards slept soundly in the deep shade of dense brush. As the sun set, and the air cooled, the leopard twins suddenly sprang to life.

Canon EOS-1N/RS, Canon EF 600mm lens, f/5.6 at 1/15 second, Fujichrome Velvia film

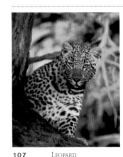

107 LEOPARD

In South Africa's Kalahari Desert, an inquisitive leopard peers around a tree trunk and watches as I try to maneuver the beanbag that supports my camera. The spots of a leopard are perfectly patterned to enable the predator to blend with the dappled light of the habitat in which it lives.

Canon EOS-1N/RS, Canon EF 600mm lens, f/11 at 1/125 second, Fujichrome Velvia film

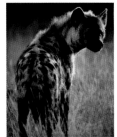

108 HYENA

Spotted hyenas, such as this one at Kwando, Botswana, are quite opportunistic. They not only pilfer other predators' kills, but also hunt in packs. Hyenas also are the primary cause of mortality among adolescent leopards.

Canon EOS-1N, Canon EF 600mm lens, Canon Extender EF 1.4x, f/5.6 at 1/60 second, Fujichrome Provia film

109 WILD DOG & HYENA

A spotted hyena is severely bitten by a pack of wild dogs. The lone hyena had inadvertently wandered into the wild dogs' denning territory and paid the price.

Canon EOS-3, Canon EF 70–200mm lens, f/8 at 1/500 second, Fujichrome Velvia film

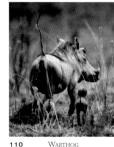

110 WARTHOG

A warthog with two tiny offspring trailing behind ambles across a clearing in the woodlands of the Kwando River region of northern Botswana. With babies this small, a warthog does not venture far from its protective den, usually a deeply dug hole.

Canon EOS-1N, Canon EF 600mm lens, f/8 at 1/250 second, Fujichrome Provia film

111 WILD DOG & WARTHOG

Caught off guard in the open in the Kwando River region, a warthog has quickly returned to its den. It has backed in, leaving its head, equipped with sharp tusks, in a position to defend itself. After a few moments, the wild dog moves on, deciding that the risk of injury is too great.

Canon EOS-1N/RS, Canon EF 600mm lens, Canon Extender EF 1.4x, f/5.6 at 1/250 second, Fujichrome Provia film

112 WILD DOG & WILDEBEEST

In the Mara River region of Kenya, wild dogs bring down a common wildebeest. By first attacking the snout and hindquarters with razor-sharp teeth, the wild dogs quickly immobilize the larger animal. Within seconds the wild dogs begin biting into the wildebeest's flesh, eating it alive.

Nikon F3, Nikkor 200–400mm lens, f/4 at 1/125 second, Fujichrome 100 film

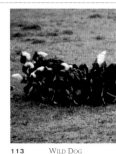

113 WILD DOG

In less than fifteen minutes after first contact, a large pack of wild dogs reduces an entire wildebeest to a few bloody bones. Early European settlers were so repulsed by the wild dogs' method of hunting that they tried to eradicate them from the African continent.

Nikon F3, Nikkor 200–400mm lens, f/4 at 1/125 second, Fujichrome 100 film

114 VULTURE

African white-backed vultures quickly move in to clean up all remaining morsels of flesh left behind from a recent kill in Kenya's Mara River region. The sight of circling vultures is often the first indication that a kill has occurred.

Canon EOS-1N/RS, Canon EF 600mm lens, f/16 at 1/60 second, Fujichrome Velvia film

African white-backed vultures have a serpentine neck, enabling them to reach their heads into the deepest recesses of a carcass.

Canon EOS-1N/RS, Canon EF 600mm lens, Canon Extender EF 1.4x, f/11 at 1/125 second, Fujichrome Velvia film

115 (both) VULTURE

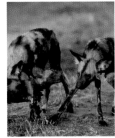

Even though the alpha male and female wild dog are the only ones in a pack to breed, most adults share the responsibility of protecting their pups and providing them with food.

Canon-1N/RS, Canon EF 70–200mm lens, f/11 at 1/60 second, Fujichrome Provia film

116 WILD DOG

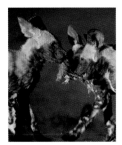

Part of a litter of eleven, these pups in Botswana'a Kwando River region played for hours near their den entrance. Here they play tug-of-war with a small scrap of fur left over from a previous kill.

Canon EOS-1N/RS, Canon EF 600mm lens, f/8 at 1/250 second, Fujichrome Provia film

117 WILD DOG

Most mammals are plagued by ticks and other insects, so they welcome yellow-billed oxpeckers as hitchhikers. Occasionally oxpeckers annoy their hosts by pursuing an insect up a nostril or two.

ALL: Canon EOS-1N, Fujichrome Velvia film
118 (BOTH): Canon EF 600mm lens, f/8 at 1/250 second
119 (BOTH): Canon EF 600mm lens, Canon Extender EF 1.4x, f/5.6 at 1/125 second

118 (both) OXPECKER
119 (left-top & bottom)

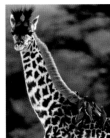

Red-billed oxpeckers are well adapted for their role: a pointed tail and sharp claws help them maneuver and hang on; a blunt, flattened beak helps them dislodge ticks, other parasites and even bits of tissue from wounds on their host.

Canon EOS-1N/RS, Canon EF 600mm lens, Canon Extender EF 1.4x, f/8 at 1/125 second, Fujichrome Provia film

119 (right) OXPECKER

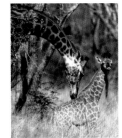

A giraffe arches her tremendous neck to sniff her young baby in the forests of South Africa's Sabi Sands Game Reserve. Giraffes with young this small are exceptionally wary of any intruder in their vicinity.

Canon EOS-1N/RS, Canon EF 600mm lens with 1.4 extender, f/11 at 1/60 second, Fujichrome Velvia film

120 GIRAFFE

Olive baboons live in large social troops. When the babies are born, they are closely guarded by not only the mother, but close relatives as well.

ALL: Canon EOS-1N, Fujichrome Velvia film
LEFT-TOP: Canon EF 100 Macro lens, f/11 at 1/60 second
LEFT-BOTTOM & RIGHT: Canon EF 600mm lens, f/16 at 1/60 second

121 OLIVE BABOON
(left-top & bottom; right)

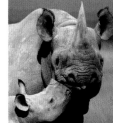

A black rhinoceros nuzzles its mother in Tanzania's Ngorongoro Crater. Black rhinoceroses are easily distinguished from white rhinoceroses by their pointed upper lip.

Canon EOS-1N/RS, Canon EF 600mm lens, Canon Extender EF 1.4x, f/11 at 1/250 second, Fujichrome Velvia film

122 BLACK RHINOCEROS

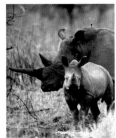

A white rhinoceros and her calf browse the bushes of a forest in South Africa's Phinda Reserve. A calf this small is a bundle of energy that runs in circles around its patient mother. I accompanied a tracker for several hours before we located the pair.

Canon EOS-1N, Canon EF 600mm lens, Canon Extender EF 1.4x, f/11 at 1/60 second, Fujichrome Provia film

123 WHITE RHINOCEROS

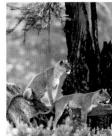

From the vantage of an acacia log, lionesses intently watch a herd of zebras pass by the edge of the forest in Ngorongoro Conservation Area of Tanzania. A few moments later, the lions descended to the ground and began stalking the herd.

Canon EOS-1N/RS, Canon EF 70–200mm lens, Canon Extender EF 1.4x, f/5.6 at 1/250 second, Fujichrome Velvia film

124 LION

A pair of ostriches with babies walk down a forest road in northern Botswana's Chobe National Park. At this age, the chicks' with their stubby little legs have a difficult time negotiating the tall grass, so the adults were very reluctant to leave the road. Eventually, we drove our four-wheel-drive vehicle off the road to get past the ostriches without disturbing them.

Canon EOS-1N/RS, Canon EF 600mm lens, f/11 at 1/125 second, Fujichrome Velvia film

125 OSTRICH

A martial eagle, one of the world's most powerful eagles, perches high on a tree limb along the Samburu River in Kenya. In this photograph, the eagle is eating a small antelope it had killed.

Canon EOS-1N, Canon EF 600mm lens, Canon Extender EF 1.4x, f/8 at 1/125 second, Fujichrome Provia film

126 EAGLE

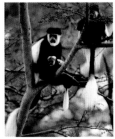

High up in a yellow-barked acacia tree in Kenya's Lake Nakuru National Park, an Abyssinian black-and-white colobus monkey cradles its baby. These large monkeys seem to fly through the trees trailing large tails with bushy white tufts on the tips.

Canon EOS-1N/RS, Canon EF 600mm lens, f/5.6 at 1/125 second, Fujichrome Velvia film

127 MONKEY

The Surma tribe lives in the forested mountains in southwestern Ethiopia. Here, the Surma are adorning themselves with designs created from a mixture of water and clay, basically finger-painting on their skin. This custom of self-adornment is practiced during ceremonial occasions commemorating a marriage, birth, or death of a tribal member.

Canon EOS-1N, Canon EF 70–200mm lens, f/16 at 1/60 second, Fujichrome Velvia film

128 (both) SURMA TRIBE
129 SURMA TRIBE

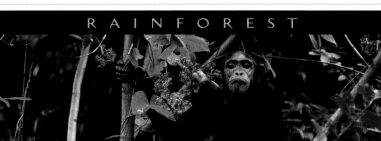

RAINFOREST

While munching berries along the shores of Lake Tanganyika in Tanzania's Mahale Mountains National Park, a chimpanzee casts an indignant look toward me.

Canon EOS-1N/RS, Canon EF 70–200mm lens, f/5.6 at 1/125 second, Fujichrome Velvia film (pushed 1 stop)

130–131 CHIMPANZEE

A mountain gorilla casually glances my way as I try to gain a clear view through the extraordinarily thick vegetation of Uganda's Bwindi Impenetrable National Park. The dense vegetation found in the mountains where Uganda, Rwanda, and Zaire share borders is probably the main reason the gorillas have survived in such a war-torn region.

Canon EOS-1N, Canon EF 70–200mm lens, f/8 at 1/60 second, Fujichrome Provia film

133 GORILLA

Early morning mists rise above Uganda's Bwindi Impenetrable National Park. Here a variety of primates live, including the largest of them all, the mountain gorilla. The Bwindi forest connects with protected forests in Rwanda and Zaire.

Canon EOS-1N, Canon EF 70–200mm lens, f/16 at 1/15 second, Fujichrome Velvia film

138 RAINFOREST

What first struck me about Bwindi Impenetrable National Park was how benign it seems. Cool and comfortable, the forest reminded me of my own backyard, the Olympic Peninsula rainforest, where ferns and mosses prevail.

Canon EOS-1N, Canon EF 17–35mm lens, f/22 at 1/2 second, Fujichrome Velvia film

139 RAINFOREST

As you ascend from the 4,000-foot (1,219-m) level on Mount Kilimanjaro's lower slopes in Tanzania to the lofty summit of 19,500 feet (5,944 m), you pass through several environments. Around 9,000 feet (2,743 m), cloud forests blanket Kilimanjaro with trees draped in mosses and lichen.

Nikon F3, Nikkor 80–200mm lens, f/11 at 1/15 second, Kodachrome 64 film

140 RAINFOREST

One of the most difficult things about photographing a rainforest such as this one in Bwindi Impenetrable National Park, is trying to capture on film what you see in person. Often the landscape is too dense to show it clearly. In this shot, taken from a ridge, I was able to find an opening in the canopy that allowed me to convey a better sense of depth.

Canon EOS-1N, Canon EF 70–200mm lens, f/22 at 1/15 second, Fujichrome Velvia film

141 RAINFOREST

I love to photograph all aspects of the landscapes I encounter, not only the "big picture" but also the minutiae, as shown in this photograph in Uganda's Kibale Forest National Park. The beautiful jade-colored lichens and tiny blossom caught my eye, so I focused on these few leaves on the forest floor.

Canon EOS-1N, Canon EF 100mm Macro lens, f/16 at 1/4 second, Fujichrome Velvia film

142 FALLEN LEAVES

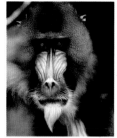

The mandrill boasts the brightest colors among mammals. Until recently, little was known of their behavior in the wild. A few years ago, researchers working in the forests of Cameroon witnessed what appeared to be a mass migration of these midsize primates numbering up to five hundred individuals. (captive)

Canon EOS-1N, Canon EF 500mm lens, f/8 at 1/60 second, Fujichrome Provia film

143 MANDRILL

A pair of red-tailed guenons watch from the safety of the forest canopy in Kibale Forest National Park, Uganda. Photographing primates in a rainforest can be difficult at best. I was able to photograph these two from a concealed position in a Landrover traveling along a rural road.

Canon EOS-1N, Canon EF 600mm lens, f/5.6 at 1/125 second, Fujichrome Provia film

144 GUENON

This photograph of an Abyssinian black-and-white colobus monkey was taken from a trail winding through Kibale Forest National Park. The amount of time that a primate usually stays in the open is incredibly brief. I therefore walk through the forest with my camera mounted on my tripod, ready for that brief glimpse.

Canon EOS-1N, Canon EF 600mm lens, Canon Extender EF 1.4x, f/5.6 at 1/30 second, Fujichrome Provia film

145 MONKEY

A young chimpanzee inquisitively watches from high in a rainforest tree in Tanzania's Mahale Mountains National Park. Researchers studying their behavior had habituated the troop of chimpanzees that I photographed.

Canon EOS-1N, Canon EF 600mm lens, f/11 at 1/60 second, Fujichrome Provia film

146 CHIMPANZEE

Chimpanzees are undeniably similar to humans. In this photograph, late-afternoon sun shines through the forest canopy and illuminates the face of this old male chimpanzee that researchers warned had a cranky disposition.

Canon EOS-1N, Canon EF 600mm lens, f/11 at 1/60 second, Fujichrome Provia film

147 CHIMPANZEE

Chimpanzees spend an inordinate amount of time sitting on the forest floor grooming each other, looking for the ticks and lice that infest these large primates.

Canon EOS-1N, Canon EF 70–200mm lens, f/4 at 1/30 second, Fujichrome 100 film

148 CHIMPANZEE

It is uncanny how closely chimpanzee behavior mirrors that of humans. It is also fascinating to see how they use their hands in similar ways.

LEFT: Canon EOS-1N, Canon EF 70–200mm lens, f/11 at 1/60 second, Fujichrome Provia film
RIGHT: Canon EOS-1N/RS, Canon EF 70–200mm lens, f/8 at 1/125 second, Fujichrome Provia film

149 (both) CHIMPANZEE

A troop of mountain gorillas in Rwanda's Parcs National des Volcans are dominated by a single large male known as a "silverback," which refers to the gray hair on his back. As I photographed his troop, he only occasionally glanced in my direction.

Canon EOS-1N, Canon EF 70–200mm lens, f/11 at 1/125 second, Fujichrome Provia film

150 (both) GORILLA

In Bwindi Impenetrable National Park, Uganda, a silverback mountain gorilla stares directly into my camera lens from a distance of about 12 feet (3.6 m). Perhaps he was studying his own reflection in the lens' glass or was simply amused by my fumbling with the camera.

Canon EOS-1N, Canon EF 70–200mm lens, f/11 at 1/15 second, Fujichrome Provia film

151 GORILLA

An adolescent mountain gorilla enjoys a snack of wild celery, one of the primary foods of this species. A steady rain fell as I photographed the gorilla in Parcs National des Volcans. The subdued light softened the contrast, resulting in a better image.

Canon EOS-1N, Canon EF 70–200mm lens, f/5.6 at 1/60 second, Fujichrome Provia film

152 GORILLA

A baby mountain gorilla stumbles close to where I was photographing to gain a better view of the intruder with the strange equipment. Whenever I have filmed mountain gorillas, the babies seem the most curious.

Canon EOS-1N, Canon EF 70–200mm lens, f/8 at 1/60 second, Fujichrome Provia film

153 GORILLA

This photograph of a flat-tailed leaf gecko involved an all-day trek through dense rainforest in Madagascar to the top of a mountain where these 11-inch- (28-cm-) long reptiles live camouflaged on tree trunks.

Canon EOS-1N, Canon EF 70–200mm lens, f/16 at 1/4 second, fill flash, Fujichrome Velvia film

154 GECKO

Jungle panther chameleons are known for their ability to change color rapidly. This particular chameleon changed from red to yellow in minutes. I was able to find many of these chameleons in a forest on the north end of Madagascar.

Canon EOS-1N, Canon EF 100mm Macro lens, f/16 at 1/60 second, full flash, Fujichorme Velvia film

155 CHAMELEON

Lemurs come in all sizes and can be found in all habitats on the enormous island of Madagascar. Pictured here is a black-and-white ruffed lemur.

Canon EOS-1N, Canon EF 600mm lens, f/11 at 1/250 second, Fujichrome Velvia film

156 (left) LEMUR

I find the red-fronted brown lemur to be one of the most approachable of the lemurs. I used fill flash to enhance the detail of the lemur, which was in deep shade on Madagascar.

Canon EOS-1N, Canon EF 70–200mm lens, f/11 at 1/4 second, fill flash, Fujichrome Velvia film

156 (right) LEMUR

The red-ruffed lemurs are my favorite primates to photograph. Their gentle nature makes them a delight to capture on film. This one on the Masoala Peninsula of Madagascar sat and quietly watched me as I worked.

Canon EOS-1N, Canon EF 600mm lens, f/11 at 1/60 second, Fujichrome Velvia film

157 LEMUR

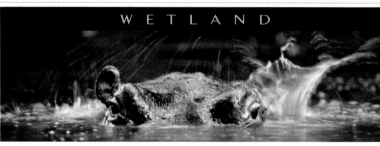

WETLAND

A hippopotamus flicks his ear and creates a stir in the slow-flowing Grumeti River, which winds its way through Tanzania's Serengeti Plain. Hippos are considered among the most dangerous animals in Africa. In this photo, the hippopotamus appears to be eyeing me.

Canon EOS-1N, Canon EF 600mm lens, Canon Extender EF 1.4x, f/8 at 1/250 second, Fujichrome Provia film

158–159 HIPPOPOTAMUS

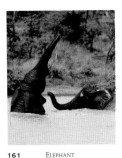

African elephants love water. It is never more apparent than when they frolic in the cool water on hot afternoons. These two young elephants in Kenya's Mpala Research Centre, Nanyuki, played for more than an hour, at times remaining totally submerged for several moments before exploding to the surface.

Canon EOS-1N/RS, Canon EF 600mm lens, f/8 at 1/300 second, Fujichrome Provia film

161 ELEPHANT

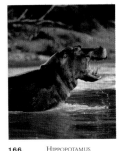

A large hippopotamus rises from murky waters in Tanzania's Selous Game Reserve. The sandy-bottomed rivers of the Selous contain the highest numbers of hippopotamuses in Africa.

Canon EOS-3, Canon EF 70–200mm lens, f/4 at 1/250 second, Fujichrome Provia film

166 HIPPOPOTAMUS

To most people who have not traveled to Africa, hippopotamuses appear to be large, lovable Disney-like creatures. In reality, they can be aggressive and dangerous, especially when surprised while out of water. I created a more dramatic image of this hippopotamus at Tanzania's Lake Manyara by taking a long exposure.

Canon EOS-1N/RS, Canon EF 600mm, f/22 at 1/8 second, Fujichrome Velvia film

167 HIPPOPOTAMUS

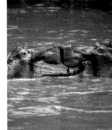

Hippopotamuses face off in Tanzania's Grumeti River. Like most mammals, male hippopotamuses engage in battles to establish dominance.

Canon EOS-1N/RS, Canon EF 600mm lens, Canon Extender EF 1.4x, f/5.6 at 1/125 second, Fujichrome Provia film

168–169 HIPPOPOTAMUS

An African elephant herd approaches a watercourse in Kenya's Amboseli National Park. Every morning this same herd routinely emerged from the forests to drink and then bathe in the water. You are never more aware of how fast elephants can move than when you see them walk toward you.

Canon EOS-1N/RS, Canon EF 70–200mm lens, f/11 at 1/125 second, Fujichrome Provia film

170 ELEPHANT

Once a thirsty herd of African elephants smell water, they move very rapidly. I used a long exposure to further convey a sense of speed. I like the effect; these elephants in Matetsi Reserve, Zimbabwe, appear almost to levitate off the ground.

Canon EOS-1N/RS, Canon EF 600mm lens, f/22 at 1 second, Fujichrome Velvia film

171 ELEPHANT

African elephants obviously enjoy a cooling waterhole in Kenya's hot and dry Nanyuki region. To get these shots, I remained concealed behind some bushes at the water's edge.

Canon EOS-1N, Canon EF 600mm lens, Canon Extender EF 1.4x, f/11 at 1/500 second, Fujichrome Velvia film

172–173 ELEPHANT
(all)

An African elephant's trunk contains approximately 100,000 muscles, enabling it to execute a great variety of precise movements, as in these two photographs.

Canon EOS-1N, Canon EF 600mm lens, Canon Extender EF 1.4x, f/11 at 1/500 second, Fujichrome Velvia film

174 ELEPHANT
175 ELEPHANT

Sunrise silhouettes the African buffalo that have come for a morning drink along Tanzania's Lake Manyara. This species rarely ventures far from water. They often stand up to their necks in water for long periods of time until hunger drives them to graze in the adjacent marshes.

Canon EOS-1N, Canon EF 70–200mm lens, f/16 at 1/30 second, Fujichrome Velvia film

176 SUNRISE

An African buffalo at Tanzania's Lake Manyara allows a yellow-billed oxpecker to clean its skin of annoying ticks. Lone buffalos are especially dangerous, occasionally ramming vehicles or attacking people on foot. Sexually frustrated and often driven from the herd, these old bulls charge anything that moves.

Canon EOS-1N, Canon EF 600mm lens, f/16 at 1/15 second, Fujichrome Velvia film

177 BUFFALO & OXPECKER

African buffalo run through the tall grass as they approach a marsh in Kruger National Park, South Africa. I especially like long exposures, which render the subject in a simplistic painterly way. This particular photograph reminds me of cave paintings from southern France.

Canon EOS-1N/RS, Canon EF 600mm lens, f/22 at 1 second, Fujichrome Velvia film

178 BUFFALO

A herd of African buffalo in search of water stir up a cloud of dust as they race across a dry lakebed in Amboseli National Park in southern Kenya. During the wet season, the lake swells with runoff from nearby Mount Kilimanjaro. Deforestation on Kilimanjaro's slopes has led to floods on the plains below, devastating the Amboseli forests.

Nikon F3, Nikkor 80–200mm lens, f/2.8 at 1/500 second, Fujichrome 100 film

179 BUFFALO

Within Botswana's Okavango delta, an African fish-eagle swoops across a lake's surface to pluck a fish out of the water. I first exposed for the setting sun, then used fill flash to add detail to the otherwise silhouetted eagle.

Canon EOS-1N, Canon EF 70–200mm lens, f/16 at 1/125 second, fill flash, Fujichrome Provia film

180 FISH-EAGLE

The sun rises above Zimbabwe's famed Victoria Falls along the Zambezi River. As tremendous as the falls were the day I took this photograph, there are times when the volume of water is so great that the rising mists completely obscure views of the falls.

Canon EOS-1N, Canon EF 70–200mm lens, f/16 at 1/15 second, Fujichrome Velvia film

181 SUNRISE

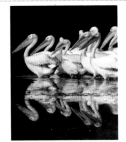

Great white pelicans amass near the mouth of the freshwater stream flowing into Kenya's alkaline Lake Nakuru. I positioned my tripod as low to the lake's surface as possible, to capture the reflections of these majestic birds.

Canon EOS-1N/RS, Canon EF 600mm lens, f/16 at 1/60 second, Fujichrome Velvia film

182 PELICAN

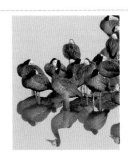

White-faced whistling ducks rest along the shore of a coastal pond in Phinda Reserve near South Africa's Indian Ocean. Whenever I have multiple subjects such as this flock of ducks, I utilize smaller aperture settings to ensure that all individuals are in focus.

Canon EOS-1N, Canon EF 600mm lens, f/22 at 1/15 second, Fujichrome Provia film

183 DUCK

A 4-inch (10-cm) malachite kingfisher warms itself in the first rays of the rising sun in the Okavango delta. For years I have tried to get close portraits of this tiny African "gem," only to be frustrated by its alert and hyper behavior. Finally, my tenaciousness paid off; actually this particular bird was amazingly tolerant.

Canon EOS-1N, Canon EF 600mm lens, Canon Extender EF 1.4x, f/8 at 1/60 second, Fujichrome Velvia film

184 KINGFISHER

An Egyptian goose is silhouetted against the setting sun in Botswana's Okavango delta. Using the equivalent of an 840mm lens requires quick responses, because the sun moves very fast at such high magnification.

Canon EOS-1N/RS, Canon EF 600mm lens, Canon Extender EF 1.4x, f/22 at 1/250 second, Fujichrome Velvia film

185 GOOSE

DESERT

A large herd of common elands stir the arid soils of Tanzania's Serengeti National Park. The largest of the antelopes, elands are very wary animals, because they are often hunted for their fine-tasting meat. In some parts of Africa, they are actually farmed like cattle.

Canon EOS-1N, Canon EF 600mm lens, Canon Extender EF 1.4x, f/16 at 1/60 second, Fujichrome Provia film

186–187 ELAND

Early morning light accentuates the textured bark of Namibia's quiver trees. An ancient form of aloe, quiver trees grow among the barren rock outcrops of the Namibian desert.

Canon EOS-1N, Canon 17–35mm lens, polarizing filter, f/22 at 1/15 second, Fujichrome Velvia film

189 QUIVER TREE

Several tribes of nomadic pastoralists struggle for existence in the hot, arid lands north of Ethiopia's Omo River. Because rains are sporadic at best, the tribes fiercely compete for the sparse forage.

Canon EOS-1N, Canon EF 70–200mm lens, f/16 at 1/60 second, Fujichrome Velvia film

194 BUMI TRIBE

In the Bumi tribe, the job of providing water for the family falls (literally) to the heads of the women. Three women return after collecting water from the Omo River several miles away. Their water vessels are hollowed-out gourds.

Canon EOS-1N, Canon EF 70–200mm lens, f/11 at 1/60 second, Fujichrome Velvia film

195 (left) BUMI TRIBE

In Botswana's Kalahari Desert, a man of the San tribe, once referred to as Bushmen, demonstrates how a hollowed-out ostrich egg serves as a water collection device. The San ingeniously place the large eggs under the crooked limbs of small trees. When occasional rains come, the drips from the limbs collect in the half-buried eggs.

Canon EOS-1N, Canon EF 17–35mm lens, f/8 at 1/125 second, Fujichrome Velvia film

195 (right) SAN TRIBE

The homes of the Bumi are made of light, easily erected materials, which is typical of nomadic societies. Here, a Bumi woman stands next to her home near the Lower Omo River in Ethiopia. The branches and grasses that comprise the roof and walls provide cooling shade during the extreme heat of the day.

Canon EOS-1N, Canon EF 70–200mm lens, polarizing filter, f/16 at 1/60 second, Fujichrome Velvia film

196 BUMI TRIBE

Handprints festoon the adobe walls of a Male tribe home. Often I have encountered the simple, yet beautiful repetition of handprints as a decorative motif throughout the world, from Australia to Patagonia to the deserts of Ethiopia.

Canon EOS-1N, Canon EF 70–200mm lens, f/11 at 1/8 second, Fujichrome Velvia film

197 (left) MALE TRIBE

Late-afternoon light silhouettes San tribesmen performing a traditional dance in Botswana's Kalahari Desert.

Canon EOS-1N, Canon EF 70–200mm lens, f/11 at 1/250 second, Fujichrome Velvia film

197 (right) SAN TRIBE

Two San men dressed in traditional skins stand against the post-sunset glow in Botswana's Kalahari Desert. The traditional San way of life has been all but wiped out as the Botswanan government has forced them into shantytowns where they are (theoretically) joining the modern world. Despite this, a few small bands of San still hunt in their traditional desert territories.

Canon EOS-1N, Canon EF 17–35mm lens, f/11 at 1/8 second, fill flash, Fujichrome Velvia film

198 (both) SAN TRIBE

The well-worn soles, characteristic of the San tribe, reveal a lifetime of walking barefoot across the Kalahari Desert. With their soles as tough as leather, San people can walk through an amazing array of environments, from jagged rocks to scorching snags to thorn-strewn soils.

Canon EOS-1N, Canon EF 100 Macro lens, f/16 at 1/15 second, fill flash, Fujichrome Velvia film

199 (left) SAN TRIBE

The bottom of a dry lakebed fractures in beautiful patterns in the relentless heat of the Namibian desert.

Canon EOS-1N, Canon TS-E 90mm, f/8 at 1/125 second, Fujichrome Velvia film

199 (right) LAKEBED

Sand dunes reaching a thousand feet into the sky create an otherworldly landscape in Sossusvlei in Namib-Naukluft Park, Namibia. The vast sand dunes that stretch along the Namibian coast are considered one of the driest places on Earth.

Fuji GX617, Fuji GX617 90mm lens, f/22 at 1/30 second, Fujichrome Velvia film

200–201 DUNES

A gemsbok is dwarfed by the vast sand dunes in Sossusvlei in the Namibian desert. One of the few large mammals that has adapted to this inhospitable landscape, the gemsbok obtains nearly all its water simply from moisture that collects on the leaves of specially adapted bushes.

Canon EOS-1N, Canon EF 70–200mm lens, f/16 at 1/60 second, Fujichrome Velvia film

202 GEMSBOK

A gemsbok effortlessly traverses the sand dunes' steep faces. Gemsbok regularly cross the high sand dunes to graze the plants that establish themselves between the dunes.

Canon EOS-1N, Canon EF 70–200mm lens, Canon Extender EF 1.4x, f/16 at 1/30 second, Fujichrome Velvia film

203 GEMSBOK

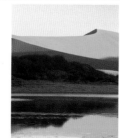

Once in a great while, rains come to the Namib-Naukluft Park desert, forming shallow lakes at the base of the vast sand dunes. Within days, waterfowl and flamingos miraculously appear. Here, the late-afternoon light accentuates the sand dunes' summits.

Fuji GX617, Fuji GX617 90mm lens, f/22 at 1/15 second, Fujichrome Velvia film

204–205 TEMPORARY LAKE

The trunks of ancient acacia trees in the Namibian desert serve as poignant reminders of an earlier time when the environment was wet enough to support vegetation. The extremely arid air literally mummifies the tree trunks, providing exquisite foreground elements for photography.

Canon EOS-1N, Canon EF 70–200mm lens, polarizing filter, 2-stop graduated neutral density filter, f/22 at 1/4 second, Fujichrome Velvia film

206 ACACIA TREE

Reminiscent of a Salvador Dali painting, two tree trunks stand in stark silhouette against the warm tones of the orange sand dunes in Sossusvlei in the Namibian desert. I love the way light and form blend in this austere landscape.

Canon EOS-1N, Canon EF 70–200mm lens, polarizing filter, f/22 at 1/8 second, Fujichrome Velvia film

207 ACACIA TREE

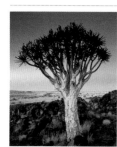

The pastel hues of post-sunset light provide an interesting complement to this simple composition of a single quiver tree atop a rocky outcrop in the Namibian desert. The quiver tree's compact form is perfectly adapted to this arid landscape.

Canon EOS-1N, Canon EF 17–35mm lens, 2-stop graduated neutral density filter, f/22 at 1/2 second, Fujichrome Velvia film

208 QUIVER TREE

A six-hour time exposure demonstrates how the stars move across the southern sky. The Southern Cross is used to locate the star at the center of the circular star paths just as the Big Dipper is used to locate the North Star in the northern hemisphere. A single quiver tree provides an interesting foreground element.

Canon EOS-1N, Canon EF 17–35mm lens, f/4 at 6 hours, Fujichrome Velvia film

209 STAR TRAILS

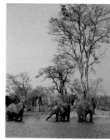

During a three-hour period, more than four hundred African elephants in various-size breeding herds came for a drink at this remote waterhole in northern Botswana's arid Chobe National Park.

Fuji GX617, Fuji GX617 90mm lens, f/22 at 1/60 second, Fujichrome Velvia film

210–211 ELEPHANT

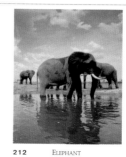

In Botswana's arid Savuti region, bull African elephants congregate at a waterhole from a man-made well. The Savuti River, a tributary of the Okavango River, went dry years ago. Humans interceded, providing water for the resident wildlife.

Canon EOS-1N, Canon EF 17–35mm lens, f/16 at 1/30 second, Fujichrome Velvia film

212 ELEPHANT

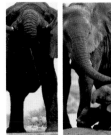

African elephants come for a drink at a few isolated waterholes in Namibia's Etosha National Park. Once their thirst is quenched, the elephants often linger at the water's edge. In Etosha, the elephants usually came to the water at the hottest time of day.

Canon EOS-1N, Canon EF 70–200mm lens, f/8 at 1/250 second, Fujichrome Velvia film

213 (both) ELEPHANT

In the Kalahari Desert of Botswana, South Africa, and Namibia, the highly endangered desert black rhinoceros clings to life; perhaps as few as three hundred are left. I stalked this rhino on foot, taking this portrait as the sun sank low over the flat landscape.

Canon EOS-1N, Canon EF 600mm lens, Canon Extender EF 1.4x, f/11 at 1/60 second, Fujichrome Velvia film

214 RHINOCEROS

Rhinoceroses and a variety of other African wildlife are etched in stone at a site known as Twyfelfontein in west-central Namibia. These ancient carvings, perhaps 6,000 years old, have been well preserved in the dry desert environment.

Canon EOS-1N, Canon EF 100mm Macro lens, f/16 at 1/30 second, Fujichrome Velvia film

215 PETROGLYPHS

For the warlike Bumi of Ethiopia, who frequently fight over grazing territory, men use scarification to indicate that they have killed an enemy. Bumi women use it as adornment.

Canon EOS-1N, Canon EF 70–200mm lens, f/16 at 1/15 second, Fujichrome Velvia film

216 BUMI TRIBE

Ankle bracelets along with arm- and wristbands are common among Ethiopia's Karo tribe.

Canon EOS-1N, Canon EF 70–200mm lens, f/8 at 1/60 second, Fujichrome Velvia film

217 (left) KARO TRIBE

Three young Hamar women of Kenya are adorned in everyday wear complete with necklaces of dried seeds and beads and metal arm- and wristbands. Their hairstyles are a combination of clay- and oil-coated braids.

Canon EOS-1N, Canon EF 70–200mm lens, f/16 at 1/30 second, Fujichrome Velvia film

217 (right) HAMAR TRIBE

Using various colors of clay mixed with water, Karo tribesmen adorn themselves to celebrate a marriage in their village. I have always been fascinated by how inventive technologically primitive societies can be with natural elements.

Canon EOS-1N, Canon EF 70–200mm lens, f/11 at 1/60 second, Fujichrome Velvia film

218 KARO TRIBE

So-called primitive art is actually very sophisticated in its use of color, form, and texture.

Canon EOS-1N, Canon EF 70–200mm lens, f/11 at 1/60 second, Fujichrome Velvia film

219 KARO TRIBE

Karo tribesmen place a great emphasis on their hair and head décor. These tribesmen show a range of styles and colors. With each composition, I have tried to emphasize what I felt was the individual's most interesting feature.

Canon EOS-1N, Canon EF 70–200mm lens, f/11 at 1/125 second, Fujichrome Velvia film

220 (both) KARO TRIBE
221 (both) KARO TRIBE

For Hamar men hairstyle signifies status and courage. Clary buns are worn only by those who have killed an enemy or a large cat. This tribesman's earrings indicate that he has four wives.

Canon EOS-1N, Canon EF 70–200mm lens, f/11 at 1/30 second, Fujichrome Velvia film

222 HAMAR TRIBE

In an attempt to achieve an unusual perspective while also trying to break the ice with the village through it's children, I laid on my back in the center of a Bumi village. Eventually the curious children approached to discover what this strange man was up to.

Canon EOS-1N, Canon EF 17–35mm lens, f/8 at 1/30 second, fill flash, Fujichrome Velvia film

223 BUMI TRIBE

Adamson, Joy. *Born Free*. Glasgow, Scotland: William Collins Sons and Company, 1960.

Alden, Peter. *African Wildlife*. New York: HarperCollins, 1997.

Alden, Peter C., Richard D. Estes, Duane Schlitter, and Bunny McBride. *National Audubon Society Field Guide to African Wildlife*. New York: Alfred A. Knopf, 1995.

Allan, Tony, and Andrew Warren, eds. *Deserts: The Encroaching Wilderness: A World Conservation Atlas*. New York: Oxford University Press, 1993.

Bonner, Raymond. *At the Hand of Man*. New York: Vintage Books, 1993.

Caro, Timothy M. *Cheetahs of the Serengeti Plains: Group Living in an Asocial Species*. Chicago: Unversity of Chicago Press, 1994.

Chadwick, Douglas H. *The Fate of the Elephant*. Toronto, Canada: Key Porter Books, 1992.

Cheney, Dorothy L., and Robert M. Seyfarth. *How Monkeys See the World*. Chicago: Unversity of Chicago Press, 1990.

Cloudsley–Thompson, J. L. *Sahara Desert*. New York: Pergamon Press, published in collaboration with the International Union for Conservation of Nature and Natural Resources, 1984.

Collins, Mark. *The Last Tropical Rain Forest*. Oxford: Oxford University Press, 1990.

Davidson, Basil. *Africa in History*. New York: Simon and Schuster, 1995.

De Waal, Frans B.M., and Frans Lanting. *Bonobo: The Forgotten Ape*. Berkeley: University of California Press, 1997.

Dinesen, Isak. *Out of Africa*. New York: Random House, 1938.

Dixson, Alan F. *The Natural History of the Gorilla*. New York: Columbia University Press, 1981.

Estes, Richard Despard. *The Behavior Guide to African Mammals*. Berkeley: University of California Press, 1991.

Fossey, Dian. *Gorillas in the Mist*. Boston: Houghton Mifflin Company, 1983.

Frame, George W., and Lory H. Frame. *Swift and Enduring: Cheetahs and Wild Dogs of the Serengeti*. New York: Dutton, 1981.

Ghiglieri, Michael Patrick. *East of the Mountains of the Moon: Chimpanzee Society in the African Rain Forest*. New York: The Free Press, 1988.

Gilders, Michelle A. *The Nature of Great Apes*. Vancouver, B.C. Canada: Greystone Books, 2000.

Goodall, Jane. *Through a Window: My Thirty Years with the Chimpanzees of Gombe*. Boston: Houghton Mifflin Company, 1990.

———. *The Chimpanzees of Gombe: Patterns of Behavior*. Cambridge, Mass.: Belknap Press of Harvard University Press, 1986.

Goodall, Jane, and Hugo van Lawick. *Innocent Killers*. Glasgow, Scotland: William Collins Sons and Company, 1970.

Grinker, Roy Richard, and Christopher B. Steiner. *Perspectives on Africa: A Reader in Culture, History and Representation*. Oxford: Blackwell Publishers, 1997.

Grzimek, Bernhard, and Michael Grzimek. *Serengeti Shall Not Die*. Glasgow, Scotland: William Collins Sons and Company, 1964.

Harvey, C. *Beyond the Endless Mopane: A Photographic Safari Through Livingstone's Africa*. Stillwater, Minn.: Voyageur Press, 1997.

Hemingway, Ernest. *Green Hills of Africa*. London: Jonathan Cape, 1936.

Huxley, Elspeth Joscelin Grant. *Flame Trees of Thika: Memories of an African Childhood*. London: Chatto and Windus, 1987.

Iwago, Mitsuaki. *Serengeti: Natural Order on the African Plain*. San Francisco: Chronicle Books, 1996.

Joubert, Dereck, and Beverly Joubert. *Hunting with the Moon: The Lions of Savuti*. Washington, D.C.: National Geographic Society, 1997.

Kruuk, Hans. *The Spotted Hyena*. Chicago: University of Chicago Press, 1972.

Lanting, Frans. *Okavango: Africa's Last Eden*. San Francisco: Chronicle Books, 1993.

Leakey, Richard, and Roger Lewin. *Origins Reconsidered: In Search of What Makes Us Human*. New York: Doubleday, 1992.

Leakey, Richard E. *The Making of Mankind*. London: Michael Joseph, 1981.

Markham, Beryl. *West with the Night*. Boston: Houghton Mifflin Company, 1942.

Martin, Claude. *The Rainforests of West Africa: Ecology, Threats, Conservation*. Boston: Birkhauser Verlag, 1991.

Matthiessen, Peter. *The Tree Where Man Was Born*. New York: Dutton, 1983.

Moss, Cynthia. *Elephant Memories: Thirteen Years in the Life of an Elephant Family*. New York: William Morrow and Company, 1988.

Moss, Cynthia, and Martyn Colbeck. *Echo of the Elephants: The Story of an Elephant Family*. New York: William Morrow and Company, 1992.

Murray, Jocelyn, ed. *Cultural Atlas of Africa*. Oxford: Phaidon Press, 1988.

Nowak, Ronald M. *Walker's Mammals of the World*. Baltimore: John Hopkins University Press, 1999.

Owens, Delia, and Mark Owens. *The Eye of the Elephant: An Epic Adventure in the African Wilderness*. Boston: Houghton Mifflin Company, 1992.

Rasa, Anne. *Mongoose Watch: A Family Observed*. London: John Murray, 1984.

Ross, Karen. *Okavango: Jewel of the Kalahari*. London: BBC Books, 1987.

Sayer, Jeffery A., Caroline S. Harcourt, and N. Mark Collins. *The Conservation Atlas of Tropical Forests: Africa*. New York: Simon and Schuster, 1992.

Schaller, George B. *The Year of the Gorilla*. Chicago: University of Chicago Press, 1988.

———. *The Serengeti Lion*. Chicago: University of Chicago Press, 1972.

———. *The Mountain Gorilla: Ecology and Behavior*. Chicago: University of Chicago Press, 1963.

Serle, William. *Field Guide to the Birds of West Africa*. London: Collins, 1977.

Sinclair, John Coffey, Phil Hockey, and Warwick Tarboton. *Birds of Southern Africa*. Princeton, N.J.: Princeton University Press, 1993.

Smuts, Barbara B., Dorothy L. Cheney, et al. eds., *Primate Societies*. Chicago: University of Chicago Press, 1987.

Strum, Shirley C. *Almost Human: A Journey into the World of Baboons*. New York: W. W. Norton, 1987.

Stuart, Chris, and Tilde Stuart. *Africa's Vanishing Wildlife*. Washington, D.C.: Smithsonian Institution Press, 1996.

Thomas, Elizabeth Marshall. *The Harmless People*. New York: Vintage Books, 1989.

Tingay, Paul. *Wildest Africa*. New York: St. Martin's Press, 1966.

Van der Post, Laurens. *A Far-Off Place*. New York: William Morrow and Company, 1974.

———. *A Story Like the Wind*. New York: William Morrow and Company, 1972.

Western, David. *In the Dust of Kilimanjaro*. Washington, D.C.: Island Press, 1997.

Williams, John George. *Field Guide to the Birds of East Africa*. London: Collins, 1980.

Wolfe, Art, William Conway, et al. *The Living Wild*. Seattle, Wash.: Wildlands Press, 2000.

Wolfe, Art, and Sir Ghilean Prance. *Rainforests of the World*. New York: Crown Publishers, 1998.

Wolfe, Art, and Deidre Skillman. *Tribes*. New York: Clarkson Potter Publishers, 1997.

Wolfe, Art, and Barbara Sleeper. *Primates*. New York: San Francisco: Chronicle Books, 1997.

———. *Wild Cats of the World*. New York: Crown Publishers, 1995.

Africa Conservation Centre
P.O. Box 62844
Nairobi, Kenya
Tel: 254-2-891360
Fax: 254-2-891751
acc@acc.or.ke

African Wildlife Foundation
1400 16th Street N.W.,
 Suite 120
Washington, DC 20036 USA
Tel: 888-494-5354
Fax: 202-939-3332
africanwildlife@awf.org
www.awf.org

Conservation International
1919 M Street N.W.,
 Suite 200
Washington, DC 20036 USA
Tel: 202-912-1000
Fax: 202-912-1030
www.conservation.org

Cultural Survival
215 Prospect Street
Cambridge, MA 02139 USA
Tel: 617-441-5400
Fax: 617-441-5417
csinc@cs.org
www.cs.org

Dian Fossey Gorilla Fund
 International
800 Cherokee Avenue S.E.
Atlanta, GA 30315 USA
Tel: 404-624-5881
Fax: 404-624-5999
2help@gorillafund.org
www.gorillafund.org

East African Wildlife Society
P.O. Box 20110
Nairobi, Kenya
Tel: 254-2-574145
Fax: 254-2-570335
www.eawildlife.org

Friends of the Earth-U.S.
1025 Vermont Avenue N.W.,
 Third Floor
Washington, DC 20005 USA
Tel: 877-843-8687
Fax: 202-783-0444
foe@foe.org
www.foe.org

International Rhino Foundation
14000 International Road
Cumberland, OH 43732 USA
Tel: 740-638-2059
Fax: 740-638-2287
IrhinoF@aol.com
www.rhinos-irf.org

International Society for the
 Preservation of the Tropical
 Rainforest (ISPTR)
3931 Camino de la Cumbre
Sherman Oaks, CA 91423 USA
Tel: 818-788-2002
Fax: 818-990-3333
forest@nwc.net
www.isptr-pard.org

IUCN-The World Conservation
 Union
Rue Mauverney 28
CH-1196 Gland, Switzerland
Tel: 41-22-999-00-01
Fax: 41-22-999-00-02
mail@hq.iucn.org
www.iucn.org

The Jane Goodall Institute
P.O. Box 14890
Silver Spring, MD 20911-4890
 USA
Tel: 301-565-0086
Fax: 301-565-3188
goodall2@aol.com
www.janegoodall.org

Missouri Botanical Garden
4344 Shaw Boulevard
St. Louis, MO 63110
Tel: 314-577-5100
www. mobot.org

National Wildlife Federation
8925 Leesburg Pike
Vienna, VA 22184 USA
Tel: 703-790-4000
Fax: 703-790-4040
www.nwf.org

Natural Resources
 Defense Council
40 W. 20th Street
New York, NY 10011 USA
Tel: 212-727-2700
Fax: 212-727-1773
nrdcinfo@nrdc.org
www.nrdc.org

The Nature Conservancy
4245 N. Fairfax Drive,
 Suite 100
Arlington, VA 22203 USA
Tel: 703-841-5300
Fax: 703-841-1283
www.tnc.org

Rainforest Action Network
221 Pine Street, Suite 500
San Francisco, CA 94104 USA
Tel: 415-398-4404
Fax: 415-398-2732
rainforest@ran.org
www.ran.org

Rainforest Alliance
65 Bleecker Street, Sixth Floor
New York, NY 10012 USA
Tel: 212-677-1900
Fax: 212-677-2187
canopy@ra.org
www.rainforest-alliance.org

Smithsonian Tropical Research
 Institute (STRI)
1100 Jefferson Drive,
 Suite 3123
Washington, DC 20560 USA
Tel: 202-786-2817
Fax: 202-786-2819
www.stri.org

Wildlife Conservation Society
 (WCS)
2300 Southern Boulevard
Bronx, New York 10460 USA
Tel: 718-220-5100
Fax: 718-364-4275
feedback@wcs.org
www.wcs.org

World Wildlife Fund (WWF)
1250 24th Street N.W.,
 Suite 500
Washington, DC 20037 USA
Tel: 202-293-4800
Fax: 202-293-9211
www.worldwildlife.org

For additonal links to extensive
wildlife and environmental
resources on the Internet, visit
www.michellegilders.com

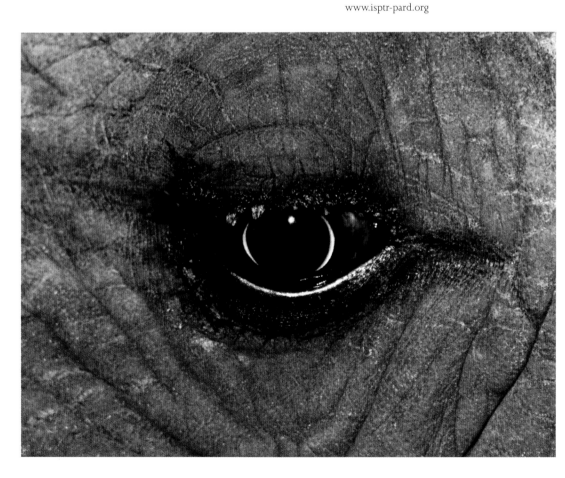

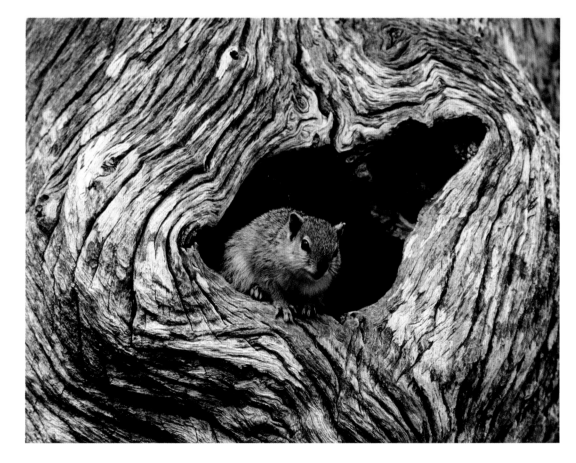

D E D I C A T I O N

To all those individuals and organizations working so tirelessly to ensure Africa's continued diversity-biological and cultural.

Despite the enormous challenges, it is because of you that we all have reason for hope. —A.W.

To Mum, Dad, Chris, Fiona, and Ellen—in the hope that one day each of you will get to see the wonders of Africa for yourself. —M.G.

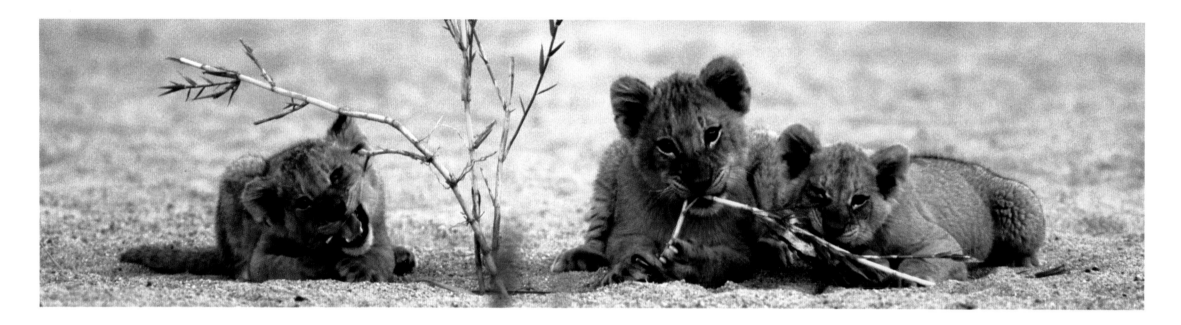

First edition published 2001 by Wildlands Press, an imprint of
Art Wolfe, Inc.

Distributed in the United States and Canada by
Publishers Group West

Printed and bound in Italy by Conti Tipocolor Arti Grafiche

10 09 08 07 06 05 04 03 02 01 10 9 8 7 6 5 4 3 2 1

Design and Typography: Elizabeth Watson

Digital Production and Scanning: Getty Images/Seattle–Richelle
Barnes, Matthew Flor, Jason Wiley, Lou Kings, Johnny Hubbard,
Stacey Lester, Curt Waller, Tim Perciful, Jay Sakamoto

Copyediting and Proofreading: Marlene Blessing and Kris Fulsaas

Production Editing: Louise Helmick

Indexing: Randl Ockey

Publicist: Alice B. Acheson

Science Advisor: Gary M. Stolz, Ph.D., U.S. Fish & Wildlife Service

Product Development: Craig Scheak

Photo Editor: Deirdre Skillman

Accounting: Lisa Woods

Project Planner: Christine Eckhoff

Image Management and Digital Prepress: Gilbert Neri, Art Wolfe, Inc.

Executive Editor: Ray Pfortner, Wildlands Press

For more information about Art Wolfe and his photographs,
visit www.ArtWolfe.com

Front cover–Burchell's zebra (*Equus burchelli*) and common wildebeest
(*Connochaetes taurinus*), Ngorongoro Crater Conservation Area,
Tanzania; p. 1–mountain gorilla (*Gorilla beringei beringei*),
Parcs National des Volcans, Rwanda; p. 2 (left)–lion (*Panthera leo*),
Ngorongoro Conservation Area, Tanzania; p. 3 (right)–Samburu
Moran, North-Central Kenya; p. 235 (left)–black rhinoceros
(*Diceros bicornis*), Ngorongoro Conservation Area, Tanzania;
p. 235 (right)–tree hyrax (*Dendrohyrax arboreus*), Ngorongoro
Conservation Area, Tanzania; p. 236–lion (*Panthera leo*), Kruger
National Park, South Africa; p. 238–Surma tribe, Lower Omo
River, Ethiopia; p. 239–Grevy's zebra (*Equus grevyi*), Samburu
National Reserve, Kenya; p. 240–Karo tribe, Lower Omo River,
Ethiopia; back cover–Masai Moran, Mara River region, Kenya

Wildlands Press
1944 First Avenue South
Seattle, WA 98134, USA
Phone: 888-973-0011
Fax: 206-332-0990
info@WildlandsPress.com
www.WildlandsPress.com

Library of Congress Cataloging-in-Publication Data

Wolfe, Art.
 Africa / Art Wolfe ; foreword by Jane Goodall ; text by Michelle
Gilders.
 p. cm.
 Includes bibliographical references (p.) and index.
 ISBN 0-9675918-1-3
 1. Africa—Pictorial Works. I. Gilders, Michelle A., 1966- II.
Title.

DT4.5 .W65 2001
960'.022'2—dc21

 2001026588

ACKNOWLEDGMENTS

PRODUCTION TEAM: Alice B. Acheson, Richelle Barnes, David Bentley,
Marlene Blessing, Nancy Duncan-Cashman, Christine Eckhoff, Joseph Eckhoff,
Matthew Flor, Kris Fulsaas, Louise A. Helmick, Johnny Hubbard, Lou Kings,
Stacey Lester, Gilbert Neri, Randl Ockey, Tim Perciful, Ray Pfortner,
Jay Sakamoto, Craig Scheak, Gary M. Stolz, Deirdre Skillman, Curt Waller,
Elizabeth Watson, Jason Wiley, Lisa Woods

ART WOLFE, INC. STAFF: Mel Calvan, Kate Campbell, Riko Chock, Chistine Eckhoff, Gavriel Jecan,
Gilbert Neri, Ray Pfortner, Craig Scheak, Deirdre Skillman, Lisa Woods. Interns: Kathy Borson,
Rita Brown, Kathy Cohen, Jason Holappa, Deborah Kielb, Alexis Wolfe

EDITIONS NATHAN, PARIS, for partnering with us so graciously once again to bring another Art Wolfe book
to France: Veronique Delisle, Dominique Korach, Eveylne Mathiaud, Michele Reby

HARVILL PRESS, LONDON, our co-publisher extraordinaire which did so much to make this book a reality:
Paul Baggaley, Andrea Belloli, Christopher McLehose, Simon Rhodes, Barbara Schwepcke, Margaret Stead

Lee Berger, Desmond Berkowitz, Alan Bernstein, Mike Fender, Mike Jacobs, Johan le Roux, Brown Mathew
ole Suya, Marilyn Paver, Michael Parver, Freeman Patterson, Alex Peltier, Cathy Schloeder, Doug Stewart,
Laurie Strydon, David Turton, Johann J. van Heerden, J.P. Vande Weghe

Ellen Riechsteiner (*All Around Travel, Seattle*); Dave Metz and Michael Newler (*Canon USA*); Natalie Abratt,
Anne Lee, Tracy Shapiro, David Stogdale, Dave Varty, and the many guides and drivers who gave their
expertise (*Conservation Corporation Africa*); Sandra Colosimo and everyone involved with the printing and binding
of this book (*Conti Tipocolor, Florence*); Patrick Donehue (*Corbis*); Steve Turner (*East Africa Ornithological Safaris*);
Elisabeth C. Miller Library, Center for Urban Horticulture, University of Washington; Marya Dominik and
Krista Letter (*Federal Express, Seattle*); Jane Goodall and Mary Lewis (*Jane Goodall Institute*); Mike Kirkinis
(*Kwando Camp*); Sally Cloke (*Kwando Lagoon Camp*); Cathy and Norman Galli (*Kwando Lebala Camp*); Katherine and
John Wreford Smith (*Mpala Ranch*); David Azose (*Photobition, Seattle*); Judi Baker, Heather Cameron, Mark Ouimet
(*Publishers Group West*); Lucy Dorick, Marlane Liddell, Ed Rich (*Smithsonian Institute*); South African Airways;
Travis Luther, Diane Shearer, Irene Swift (*Sudden Printing, West Seattle*); Giselle Lathourakis (*Tabula Rasa Press*);
William Conway, Amy Vedder, Bill Weber (*Wildlife Conservation Society*)

Monika Thaler (*Frederking and Thaler Verlag, Munich*) for never-ending advice and encouragement.

Mark Getty and Jonathan Klein (*Getty Images*) for their continuing support.

Special thanks to Charles Merullo (*Getty Images/London*), for believing in this book long before
anyone else did and for helping so much to make it all happen.

—A.W.

I would like to thank the many people who offered their time to review the text of this book, in various stages of completion. Particular thanks go to Delano Arvin, Anne Brown, Doug and Gail Cheeseman (*Cheeseman's Ecology Safaris*), Dr. Chris Herlugson, Carol Klein, Dr. E. J. Milner-Gulland (*Imperial College, London*), Russell Mumford, Jennifer Parnell, Jennifer Purl, Gary M. Stolz (*U.S. Fish and Wildlife Service*, and an associate professor at the University of Idaho), Declan Troy, Claire Waddoup, and John Wilson. Each offered suggestions that helped considerably in getting to the final work; I am forever grateful that many, although scattered across the globe, are enduring friends. I would also like to thank Art Wolfe and Ray Pfortner and the rest of the staff at Art Wolfe Incorporated for their help throughout. Marlene Blessing offered her editorial skills to improve my text, and to Americanize my turn of phrase. Any mistakes in the text and captions remain my own.

Thanks and a great deal of love, as always, go to my family, for reading whatever I send their way, and always responding with unwavering support. —M.G.

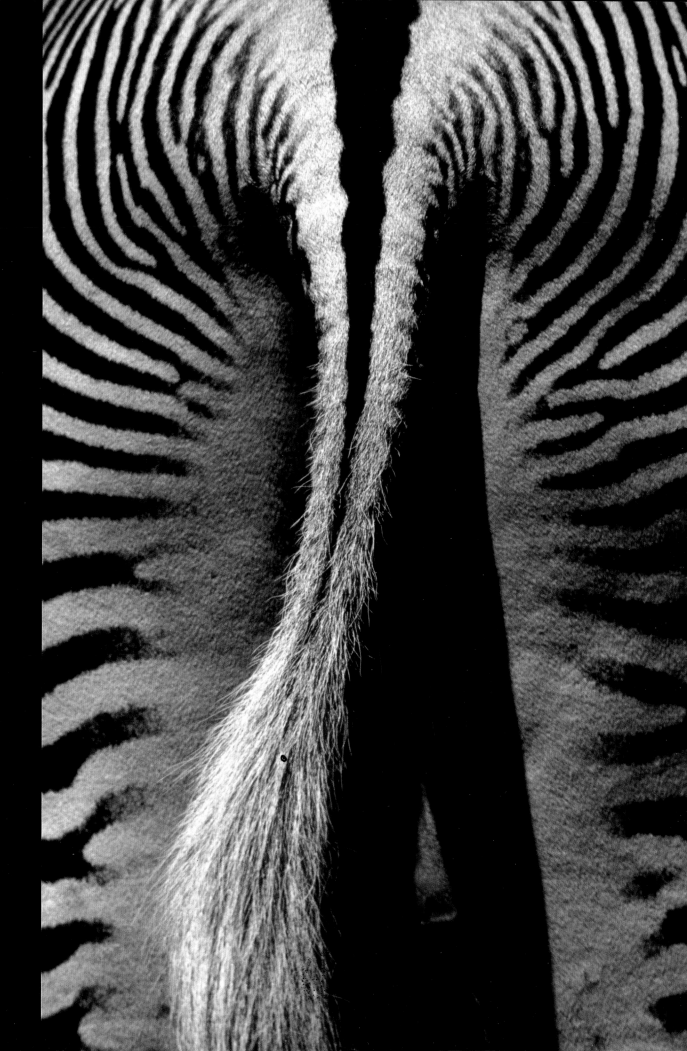

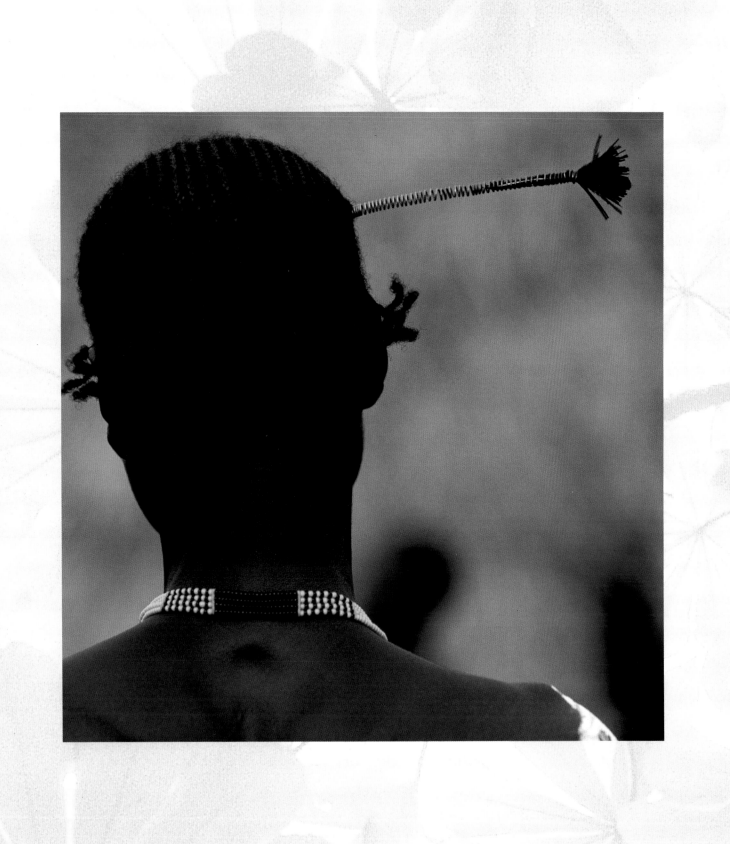